TERRENCE MALICK

Terrence Malick
Rehearsing the Unexpected

Edited by Carlo Hintermann and Daniele Villa,
in collaboration with Luciano Barcaroli and Gerardo Panichi

FABER & FABER

First published in 2015
by Faber & Faber Ltd
Bloomsbury House
74–77 Great Russell Street
London WC1B 3DA

Typeset by Ian Bahrami
Printed in England by CPI Group (UK) Ltd, Croydon CR0 4YY

A CIP record for this book
is available from the British Library

ISBN 978-0-571-23456-1

FSC
www.fsc.org
MIX
Paper from
responsible sources
FSC® C101712

Dedicated with gratitude to Franco Quadri

In memory of Arthur Penn, Irvin Kershner, Stevan Larner

Contents

Illustrations

Acknowledgements

A great many people made this book possible. Our deepest thanks go to Terrence Malick and his wife Alexandra 'Ecky' Malick. During the long gestation period of this book, they never ceased to support and advise us. We got to know Terrence Malick's deep humility, as well as his generosity since he opened the door to the numerous collaborators who make his cinema what it is. They played a fundamental part in the making of this book. We must emphasize that Terrence Malick was not involved in the creation of the book: it stemmed from our own desire to understand and introduce the reader to the extraordinary universe of his filmmaking.

We would also like to extend our thanks to Terrence Malick's assistants, Sandhya Shardanand and Tyler Savage, whose help over the years proved indispensable. Sarah Green and Nicolas Gonda, the producers of Malick's latest films, greatly supported us in the creation of this book. Lastly, our deepest acknowledgements go to all the interviewees, whose voices offered a personal, unique vision of Malick's cinema and of cinema in general.

We would never have been able to complete this book without the help of Miranda Saccaro, assistant to the editors, and Maria Galante, editorial assistant.

Days of Heaven chapter:
Richard Gere's contributions are extracts from the interview done by Kim Hendrickson for the *Days of Heaven* DVD distributed by Criterion, 2007.

Nestor Almendros's contributions are extracts from his autobiography *A Man with a Camera*, translated by Rachel Phillips Belash, Faber and Faber, 1984.

ACKNOWLEDGEMENTS

The Thin Red Line chapter:
The contributions of John Toll are extracts from the interview
by Stephen Pizzello 'The War Within', *American Photographer*,
February 1999.

Introduction

This book is not meant to be a biography of Terrence Malick. From the very first moment when we started working on this project, we understood that Malick's decision not to speak about his filmmaking is deeply rooted in his conviction that films should speak for themselves, and live beyond the single event of a screening. We could not but respect this decision. Rather than Malick's voice, the core of this book comes from the words of his closest collaborators and friends – cinematographers, set designers, costumers, cameramen, directors, producers, intellectuals, and actors – all of which form a fascinating, kaleidoscopic vision of American film in general and Malick's work in particular.

Through their voices, Malick's filmmaking loses the dimension of mystery often attributed to it, that it is the fruit of a reclusive man, distanced from his contemporaries. Instead, the work comes into focus as the product of a tight network of exchanges among collaborators who share a vision of film – and of life itself. This mirrors Malick's artistic growth: there is a continuous development throughout his filmmaking, culminating in the latest films that Doug Trumbull – director, producer and pioneer of visual effects – defines as 'Hypercinema', a kind of expanded cinema where the film does not just fade out on the screen, but continues to generate new ideas in the audience.

This book is the fruit of a journey begun years ago when a group of friends started to think about making a documentary on Terrence Malick. We four friends, Luciano Barcaroli, Carlo Hintermann, Gerardo Panichi and Daniele Villa, were working together at the historic Italian publishing house Ubulibri under the guidance of the late Franco Quadri, a great friend, mentor and intellectual. We wanted to make our first documentary. After

having edited books on Otar Ioseliani, David Lynch and Takeshi Kitano, we chose Terrence Malick as our subject since his films were a kind of prism through which we could view American cinema.

The next step was breaking through Malick's diffidence for such a project. We met in Milan in 2001 at a screening of the restored copy of *Badlands* organized by our friend Enrico Ghezzi during the *Milanesiana* event. From that moment, our friendship has deepened year after year. In 2002, the film *Rosy-Fingered Dawn: A Film on Terrence Malick*, directed by Luciano Barcaroli, Carlo Hintermann, Gerardo Panichi and Daniele Villa, was presented at the Venice Film Festival. Then our work on this book began.

During this journey, we have had the occasion to meet and exchange ideas with some of the most interesting personalities in cinema, and as a result we have grown. For this, we are most grateful.

We also had the pleasure of collaborating with Terrence Malick artistically, producing the Italian unit of *The Tree of Life*. This experience strengthened our friendship with some of Malick's long-time collaborators and allowed us to observe, up close, the making of his following film, *To the Wonder*, to lend a hand when needed and to receive help in turn with our own projects.

At this point in our journey, it is difficult to observe Terrence Malick's work from a distance. This sensation of being drawn into his world is exactly what a more sensitive spectator feels when watching each of his films. We start to reassess our own lives and ask ourselves questions that would otherwise lie dormant.

Terrence Malick's films enable the audience to recognize his courage and humility as he follows his dream – a process which, in turn, enables him to open himself up to the influences and input of others.

As we wait for his next films to astound us, we're grateful to this man who is much more than just a filmmaker.

Introduction

We conclude this introduction with the words of Jack Fisk, the production designer of all Malick's films, who requested they be used as a preface to his contribution.

I would like to preface my answers by saying that it is uncomfortable for me to talk about Terry's work. The thoughts here are my own and may not reflect Terry's ideas. I wish more people could experience his working process and see his films come to life – I feel privileged and I am thankful.

Formation

Born in 1943 in Ottawa, Illinois, Terrence Malick spent his childhood in Oklahoma and Texas. He attended St. Stephen's Episcopal School in Austin, and in 1961 he began a philosophy course at Harvard University. In his first years at Harvard Terrence Malick met Jacob Brackman, with whom he lived at Adams House. Jacob Brackman went on to act as executive producer and second unit director on Malick's second feature film, Days of Heaven.

JACOB BRACKMAN

I first met Terrence Malick when I was eighteen years old, we were freshmen taking a course with Paul Tillich[1] called 'The Self-Interpretation of Man in Western Thought'. Each of us became friends with Paul Tillich's assistant, Paul Lee, who was a student of the Harvard Divinity School.[2] It wasn't until the following year, what we call the sophomore year, that we all got together. We both wound up at Adams House[3] at Harvard and saw each other in the dining hall and in the library. I mostly saw Terry in the library since he was always there; he was trying to catch up on things that he felt that everyone at Harvard had read but he had not, including *Winnie the Pooh*. I remember we met after we had each seen the Alain Resnais film *Last Year at Marienbad*.[4] We both had been captivated by the match game that the protagonists play in the film. There are one, three, five, seven matches in rows and the person who is left with the last match loses. So we were kind of hustling each other at this game, pretending we didn't know how to do it, but we both knew how to do it. I would say that was the beginning of our friendship; we were nineteen then.

I

Although I started out thinking I would major in Philosophy
– which is what Terry did – I ended up in American History and
Literature. The atmosphere in Harvard was about to undergo a
big change. John Kennedy was the President but before he was
assassinated and before there was anything like hippies, there
was the tail end of the previous culture. You could say there
was a Beatnik element, a kind of rebellious thing, James Dean
rebelliousness. Several years later people were going to the South
for civil rights, they were marching against the bomb, but that
was just a new element, the main atmosphere in that period was
very much still the 1950s – 'Eisenhower America'. Among the
professors, another person we were both very close to was a
philosophy professor, Stanley Cavell. Stanley was never actually
a teacher of mine, he was just a friend, but he was Terry's teacher
and ultimately Terry's tutor and the supervisor of his Honours
thesis. At that time he was between marriages and so was liv-
ing in Adams House and he had a daughter who would come
and visit him. He was open to friendships with undergraduates
though that all ended for him in the 1968 revolutions. Terry and
I didn't spend time with him together, just separately – there was
probably a little rivalry for his affection. He is somebody who
has since written a number of books about movies.

Stanley and I were interested in movies and we would talk
about them – this was before either of us had any professional
interest in them, although I reviewed movies for the college
paper, the *Harvard Crimson*, and some of the things that I said
in my reviews were influenced by conversations I had had with
Stanley. This was before he had ever published anything and
he was still struggling to work out what he felt he could write.
Several years later he started to write and has written prolifically
ever since. But even before Stanley started publishing his key
studies, Terry thought that he was one of the significant figures
in contemporary American philosophy. There was a whole cir-
cle of people around him who were mostly graduate students
in philosophy and Terry became part of that circle. There was

another Harvard professor who made a very strong impact on me, William Alfred[5] who was a playwright and taught playwriting, but the course included a whole lot of movies. He was very close to Robert Lowell,[6] and he wrote a play called *Hogan's Goat*[7] that Faye Dunaway starred in. The conversations with Stanley Cavell about movies and the impact of William Alfred's teaching were two elements that made me think about cinema. As an undergraduate, Terry did not show interest in cinema as a profession. He was involved in theatre in the sense that he played Malvolio in *Twelfth Night*. But I don't recall theatrical activity or any particular bent towards movies. I would say he was possibly more interested in writing.

In 1965 Terrence Malick was awarded a degree in philosophy with summa cum laude *and Phi Beta Kappa honours,[8] after having spent one year in Germany. He then won a Rhodes Scholarship[9] to Oxford University, where he worked, under the supervision of Professor Gilbert Ryle, on his PhD thesis on the concept of the world in Kierkegaard, Heidegger and Wittgenstein. After leaving Oxford, Malick taught philosophy at the Massachusetts Institute of Technology in Cambridge, standing in for Professor Hubert Dreyfus, who was on leave for one year. The course was mainly on Heidegger – Professor Dreyfus being one of the main exponents of Heidegger's thought in America.[10] This teaching stint concluded with the English translation of Heidegger's* Vom Wesen des Grundes – The Essence of Reason – *published in 1969 for the Northwestern University Press in a bilingual edition. The spell teaching kept Malick and Jacob Brackman apart for some years. However, the two met again when they both started working on* The New Yorker *magazine, where they also met one of the most important editors of the time, William Shawn.*

JACOB BRACKMAN

I wouldn't exactly say that Terrence Malick was starting a career as a journalist – but even while he was still at Oxford, he was

a stringer for *Newsweek*, so he was kind of floundering around at that point trying to figure out what to do. He and I were on *The New Yorker* magazine together, we wrote a piece together when Martin Luther King was killed, and another one when Robert Kennedy was killed, which wasn't published. This was all around 1968, and in that period he was working on a major piece of journalism regarding Che Guevara and Régis Debray.[11] He interviewed Régis Debray at length in Bolivia. He did an enormous amount of work on this project. But for one reason or another, it never came to fruition. This article on Guevara was a big undertaking for someone who didn't have that much experience as a journalist – extremely ambitious. I think Terry didn't want to undertake such a complex job again without completing it. Anyway the relationship with the editor of *The New Yorker*, William Shawn,[12] was very important for both of us. Mr Shawn was very sensitive, shy, and extremely polite and I think that his temperament influenced Terry a lot; in my opinion, it kind of smoothed Terry's own temperament, which, at the time, was a kind of 'hail fellow well met' from Texas. Anyway, at this point in his life Terry was thinking about what he could do with himself: he was not happy with the idea of the academic life; he was thinking about being a writer, but I think he found the loneliness that writing demanded a little bit frustrating as opposed to movies. He would use the analogy: 'In movies you set everything up and then there are so many people around you doing their job, that it all just sort of carries you downstream, all you do is just put your raft in the river and then you just go downstream, day after day what you have to do is spend your time rafting. It's all there in front of you, as opposed to the blank sheet of paper that a writer faces.'

Along with Jacob Brackman, who in the late 1960s wrote critical film reviews for The New Yorker, *Terrence Malick began to be interested in movies. At the same time, the American Film Institute established a school where film direction was taught*

4

both from a practical and theoretical point of view. The school's director was George Stevens, Junior, the son of the filmmaker George Stevens. The school was not structured around a university degree: it was mainly focused on forming new directors who already had a solid university foundation. Terrence Malick, Paul Schrader and, some years later, David Lynch were among its alumni.

GEORGE STEVENS, JR

I had come to work for the Kennedy administration, heading the film division of the USIS (the United States Information Agency) at the time that the National Endowment for the Arts was created. Nobody knew quite what to do about film, so I proposed the American Film Institute, the AFI, and was asked to be its founder. There were many aspects to the AFI: in Washington we had the film preservation programmes, education programmes, a magazine called *American Film*, while the conservatory for filmmakers was based in Los Angeles. There were film training programmes in several universities at the time – at the universities of California, Los Angeles, New York, Southern California and Columbia – and we saw ours as not being in competition with them, but more of a bridge between the learning of filmmaking and the practice of filmmaking. We started with the idea of having what we called a 'tutorial approach' where great filmmakers would come and share their knowledge with the students, or 'fellows' as we called them. Seminars were held by filmmakers like Harold Lloyd, King Vidor, George Stevens, William Wyler, Billy Wilder, Federico Fellini, and Ingmar Bergman. It was a wonderful atmosphere. In one important way the AFI was different from the other universities: the people who came to AFI had mostly completed their college education and were simply concentrating on learning filmmaking at our conservatory, whereas the people at UCLA or USC were doing their undergraduate work or graduate studies in many different subjects.

Another important thing is that in selecting people for the AFI,

we were less interested if they knew how to focus a camera or operate a moviola; we were interested in what kind of people they were, what they would bring to the film medium once they learnt how to do it and I think that Terrence Malick, David Lynch and Paul Schrader are all good examples of choosing people who really had some artistic and intellectual sensibility that would make them interesting filmmakers, rather than film mechanics.

JACOB BRACKMAN

It was I who 'brought' Terry to the AFI. I had written a long piece in *The New Yorker* about *The Graduate*,[13] and as a result of that I had been engaged by George Stevens, Jr as a consultant in about 1968–69. My job was to help organize and admit the first class of the Center for Advanced Film Studies. They had inherited a greystone mansion in Beverly Hills. First of all I urged Terry to make a film and apply – he was at this point in Cambridge, teaching at MIT – which he did. I was on the Admissions Committee for that first year of fellows; my speciality was writing about movies, rather than making movies. Paul Schrader was selected for the same class and also the cinematographer Caleb Deschanel[14] and the screenwriter Thomas Rickman.[15] There were ten people in that first class who went on to careers in the movie business. When we were discussing the selection, I remember telling George Stevens: 'Terry Malick is the most likely to succeed of anybody I have ever met.' And, at the end, George and Terry became lifelong friends.

GEORGE STEVENS, JR

I remember having a conversation with Terry on the terrace of our headquarters – it was the late '60s and everybody was expressing certain kinds of attitudes and I remember that Terry was the only one out of all the applicants who came for the interview wearing a coat and tie. He was clearly an extremely interesting person, and he was such a well-rounded individual, in terms of his interests and knowledge. He loved European

cinema, but he was not unique in that way – it was the era of Truffaut, Antonioni, Fellini, Bergman – everyone had a knowledge of European cinema. An important point of reference for us was the Cinémathèque Française, and the work of its director, Henri Langlois. I had met Langlois at Cannes before the AFI was started and he was always railing at me about the importance of preserving American films so I would say that he influenced me and made me more aware of the problem we had in the US in terms of the absence of a programme for preserving films. The importance of the history of American cinema is something that we tried to convey to our students.

An important encounter for Terrence Malick in this period is that with Stevan Larner, who taught at the AFI. Larner became the third director of photography on Badlands, *after Brian Probyn and Tak Fujimoto had left.*

STEVAN LARNER

I first met Terry Malick at the American Film Institute in 1970–71. Terry had done some very interesting things in his life at that point, and he spoke beautiful French and Spanish. As a student, he was asking himself important questions, because the cinematography will tell the story better if you ask yourself why you are doing it in this way; otherwise it's liable to be pretentious, or the technique will get in the way of what you're trying to say. The audience will be too aware of the camera if it makes moves that aren't justified, or if the lighting doesn't have the proper quality, which is hard to define by just sitting here talking about it. It's something you have to previsualize; you have to decide what something should look like, what emotion you want the lighting to convey to the spectator. Cinematography is really like the pages in a novel, except it's much faster, the image has to really grab you, it really has to participate in the whole thing, and Terry understood this.

GEORGE STEVENS, JR

Terry had a very prodigious imagination – he was full of ideas – he knew his own mind. He wasn't always seeking approval or confirmation, he knew what he wanted to do and did it. I think that he had a good relationship with our teachers, like Tony Vellani,[16] who was a close friend of mine from Bologna and had worked in the US and had worked with my father, George Stevens. He was highly regarded in terms of a real knowledge of the creative aspect of storytelling and filmmaking. What was really important at that time was just the opportunity to be there, working on films and having people like Tony to discuss your scripts. The student also had an opportunity to see films every day and discuss them. The seminars were another important moment of confrontation. I'm sure, for example, that Terry met my father. He did a seminar at the AFI about *Gunga Din*[17] and they had conversations. I don't know which filmmakers influenced Terry, but I know that the seminars helped all the fellows in building a personal approach to filmmaking. I remember when Terry was shooting his student film *Lanton Mills*, he had Harry Dean Stanton and some other actors whom he got interested in working with him. It was a Western, and it was a very, very good student film. I think that any filmmaker who wants to put his own stamp on his work finds a way to maintain control over his projects and Terry found his own way. With every film that he has made, he has never ended up in a position of a studio changing his film. He has been very successful in finding the means of controlling his work, which makes it possible for each of his films to be his own personal statement.

MIKE MEDAVOY

In the late '60s Monte Hellman was directing a movie, or getting prepared to direct a movie called *Two-Lane Blacktop*,[18] and he was looking for a writer. I went to Monte Hellman's office at CBS and there was Terrence Malick's proposal on how to do this film. I read it and thought what a wonderful approach it had,

so I took his name down and then called him up on the phone and asked him if he had an agent. He was going to the American Film Institute, and he said no. He went around town and did his homework to find out who I was and what I was doing. At the time I represented George Lucas, Spielberg, Coppola, Robert Aldrich, Hal Ashby and a lot of actors like Donald Sutherland, Jane Fonda, and Gene Wilder. Also I represented a number of other people's interests in America, like Antonioni – I was his friend, and Truffaut's friend as well. So Terrence Malick decided to join in and I became his agent. Before he made *Badlands*, I worked with him looking for writing jobs. He wrote a film called *Deadhead Miles*,[19] *Pocket Money*,[20] the rewrite on *Dirty Harry*,[21] and other things like that.

JACOB BRACKMAN
Terry wrote a draft of *Great Balls of Fire*,[22] the Jerry Lee Lewis picture – Mike Medavoy got him that job – but I think hardly anything that Terry wrote was used; it was considered too dark. At that point, Terry and I were helping each other on whatever we were doing. I wrote *The King of Marvin Gardens*[23] which Bob Rafelson directed. It went to the New York Film Festival the year before *Badlands*.

At this point in his career, Malick encountered Irvin Kershner. Kershner, a teacher at the University of Southern California, had a very unconventional approach to filmmaking.

IRVIN KERSHNER
I never tried to find a style or anything, I let the script speak to me because every script speaks differently – some speak loudly, some speak softly and you have to listen to what is being said, not what actors say but the movement of the film, what the film is saying, and that becomes the style. All you are doing, really, is exploring the possibilities within you. I don't think you can get away from yourself. This is something that I said to Terry

when we first met. I remember he had just come to Los Angeles and he didn't have a place to live. We talked about his great-grandfather who was a kind of Armenian brigand, a revolutionary; we became friendly and saw each other a lot. He was very philosophical, very poetic, well-read – I loved it. The one thing I couldn't discuss with him was Heidegger! I never made sense of Heidegger and I'm not the only one. One day I was offered a script by Warner Bros called *Dirty Harry*. It was about a rogue cop, who takes the law into his own hands to shoot and kill little bad guys, guys who were trying to get some money out of a till of some little shop or little market or a gas station. The script was written by the husband-and-wife team Harry Julian and Rita Fink.[24] Warners said it needed a rewrite, so I was hired as the director and I went to Terry and we started talking about it. The thing that bothered me about *Dirty Harry* was that he was outside the law, which is okay as a dramatic device, but it better be for some good reason – to go out and kill little schmucks who were just doing the till wasn't good enough. Terry agreed – so I said: 'Why don't we have a rogue cop go after the big boys in the drug industry and start to kill them, don't kill the guys on the street! If you are going to kill somebody, kill that bastard who is way at the top!' It was a social statement, in a way. So Terry began to play with the script and we would meet and while that was being done the studio was moving ahead, they wanted me to find locations. Already I had in my mind what we were going to shoot and so we chose San Francisco and went there. We picked the rooftops because the protagonist was going to have a gun that he built to shoot from a long distance; and we changed Harry from a rogue cop to someone who wanted to be a cop very badly, who wanted to do some good, but couldn't get in, so he set himself the job of doing what the cops should be doing: getting the bad guys, the really bad guys at the top. The script developed in this direction. It was a very interesting script with a lot of unusual elements. So we started to build the sets in San Francisco, I had the rooftops picked out and meanwhile

the studios said to me: 'Who is going to be the star?' – that was
the big thing – 'This is Warner Bros. We do important pictures,'
and my first thought was: 'What about Marlon Brando?' He was
slender at that point and, of course, one of the greatest actors in
the world, so they authorized me to go to Brando and make a
deal. So I went and met him. He was lying in bed, dressed, open-
ing a refrigerator by the side of his bed and taking out a can of
something and drinking it. His Saint Bernard dog was walking
in and out, and jumping round the bed. He wanted me to tell
him the story, so I did and he said: 'Well, I'll tell you what I'll
do, I'll take it and read it and also give it to my adviser.' Well,
I found out that his adviser was his make-up man or someone
on his crew – 'I'll let you know.' I spent a couple of hours with
him, very cordial. I felt very honoured. I left, a week went by
and because Marlon Brando didn't call, I got a message from
the Studio: 'We want to do a picture with Steve McQueen, this
project is perfect for him – an angry Steve McQueen – we want
you to go and contact him.' Now, I happened to know Steve
McQueen, I'd gone to his house in Palm Springs and I once had
an office in his building, so my agent found him in Switzerland.
Before I contacted him, I asked Warners: 'What about Brando?'
'He's not going to do it,' they said, 'talk to McQueen', so I called
him. I said, 'I'm sending you a script,' he asked me: 'What's it
about?' and I replied, 'It's about a rogue guy who wants to be
a cop, I wrote it with a young talent, Terrence Malick,' and he
finished the conversation: 'Are you going to direct it? Okay, send
it!' The script was shipped to him. I talked with Terry about this
crazy position: you never talk to two stars at once, so it went to
Brando and it went to Steve McQueen. I was picking up a crew,
getting a cameraman, flying back and forth to San Francisco,
which took about another week. Then I came in on a Monday
morning and I got a call from Brando who said: 'Okay, kid, I'll
do the film! I like the script,' so I go, 'Great! I'm going to do a
film with Brando!' I was really excited and a little scared. I told
Terry and he said, 'Yeah, Brando will be incredibly good!' At that

point Terry didn't think of himself as a director, he was interested in the words on the page. So I ran to the office and here were the Big Wheels at Warners and I said, 'I just heard from Brando! He wants to do it!' And they replied, 'Uhm . . . yeah . . . well, we aren't that excited about Brando . . . the young people don't really care about him. We are going to have to pass.' I crawled back to my office and the phone rang and it was Switzerland: 'Hey, I read the Terrence Malick script and I love it' – it's Steve McQueen – and I replied, 'Okay, Steve I'll go to the office and tell them; I'm sure it's a done deal.' Second time that morning I ran over to the office, walked in like an idiot, saying to the president of the company, 'I just got a call from Switzerland, Steve McQueen is on, he wants to do it!' and he said, 'Well, we got a problem. Over the weekend I had a barbecue in Clint Eastwood's house, I told him about the script, but I told him about the original script, the original idea, and he said it was great. I also told him that there is another script now and he said he would read both and we made a deal with him!' I was surprised: 'Made a deal with Clint Eastwood for that part? For the part that I had written with Terrence Malick?' He wasn't right for that part, the role was right for an angry Brando, or Steve McQueen, but it wasn't right for a Clint Eastwood who had a totally different image, so they said, 'We are waiting to see what he wants to do.' I said, 'Well, you had better call my agent who handles Steve McQueen and Brando.' They promised Steve McQueen another picture at an accelerated rate, and made a deal. Clint Eastwood read the two scripts and preferred the old one; the character was more heroic for him. 'More heroic? Killing little schmuckies?' The sets came down: the locations were gone, and I was gone too, because I said to myself, 'Wrong casting – you don't want to do it.' I had worked so hard on that with Terry and suddenly having to shoot that old script? No, it wasn't for me. And so I was off the picture after working on it for over a year, working with Terry, who got paid something and I got paid some little money and the picture was made and it was a big hit. But it was

a different kind of picture and Clint Eastwood hit the big audience. That was the story.

After the encounter with Irvin Kershner, Malick's most important meetings in this period of his career were with the film director Arthur Penn, and Jack Fisk, a young art director at the beginning of his career in films, who became one of Malick's regular collaborators.

ARTHUR PENN

I knew Malick before he was making films: he was really a philosopher-journalist. We met when he had seen *Bonnie and Clyde*.[25] We had many jokes about that film; my assistant was a woman named Jill Jakes and they got married. So, I knew Terry during all that period, and he said, 'You remember that case that took place up in the Dakotas, where these two young people went on a killing spree?' I did remember the case, so we talked about it, and he started to think about his first film, *Badlands*.

JACK FISK

I studied fine arts at Cooper Union in New York. I wanted to be a painter. I saw a show by Robert Rosenquist; he painted billboard-size paintings, about 80 feet high. So I went to Los Angeles to paint billboards, and when I got there all the scenic artists in the studios were painting billboards because there were no films being made. Then I got a job on a non-union film, *Angels as Hard as They Come*[26] – Jonathan Demme was the producer and writer – and got hooked. At that time I had friends who were going to the American Film Institute and one of them told me that Terry was making a film about the '50s. I thought that would be great, so I started researching the '50s. I hadn't met Terry yet, but he had heard that I was researching his film, and wanted to work on it. So we met and got along instantly. He's so trusting, he just said, 'You wanna work on it?' And I did.

During this period, Malick met the independent producer Edward Pressman, who had established an independent production company together with Paul Williams who at the time was working with Jacob Brackman, through whom Pressman came to know about the Badlands *project and decided to produce it.*

EDWARD PRESSMAN

I think I decided to study philosophy through a process of elimination. It seemed to me the most encompassing subject to my artistic interests, my academic interests. The most encompassing and the least limiting. And I think film – again by a process of elimination – seemed the most encompassing arena of bringing in the academic interest I had. I was also brought up in a business family: my parents were in the toy business – my brother still is – and I felt that film was the least limiting of professions. Growing up in NYC I loved films; my uncle owned two movie theatres up in Washington Heights, and I used to sell popcorn every weekend and see four movies a day. At the very beginning, film as a career seemed so remote and impossible, but when I was at Stanford I met a young student there, his father was a director and we talked about making films endlessly. We didn't do anything, but that started me thinking. When I went to England to graduate school I met Paul Williams.[27] He was a director and he gave me the confidence to get seriously involved in film. It was through the partnership that we created, Pressman-Williams, that I started to look at film as a real possibility, a life's work. I grew up very much influenced by the French New Wave, it was a very politically active period and we all thought that film could change the world. It had a real significance that was not simply entertainment. I got into films in that environment and I think that that kind of *auteur* approach to filmmaking has always been the biggest influence on what I was doing then, and probably still is.

JACOB BRACKMAN

At that time I was working on a project with Paul Williams and telling him all the time about Terry, so he and Ed Pressman were very aware that Terry was putting together *Badlands*. I introduced Terry to Pressman and they started to think about a possible production strategy. When Ed Pressman and Paul Williams became partners and made their first couple of pictures together, you would never have imagined that Ed would have gone on to a thirty-five-year-long career and that Paul would disappear, but that's what happened. The people we are talking about are fringe characters – as opposed to say Warren Beatty or people who were kind of born into Hollywood – characters who just floated in the movie business from left field.

MIKE MEDAVOY

It was an interesting period because the filmmakers of that time were very conscious of what was going on in Europe where lots of changes were happening. So it was a combination of looking at the filmmakers of the 1940s and the filmmakers from Europe and putting that together as an American Experience. Television had not really entered the picture as much; it wasn't really until the mid-1970s that television directors started to take a hold. It was a very creative generation because the Vietnam War had started; there was lots of thinking. The music world had changed – the Beatles had come in and the Rolling Stones; there were influences from French and Italian filmmakers and British filmmakers like Karel Reisz, Tony Richardson, Lindsay Anderson. There was a ferment of ideas and American filmmakers were really taking all that in, taking it to the next step, as they saw it. And all of us had contact with each other – Spielberg, John Milius, Terry, Irvin Kershner had all worked on projects together. Everybody had contact with everybody else.

On the rare occasions when Malick spoke publicly,[28] he always underlined how much Irvin Kershner was a mentor to him.

Kershner represents a very precise way of approaching film-making: concern for character, realistic settings, awareness of social content. Kershner also acted as a liaison between Terrence Malick and cinematographer Haskell Wexler, who suggested Tak Fujimoto as the DoP for Badlands, *as well as Nestor Almendros for* Days of Heaven.

IRVIN KERSHNER

Haskell Wexler had a business in Chicago – he was doing commercials and documentaries; he had a little studio. I was doing *Confidential File*[29] and he had come to LA for some reason and saw one of the shows on a Sunday night. I was doing photography like no one else was doing on television; I was doing it super-real like it was a documentary but they were re-enactments, black-and-white re-enactments, and he was so impressed that he searched me out, and said, 'Jesus! How do you do these things?' and I just said, 'I have my Bolex camera, I have my lights, I have an actor who assists me and I shoot.' And he said, 'Can I take some of these films back to Chicago with me? I want to show them to my collaborators.' So I gave him a batch of them; most of them were six to ten minutes. When he came back to visit me he said, 'I would like to do a feature, eventually, and I want you to shoot it for me' – he wanted me to be his cameraman, which is what I wanted to be in the beginning! I was forced to be a director, in a way, because of the union. I had no relationship with anybody in the union and to be a director of photography I would have to start from the beginning, carrying cans and other things. But I was teaching at the University of Southern California, I knew about emotion, so I decided to be a director. Haskell became my friend so, when I started setting up *Stakeout on Dope Street*,[30] I went to Haskell, 'Why don't you shoot the film?' and he said, 'Jesus! But I'm not in the union,' I replied, 'It's a non-union picture,' and he goes, 'Okay. But I'm trying to get into the union, and I'm having a lot of problems, so I have the lawyers on to it.' Finally he said he would do it, but wouldn't

put his name on the picture: it's his two children's first names. He did it and he had to hide when the union came onto the set to check us out. I told them I was doing a documentary, because all we had was a camera, a tripod and a couple of lights. He shot it and then when I went to do *The Hoodlum Priest*,[31] I asked him if he would do it, and he was now in the union, so it was more simple. He did a great job in black and white, and we did it in the middle of summer in St. Louis, Missouri. It was horrible, it was so hot, we didn't have stunt people, so we used the local police department. We did the picture and Haskell held his own camera, it was an Éclair, and I held the battery operating the focus. He did a beautiful job. Then I was going to do a big film with Warners – with Richard Burton and Liz Taylor. I was working on the script with this wonderful writer, Edward Albee.[32] At one point I talked to Haskell and said, 'Haskell, this film is so raw, why don't we do it widescreen, black and white?' It had never been done before, and he replied with enthusiasm, 'Yeah, I love black and white, most cameramen couldn't handle it; colour is much easier.' So we did some screen tests with the actors for Warners and Jack Warner looked at it and said, 'The casting is okay, but the look is absolutely great! I want this picture in black and white, widescreen!' Then I got locked out of the box because Richard Burton had promised his next picture to Mike Nichols, who was a friend, so I said to Jack Warner, 'Go ahead, do it with Mike! I don't care.' I had been working on the script with Albee, and that was a great experience, but I didn't realize they were going to take Haskell away from my other picture, *A Fine Madness*,[33] which was shot at the same time and produced by Warners. I had bad problems with the new director of photography because I had developed the black-and-white approach with Haskell. Anyway *Who's Afraid of Virginia Woolf?*[34] won five Oscars, including the one for best cinematography. The black-and-white widescreen was absolutely great and I'm happy that Haskell got the award. The new director of photography never gave me the look I wanted for *A Fine Madness*, but that's the

world of the studios, they control everything. I didn't have the power to say, 'No, I want Haskell!'

When Malick was referring to me as a mentor I think he was just being kind. We talked a lot, I tried to be very open, and he is a good listener; that is one of his great powers: he listens and processes everything, he doesn't throw anything away. He processes what he feels, what he sees, what he hears. To me a sign of intelligence is the ability to relate one thing to another, and he can do it – it's infinite. So, I think that what he means by calling me 'a mentor' is that I was one of the first ones who took the time to really talk to him, especially about film. And I only knew a little more than him at the time, but I was steeped in the documentary tradition, how to approach reality. I hate naturalistic art, but I also hate pure abstraction. I'm also happy that later he worked with Haskell Wexler, because they have a similarly brave approach to filmmaking. I also think Terry had taken into consideration our previous experience before he started to make *Badlands*.

The new movement of filmmakers, mostly formed at the American Film Institute, at the University of Southern California, or at New York University – Terrence Malick, George Lucas and Martin Scorsese – emerged together with a new generation of actors. Dianne Crittenden, casting director of Badlands, *witnessed a big change: the choice of actors started to be oriented towards more authentic faces.*

DIANNE CRITTENDEN
Before I cast *Badlands* I worked for Howard Zieff. At that time, in the early 1970s, he was the top commercials director in the US. His way of working was not to hire models, or actors, for commercials but to get real people, and so that was the way I learned how to cast: to get people who looked like they belonged in the role, not like Doris Day with make-up on. When I moved from New York to California that was the beginning of a new

way of thinking about casting, and about acting. Everybody was interested in trying to find those new faces, those new people. When *Badlands* and *Days of Heaven* were made, the way films were made was changing – you had Francis Coppola and Bob Rafelson, and people like that; films were no longer the nice, shiny, happy ones like *Pillow Talk*[35]; it wasn't Rock Hudson and Doris Day. I think probably it had a lot to do with European cinema, because after World War II people were looking for movies that had something to say, that had some depth and some meaning, so the foreign films, like those by Ingmar Bergman, were felt to be deeper, and I think that Terry was affected by that, certainly I was affected by that. So, as well as learning from Howard Zieff, I also learned from *Ashes and Diamonds*[36] and *The Seventh Seal*,[37] and those movies that were made in Europe after the war. So, this changed the way things were done: if you were looking for somebody who was a street urchin, you were not going to go out and get a Shirley Temple and make her up to become a dirty-faced urchin; you wanted a certain authenticity and that's something Terrence Malick has always been after, it's what certainly appealed to me about working with him, as it certainly was a great challenge.

EDWARD PRESSMAN
When we were starting, Shirley Clark and John Cassavetes were leading an independent movement which was very, very sparse and didn't really exist in any significant way. Our company was really one of the only companies doing independent films, except for a company called BBS which was Bert Schneider, Bob Rafelson and Steve Blauner. They did *Easy Rider*,[38] *Five Easy Pieces*,[39] *Drive, He Said*[40] – a bunch of very interesting films. They were the other entity that had a similar sensibility to us. But at that time there was no institutional way of financing independent films: there were just the studios. There were six studios that controlled the distribution outlets and there were no other avenues. So, when we were doing the De Palma[41] movies – *Sisters*

and *Phantom of the Paradise* – and *Badlands*, they were a kind of an anomaly. They were not part of an independent movement as such, they were sort of freaks out in the wilderness.

DIANNE CRITTENDEN
Nowadays all I have to do is send emails to people to say I'm looking for actors to play a certain role and I get millions of ideas back from people all over the world who may want to play the part. In those days we had nothing like that, you really had to go from people that either had been seen in other films, in which case you were going to wind up with people from the ilk of films that were made in those times, or you took people, like I did, who had worked on stage in New York. Those actors were not from the kind of sit-com acting – now it's very hard to get them out of that kind of attitude; in those days finding people that had done theatre like Richard Gere and Martin Sheen gave us an advantage, because you had people that had learned to create a role from beginning to end. In New York there was a much smaller group of actors, which included Al Pacino, Robert De Niro and everybody knew everybody. When I asked Martin Sheen to audition for *Badlands*, at the beginning he said, 'It's not for me, but I know somebody else that might be good.' Actors didn't do that in Los Angeles, it's a New York kind of thing related to theatre, everybody was very generous helping their friends out. It was a very different kind of environment, it's where I come from, and that's how I like to work.

IRVIN KERSHNER
Every actor and every director has a signature, just like every composer has; I can hear a composition, turn it on in the middle and, listening to the chord structure, I can almost tell you who the composer was, if it's a composition of Sibelius, Stravinsky, Prokofiev. When I used to teach at the University of Southern California and George Lucas was one of my students, I would go down to the archives and take a can of film, 900 feet or so,

in the middle of a film and bring it up and project nine minutes, and I would say, 'Okay, write the story that came before and then write the story that came after, fill in the film and use this as the first act, second act or something else.' It was a good way to learn to construct a story, and I began to see the signature of the good directors, and it's there like with the good composers, with their chord structure. Every director who develops a style has a signature. The signature is how you move the camera and how you move the people. Terry moves the camera in a very limited way, which is good; he moves it not for dramatic effect, but to merely keep the action in the frame; he puts the lens in the one place where it should be in the scene. There is always one place that's best in a scene. You gotta find that – it's a sort of sweet spot. And he can stage for that and he moves the camera for that. Buñuel is a good example: he only moves his camera to keep the action going. So, Terry has a signature and only good directors have a signature – and that's another thing that you can see from his first movie, *Badlands*.

JACOB BRACKMAN
Terry knew a lot about cinema but I think he was not a cinephile, compared to Bogdanovich who was such a student of film, had studied and indeed written monographs about the films of John Ford, Howard Hawks and studied the even more obscure directors like Douglas Sirk. Terry was a well-educated liberal arts person, but he was not 'fanatic' about film like the French Nouvelle Vague people, the *Cahiers du Cinéma* people, who had studied American films. Terry kind of made it up as he went along, and, in a way, he was doing this without having the kind of background that film students who get to make movies have. He used to say he couldn't shoot an episode of *Kojak*, the TV series, because he wasn't interested in knowing how to cover a scene. So he developed his own style, I would say mostly in the cutting room on *Badlands* and also the way he figured out how to work with voice-over. These were things that he didn't learn from anyone

else, he kind of invented them. He was not an artistic type necessarily. I knew people in our class who arrive in Harvard at eighteen, and think they're 'artists' – many think they are going to become great artists, or are going to be writers like Joyce or Proust! Terry was not like that at all, he was a humble student. So, as an undergraduate, and in those first years of trying to be a journalist and testing academia and so on, Terry was not so arrogant as to think he could also become an artist. It probably wasn't until people told him he was one, after *Badlands,* that he started to think that maybe he could become one!

ARTHUR PENN

If you make a film for the studios it's a very different experience and not very interesting because there are too many people who interfere. Everybody knows how to make a movie! Everybody! You ask anybody on the street, 'Was it a good movie?' 'No, it was not a good movie! Here's what I would have done!' and they tell you how they would make the movie. So, Terry didn't want that. He knew we didn't have trouble on *Bonnie and Clyde* with the studio while we were making it. We had bad trouble trying to distribute the film. So Terry knew a lot about our experience. And he was very wise: he knew, as we know today, that with a really small amount of money and a very simple little story we could go out and make a very good film. And that's exactly what happened. Terry was free to make *Badlands* the way he wanted to make it. We always used to have fun together. There is a scene in *Bonnie and Clyde* where the protagonists pull into a little gas station and they meet Michael Pollard. The car doesn't work and he just blows on the engine, and they say, 'What was wrong with the car?' because now it starts. And he goes, 'Dirt!' That was a line we used to say all the time: 'Dirt!' That's the way Terry would think of a film. Which is: you go in and you make it, you just make it.

Badlands

Badlands was inspired by a tabloid story: a killing spree by one Charles Starkweather who, after killing the parents and the two-year-old sister of his under-aged girlfriend, Caril Ann Fugate, fled with the girl on a blood-tainted honeymoon pursued by the police, committing seven other more or less gratuitous homicides. The Starkweather case caused a sensation in the media, fixing itself in American culture as the first case of random murder, and as a doomed love story.

Holly (voice-over)

My mother died of pneumonia when I was just a kid. My father had kept their wedding cake in the freezer for ten whole years. After the funeral he gave it to the yardman. He tried to act cheerful, but he could never be consoled by the little stranger he found in his house. Then, one day, hoping to begin a new life away from the scene of all his memories, he moved us from Texas to Ft. Dupree, South Dakota.

[. . .]

Little did I realize that what began in the alleys and back ways of this quiet town would end in the Badlands of Montana.

JACOB BRACKMAN

After *Lanton Mills*, Terry embarked on *Badlands*. He *had* to get it done – he had to. It was so obviously a critical point in his development and the thing that he did of raising the money in dribs and drabs, working on the script and getting it cast – you know, the whole thing is kind of the myth of how somebody becomes a filmmaker, but actually Terry is the only person who ever did it!

Badlands as a debut is compared to *Citizen Kane*. But at the time that *Citizen Kane* was made, Orson Welles was a world-famous radio and theatre director, everybody knew of him as a major talent. Whereas with Terry, absolutely nobody knew about him, he had no theatrical history of any kind. In a way, he came completely out of nowhere!

ARTHUR PENN

I don't remember in detail what we spoke about when I met Terry. It was such an American story, a strangely American story. Two, almost children really, living in that part of the country which is really not very populated, very restricted in terms of outlook, religion and so forth. But it seemed like a compelling story. And it had only a little relationship to *Bonnie and Clyde*. Bonnie and Clyde were from the same kind of background, only they were very different – they didn't just go out killing people. They were bank robbers. Many people associated *Bonnie and Clyde* with *Badlands*, but the protagonists of my film were living during the Depression, when the banks were closing, when farms were being taken away by the banks. The two protagonists of *Badlands* are from the '50s: it's twenty years later. It was a very different country in the '50s. We had been through the war, and that generation had come back from the war. It was both tighter and a little bit wilder. I still don't know the motive for these two people in *Badlands*. Do you know what made them do it? I think it was the sense of adventure, the sexual freedom that they must have found in it. We have to remember that America is a very sexually repressed country, particularly out in the Far West. And there's a certain thing about that film which is that once they get the taste of freedom – admittedly it's freedom to kill people – but it's also freedom to live without restrictions. And that was unusual in that time.

EDWARD PRESSMAN

I can't say I imagined the lasting value of *Badlands* as a film when we started, and the kind of significance Terry's work would

have to many people today. When we started, it was the exciting prospect of doing a film with a filmmaker who seemed talented and with a great, quiet confidence, and a know-how that seemed advanced to me, at the time. He was working with the help of Arthur Penn, George Segal[1] and Warren Oates early on, so we were dealing with people whose confidence in Terry was re-inforcing my own. These established figures were galvanized by Terry's vision. I was a newcomer who's feeling my way, whereas Terry had a maturity even then and was very impressive to me and gave me the confidence to support him. We didn't go into it thinking this was a masterpiece. This was a movie we believed in, and the relationships and feelings we had shooting it have lasted all these years, just as the film has lasted. It was something that was very special and very rare at the time. I don't think I realized that, as it was one of the first films I was involved with. For me it was the way filmmaking should be, but in retrospect, I see how unique and extraordinary it really was.

MIKE MEDAVOY
Badlands was mainly a project that Terry and Pressman put together. I had introduced Terry to Max Palevsky,[2] who is a close friend of his now; I asked Max to put up some of the money. There was also a script that Terry wrote and was paid for, so he put up some of that money to finance the film. It was prob-ably one of the first independent films. There had probably been other independent films, like *One Potato Two Potato*,[3] but it's a landmark film in the sense that it was thought of as a really important film, about a really difficult subject.

EDWARD PRESSMAN
I think when we started, the films that we did, we approached it with all innocence as if it was a Broadway play. We raised money through selling shares, $1,000 or $5,000 increments; we used our credit cards and I used my family's toy company credit with the laboratories and the equipment houses. We owed

money, but at least they left us for a time without having to come up with the cash. We were scavenging in the most primitive way: Terry brought in some financing from Max Palevsky and William Weld[4] and some other people that he knew. On our side, I think my mother was the biggest help of all. She not only gave the credit of the family business, but also lent me money and was of great support. So it was not systematic by any means, every few weeks we were not sure we could cover the payroll. It was a total bet and we were doing it at the very same time as Brian De Palma's *Phantom of the Paradise*, which was also going through difficult financial problems. So it was a great time, but it was economically out there on the edge. I remember while we were shooting, one of the production people who was working on *Badlands* was very dubious about the whole process because it was such an unorthodox approach to making a film. And he left, went back to New York and told my mother the film was a disaster, that she ought to just stop helping me right then and there, that she was throwing her money away.

ARTHUR PENN

When the film was finished, I remember I was up in California and Terry was showing it to the people who had put up most of the money, and when the film was finished I think they didn't like it very much. But I said, 'It's a great film!' So, I helped persuade them, I think, that it was a very important film.

EDWARD PRESSMAN

Arthur Penn is a very significant filmmaker, and at that time his offer to lend his name as an executive producer, from my perspective, was very important in giving legitimacy to the production as we tried to raise the financing. It was basically his offer to just lend his imprimatur to the film that was so important at the time; and then later he said, 'If you don't want to put my name on it, you can do whatever you want.' I don't even think his name was on the film when it came out. It was a real

gentlemanly support, but in the early stages his involvement was one of the things that attracted me to the project and I could talk to other people saying that Arthur supported it; it meant a great deal. It also helped that Warren Oates[5] came in early on, because he was such an important figure at the time. The films he was doing were right there on the cultural edge. When the film was completed, the plan was to show it to the likely distributors, which were the Studios. The key people that we wanted to show the film to were alerted by different friends that we knew, and we set up screenings for the ones who were the most receptive. There was a company named Cinema V run by Don Rugoff[6] who owned some theatres in New York; he was a stalwart of the independent movement and a sort of forerunner of Miramax. They distributed Z, the Costa-Gavras film, and the early Milos Forman film *The Fireman's Ball*. He wanted to buy the film, but then we showed the film to Warner Bros and John Kelly, who was running the studio, immediately responded. So there was a bidding war between those two companies. I can't remember any other company wanting to do it, but I think Warners paid $1 million, which at the time was unprecedented in terms of independent films getting such an advance distribution. We went with them and Rugoff was very unhappy. At the beginning everyone worked for very, very little with the hope that if the film succeeded they would get more. We had deferred payments, and all the deferments were paid when the deal was done with Warners. I remember Warren Oates, who did more than fifty movies, some of them great successes, said, 'This is the first time I got my deferment paid on a film that was not a huge success, but that was done for so little.'

The main characters of the film are Kit Carruthers and Holly Sargis, based on Charles Starkweather and Caril Ann Fugate. But the script, even though it essentially represents the various stages of the killings and the escape of the two, is not just a simple retelling of the story in film form. Badlands *explores the*

emotional tension between the odd innocence of their love affair and the homicidal violence of their fugitive journey.

For this reason, Malick preferred actors who were not only ready to follow him in the challenge of producing an independent film, but also to test themselves in a journey of discovery into the mentality of the characters. For the role of Holly, Sissy Spacek was soon chosen, a young twenty-two-year-old actress who at the time had only played in a couple of films.[7] There were many candidates initially for the male lead, but the meeting with Martin Sheen was decisive. In the end the role was his, even if at the time he was over thirty and had to play the boyfriend of a girl who in the script was little more than an adolescent. The script was changed to fit the characteristics of Sheen and his age.

DIANNE CRITTENDEN

My cousin Dona[8] was working for Terry. She was working as his assistant on *Badlands*, and she wasn't getting paid. So I said to her, 'You cannot work on a movie where you don't get paid!' And she replied, 'Well, I don't know how to say that!' I had been working as a casting director for about three years at that time, that is why I felt secure enough to say to her, 'Well, I will come and tell him.' And the next thing is I got hired and started working for him as casting director – with no pay too!

Both of us eventually got paid, but at that time he didn't have the financing, so . . .

Terry is such an interesting man and the script was so wonderful that I just thought I had to be a part of this!

The first one cast was Sissy Spacek. She is somebody that Terry found or heard about in Texas – he wanted both of them to be authentic Texans. Obviously, Martin is not a Texan, but Sissy is and had the accent. You know, when most people become actors they eliminate their accent, but Sissy had it and she just had all the right qualities: naive and ingenuous; and somebody who could, you know, sit there with someone who had just murdered her father and be reading magazines about movie stars . . .

Badlands

SISSY SPACEK
I don't think I had even read the script when I met with Terry. It was in a wonderful house somewhere in Hollywood. I think it was a friend's house he was just using, an old Spanish house with no furniture. He had a couple of chairs and a couch, I think, and a coffee table, and that was the extent of the furniture. He kept telling me about this art director, Jack Fisk, who was working on his film and he'd tell me the things they were going to do. They were going to do opticals, they were going to get midget farmers – all kind of crazy ideas. And he would have lines written down on little rolled-up pieces of paper and he'd hand it to me and say, 'Say that line,' and I'd roll out this little tiny piece of paper and read the line and he would just dissolve into hysterics and laughter. I think at that time he didn't know what I did before as an actress, I'd made a couple of meaningless films. I think I'd made two films but they were inconsequential. I think my ace in the hole was that I was from Texas. It was a little bit like with Jack, it was just an instant thing, an instant connection between us and it still is. You know, when you're from Texas, it's like being a member of a very exclusive club; we spoke the same language, and I think that Terry was enchanted by my accent which was, believe it or not, heavier than now. Terry is very connected to his roots, as am I. He used my background in the film; in fact, Martin said, 'What's a little girl from Texas like you doing here?' I also remember going with Terry to a music store in Hollywood Blvd to get a Starline baton, twirling for him in his front yard. So as I was getting new pages for the script, Holly became a strawberry blonde who twirled. It was wonderful because he began to take things from me, he really made me feel like I was part of the process. I thought the character was me. Terry had a way of making me feel like . . . You know, I walked in the door and I was Holly. And so, instead of me asking him what Holly was like, he was asking me questions: 'What do you think about this?', 'How do you think Holly would do this?' and so, right away, he gave me ownership of the character. I don't think that

at that time of my career I even really thought about it. I trusted Terry, it was like I was the raw product and he was the puppeteer. I trusted him so much and our connection was so instant that I never worried about or thought about it much, she just was. And really, I was cast before Martin and so I was meeting all the hot young actors in Hollywood and there were quite a few of them who were wonderful.

DIANNE CRITTENDEN
Badlands was based upon the story of Charles Starkweather who was a real person, and so I know that Terry did a lot of research before he even started it, and then I did my own research. You know everybody said: he was like the boy next door, he was very charming, he was a good son, he went to church, and nobody believed that he could become a killer. So in the casting I was looking for a person who you would never believe could kill anybody.

The choice of Martin Sheen was another accident. I was waiting for an actor to arrive. I was working out of a hotel and I was standing by the window looking for the actor when I saw Martin Sheen walk by and I had seen him in a play, Tennessee Williams's *The Rose Tattoo*, in New York before I came to California. And so I ran outside and asked him if he could come in and talk to me while I was waiting for the other actor and – very much like I decided to work on the film with no compensation – he said to me, 'Well, you know it's all very nice but I am not really interested in doing an independent movie because you don't get paid and they never get released . . .' So I said, 'But this is so good, why don't you just take these couple of pages of the script and have a look at it?' He replied, 'Well, maybe I might have some friend or my brother might be interested . . .' So he took it with him and then about a half-hour later he came back and he knocked on the door and said, 'I wanna do this – this is really good!' So that is what happened and that's how he came in.

MARTIN SHEEN

I had gone to a hotel over in Hollywood one day, many years ago, to do a commercial, or to read for a clothing commercial, and as I was leaving the production there, Dianne Crittenden stopped me coming out of the hotel and said that she was casting a film by an unknown director, a first-time director, and she wanted me to do a little video to show to him. And she said that he knew of me, but didn't think I was right for the part and that she wanted to surprise him by showing him the video, and see if she could change his mind. I said, 'Of course, I'll do it.' And so I came back in the hotel, she gave me a couple of scenes, I studied them, and we did a little video and I talked into the camera, and I forgot all about it. Some weeks later I got a call from this guy, Terrence Malick, saying that he looked at this video and he was having second thoughts about me and could I come in and meet him and talk about the film, and I said, 'Of course.' And so I went to meet with him, and I liked him instantly. We talked about everything: family, career, art, literature. It was fascinating to be with him because he had this broad experience in life: he had been a still photographer, he had been a professor, he was a Rhodes scholar, he had studied in England, he was teaching at MIT, he was a reporter for *The New Yorker*, and he was still young, younger than I, he was still in his mid-twenties when I met him. He had this whole background, he seemed to change careers every couple of years, and he had this incredible education. But he wasn't just an intellectual, he was deeply involved with his knowledge, you know, he took education very seriously. Formal education to him was just the beginning, life was what really interested him.

SISSY SPACEK

I remember Terry, before the audition, thought that Martin was much too old to play Kit, but just as a courtesy he was going to meet him again. And he said to me, 'You know, he's much too old. So we'll just go through the scene and put him on tape like we are doing everyone else. But he's too old.'

MARTIN SHEEN

He wouldn't give me the script, but we talked a lot about it and about acting and filmmaking, and so forth. And he asked me to come again, and again and again. I can't remember how many times I would come and do little videos, where I would do a little scene or two. And then, one day I went there and I met Sissy Spacek. She had already been cast as the little girl, and we became friends. And we started doing audition scenes together on the little video that he had in his home, somewhere up in the Hollywood hills.

DIANNE CRITTENDEN

Making casting choices has always been very hard on Terry.

There were many people who wanted to do *Badlands*. Peter Fonda was one of the people. One person I remember I thought was really good who wanted to do it was Don Johnson. I think we talked about anyone who was an up-and-coming actor at the time . . .

There were a lot of people that I had met when I was doing commercials with Howard Zieff,[9] when I was in New York. So, as I said, I knew all these people from theatre, and I met people like Robert De Niro and Richard Dreyfuss and people that, at that time, nobody knew who they were, because they had only done theatre in New York – obviously, they then went on to do other things. So I brought in people to meet Terry, people like that who I knew and who I knew were very good actors. But Terry really was not really comfortable with the audition process . . . and he would meet people and he just thought everybody was great.

Howard Zieff did the very first commercial for Sony video, when video became personal video; previously, there were huge machines, and you had separate camera and reel-to-reel machines. But Howard had the very first Sony personal video recorder in the United States because he got the prototype to use to make commercials for it before it was even in the stores. That is how I learned to use video – I was the first casting director

ever to use video to audition people. And when Terry couldn't make up his mind and just kept falling in love with people and not being able to figure out what to do, I suggested that I get one of these video recorders and put it into a room somewhere and *I* would audition the actors. So that was how it happened with Martin Sheen – he came in and read that scene and it was on videotape. Otherwise, Terry would probably not have met him because if he hadn't auditioned he wouldn't have done this whole thing of flicking his hair back to make himself look like James Dean. When the movie took place every boy wanted to be like James Dean – that was the idea, the character would be like a James Dean character. So if we hadn't done that with the video, I don't know that Terry would have been able to see Marty in that role: he thought he was too old.

SISSY SPACEK
Martin came in and he was Kit. I had been playing this scene with all these different actors and they were just terrific and wonderful, but when Martin came in it was just alive, he just blew us away. And when he left, I remember, we were all kind of . . . because you know, we had this talk before he came in that he was too old. Well, at that point we were all just desperate to have him. He was amazing and that's really when everything began.

MARTIN SHEEN
Finally one day, he sent me the script and he said, 'I want you to know what the project is all about.' So I read the script and I was so impressed, but I felt pangs of conscience, because in the script the boy was nineteen. I'm already thirty-one. But he said, 'I know that you're too old, but I'm thinking of making the part a bit older, if I go with you,' and he said, 'It's down to you and another fellow.' I didn't realize at that time who the other fellow was, but he was Peter Fonda. I learned that years later, and so, I'm sorry about that, Peter. And then I remember the night that I

got the part, it was just a deeply emotional moment. I was doing an episodic show called *Mannix* – *Mannix* was a popular TV series – and my wife called me at the studio and she said, 'Terry called and asked if you will drop by the house and pick up the new version of the script.' I said, 'Oh my. Okay.' So I finished shooting in the evening and I went to his home and he gave me the final draft of the script and we talked for just a very short time. He said, 'Please, read this. I think I've got to make up my mind real soon and I want you to have the script.' I said, 'Okay,' and I kind of forgot about it. I put it in the car, you know, and by the time I got home he called. When I walked in the door, my wife Janet said, 'You got the part in *Badlands*.' And I said, 'Oh my! Okay.' And I went to bed early, because I had to wake up at 5 o'clock in the morning. And I wasn't able to focus on it because I had to work the next day, and I was thinking of my lines, and the scenes I had to do the next day. The day after I threw the script in the car – 5 o'clock in the morning, still dark outside – and I'm driving to work, and I'm driving along the Pacific Coast Highway, and the sun is coming up . . . and I'm listening to Bob Dylan on the radio, and they're playing 'Desolation Row' from one of his early albums, and it hit me, that I was going to play Kit, in *Badlands*. And it was the most extraordinary thing that had ever happened in my career. And I began to weep, with joy . . . And I had to pull off the highway, and stop. I sat in the car, I'm choked up now thinking about it, and I wept with joy that I felt, finally, I was going to be realized as an actor.

In the film, Kit's character is that of a lonely youngster who works as a garbage-man and fantasizes about himself as a sort of misunderstood 'rebel without a cause'.

Holly (voice-over)

Kit made a solemn vow that he would always stand beside me and let nothing come between us. He wrote this out in writing, put the paper in a box with some of our little

tokens and things, then sent it off in a balloon he'd found while on the garbage route. His heart was filled with longing as he watched it drift off. Something must've told him that we'd never live these days of happiness again, that they were gone forever.

JACK FISK

I think *Badlands* is so lyrical and poetical all the time. I think that to watch a movie about a killer and be sort of enamoured with him and fascinated . . . the violence is the least important part of the film.

SISSY SPACEK

When Terry showed the film to Caril Ann Fugate, the real historic character, she said the only similarities between Charles Starkweather and Kit Carruthers were that they both were garbage men and wore cowboy boots. So Terry just used that as a springboard to lay it all out. He used them, to hang his storytelling on.

BILLY WEBER (EDITOR)

It's a story of a serial killer essentially, the Kit character, but the movie doesn't play on that, does not make him out to be this dark killer. The way Terry dealt with him, it was almost more like a fairy-tale 'telling', considering what the character did and how cold-blooded he was in his killing. And yet at the same time he had this strange sense of humour and strange view of life, almost a courteous, well-mannered view of life even though he killed her father and he killed the people that came after him in the wood. But it was Sissy's voice-over that sort of conveyed that fairy-tale quality of it, especially when she talks about '. . . the men that came after him . . . they knew what they were asking for, so they deserved to get shot . . .', just this perverted view of life that that character had, although it was very close to the real character that it's based on – who had almost a movie-view of his own life and idolized James Dean.

MARTIN SHEEN

This boy, Kit Carruthers, lived in his head. He had an image of himself that wasn't at all true; he fancied himself like James Dean. He was very fastidious, he picked up papers and he had an image of everybody that was hopelessly inaccurate. But it was his image of people, and events, and things . . . So by the end of the film, when he's finally captured, he builds a monument to the spot where they caught him. He builds it himself, to dedicate the moment, so that it's not forgotten . . . in history! It was a bizarre image this guy had of himself. But, in order to play the character, I had to live inside that image, I had to live in that fantasy.

And, so, whenever we were doing a scene, I knew when I got it in that groove, in that zone, I was okay, when I talked in that monotone kind of way, when I played that seriousness, that was obviously an image. Like when he's talking to the rich man, the owner of the house they have invaded, and he's saying to him, 'We're gonna go now, and we're gonna take the car, and don't worry. I won't let her drive it' . . . in other words: 'You're safe. Everything is safe with me.'

Holly (voice-over)

Kit was the most trigger happy person I'd ever met. He claimed that as long as you're playing for keeps and the law is coming at you, it's considered okay to shoot all witnesses. You had to take the consequences, though, and not whine about it later.

MARTIN SHEEN

One day Terry gave me an image of the gun, he said, 'Well, you know, Martin, that gun is like a magic wand. You can't deal with someone, it solves all of your problems . . . Pah! He's removed. Problem solved. Think of that gun as a magic wand.' That was a big image!

So, whenever I had the weapon and I was walking around with it, you would never know what he was going to do! And

the excuses that he would use for his behaviour: 'Well, he just wouldn't listen to me, he couldn't understand . . . so I had to pop him,' as if, of course, now, you understand why he killed another human being. The *bizarre* image he had of himself was paramount to the character. If you didn't get that right, the film wouldn't work.

SISSY SPACEK

Holly is a little girl and he was incredibly slick and just swept her off her feet. She was thirteen, and he was a smooth operator. He comes by in the garbage truck and he says, 'What's a little girl like you doing in a place like this?' Didn't he say that? Something like that. I think he was just the first male to ever notice her. She was just so naive she was easily impressed.

GEORGE TIPTON (COMPOSER)

Why would Holly be interested in him? Terry wanted to know, and the best he could come up with was that she hadn't been presented with very many other choices, there wasn't another hero guy around, her father was a crummy guy . . .

MARTIN SHEEN

In his mind Kit had to remove the father, in order to have a place in her life. She was basically his idol, he adored her. But he had to treat her as if she was lucky to be with him. She may not realize it at the time, but as time passes she will realize she was with an historic figure, and this time was the most important time she'll ever spend. But remember: the story is told through her point of view, she narrates the story. Kit has to fit into that thing, so he had to make a lot of adjustments. He thought she was just a little piss-ant, but he realized that she was quite substantial – he never had a relationship with anyone quite like her – she thought for herself, she could play a musical instrument, she got good grades in the school, she was revered in the community, she had a home, she was grounded. And he wasn't, he was everything outside her

world. But he had to pretend like his world was where he was going to bring her. In fact the reverse was true: he went into her world. But he brought this image of himself in with him.

Holly (voice-over)
Kit knew the end was coming. He wondered if he'd hear the doctor pronounce him dead, or if he'd be able to read what the papers would say about him, the next day, from the other side. He dreaded the idea of being shot down alone, he said, without a girl to scream out his name.

MARTIN SHEEN

Kit had this image, this very, very conservative, insightful, image of himself, in regard to history and events, that he had to be 'specific'. It was almost as if he had to play this role out – in order to be himself. What he never realized, of course, was that it was his false self. He was playing an image, so he was always 'on' and his image was fed by the image of James Dean, but it was a Hollywood image, it was a fantasy, it was false. But he thought, 'Well, maybe this is what it was like to be James Dean, maybe this is how Jimmy felt about things . . . But he could never articulate it, and Jimmy's not here to tell you how he felt about things or show you how he felt about things, so I'll just assume that personality . . .' So that's what he did. He never got close to himself, because he was a little sod-off cross-eyed punk. He didn't have a life. But with her . . . He had the prettiest, brightest girl going and he felt – I think – that as long as he was this great character, she'd be glad to be with him, and she would record his history. Accurately. And he would be revered later, just like James Dean was.

GEORGE STEVENS, JR

Terry and I lived near one another and we talked about *Badlands* and how the Starkweather character had certain similarities to James Dean and he was interested in what I knew about James

Dean. I mean, Jimmy Dean was unique and his tragic death high-lighted his uniqueness. He became kind of like an eternal figure in cinema. Clearly Terry and Martin were influenced by Jimmy, so we talked about those things.

SAM SHEPARD

James Dean is myth. There was an extraordinary genius in those three films he made. Without even trying almost. I suppose there was incredible labour involved, but they seem almost effortless. There are moments in those films that are just unachievable by contemporary standards. I haven't seen actors anywhere near approaching that kind of brilliance. Except maybe occasionally. So for that alone I can see why Martin would be trying to hon-our that, in some way, and I think he did. I mean, isn't that the comment the sheriff makes in the police car at the end? He says, 'You look just like that guy.'

MARTIN SHEEN

Terry and I shared this great love for James Dean. He had had a powerful effect on both our lives when we were younger; he was my hero when I was growing up . . . He was the main reason I wanted to be a film actor. James Dean was the most powerful figure in cinema, in my lifetime – with the possible exception of Marlon Brando, whom Dean himself admired more than anyone else. When I saw it in the script I thought, 'Wow, gosh, this is so personal!' And I wondered if it might be a deterrent as well, because I looked somewhat like Dean when I was younger and I was compared to him a lot when I was coming up, and I kind of fancied that. I thought, 'That's not bad, to be thought of as like James Dean.' But I didn't wanna do it in a movie, where a guy said that he was delighted that he reminded people of James Dean . . . that I didn't want. But now, clearly, the character in *Badlands* had those feelings, and I had to deal with them, but we shared that.

And it was helpful in understanding the character, to start

from that. If he had gone with the younger guy, if he got an eighteen-year-old boy or a nineteen-year-old boy, that lad might not have shared that intimacy with James Dean that the character had. Of course the story was set in the 1950s, it was supposed to be in 1958–59, and Dean would have been newly dead at the time, I think he died in '55, so he was much on the consciousness of the public. Hollywood was still looking for another James Dean, at that time.

James Dean was not realized fully, in his lifetime, he had to wait till he died, and he died very young. And Kit thought that he could have the same kind of image after he was dead. So he chose Holly to tell his story, but he kept up that image, the whole time. And he thought she was buying it. But she had left him a long time before then. She was living in her head.

SISSY SPACEK

She wasn't really in touch with reality. There was a time where – I remember walking out of the rich man's house – she had a little sense of drama. The shawl over her head . . . There was a real matter-of-factness, but a real sense of fantasy. Just like when he goes and he suddenly becomes very parental and says on the Dictaphone, 'Listen to your parents, they have a line on things.' And since then I think we're probably seeing more of that sort of isolation, where people just kind of go off and live those short and dramatic lives, like Kit did and the mark he was going to leave on the world: 'I always wanted to be a criminal, just not this big a one,' or, 'Here I'll mark the place where it happened.'

MARTIN SHEEN

There is a little moment in the film, after he's killed Cato, his friend, and he carries the body down to a boxcar, and throws it in the boxcar and closes the door, and he has a private moment down there, where he rages, stomps around and talks to himself. He's furious! . . . that all this has befallen him and he has to do it on his own, and life is totally unfair: 'This is what happens to

great men all the time . . . They end up carrying the final burden
by themselves, and no one will ever understand how difficult it
is to be a great man and carry such heavy burdens!' And that
moment, when you see I'm down there raging, Terry just gave
me a couple of things to say – I remember we shot it on a wide
angle – and I'm down there talking to myself and screaming, and
he said, 'Just do whatever you like,' and 'Just let us know you're
very unhappy with what's befallen to you, and kinda make sure
that no one else sees you in this weak moment. You have one of
those moments where great men rage and have it out with the
gods, the fates, but you don't want anyone else to know it.' In
fact, Kit really hoped somebody was watching to record it. That
was the most telling moment. And I didn't realize how powerful
that moment was, even when I saw the film. One day I was talk-
ing to Al Pacino and he pointed out that that moment was the
best moment I had in the film, and it was his favourite moment,
because it told the whole character, in that one, brief moment.
And I realized he was right. That was Kit, in that moment. If
you could do that moment, you had the character. And you saw
where he'd been, and you knew where he was goin' – from that
scene. It was such a fantasy, and yet it was such a reality. So let
that be a lesson to you . . .

Holly (voice-over)

Kit made me get my books from school, so I wouldn't fall
behind. We'd be starting a new life, he said. And we'd have
to change our names. His would be James. Mine would be
Priscilla. We'd hide out like spies, somewhere in the North,
where people didn't ask a lot of questions.

GEORGE TIPTON

We're talking about characters who actually did these things,
not characters who came out of a writer's imagination. But Terry
was making it into that. He was adding that which none of us
would ever know, by setting them in visual settings that were like

Robinson Crusoe for children. Whatever they were, they hid out, but they were not exactly hiding out, they were playing; that's the terrible part about human beings – they can block out the consequences from their actions; the consequences of actually killing other people.

We've had plenty of examples of that in this world, so they were just doing that and I don't know how deep you can go into these kinds of ideas, but Terry did and he was very sincere.

MARTIN SHEEN
They were products of the culture, which was influenced by television and movies and magazines. And so, very often in the film – no matter what we've done in the previous scene or sequence – he would clarify it, with something very, very precise. For example, when we left the hide-out – you know, when I shot some of the people who were trying to catch me – and we're driving off across the prairie, she's reading from a Hollywood fan magazine, as if nothing has happened, as if we are just two teenagers out for a date. She's reading me a quiz from the magazine, 'True or false? Eddie Fisher did this and that?' And I'd answer, 'That's false.' 'True!' she'd answer . . . And that scene in particular was very, very clear and precise about what they were thinking. They lived in fantasyland, but they thought that they were quite normal. They thought they were just like any other teenagers, they were just out on a date, everything's fine, you know. They were not dealing with any reality at all. And I think it was a journey into the mind of this madness that allowed Terry to do it.

The film was shot in the summer of 1972 in La Junta, close to Pueblo, Colorado. The place was chosen both because it was very similar geographically to the 'Badlands' of South Dakota, where the true story of Starkweather's rampage had taken place, and because of its desert-like remoteness.

Badlands

KENNY HILTON

I was going to go to college on a football scholarship but I lost it because there weren't enough minorities, so then I decided I wanted to be a forest ranger; I really didn't know what to do. So I went to school here at the local school community college and took a theatre arts class and got bit by the Theatre Bug. And when the movie company came in to start filming, and Terry and his wife rented the house next door to my grandmother, my grandmother dared me and said, 'Well, you're such a hot shot, why don't you go and get a job with the film company?' So I went and met Terry's wife and she said they didn't hire locals, but her guard dog liked me. So the next day I got a call from her: 'My dog likes ya, I guess we'll hire ya!' And that's how I started as a production assistant with Jack Fisk. He liked my work and asked if they could have me in the art department. To cut a long story short, I ended up being the set decorator. I'm still poor but it was quite an experience.

JACK FISK

I don't remember exactly how La Junta was found. I think Terry had been out there several times before any of us and decided on that town, he just liked the look of it. There were three towns together that were Swink, La Junta and Rocky Ford, and between the three towns we put together one town. They were great American architecture typical of small American towns. And there were expanses of prairie outside the towns which was great because it would make you feel very insignificant to be in that big environment, but also a certain security about being in the villages.

MARTIN SHEEN

We were four months shooting that summer. We lived in this little community and my kids became part of the neighbourhood. It was one of the best times in my life. I look back on it and feel like I grew up there. It was my town.

SISSY SPACEK

We got to know all the little kids in the neighbourhood. They would all just come to where we were shooting and sit around on the grass. I remember there was a little girl who would often come, and one day I pointed her out to Jack and I said to her, 'What do you think about my boyfriend?' And as you know Jack has this great lucky space between the two front teeth, so she said something like, 'He's real cute except for that missing tooth.'

JACK FISK

In LA the public is hardened to filmmaking and they are always trying to raise the price of this and that, but in little towns like La Junta, especially back then, the novelty of film made everybody excited and joyful. They loved being a part of it and they would help you. I remember one day I was out trying to put a windmill up by myself. I put stakes in the ground to hold the legs and I put a rope on it and tightened it to the van I was driving. I would raise it up and then it would fall the other way. And I said, 'What am I going to do?', because I was out there by myself and there was no way to do it. Just then I saw, a quarter mile away on the highway, a crane going by and I got in the van and went rushing down the road. I got down to the road and I asked the guy with the crane, 'Can you help me pull up the windmill?' He looked at the windmill and he said, 'I've got a job to do but I'll be back in an hour and then I'll help you.' And he came and he helped me with no charge. They were all very kind and collaborative.

KENNY HILTON

Most of that crew were young people, just starting their career, so they didn't have huge egos. I think they just enjoyed being out of LA in a nice, friendly, different country environment. They were accepted by the community. In fact, several years later, they made another film out here and the reception to that crew was

much different, because everyone was arrogant, starting with the actors. Martin and Sissy were just common, they didn't have that arrogance about them.

SISSY SPACEK

On the set Martin Sheen was so incredible because he probably had more experience than all of us put together, except Warren Oates, but he rolled cable. There was no separation between anybody on the set and I think that Martin was really responsible for a lot of that: if the crew needed any help in wrapping cables or whatever, he did it.

JACK FISK

There were no stars. And the ones that wanted to be, you know, they left. The actors never varied. A lot of the crew members would get upset with the way we'd be working, but not the acting crew who were on all the time because we never quite knew what Terry was going to shoot the next day, so he liked to have the actors around. If there was ever a short hand, they would pitch in and help. It was wonderful. And that was our whole world. I mean, we didn't think beyond a fifty-mile radius of La Junta. The rest of the world didn't exist.

SISSY SPACEK

I remember some crew members from another film came through. They had been in a location somewhere and they were driving back to Los Angeles, and they came through La Junta, and I remember thinking: they are making a film somewhere else? Terry made it seem so important, it was just everything. We were in a time warp: we never worried of how many hours we worked, or how early we had to get up; we never worried about what scenes we had to do. We all trusted him: I know that Jack did, and I did. We just trusted him. It was a wonderful thing, and that's rare to experience. It was like he was our leader and we were following him into combat; it was fun.

EDWARD PRESSMAN

It was a very, very congenial set; in some ways it was like a family. People got together every night after shooting, in a kind of familial way that is not often the case. But in *Badlands* it was. Terry invited everyone to see the dailies, I guess because of the challenges of doing this film which were physically demanding. Jack Fisk was building things by hand as we were shooting and the movie was done by the seat of our pants, so the experience of making the film was difficult. But a core group of people evolved as the heart of the film, and for those people it would be a memorable and very warm experience that they remembered.

SISSY SPACEK

I don't even remember struggling with a scene to make it work. They all just seemed so easy. There was so much that came out of the moment. Terry would set up a situation in a wonderful location, a fabulous set with great props, and we'd come in and then just do it. Things would just happen, and I think that Terry loved that: he loved not over-rehearsing. He didn't want to 'beat a dead horse'.

MARTIN SHEEN

Very often he would shoot the scene as it was written and as he directed: 'You go over here, you go over there, you meet here, you do this, and you exit.' And then he would always say: 'All right, now do a take with what you feel like doing. Incorporate some of these elements that I have asked you for, but you do it your way now. We have what I want, I'm happy. Let's see if you want to do something different, however you feel it.' And we would. And I think that that was a technique, because we would relax, and we would do funny things, things that we might not normally do, and he used a lot of that footage in scenes. And it was actually very ingenious because he got us so disarmed and so comfortable in front of the camera. I tell you, honestly, *Badlands* was the first film I did where I was not nervous on camera.

Where I didn't shake inside, or I wasn't scared. I was totally and completely relaxed. All the time, in every take. I was calm as a cucumber. And it was in large measure because of Terry. He had such confidence in all of us.

ARTHUR PENN

The trouble with established actors is that they become icons, they become fixed statues and they want to keep imitating what they've done before. So then you see them go, their career simply disappears because they are not interesting. I've done some films with a lot of famous actors, maybe too many, but they don't show up just the one person. They come in a group. They have people around them, and people getting things for them. They get to the point where they say, 'I'd like some water, I'm the star.' Somebody runs in, picks up the glass and gives it to them. It becomes a completely artificial life. So, I understand Terry's impulse to look for some young actors or actors who were unusual. You need actors with courage, who are brave, you know. Most actors, they don't want to take a chance, they don't want to look foolish. Martin Sheen was a very unusual actor.

MARTIN SHEEN

My very first shot in the movie is with Warren Oates, out on the prairie. He's painting a sign, I drive up and we have this little scene, and I'm eating a peach. And that morning, before I left for work, I combed my hair and I shaved very nice, I looked very clean. And Terry came up to me and he's looking at me and he says, 'Oh, gosh, Martin! You look so . . . so neat!' and he said, 'Do you mind?' And he reached down and got a handful of dirt and put it down in my hair, to take the shine out from the shampoo I just had a few hours earlier. To make me look more dirty, to make me look more real. I loved him for it. That was his first direction: dirtying up my hair.

SISSY SPACEK

Terry was wonderful to work with and Martin and I both felt very connected to him. When we were working he didn't have a monitor to look in, he was right beside the camera, he was watching, and you could hear him – when he thought the scene was going splendidly, he would be trying to cover his giggling. And that would just push you on. You would just feel invincible working with him and that was a great gift that he gave: that connection with us so that instantly after he cut, he would come to us and mention the little details throughout the scene he wanted us to make adjustments to. You get so spoiled working with someone like that who knows what they want. Oh! It's heaven.

STEVAN LARNER

Terry was very good at this actor/collaborative thing. He doesn't want to be the bad-tempered *Mr Bangs*-type director, he wants to collaborate with the actor and have the actor collaborate with him, and get something that really is the expression of an idea that they have both worked on. He manages to direct his actors whereby the idea comes out of the actor as if he had thought of it, and he hadn't been told what to think. That makes for a very real convincing performance. Terry did not show Martin and Sissy what he wanted, he described what he wanted. He described what the state of mind of the person involved should be, in that particular scene. He described this in great detail and he continued describing this as the scene and rehearsals progressed, as the scene was even being shot. I remember one scene, practically at the end of the picture where the two have been arrested. I'll never forget the way that Sissy holds her handbag as she's being led off by the State Troopers. That was something that she found all by herself. The way she held this handbag made her look so vulnerable and so plunged into a world in which she really had no business being, but which she was going to be in: she was going to prison. That's the kind of lucky accident in this kind of

a film. If the director shows an actor what to do, then you just get some cornball imitation of what the director showed. But if the director can find a way to explain what he wants the person to do and why, and leaves the actor to find it, then you get something believable. That's what Terry did very well in this film, and I think that Martin and Sissy and everyone else involved in the film in the principal roles all went along with it, and were therefore able to make a serious contribution to the film. And that's the way it should be, it's a team effort, everybody has to be working together, and that's what *Badlands* was: everybody was working together.

MARTIN SHEEN

It was the first time in my life that, as I worked on a project, I knew I was working with a genius. We all did. That's why we worked so hard, even if there was so little money and everybody worked for nothing. We knew how important it was to Terry and we all wanted it to succeed for him. As he'd worked so hard, and we could see his vision. At the time we were doing it I knew this was the most important project of my life, from the first day on, I knew it! We all knew it and we would die for this guy.

JACK FISK

Did Martin tell you about the time he had to hold to the power terminal at the power plant? He had to grab it and Terry had the power shut off for the shot but he told Martin, 'Don't worry, it won't shock you, go ahead and touch it.' And Martin said, 'Why don't you touch it first?' And Terry goes, 'No, you touch it.' And Martin goes, 'No! You touch it.'

MARTIN SHEEN

He took me up the top of a big water-tower, to play a scene up there, and I went up by myself and I was terrified. The camera was down on the ground and I had a walkie-talkie. My hands are shaking and my voice is quivering and he's talking to me:

'Can you do this now, Martin? Can you get over a little more to your left?' The wind was howling and I thought it was going to blow me out of the tower and I was going to die. Then, looking through the lens, he saw my hair blowing and he realized the danger so he said, 'Gosh, it's awful windy up there, are you scared?' I said, 'I sure as hell am.' There were moments like this when we had just so much fun working with him.

KENNY HILTON

One of the funny things was that there would be these chase scenes, and I got to double for Sissy because of my long hair. I'd ride in the passenger seat and Terry would jump in the car and be Martin and we would go off in the prairie driving this Cadillac. One time there was a ravine to the side of us, and he kept on saying, 'Do you think we could jump that? Do you think we could jump that?' And I said, 'Maybe . . .' That was never in the movie as the Cadillac did not make the jump! We went: boom! Just right into the edge. I was a little sore for a few days, so was he. We weren't hurt really bad because of the seat belts, just a little bruised up. But we didn't try and jump another ravine in a Cadillac. Terry was the stunt driver in a lot of those scenes: bare-knuckled, squatted down in the seat. It was loads of fun, he was a real hands-on director. He was obviously getting pretty short on the budget production money for him to do the stunt driving and me to sit in for Sissy.

JACK FISK

In the end Terry was shooting a lot himself. I remember going out to the prairie for a shot and he had found a Corvette car, which is a car that has the trunk in the front and the motor in the back. They had taken the hood off and he was strapped in the trunk of the car, which is the front of the car, and he had a football helmet on that wouldn't protect him at all. He had a seat belt holding him down and he was holding a little Arriflex camera and telling the driver of the car, which was the stuntman,

to drive very fast across the prairie. And he was going to shoot it. Whenever the cameraman avoided something for the sake of safety Terry would say, 'Well, I'll do it.' He loved it.

MARTIN SHEEN

Terry photographed a lot of the shots in the piece, not the scenes, the dialogue, but a lot of the visual shots that we did. Some of them were done on the way home or the way to work. We would see a sunrise or a sunset or a moon or something, he would stop the car, jump out, grab the camera and say, 'Go on out there, Martin!' And I'd go out there. And he'd say, 'Do something!' And I'd do something, and he'd film it. And these shots are in the movie.

KENNY HILTON

When we were doing second unit work and Terry didn't know what he wanted to do or what he wanted to shoot, he'd just split the crew into two football teams and had a football game out on the prairie. He was a footballer, he was a quarterback and he loved football. And I was a football player too. There were days when we'd spend one or two hours just playing football and then he'd say, 'Ahh! Okay! I know now what I want to do.' And we'd go off. I guess it was his release to take his mind off the film. And he'd get this blast of inspiration.

One of the most successful collaborations was the one with the art director Jack Fisk. Sent to La Junta ten weeks before the beginning of the shoot, Malick afforded Fisk great freedom. He was aided in this by Kenny Hilton, who found the locations to help realize Malick's vision.

STEVAN LARNER

Jack Fisk was a one-man band: he was the prop department, he was the set dressing department, he was the production designer, he found things in the middle of Colorado that you could never

imagine! He found incredible stuffed animals that we put in shots, he found Sissy's wonderful clarinet! Part, I think, of the beauty of the image is what Jack provided for us to shoot.

JACK FISK

I think a lot of it was just the excitement about films and the possibilities – trying to figure out the language and how we might create some impact by distorting reality. But without making it so unbelievable that you would pull away from it. Terry's like that all the time: he's very inventive and it's exciting to be working with him because you see his mind reacting to every influence in his life; his fondness for the unknown kept everything so fresh and alive. Nothing was over-rehearsed, nothing was over-planned. Often he would see the sets for the first time when he'd come to shoot. You work more from your guts than from your brain.

SISSY SPACEK

Jack hadn't really done a real film at that point, he didn't know what the approach of a typical art director or production designer was. So he production-designed and art-directed as well as being the set decorator and the construction co-ordinator. He did everything! And I remember thinking he must not have been very important when we were shooting because he was doing all the work. He was never sitting, he was always hollowing lumber, he always had paint all over him, he was just busy all the time. And he had an assistant who just sat around and talked about what they were going to do, so I thought, 'He must be the boss!' because Jack was doing all the work.

Holly (voice-over)
We hid out in the wilderness, down by a river in a grove of cottonwoods. It being the flood season we built our house in the trees, with tamarisk walls and willows laid side by side to make a floor. There wasn't a plant in the forest that didn't come in handy.

JACK FISK

I enjoy working, it's more like sculpture or painting, you know, to build sets, to age the sets. For example, building the tree house was a blast. We built it in one day. We got that idea sort of at the last minute and Terry set back shooting on that scene, he did something else for one day. Then they came in the next day and shot and it worked out great. Terry gives you the confidence to try things; he makes you feel like a contributor, a collaborator, so that you really feel that it's your film.

KENNY HILTON

We actually found a big cottonwood tree that was forked properly, so we went and just cut off the poles we needed and started building this three-layered tree house. Just out of the branches and limbs that were available to us. And we made all the wire baskets and cages for the chickens out of tamarisk. It's an easy tree, shrub bush, easy to bend. Everything was made out of there, out of the location we were at.

SAM SHEPARD

There's that one scene too, in *Badlands*, when they make that tree fort, and they're out there and they look out one time and there's a llama. Isn't it a llama or a camel that goes through the background? And it just goes through and nobody says anything about it. It's great. It's like the bear up the stairs in *The Phantom of Liberty* by Luis Buñuel.

KENNY HILTON

Terry was a stickler on having that creative control. He had in mind what he wanted to do. Like when we were out there at the tree house scene, he said, 'I want an exotic animal running through the forest or the river bottom.' So I said, 'I know where we can get a llama!' So I went and borrowed this llama from some good friends who said, 'You can use him as long as you can control him.' The funny part of the story is that the llama broke

away from the man who had him on the leash and it took us about two weeks to find him down the river bottom. My friends were not too happy with me.

Holly (voice-over)
Kit never let on why he'd shot Cato. He said that just talking about it could bring us bad luck and that right now we needed all the luck we could get.

JACK FISK

A lot of the settings just evolved. Some of them evolved after I met Sissy – her character – some of them evolved from my own childhood, some of them evolved from the script and some of them just from the movie-God who put everything together. For example, Cato's house evolved because Terry loved the way one of the people we met in La Junta looked, and he wanted to use him in the film. So one day this guy said, 'Well, I've got 30,000 acres in Lamar and there is an old house in there.' So I went there to look at the house. It was just this little kind of mud hut and we decided to make that Cato's house. Then I found out that a guy had died in one of the towns where we were working, maybe it was in Lamar, and I talked to the family and they let me have everything that was in the house.

SISSY SPACEK
We still have this big bowl of string.

JACK FISK
Yeah! He had these big bowls of string where he saved everything: little crickets and bugs and there were jars with black little spiders. So I ended up giving the family, I think $50, taking everything out of his house and taking it to Cato's. For them they got their house cleaned up, but there were some wonderful things. I can't even remember all the elements, but they were so beautiful that I ended up putting shelves in front of the window so they were backlit.

Badlands

SISSY SPACEK

What about the train car near Cato's house?

JACK FISK

That evolved because in Colorado people were taking old train cars and putting them in their yards for storage. So we just saw that and thought we should incorporate it. A lot was dictated by our budget because we didn't have any money. And because we had so few pieces we chose them carefully, and because they are not many things competing against each other you notice the elements and it's a style that was created because of the budget. But Terry loves it. Even today, when I work with him he goes, 'Do we have to have any people in this village? Do we have to have any furniture?' So I found out – and it's guided me – that sometimes by not having a budget and by doing less, you end up doing more. Fewer things become more powerful.

Malick's unconventional shooting method led to a clash with his DoP, Brian Probyn. Tak Fujimoto,[10] who subsequently became one of the most important Hollywood directors of photography, followed Brian Probyn. Haskell Wexler who, years later, would photograph Days of Heaven, *suggested Tak as a replacement. Fujimoto, however, had to leave the shoot for a previous commitment. Stevan Larner finished the shooting, recreating the spirit of collaboration and exchange of Malick's study years at the American Film Institute. The interchange of three directors of photography is not apparent in the final film, showing Malick's ability to impose a personal look on his film. In fact, Malick himself shot many of the more abstract shots which define* Badlands.

EDWARD PRESSMAN

Terry had Brian Probyn as the first cameraman. It was a very arduous shoot, very hot, he wasn't a young man. At a certain point he had to leave and the assistant Tak Fujimoto came on, and then Stevan Larner came on, so there were three cameramen

and yet the film looked seamless. Certainly that's an amazing process to deal with. At one point I think Brian and the script supervisor didn't understand Terry's editorial approach because he didn't shoot conventional footage. They would shoot with a clapper upside down in protest. They said, 'This isn't going to match,' and things like that. But Terry had a very clear vision and despite these people who were much more experienced than him, questioning the approach, Terry had a very clear idea of what he was after, which turned out to be right. But during the process there was a lot of questioning and wondering what was this gonna be.

JACOB BRACKMAN
I think Terry was very aware that, by this strange process where he got *Badlands* made, he was now in a position to make movies without having learned a lot of the things that, say, Scorsese and Coppola learned in film school, or other people who had worked in television, like Arthur Penn, whom his first wife Jill worked for, had learned through direct experience. Arthur, who was someone we both knew when we were in our early twenties, came up doing this *Playhouse 90* live television[11] and learned to do everything kind of hands-on. Terry came to it 'full blown'. He was a movie director but lacked quite a bit of education and he was very aware of that!

JACK FISK
People who had had more experience had a harder time working with Terry than all of us. Terry would have it organized that we would shoot some scene in the morning and the morning all the trucks would go out to prepare and then Terry would see a beautiful sunrise or get an idea during the night and he would say, 'No, I wanna shoot over here!' And the production people were pulling their hair out!

Badlands

JACK FISK

That was shot right near the parking lot of the motel we were staying at. Terry saw the moon coming up and called to Martin and got the prop of the gun and they went out and did the shot because it was so beautiful. But that's Terry, he's like that: he sees a wild animal or a cloud formation or the wind hitting a leaf, he'll stop everything else to shoot that. When we were shooting *The Thin Red Line* we would have hundreds of extras but if a special bird flew by he would stop everything to shoot the bird because he loves animals. And at that time he said that his approach to filmmaking was like combat, it was him against the world. And he was like a soldier out there fighting for every shot. And when people would get upset with his methods, they would just suddenly become the enemy, making him fight harder to achieve his shots. He went through three cameramen, two different sound men. It was unbelievable, the turnover that he just kept constant making his film. You have to be training to keep up with Terry.

KENNY HILTON

Things got pretty tense. In fact, out of the tree house scene a big fight broke out between Terry and the assistant director, who was obviously out of town on the next flight. And they brought the new one in the next day. Things got pretty hectic for Terry, there was a lot of pressure on him. This was probably after two and a half months of just constant filming every day – even working at night. The stress levels built up. Everyone worked twelve- to sixteen-hour days, some longer when there were night shoots. Especially if you are creatively responsible for everything, your stress level would be higher than just another regular crew member.

HASKELL WEXLER

I saw *Badlands* when it first came out, and I liked it very much. I had something to do with the photography. Terry began shooting with a British cameraman, Brian Probyn, and he couldn't go

57

on for some reason, and Terry talked to me and I suggested Tak Fujimoto. He'd been my assistant for five years – he'd gone to the London Film School – and he was quite capable of shooting. And so I think that that look that Terry, Tak, and Stevan Larner got for that film was quite unusual, quite advanced. I just remember my response to the visuals. It felt direct and simple, it didn't seem cluttered with artifice. Our job as directors of photography is to direct the eye to certain places. And it seemed like it did that practically all the time.

STEVAN LARNER

Terry's view of the image was that it should be completely logical: there should be no artificiality or pretence about it, the lighting and the camera moves had to be completely justified. They had to be not stuffy or weighty or old-fashioned, they had to make sense; everything had to be done for a reason. Having studied philosophy, Terry would instantly see through something that looked phoney and he'd tell you exactly why and we'd find a solution and there we'd go. The governing criteria would always be realism, emotional content and the logic of what the cinematographer was doing. It takes people like Terry Malick and a small, well-disciplined bunch of the same personality as Terry's to break through the heavy Hollywood approach – this big business, this huge machine that sort of grinds out these movies – to find something that's different, something that's independent and something that's free of spirit. So I was very happy to be involved in *Badlands*. I was the third cinematographer. Terry thought of me who he'd been involved with at the AFI. So I went out to La Junta, Colorado, and I remember I had a lot of my own equipment. I had an Éclair Cameflex[12] – that is the Deux Chevaux of cameras. Like the French car it never breaks, it always works, you can fix it yourself, it's a terrific camera – and I had one of these and I remember being on the plane and didn't want to pack it in a case as I was afraid that something might happen to it. So I remember I had it in a paper bag and when I

got off the plane in Colorado Springs where Terry's wife picked me up she said, 'What's that in the paper bag?' 'It's my camera.' 'What's it doing in a paper bag?' 'It's the paper bag school of photography!'

EDWARD PRESSMAN

At the beginning we shot with a small crew for some weeks and then Terry went for months and shot all kinds of imagery and stuff just with him and a cameraman. The script was beautifully written – it just was not a conventional script. But I think a lot of what the movie was, was discovered in the process.

STEVAN LARNER

We started working and the more we worked, the more we talked. Terry had gone to Harvard and I had gone to Yale, and Harvard and Yale are sort of friendly rivals, there's a football game around Thanksgiving time and it's a very, very important part of the academic year. The fact that we were on a par, education-wise, sort of helped us respect each other and made it easier for us to communicate. A lot of these ideas about how to make a film, and this is Terry's first film really, were set up in such a way that you could look for an idea and shoot a certain amount of footage, exploiting this idea. If it didn't really get to the point that you had hoped the idea would, and you threw it all away, it didn't ruin the budget because we were a very small crew and we could do a lot of very far-out stuff and not get into trouble. There was no producer looking at the dailies back home, then calling and saying, 'Why didn't you do this, shoot this close-up or anything like that?' – nobody saw our footage except the editors, so we had a lot of freedom. We had a Cinemobile Mark IV[13] for a while, we had a Mitchell BNCR reflex[14] for our lip-synch work and we had my Cameflex and there was an Arriflex[15] also on the Cinemobile. We had a bunch of nine-lights[16] and a bunch of inky equipment.[17] We didn't have any arcs[18] – this was all before HMI lights[19] existed – so I think the heaviest artillery we had was the

nine-lights. The Cinemobile driver was very helpful and all the local talent, who Terry had sort of trained before I got involved, were very helpful and we were able to do an enormous load of things. We did dolly shots off of cherry-pickers, we used them like crane shots, I should say. We did have a fisher dolly, we had track and we had everything we ever needed, but as I say we were only about four of us!

Holly (voice-over)
In the distance I saw a train making its way silently across the plain, like the caravan in *The Adventures of Marco Polo*. It was our first taste of civilization in days, and I asked Kit if we could have a closer look.

SAM SHEPARD

Terry is this strange combination of being extremely vulnerable, and at the same time very present in the moment. I think it's the vulnerable side of it that helps him to be in all of nature in a way. And that's a part of his genius, I think, this ability to see the moment and say, 'Okay, now, if you don't get this, we'll never get it.' What's fantastic is this ability to just do it and to ignore the conventions of how you shoot a movie.

BILLY WEBER

In the case of *Badlands* Terry did follow the script. He had actually written in the script the images that you see in the movie, even if there is no dialogue – he would write in the description, 'He looks down the driveway and sees a cat cross the driveway, sees a person walk past carrying a bag of groceries,' and he shot that. He shot all the images of nature during production, all interspersed throughout and whenever he would see anything that was interesting in that respect, in the sense of nature or the world around us. I think he did that for many reasons. Life goes on on every level, regardless of what's going on in your personal life, all of these other stories are continuing nature's

story. It's a theme that I would say runs through all of Terry's movies and I think it's something he cares about very deeply. It's a very spiritual quality that he wants to put into a movie.

STEVAN LARNER

As I remember, there was a first draft of the script, then there was any number of scripts, and Terry would write the night before whatever was going to happen the next day. As it went on, the film developed and so, in effect, many times the script was written after we had shot something.

MARTIN SHEEN

Terry understood filmmaking. He was not just a director, he was not just a writer, either one of them is enough: he was a filmmaker, he saw through everything. Everything had a purpose. Everything was part of something else. And he loves nature. He would shoot for hours, little things and little animals, on the prairie. The wind, blowing a reef in the night . . . the light on something! Light was so important to him. He loved the emotional effect that a visual had on you! He projected that always. He was always behind the camera.

STEVAN LARNER

Well, to flesh out the story, Terry felt he needed a lot of insert work, and some of this we did when we were in Colorado. We did a whole lot of Disney true-life nature series kind of stuff, macrocinematography of roots, of strange little things you find in nature, we did a lot of that.

ARTHUR PENN

I think Terry has a personal passion for the very long shots, or the very near close-up of nature. That's Terry's personal passion. He likes that. And I think, very sensibly, in making a movie we don't use the lenses nearly enough. You know we use them, we make pictures. But the lenses – those intense close-up lenses, or

the very long lens – they are thrilling, they can be visually thrilling, and I think Terry had the sense of that.

JACK FISK

I think that Terry uses a lot of cutaways to animals in his films; this is only my own opinion, because I think he sees us all as sort of animals, as part of the earth. Sometimes we see more of what we are in animals than we see in ourselves; we've learned to hide our fears and our emotions, but animals are instinctive and they work from their guts. They work on instinct but we sort of introduced reason and sometimes we are less successful because we are trying to figure things out. He loves to shoot animals, he's always done it.

BEN CHAPLIN

Terry is a bird-spotter. He loves them, he knows a lot about them, he loves nature. I guess like any nature-lover he accepts the violence of it. He accepts the beauty of it, the innocence of animals, but also accepts their viciousness as part of life.

JACK FISK

I understood from Terry that as an audience we react more to animals if they are injured because we don't know if they are faking it or not. Humans, you know, they are not really gonna kill humans. We seem to have more connections with wildlife. I think when Holly Sargis's dog got thrown in the river was an example: you felt more for her losing her dog than for Cato being shot or her dad getting shot.

Holly (voice-over)
We had our bad moments, like any couple. Kit accused me
of only being along for the ride, while at times I wished he'd
fall in the river and drown, so I could watch.

Badlands

JACK FISK

His use of voice-over is unique, in that he is not explaining the story but he's adding a whole other level to it, a layer. People used to think that if you had put voice-over you had problems.

EDWARD PRESSMAN

I think one of the things people often criticize about movies that use voice-over is how it can be used as a crutch to save or fix movies that don't work. I remember when *Badlands* came out, making clear to people that the basic idea of the voice-over was there from the beginning. It was in the screenplay and very much an integral part of the fabric of the film, very elegantly thought through. I think the counterpoint of what's happening and what you hear is so essential to the ironic tone of the film that made it so special and, you know, witty.

SISSY SPACEK

It makes me laugh because usually what Holly is saying is in direct contrast to what you are seeing. For instance, the car is driving at 100mph across this bare landscape, full of dust, and she says, 'Kit told me to enjoy the scenery, and I did.' And it's just nothingness.

Then there was this thing of writing words: 'I was feeling kind of blah, like when you are sitting in the bathtub and all the water's run out,' or 'I was writing entire sentences with my tongue on the roof of my mouth where nobody could read them.' Number one: I think that it made you realize what a child she was; and number two: they were funny. Holly's take on what was happening was such a fantasy and so different than what was really happening. And I think that that was what was clever in how he used the voice-over. I have never seen anyone else do it. I think that it also gave you a sense that Holly's world, it was sort of . . . play-acting.

STEVAN LARNER

Terry would spend practically every night writing. After we shot, he would go back to the hotel room, lock the door and he would write the voice-over, write what he was going to do the next day and write dialogue; he was an incessant writer. And the actors went along with this – no problem – you know, it was a collaborative effort.

SISSY SPACEK

He kept adding and changing things. We recorded the voice-over at his house in LA in a bedroom with blankets nailed up on the walls. We didn't do it in a studio, we did it in his house. Martin laughed because I'd say, 'I went to town, I went to town, I went to town' – her inflection hardly changes each time and is always an undertone – and Martin would go: 'Whaaaaat!!!!' Because, you know, he thought I was saying it exactly the same, but the most little inflection was important to Terry. That was kind of a running joke.

Terry would hand me a line and ask me to say it, and I would say it and he would just fall over in fits of laughter. There wasn't really any great plan, but Terry knew how to use me for his own devices and it was just a great collaboration. So I don't know where that flat quality that Holly had came from. I think that it might have come . . . he gave me something and I just said it, plain. That's what he responded to, that's what he liked. I felt there was a little invisible thread from the actors to Terry while we were shooting – we just would know what he liked and what he responded to. He would talk to you about nuance, the nuance of a word. He was really specific in what he wanted. You know, so much of a film is casting. I think once he got the people that he wanted he just guided us through it. That's all I know.

ARTHUR PENN

That he made the narrative in this peculiar way is his secret or his technique. I think it's a personal thing. For instance I used

a voice-over in *Little Big Man*²⁰ of Dustin Hoffman, but it was a very old man who was telling the story. I made another film that's called *Georgia*,²¹ in Europe, that has four different narrators, four different people telling the story. I'm sure it has been done a lot. But Terry has his own way. He is a good improviser; he improvises a lot.

Holly (voice-over)

One day, while taking a look at some vistas in Dad's stereopticon, it hit me that I was just this little girl, born in Texas, whose father was a sign painter and who had only just so many years to live . . .

 It sent a chill down my spine, and I thought: Where would I be this very moment if Kit had never met me? . . . Or killed anybody? This very moment . . . If my Mom had never met my Dad? If she'd never died? . . . And what's the man I'll marry going to look like? What's he doing right this minute? . . . Is he thinking about me now, by some coincidence, even though he doesn't know me? Does it show on his face?

JACK FISK

I think Terry had asked about a stereopticon and I found one in a thrift store there, with just a pile of old pictures. So I bought a stereopticon and the pictures and then Terry went through them and picked those he liked. It opened up her world by exposing her to images of Egypt and various romantic characters.

STEVAN LARNER

We shot an insert, after the shooting, to sort of symbolize the world that's out there, this wonderful, romantic world out there, that you could travel and see, that these people were not going to really ever get to see. So in my back yard we got the stereopticon and we set up in front of the camera, and made an insert with a zoom lens, where the camera goes through the three-dimensional image of the stereopticon and centres on different views.

Holly (voice-over)

For days afterward I lived in dread. At times I wished I could fall asleep and be taken off to some magical land, but this never happened.

MARTIN SHEEN

I think Holly kind of knew, not too far into the story, that she was with the hell-bent type here. Kit didn't seem like it but, he was a very dangerous guy . . . and maybe she had better keep something for herself, and so she did a lot of things secretly, she kind of kept her own storyline straight, but she included him in the broader picture. Kit didn't have a clue, because he had no storyline. His storyline was her. He thought, 'She's gonna live to tell the story. She will get it all right. I just keep up with my part of the bargain, which is to be this, this great adventurer. But she's the one that's gonna live to write the history. I just want to make sure that she gets it right.'

EDWARD PRESSMAN

I think that there is a sense of fantasy: both in Kit's mind in terms of who he thinks he is, like James Dean, as a great figure or movie star; and then the moment when Sissy is looking at the stereopticon and thinking of worlds so far away – the Sphinx, and Egypt and all – she's thinking of what they might become, kind of dreaming and yearning for a world so far away and yet a sense of future that young people always have, of what might be . . . In that sense it's make-believe, in a very poignant way. I've seen the film so many times but I think that's the most moving aspect of it, a kind of yearning for a beautiful future, which is so remote. And yet that possibility is in everybody, even those two crazy characters. So it's universal in that sense.

Holly (voice-over)

I felt all kind of things looking at the lights of Cheyenne, but most important, I made up my mind to never again tag

Badlands

around with a hell-bent type, no matter how in love with him I was. Finally, I found the strength to tell Kit this. I pointed out that even if we got to the Far North, he still couldn't make a living.

MARTIN SHEEN

The point I think where she understands that she will leave him is when they're driving, and in the narration she talks about spelling out whole sentences on the roof of her mouth, with her tongue. She was keeping something from him – 'This is something he couldn't know about' – it was hers, and she was already departing from him, she was planning on another road – she was already on that road: it was just a question of time. And that time happened just before the capture, when she said, 'I'm not going,' when the helicopter showed up and she gave up. She agreed to meet him at the Great Grand Coulee Dam in some future year . . . she was gone by then. And he kind of knew it, and I think that's one of the reasons he built the monument to himself when he got caught, because she wasn't there. If they'd been together when he finally got caught, when he surrendered, then he would have told her to build the monument, and maybe she'd have done it. But she'd already started to drift; she was already gone in her mind, and it was only a question of time before she said, 'I'm not going.' He realized that that's part of the journey – 'Cause you have to go on alone . . . really great men do things alone, and no one knows it' – he's still in that awful, awful fantasy.

STEVAN LARNER

After the shooting we got back to LA. Terry was using my moviola because I had a cutting room for my documentary film production. In the cutting room you could get an idea of an insert that you might need. I think one of the key scenes in the film is the summation of the high school romance between the two protagonists, and that is the sort of Prom Scene in which they are

67

driving in this car, in the middle of the night and they stop the car, and they are listening to the car radio – playing 'A Blossom Fell' by Nat King Cole – and they get out and in the light of the headlights of the car, in the middle of nowhere they have their 'Prom Dance' – which, in a sense, is the end of adolescence. The Senior Prom is a high point in one's high school career and these people had dropped out and this is all they got.

The voice-over referred to the 'distant lights of Cheyenne' that you could see – well, we were a long way from Cheyenne in La Junta, and we didn't shoot anything like that while we were there. So when we got back to LA we thought that we ought to have a shot of the 'distant city of Cheyenne' at night, so you know what we did? I took my Cameflex, and my wife and I went out on the Pacific Coast Highway, in Malibu, and found a place at night where we could see the distant lights of Malibu in the distance and nothing else! Nothing but blackness and these distant lights of Malibu that we passed off as Cheyenne, so we shot that and that's what's in the film!

BILLY WEBER

I got involved in *Badlands* before they started shooting. I was an assistant editor on a movie that Robert Redford was in, called *The Candidate*,[22] and there were two editors on that movie, and one of those editors, Robert Estrin, was hired to edit *Badlands* and he asked me if I wanted to be his assistant, and that's how I met Terry and got on that movie.

Working together was fun – we had a good time – but Bob left the movie before it was finished and so I finished the picture with Terry. But that was a long process, it was fifteen months. Bob left the picture probably three or four months before we finished.

GEORGE TIPTON

When I met Terry he was sitting behind a moviola and the clacking of the moviola was roaring round all the various other rooms there. He stopped it when I came in and he said, 'Hello.' And I

said, 'Are you Terry?' 'Yes, I am. Are you George? Well, come over here let me show you something. I've got a scene here with some music I really like for it and I'd like to know how you like it.' As usual you hear the clacking of the machine come up and here's some music behind it that I didn't recognize at all and a scene that had something to do with something that looked like some Tarzan setting, it was in trees . . . And he said, 'Well, you know, this is a scene where these two characters are really, well it's hard to describe . . . I'm trying to make them appear really quite innocent and . . . like sprites that come out of the earth, do you know what I'm talking about? Well – the problem is they have just killed someone! This is a story about someone who did that . . . did you hear about the Starkweather trial?' 'I think so,' I said, 'I remember it's about somebody being chased all over the country.' 'Well, this is what we are doing here: we're telling the story about two young people who have become involved in a horrible sequence of events,' and he says, 'I would like to explore the idea that perhaps they're doing this, yet they are totally unaware and innocent of what they're doing – it seems to me that they couldn't have done what they've done without being unaware of the depth of that.' So he says, 'I'm showing this to you because I think this music expresses their freedom to be young.'

JACOB BRACKMAN

In a way the music of *Badlands* is like a Stanley Kubrick score because it contains such disparate elements; it's not of a piece, there's some classical or semi-classical, like Satie and Carl Orff, but also some folk and some improvised guitar, all kinds of stuff. At that time I was writing songs with Carly Simon who was married to James Taylor[23] and I introduced him to Terry. The piece James did is, in a way, the theme of *Badlands*: it's when they take off in the car, after their idyll in the woods is busted up. James's music does give you that sense of escape and of that solitude. Later, he did a version that had lyrics to it and put it on an album called *Migration*.

BILLY WEBER

Terry always wanted to use the Carl Orff music. Before he even started shooting the movie he knew the pieces he wanted to try. The Satie music was different, that was an experiment that we tried – we tried lots of different pieces of music. It's something that we did on all of his movies: you experiment with a lot of different pieces of music and in some cases this changes the editing. What happens is you don't change the editing until you really feel like you have found the right piece of music and when you find it, it's because you feel it works with the cuts that you have made already. Then you make slight variations in the editing, but you pretty much go with what you have.

JACOB BRACKMAN

I was also in the cutting room a lot and helping with the voice-over. Terry would try so many different pieces of voice-over or different pieces of music, along with different sequences, he'd keep trying them over and over and looking at them and then kind of intuitively matching them. There's a perfect length for each cut, and as the sound and the picture comes together emotion is created, in a mysterious way somehow.

BILLY WEBER

So much of the editing has to do with the rhythm of the movie, and I've always felt that if you're in that rhythm, especially with Terry's movies: it's not hard to find the place even for shots that seem to belong to different universes, and different scales – for example, the close-ups of nature. You sense the right time to do it. I actually think that all movies are like that; the film speaks to you when you're editing it. It almost tells you when you need to try something like that.

In *Badlands* we ran the movie for George Tipton with the Carl Orff music and with the Satie music and George basically added incidental music that he felt was in the style of the other two.

GEORGE TIPTON

I liked the music he had chosen. I really have to say I liked Terry and I was intrigued with him being interested in what was going on in their minds, in contrast to what they were doing.

Generally, Terry would have the music to play for me that he wanted to fit the scene, and it needed to be not only reproduced and re-recorded, or simply transcribed, but I had to add front to it, or stretch the middle section if it needed to go longer to keep it in the same style. In other words, it became Orff music that was adapted but had to be created for the places where it didn't exist.

Musically, it would continue what was there, but when it stopped I had to make it so that it would go on longer, without repeating it. Most of that music had a repetitive kind of sound to it, but it needed to be knitted and woven together.

Holly (voice-over)

I grew to love the forest. The cooing of the doves and the hum of dragonflies in the air made it always seem lonesome and like everybody's dead and gone . . .

When the leaves rustled overhead, it was like the spirits were whispering about all the little things that bothered 'em.

GEORGE TIPTON

Because the music had already been transferred over to one of the moviolas, so he could sync up the music with a scene, he would adjust the music to fit the scene he was showing me. It was music from Orff's 'Children School Work': it has marimbas and sounds like dance music. Also there were other sounds in other Orff works, something that sounded like witches or grey-haired ladies. These sounds were vocal sounds but they were not sounds that you could relate to as language. He said an interesting thing: 'I don't know what they are saying but I want the sound of these voices – a kind of whispering,' and so I said, 'All right, I will transcribe phonetically the sounds that I hear from this recording of this Orff work. We'll just have the girls and fellows that we

record with read it and sing it to these syllables, but they won't be English and they won't be German and they won't be anything. No one can sue you for copying someone else's words . . .'

This was unlike any other experience I had had with somebody who has finished a film and wants music for it. This time it was someone who hadn't finished editing it but knew what music he wanted. I was all for doing that, because I had worked with songwriters before, and Terry was like a songwriter: someone who had finished his song and needed it to be supported with a musician who could deliver that music in the form that he wanted it in. That's how we worked.

IRVIN KERSHNER

When Terry thought the movie was finished I got a call from him: 'Can you come in and take a look at the picture?' I asked, 'How long is it?' And he replied, 'Something like two and a half hours or more.' So I said, 'You got to cut it down.' 'I don't want to cut it,' he said. And I replied, 'But, geez, you have to cut it . . . it just won't play.' Usually a picture will be a lot better if you compress it, that's what a film is: a compression of time and space. Then he called and said, 'Yeah, maybe you're right, can you come in and look at it?' So, I came into the editing room and I sat for hours at a moviola, you know with the film going through, with the sound, and I'm watching. 'That's great, that's redundant . . . You have already made the point in this scene, you're just repeating it.' And he'd make a note. I just went through it, talking through it. It was off the top of the head, I was not looking at it on the big screen and really analysing it: it was really 'what hit you right there', because I knew the script and he followed a lot of it.

So we made the cuts that I thought should be made, because he was kinda lost at that point. He'd shot so much footage and it was all interesting, all interesting . . . He wasn't a filmmaker at the time, he was someone who loved film, and who saw a metaphor in everything. And he was fascinating. He has a vision that no one else has.

Badlands

MARTIN SHEEN

The first screening I saw was a rough-cut without music; it was not the final film. I was so pleased with individual scenes, and with sequences, but I couldn't see the whole film, so I was somewhat confused. It was only months later, when I saw it with the music and the narration that I realized that he'd done it. Because even when we were filming, we didn't have any idea of what the narration would be! And very often we would get to a point and we'd say, 'Well, now, what follows this, Terry?' And he'd say, 'Well, that's in the narration. I gotta work on it yet, it's in my head.' And so we trusted that, and thank God we did! Because we weren't looking for 'results' when we were doing it. Just increments, we were interested in doing little bits and pieces as we went along, we didn't have any result in mind for the whole picture.

BILLY WEBER

In the case of *Badlands*, Martin Sheen unconsciously became that character. He didn't realize it himself until after he saw the finished movie, and I wouldn't really say it was based on anything other than it was all just coming out of Martin. We had a great moment when we showed Martin the movie, when it was done, and he left the room after seeing it – he was so upset – and he said to us afterwards, 'He's a killer . . . he's a horrible killer.' He didn't realize it while he was playing the part because he was so involved in that character and he didn't see himself as a cold-blooded killer at all. He was very moved by the film and I think that he feels like it is some of his finest work. There wasn't a moment when you felt he wasn't in that character, when he wasn't just totally involved.

MARTIN SHEEN

When I saw the film at the New York Film Festival, at the first screening, I couldn't get out of my chair, I couldn't believe I'd done it! And I kept saying to my wife Janet, 'Can you believe

that? Do you see that? Can you believe that he did it?' You know, he took like almost two years to edit! And he did extra shots, on his own, in the desert, with animals and nature. I thought, 'Oh my God! He did it and far surpassed any level that I had hoped it would reach!' I mean, he went over the moon! And I couldn't have been happier. And I've never been that pleased with a film since. Never. Frankly I don't expect to be. I don't think he can do that again. I think today it would be much more expensive, you couldn't shoot for four months with a small crew, on a distant location, with that personal a film, today. They just wouldn't let you do it – they wouldn't give you enough money to do it – unless you are Terrence Malick!

EDWARD PRESSMAN

I'm trying to remember the first time I saw the film. I remember so well the night it was first publicly screened, it was an amazing night. I'm a great Nat King Cole fan and I remember the first time I saw the film having a real emotional response to the film. In particular the scene where they are dancing to 'A Blossom Fell' – to the lights. I was very moved by the movie and I think that moment comes back to me as the most immediate recollection of that experience. I always loved the movie, but that's what comes back to me when I just start thinking about it. It brought tears to my eyes.

ARTHUR PENN

When I saw the movie, my impressions were that it was a better film than I had expected. I mean, I knew the story, I knew how intelligent and sensitive Terry was, but I didn't know if he would be able to get that on film. You know, the first time out is not so easy. But he did: it was extraordinarily good. He has a line, a very strong intellectual line, and when he was operating on that, he was making a good film. So when I saw the film it was both familiar and better than I thought it was going to be.

But the biggest problem in those days – as today – was always

distribution. I said before, we can make a film for relatively little money. It wouldn't cost very much, but when you finish with the film, how do you get distribution? Particularly when studios viewed a film like that as if it was sort of the enemy: 'We don't want those enemies.' For instance, during the period of the great neo-realism of Italy, there was a wonderful man here, Amos Vogel,[24] who was a distributor, and he found all those wonderful films of Rossellini, of De Sica, and he bought a couple of little theatres and he started showing those films. And they made a very big impression here. What happened then, what happens always with capitalism, is that the powerful money buys up this material. When we look at Miramax – thirty, forty years after Rossellini and De Sica and Fellini – they bought a couple of films: Irish films . . . and they figured out, 'Let's show them in small theatres in a couple of big cities,' and that's exactly what they did and they made money. That's pretty much what happened to *Badlands*. *Badlands* didn't get distributed all over the country because people figured, 'That's not a movie that the audience is gonna go see. They want movies with movie stars, certainly not movies about two kids killing people.' The question of distribution is a question that was serious in America and now it has spread to Europe where American films push European films out of the way. It's their power. Think for a minute – instead of a European film an unusual American film: they don't want it around, they don't want it. They are gonna make it difficult for those films because they want their films to go into the big theatres at big prices and stay that way. Well, that was exactly the situation that was true then. And it comes in stages, it's gonna come again. I think right now small American films like *Badlands* are gonna get made and shown.

EDWARD PRESSMAN
The screening at the New York Film Festival was great, a sort of première, but Warner Bros decided on a problematic distribution strategy. They had a very commercial movie, a film recently

come out, called *White Line Fever*,[25] which was a successful road movie with a lot of action in it. So they decided that *Badlands* could be sold like that, like a straight action film. They also did a preview for *Badlands* with an audience, and they teamed it with *Blazing Saddles*, the Mel Brooks comedy. Which was an odd choice. I remember there was a fellow working for Warner Bros called Leo Greenfield, he was outside the theatre, he said these were the worst preview cards in the history of Warner Bros. The audience who came from seeing *Blazing Saddles* didn't get *Badlands* at all. 80 per cent of the people just said, 'Forget it!' So Warners was, I think, discouraged by that reaction and then decided to open the film in the biggest theatre in Los Angeles, the Village Theatre in Westwood, as a very kind of exploitation action movie, which didn't work at all. So the film's initial release was very unsuccessful. The film didn't play long.

I think its reputation came over time. We actually re-released the film a few years later, with our own resources. We opened the film in Little Rock, Arkansas, because it was a non-expensive way to try it out. And then we went to Memphis, Tennessee, which was bigger, and then Dallas, and then Warners took it across the country again with the help of another company out of Boston. This re-release had a lot to do with re-establishing this film because there was always a strong critical support in certain places, but not across the country by any means. The *New York Times*, the support of the critic Vincent Canby,[26] was very, very strong, but a lot of critics across the country were very dismissive. It took time for the film to gain its reputation.

RICHARD GERE

I'd seen *Badlands* and was blown away by it. Well, theatre was really where I was coming from. I didn't really care about film at that point. I was all about theatre. But I remember talking to my agent saying, 'Look, if this guy's making a movie, that's something I would be interested in.' I think Terry tapped into something with *Badlands* that was powerful to me and powerful

to other people, although I think it was a total disaster commercially. I think I actually saw it on 42nd Street with some Japanese monster movie. And it played a weekend, I think, and was gone. But it certainly was part of a zeitgeist of that time.

SEAN PENN

When I saw *Badlands* it was the beginning of my getting interested in directing movies, that's what my impression was . . . I just thought 'wow', it was a very visceral reaction I had to this sort of poetry that was disguised by a kind of objective presentational idea, relative to a story that severe, with characters that severe. I thought I had never seen people in a movie doing such horrible things where they were neither judged nor romanticized, but just presented. Where it wasn't just the literature of that and the acting of that, but also the composition, the kind of simple images that added up to what I remember as a beautiful movie. I just had not seen anything like that before. I also felt that there was a more authentic ear at work. When one listens to the narration of Sissy Spacek in *Badlands* and by Linda Manz in *Days of Heaven*, there was such a trust in the authenticity that those two actors brought to the narration. There wasn't a kind of need for transparent fireworks – he trusted that it was going to be interesting, because it was real, and so I was just taken by that.

SAM SHEPARD

I instantly loved it. I instantly felt like we were in the presence of a unique filmmaker, particularly because of the narration. The way it was narrated in Sissy's voice, her presence in the voice. I thought it was extraordinary; it was very, very different. I mean, you could instantly tell that this was a filmmaker, not just someone making movies for Hollywood.

There's a great temptation to moralize about murder, you know what I mean, the right and wrong. I don't think Terry is so interested in the morality. It's the predicament, the situation,

the event. Now, of course you can say it's a very bad thing that people died on this spree of theirs, that these people are in fact murderers, et cetera, et cetera, et cetera. I don't want to speak for Terry, but to me they're not morality movies, they're not about what side you're gonna take, and that is beautiful, in a way. Peckinpah did the same thing, with the one he did with McQueen and Ali MacGraw, *The Getaway*.[27] Anyhow, to me it's not about morality. Although you can make it that way.

BEN CHAPLIN

I can't think of a film I like more than *Badlands*. Considering that it's a debut and it was written and directed by the same man who was thirty-one or whatever he was, it's just incredible. And it's a short film: it's an hour and a half. I have seen *Badlands* probably ten times. Every time I see it there's something I missed. It's so simple and yet so complex. Like great poetry . . . the great poets say the most with the least words. I think *Badlands* typifies that, and yet it has wit. I think *Badlands* is nihilist and yet spiritual in the end – at the same time being this incredible cold examination of cold-blooded murder. Martin Sheen is funny in it and yet he is so diabolical. Terry is without judgement: he doesn't patronize his characters; he doesn't judge them, even if they are murderers. There's a Christ-like quality to that. Of forgiving and non-judgement and what does it matter anyway. He believes in humanity. You could argue from his films that he doesn't, but there is a warmth underneath them even though they are about men in extremes; man at his worst. He has a faith in us.

MARTIN SHEEN

Terry comes to you as this full person. I mean he's not specific about spirituality, but his whole character is spiritual, he can't separate himself from his spirituality, though you might not be able to identify it as such. He might call it his 'humanity' maybe – he might not even use the word 'spirituality', I don't know, but it is something that everyone else would see. He might be the

last one to see it in himself. He's also extremely shy. I remember one time, walking down a street with him in Paris, and someone recognized me. He said, 'Ooh . . . you are Martin Sheen,' and I said, 'Yes . . .' 'Oh! *Badlands* . . .' and they'd go on and on and on about *Badlands*. And I looked around and Terry was gone . . . he didn't even stop, he was gone! He's so shy . . . And another time: we were at the National Museum, in Washington – he wanted to look at a photography display; he was gonna do a movie about a photographer in the early West – and he took me to this exhibit, and a group of people recognized me and he disappeared, again. He ran away. He is just not comfortable being recognized for what he does. I think he's only comfortable with being recognized for who he is. And 'a filmmaker' is just a very small part of who he is.

The spirituality evoked by Malick's collaborators has a clear echo in some scenes of Badlands. *One of the clearest examples is surely the one in which Kit sets Holly's house on fire, where the body of the father he has just killed lies. The house on fire is both a funeral pyre and the symbol of the passage to a new era in the life of the characters. The solemnity of the scene is enhanced by Carl Orff's music rearranged by George Tipton.*

JACK FISK

Terry has a lot of recurring elements in his films; one of them is fire. For the fire scene in *Badlands* we ended up building a set outside, and the elements were magical. I mean there's something fascinating about fire, something purifying and cleansing. He likes elements like fire, water, wind, air – all the basic elements. But sometimes we forget, we don't incorporate them, and symbolically it seems like fire is so strong.

GEORGE TIPTON

I remember the scene where Holly's house is burning. That was a very important scene to Terry. I don't think that this was something for the camera, I suppose he just wanted that purification

thing. I can't speak for him, but purity comes from trial by fire and there are many examples in literature. Our whole life experience is trial by fire, a different kind than the one burning the house down, it's the fire of life . . . and it goes from one life to another, as far as I'm concerned, and we all partake of it and live it.

The evocative power of Badlands, *together with Malick's desire to be close to the characters without judging, urges the viewers to reflect upon America's nature. Malick's approach of never moralizing allows different and contradictory elements to coexist.*

SEAN PENN

Terry has only gained from his worldliness and his travels and his studies – he's been able to have a bird's-eye view of America, as well, but there is nothing more American than a Texan, for better and for worse. And so, when I see his movies – and this was my reaction when I first saw *Badlands* – it was an America that made sense to me – for its beauty and for its ugliness, and for its poetry.

SAM SHEPARD

There is something deeply American in this story. It's this thing of unruliness, of something wild trying to be contained in a social context. I think America's like that. It's totally wild and yet we always try to contain it. The Democrats and the Republicans, they're always trying to contain it in some form, politics can't contain it, religion surely can't contain it. There's a wildness about it. If you want to call it American, I suppose you can. There is always something busting out. That's a good thing.

SEAN PENN

I think that Terry is also American in the sense that he's more American than what they generally get as a filmmaker, because he

noticed America; he knows it like an Indian knows America; like some kind of a shaman knows it. If a bird flies by in America and he has seen it enough, he hears it, he knows what kind of bird it is; if it's a tree he knows what kind of tree it is, he's noticed it. He reminds me of people like Edward Abbey[28] or Wallace Stegner[29] who were naturalist writers. There is a big part of Terry that's a naturalist, because he's from here; I think he probably knows a lot about it all around the world, because he is very scholarly about those things, but I think that he grew up having a fascination with this landscape. It's a landscape which is quickly being destroyed and certainly the culture ignores it more and more, but he is that rare combination of someone – again I use that word – 'academic', because we know his history, academically he's advanced, a Rhodes scholar and all that kind of stuff – one doesn't automatically equate that with somebody who's interested in the things that are part of the natural environment . . . It seems that the culture has devised academic study to be related to economic gain and in his case it's not been like that, it's been a much deeper exploration of the world he lives in, spiritually and naturalistically. He is a very religious person and so his relationship with America is not necessarily in the way that we generally view people's relationship with America – he is not out there raging against the contradictions, as much as he is balancing the contradictions. That's been the case with all his movies.

SAM SHEPARD

I don't know many Indian shamans. So I cannot make the comparison with Sean Penn's point of view. I'm joking. I don't know what this is, but every artist I've come to highly respect has this thing in common which has to do with aloneness, which has to do with the starkness of what it is to stand alone. And I think that's what Terry has. There's something about it in his works. He is not so interested in being part of the pack. Not interested at all. He has got his own things. And I think he has been true to it in everything he has done. So far. I mean that's kind of what

you should do as an artist. What else is there? But you don't see that very often nowadays.

SEAN PENN

Terry is concerned with the way that we are innocent, he's concerned with the way that we're damaged, with the way that we're cruel, the way that we love – he's concerned about all the things that represent our lives. And I do think that he is a real poet among academics. 'Cause he's both. He's a very complicated guy. I mean, we used to laugh a lot because he is such a gentle person. We would laugh a lot wondering, 'Where is the guy that made *Badlands*? Where in his face?' And once in a while you would see a kind of flash in his eyes. Terry would be talking, and then there would be these moments of these eyes going wild. And you think, 'Oh, there it is. There's the guy that made *Badlands*.'

BILLY WEBER

One of my favourite moments in *Badlands* is right at the end of the movie: when the plane is taking off with Kit and Holly in the plane and instead of cutting into the plane first, we cut to a man carrying a mail sack along the runway, who has no idea that a plane has just taken off with these two fugitives who were killers and he's got so many other things on his mind that had nothing to do with that. It was a great moment for me, because it just showed other lives going on, other things going on in the world that have nothing to do with this and that. That to me represented so much of what the movie was about: there are all these things that go on in the world, some of them are horrible, some of them are not, some are mundane, and that shot sort of said all of that for me. There is also a famous painting, *The Sleeping Gypsy* by Henri Rousseau, where a gypsy is asleep under the moonlight and a lion is sniffing at him while he's sleeping and he has no idea that this is happening to him, and it's such an amazing moment, and he will never know that that happened.

Holly (voice-over)

Kit and I were taken back to South Dakota. They kept him in solitary, so he didn't have a chance to get acquainted with the other inmates, though he was sure they'd like him, especially the murderers. Myself, I got off with probation and a lot of nasty looks. Later I married the son of the lawyer who defended me. Kit went to sleep in the courtroom while his confession was being read, and he was sentenced to die in the electric chair. On a warm spring night, six months later, after donating his body to science, he did.

Days of Heaven

The shooting of Badlands *deeply influenced the way Malick approached filmmaking.* Badlands *had proved how essential it was to take advantage of the moments during which 'small miracles' occurred, and shown the need for sensitive collaborators to help capture these moments on camera. This is why the contribution of a production designer such as Jack Fisk, who is always ready to organize the set to give the director the chance of shooting from any chosen angle, leaving him free to follow the rhythm dictated by the action, is fundamental. At the same time, organizing these expressive moments required a very sensitive editor, capable of cutting the images without obscuring their force. Billy Weber adapted himself to this working method, which would soon become his professional creed. Aware of all of this, Malick started thinking about a new film in which all the intuitions which matured during the* Badlands *experience could converge. With* Days of Heaven, *Terrence Malick, Jack Fisk, Billy Weber and the directors of photography Nestor Almendros and Haskell Wexler came to realize that it was the film itself which would suggest the timing of the shooting.*

Days of Heaven *is set in 1916 on a great farm in the Texan panhandle owned by a young, lonely farmer played by Sam Shepard. A number of workers, many of whom have come from the urban and industrial East Coast, arrive to work as temporary labour for the wheat harvest. They are uncomfortable in such a harsh and solitary environment, where man becomes insignificant in the face of the forces of nature. This group includes Bill (Richard Gere) – fleeing from Chicago after having accidentally killed his boss at the steel mill – along with his sister Linda (Linda Manz) and Abby (Brooke Adams), Bill's girlfriend; Bill*

decides to treat Abby as his sister and not to reveal their rela-
tionship publicly.

JACK FISK

For the title sequence, Terry used some photographs by Lewis
Hine.[1] The photographs showed workers and the suffering they
experienced. In Terry's mind these people coming to Texas were
city workers being put into a landscape that was different than
the one they normally habituated. Seeing these photographs
helps you see how foreign it was for them. Living out on the
prairie and being so small in these big surroundings was harder
for them to deal with than being in a house or being in the city.

SAM SHEPARD

I loved the predicament, the situation, and the era, the time of
the film. It was that curious time, particularly in the South-West,
at the turn of the century, when the horse was being pushed out
and the car was coming in, the train was coming in. You had this
clash between ranching and the industrial revolution. And that
era is incredible, because of the way things bumped together.
The characters seem to be icons of that era, and that's what fas-
cinated me first of all.

Officially the Frontier was closed around 1890, but in fact
the Frontier was being newly discovered by the white, European
population. So, you still had this very primitive culture bumping
up against Eastern influence. It's still a very raw, primitive kind
of existence out there in the hinterlands. The landscape really
shaped those people. It carved them in a way that it didn't in the
East. Because it's so harsh, it's so stark. There are no trees, there's
no water. It's the bare bones. So who those people became had to
do with the landscape. There's no way to separate them.

But then of course, Terry takes it even further because he
brings people from the East Coast culture into this landscape.
That's one of the most beautiful things in the film. He brings
in these girls with these city accents into this landscape of the

South-West. It's the contrast of these things that makes the poetry of the film.

So, the centre of the film is this head-on collision between the urban and the rural. The centre of the film doesn't lie in one or other of the characters, it has to do with the era, with the time – a crucial time. The railroad was coming in, and we were exploiting the land, and we were marching forward with 'Manifest Destiny', and all this other shit. But what was actually happening is that there was a horrible collision of cultures taking place.

RICHARD GERE

We played the film as 1916 or 1920, I can't remember exactly. It was post-World War I, and I think it was about post-agrarian, pre-industrial society. I'm flashing now on an image of Terry taking an old tractor and riding it through the fire in the fields. And it was kind of a monster, a metal monster in the fire. I think that the movie had to do with that, a kind of a sense of soullessness almost. It was probably closer to *Metropolis*[2] than something just about society; it has some spiritual resonances. It's about the interior and exterior universes. And you are either in rhythm with it or you are not. The Industrial Age was creating a rhythm of its own which wasn't necessarily in tune with the real world. I think that is probably more where Terry was coming from.

PAUL RYAN

In 1916 the country was still expanding and the parts of the country out west were still so wild. There is a great moment in the movie when the protagonists leave the city, and it cuts to a wide shot of the bridge, with the train going over it and the banjo music comes in and suddenly it's like the whole world expands and you are crossing a bridge into a new land, one that's as yet undiscovered. The way this shot is placed in the film is wonderful, Billy Weber did a great job. In terms of metaphor, that was what Terry was saying: I remember we did a lot of shots that were meant to be used as point-of-view shots; a lot of shots

of just looking out over the wheat fields, just watching how the wheat waves like an ocean as it blows in the wind, things that I knew Terry was looking for – expansiveness was the main thing.

The farmer is a lonely character who lives in a big Victorian house, the only building standing out in the ocean of wheat of his property. His destiny is sealed: although he is very wealthy, an illness leaves him with only a few months to live. Bill comes to know this, and when the farmer shows an interest in Abby, Bill pushes the girl to marry him so as to escape from their life of hardship and misery and obtain an otherwise inaccessible wealth.

JACOB BRACKMAN

Regarding *Days of Heaven*, one of the very big differences with the final version of the film was that the farmer, as originally conceived, was a much older guy and we were thinking about actors like Warren Oates or Ben Johnson. But somehow, because he was older, Abby – the woman Brooke Adams ended up playing – didn't really fall in love with him; instead, it was a kind of misunderstanding that resulted from Bill's bad faith in allowing her to marry him, making a whore out of her, in order to get money out of this sick old guy. Then the change to a younger guy and having Abby really fall in love with him was the result of some conversations we had with Wallace Shawn. Wallace Shawn is a playwright and actor, but he was also a classmate of ours at Harvard and son of William Shawn, the editor of *The New Yorker*. After talking with him Terry decided to change the character of the farmer.

DIANNE CRITTENDEN

Before the shooting, in the script, the little girl, Linda, was supposed to be Abby's sister and not Bill's sister. So when I saw the finished film and she was Billy's sister I was shocked. In the original script Abby had so much more motivation to marry the farmer, because with this decision she was also saving her sister. I

felt that if she had no other way of taking care of her sister, then it gave her much more reason to marry the farmer. But if she was Bill's sister, then I felt the motivation was not very clear. But I think that was what Terry liked about it, because in the end she really does fall in love with the farmer, so she is doing it for him.

JACK FISK

The clashing elements in *Days of Heaven* came in building the house: it wasn't a Western house. It was more of an East Coast home.

Terry showed me the photo of a house that he liked. It was an American house of the turn of the century, with a porch. He liked the idea of a belvedere because the wheat was like an ocean. From these houses, widows would look for their husbands who were lost at sea; they had widow walks. Of course, I looked at a little bit of Edward Hopper but the inspiration came from other elements. It was to take advantage of the wheat being like an ocean, it was to give vertical lines in a very horizontal landscape, so we looked for towers and everything that was vertical to make it stand out. Being vertical, the house just popped out from the landscape: it became kind of a character on its own. We also put some gates up and I moved these gates around many times. We built them and we kept putting them up and then they would go down, and we'd put them somewhere else. If you see the film you will notice wagons going through these gates; somehow, it became a really neat symbol having this human element out of nowhere. The gate defined a property if you couldn't grasp how big it was.

SAM SHEPARD

They said that the pioneers close to old abandoned houses used to put lights in those houses so that they would feel less alone. So they'd be under the impression there was a neighbour, but there was nobody there. They had company in their imagination. That's how lonesome they were.

But I didn't have to work with that loneliness to play the farmer: I always felt that I understood that. Terry and I both came from similar backgrounds, although he grew up in Texas and I grew up in Southern California, in the desert country of California – anyway in a remote, rural place. Through Terry, I felt this sort of haunted sense of where he came from. What I wanted to do was to try to capture this ghost.

The figure of the farmer is also very typical of that place. A man who tries to create a dynasty and succeeds. Yet he's extraordinarily empty and alone. And that would never be resolved. Never. It's like the Citizen Kane character, except that it's rural, South-Western. A haunted character who never ever has a true home.

On the other side, the brother and the sister are supposedly conspiring – they're trying to get things for themselves – whereas the farmer innocently falls in love with her. So, without being overtly concerned about the right and wrong of things, there is this contrast between the manipulative 'big city' corrupt thing and this innocence. Whether, in fact, they are is another story. But I think those are the elements that Terry makes collide in the movie that cause it to be so compelling.

BILLY WEBER

A lot of the house is based on what it was really like at that time. A farmer in Texas at that time would have a grand Victorian house in the middle of nowhere. Part of that is based on the movie *Giant* where there is this huge house in the middle of an area of oil fields.

I think it was meant to have a real Victorian quality to almost make it untouchable – especially to Richard Gere's character. There's that scene where he walks in the house when Brooke Adams and Sam Shepard's characters have left to go on their honeymoon. He feels so alien in it and, ideally, he would sense that he doesn't belong to that place. It's a place where he's not allowed in. I think that was definitely part of the intention.

PAUL RYAN

The way the house is placed on the hill and its structure made it a sort of castle. The character of the foreman at one point says, 'Don't go near the house.' He always comes down from the house to see the people, then he goes back up to it; it's a very unapproachable thing. It's even interesting on the inside, how you go through it. There is a kind of mystery.

JACK FISK

Terry might have had an idea about the contrast between interior and exterior. The thing that I remember most is that the interior was the bedroom, which created a lot of the problems – Brooke Adams's character was having an affair with Sam Shepard's character but Richard Gere was, in reality, her husband, posing as her brother – so it became very strange. So, that sort of inner sanctum contained the nucleus of their whole problem; it began in that house. We felt that the interior of the house had this human identity and then there is God's identity outside. And God is much more powerful than man. For me, houses are kind of unnatural; we probably were built originally to live in caves and out in the landscape, so that anything we manufactured is unnatural, in a way.

SAM SHEPARD

I think that a man like that, living in that sort of solitude, has a notion of who he is quite different from how we perceive it now, with our complicated ideas of personality and of who we are, of what we identify with. Those men, particularly at that time, identified with things that had to do with the land: the horse, the cattle, the water – things that were absolutely calculated. They were there or you wouldn't be there. You are on a good horse or you're on foot. If you had a good horse, you were a better man than you would have been on foot. If you had good cattle, you were a better man than the man that had no cattle. Or you were a better man if you had someone who cooked for you. Those

were the type of things that built the idea of who I am. That sort of simple, direct thing. They knew who they were by what they needed to know, not by supposing they were somebody.

So it was a very different culture. I don't think we can judge it now by how we perceive the notion of self. The notion of self now is so fucked up. We don't even know who we are. But they knew who they were in those very simple terms: 'Land goes from here to that rock over there and then goes over there'; 'Those cattle are mine, those cattle aren't mine'; 'I have water thirty miles from here and I know exactly where the water is and where to take cattle to the water.'

JACOB BRACKMAN

Originally, it was just Terry and I. I was the producer and Terry was the director and we were trying to get the movie financed by getting an actor to play the role that Richard Gere ultimately played – we tried to get Al Pacino and then we tried to get Dustin Hoffman. If we had succeeded there, we would not have needed Bert Schneider, but since we couldn't get a star and then basically decided to do the picture with unknowns, Terry started talking to Bert. Bert's father, Abe Schneider, was the president of Columbia pictures and Harold and Bert's company, BBS, had a deal with Columbia, but that was all well before *Days of Heaven*; by the time *Days of Heaven* was being put together, BBS didn't exist any longer and Bert was on his own. BBS had a wonderful run – you could say it began with *Easy Rider*, that was 1969, and maybe the last picture was Peter Davis's Vietnam picture *Hearts and Minds*[3] that Bert produced. That was the beginning and the end of BBS; they sold the building they owned and everybody went their separate ways by around 1974. When we started the production of the film, Bert was on his own, but he had status: he came from a rich family and he had money – so he approached Barry Diller[4] at Paramount and said, 'I'll deliver this picture to you for 3.5 million and if it goes over that, I will pay for that out of my own pocket.' That's called a negative pickup deal and that

was the deal he made. Then later, after the picture was all done, and while it was being cut and it was clear that it was going to cost more than that, and Bert stood to be liable for the overage, he went back to Paramount and said, 'Listen, we're giving you a lot more than we said and we're going to blow it up into 70 mm,' and he brought them a reel showing the locusts and the fire scenes, and basically they said, 'Okay, we're going to give you an additional allowance,' which covered the additional editing time.

MIKE MEDAVOY

After *Badlands* I went to United Artists and became the Head of Production, but I didn't get involved in *Days of Heaven*. I had partners and the group felt it wasn't the right film to do. It was, I think, in part its sparsity; it was also more expensive than the first film; the cast was unknown – there were a number of reasons.

EDWARD PRESSMAN

I remember Terry was working on *Days of Heaven*, but not immediately. After *Badlands* was finished, I think he wasn't anxious to direct again: it was a great ordeal and it was very demanding on Terry's psyche and physical stamina. I think he was not about to start directing a film very quickly; when he started working on *Days of Heaven*, I would have liked to have been involved, but as it turned out Bert Schneider and his brother Harold did an agreement with Paramount. So I was not involved – not through any choice of mine but because it was easier for Terry to do it that way. Paramount had the money to finance the film and Bert was a good producer; he'd done some good movies and was ready to jump right in and do it. But *Days of Heaven* went through lots of difficulties because Terry had this unique way of approaching his films: he would shoot a lot at magic hour to get that imagery, a very narrow work time and also the film took a long time to be edited. So that created some tension.

PAUL RYAN

At the end Bert Schneider produced the film, but Harold was more of a line producer and dealt with everyday things during the shooting. I think they were interested in maintaining independence, which would allow the director to do whatever he wanted, not have a studio control it, not have anyone saying, 'You can't do this,' or 'You can't do that.' I thought Bert was great: he insisted on things being done; he was a realist.

RICHARD GERE

At the time there was a scene in LA that was very connected to movies that were expressing what was going on in the world at that time – not necessarily directly about Vietnam or anything else. Just expressing a kind of energy and questioning. I was a young man at that point and felt connected to that, as most people of that time did. Bert and Harold Schneider came from this scene. I remember a drama about the budget of the film. But there's drama on every movie. No matter how much money is in a budget or what the expectation is of what's going to be spent, it always ends up being a fist fight at some point about: 'Well, I need more. I need another day. I need this. I need that.' And if you really care about the film and you're the director and the writer and the actor, you want the best you can possibly get for your project. And so, that always happens. I've never been in a project that didn't need more money and there wasn't screaming phone calls.

BILLY WEBER

We were financed by Paramount Pictures but it was a very low-budget movie compared to other Paramount projects, so they didn't pay a lot of attention to us, and they didn't get any dailies on the movie at all. There was another movie shooting at the exact same time, a movie called *Sorcerer*,[5] directed by William Friedkin that was causing a lot of problems for them, money-wise, so it drew all the attention away from us. So, no one really

knew what was going on where we were. We showed them the movie twenty months after we shot it.

JACK FISK
We only had four weeks of pre-production on *Days of Heaven*. It's amazing, if I think about it now, that we were able to complete it. But we had a problem finding wheat, we needed tall wheat. Originally, Terry had written a story for Texas, but the wheat was too small, it's all hybrid. So we moved further north and further north and the production got delayed as we went further north because they were harvesting all the wheat in the south. We finally ended up in Canada, it was our last chance. Harold Schneider actually found the locations; I had been looking all over Canada, but he somehow found this location, heard about it. And we went there and the wheat was very unusual because it was very tall. It was farmed by Hutterites, who are Russian farmers, like the Amish. We made a deal with them, but there was no house, there were no roads to the location, so we had to make some dirt roads and we built the house. I remember I was doing the drawings for the house on the aeroplane flying up to start building it. We had four weeks: Terry said they were going to harvest the wheat in six weeks. He said, 'I need to be able to see the wheat around the house.' I said, 'Well, how about the inside?' He said, 'I need to be able to shoot that at the same time because I want to have big windows, shooting inside looking out.' So, then the house had to be done inside and out in four weeks. I was too young not to know you couldn't do that – but we did it.

NESTOR ALMENDROS
The location the producers discovered in the south of Alberta was in an area belonging to the Hutterites, a religious sect that left Europe many years ago because of intolerance and they really live in another age. As a community, they cultivate wide expanses of land, where they grow a different kind of wheat,

longer than today's strains. They make their own austere utensils
and furniture. They have neither radio nor television. They eat
natural food, which makes their faces different from ours. Some
of these people took part in the film as extras. That whole area
belongs to another epoch, and an hour's travel took us daily
from the twentieth to the nineteenth century. There is no doubt
that the atmosphere peculiar to this place heightened the authen-
ticity of the images in *Days of Heaven*. And there were also
the tall, wine-red silos and the old steam-driven farm machines
belonging to private collectors who let us use them, as well as the
extraordinary virgin landscapes of Banff.[6]

RICHARD GERE

Terry works from a sense of space and it is not important
whether it's mental space or spiritual space or physical space.
And that place in Canada was extraordinary: these prairies that
just go on forever like an ocean of wheat. You see the Rocky
Mountains in the far distance. Certainly, you get a sense of
poetry, internal and external, immediately in a place like that.
I also remember going and visiting the Hutterite communities.
My family came from Pennsylvania, not far from Amish com-
munities, and so it wasn't totally off the planet for me. But,
certainly to have this ocean of wheat that just goes on forever
and to have these people around who clearly had one foot in a
different century was terrific for us. It just allowed us to dream
in another time and space.

SAM SHEPARD

The house was built basically out of cheap plywood, three-
quarter-inch plywood – very, very thin sheets. And when you're
on the plains the wind's constantly blowing. So, to keep that
house intact was a big job, it was like setting up a sail. The wind
was constantly beating it and hitting it. It was just incredible,
enduring that prairie wind.

JACK FISK

We had ten carpenters working on the house. They came from California: we made a deal with them, a contract to build the house. Then the house where the workers lived, I got the Hutterite kids to come up on Sunday. They were all good carpenters, and I would go down with the van and after church they would sneak away from their community and come up and build all day. They did that in four weekends, and they weren't allowed to work on Sundays but they would sneak up there and I would pay them five dollars an hour. I felt terrible in the end because I heard they bought a TV set and they are not allowed to watch television. But they put it up in their attic so they could watch baseball games; they fooled their mothers.

HASKELL WEXLER

Terrence Malick is a very intense, dedicated, visually concerned person who communicates in less traditional ways. It doesn't mean he doesn't communicate, but it requires a sensitive director of photography, and – I'm sure – a sensitive production designer, a certain tuning-in on his frequency; but once you do, as *Days of Heaven* shows, it comes out pretty good. So it was a very collaborative effort, and the location helped us find some great elements.

RICHARD GERE

I don't think Terry even talked with me about the story. Terry doesn't talk about those things. It probably makes him very good as a filmmaker because films are not about talking. It's about images and feelings and moments. It's not even about story in the end. You don't remember stories as much as you remember a moment in a movie that somehow cuts through everything else like a dream image.

JACK FISK

I remember, when we started shooting, there was a beautiful train that we found. We shot the scene with the workers on the

train going by, and they were talking, they were going to look for summer jobs out of the city. Then we were shooting down at the river when we had finished with the train and it left and it went across this great trestle bridge and we shot it and it's just this wonderful silhouette so evocative of the period and so beautiful – the imagery of this train going across the trestle, with the river going on underneath. Some of the imagery is created just from the great landscapes up there where we shot in Canada, and some of it is man-made elements sneaking in like the train and the trestle.

SAM SHEPARD

One time Terry said something to me about the past; that he prefers the past; that he wanted to be in the past. He thought that there were more possibilities because of memory and time. Time passing. It's about something recalled; something coming back; something that occurs in time. You don't get that chance so much in a contemporary film.

JACK FISK

It's wonderful to see Terry's films because they change depending on where you are at the time you see them. I think when you watch a good film – as with a painting – you bring a lot into it, your whole life up to that point. And there are sometimes things that Terry creates for one reason, but you interpret for another that reflects your life. In that way, it becomes in part the viewer's creation and it's exciting. I think Terry does that consciously so as to make films accessible from many points of view. I mean we never tried to pinpoint a period where you go, 'Oh, this is 1916!' but to make it more universal it could be today, it could be a hundred years ago, it could be ten years ago.

ENNIO MORRICONE

In creating the music for *Days of Heaven* I tried to evoke an atmosphere of open fields, an 'out of time' feeling, suspended,

difficult to identify with a definite period. A tonal music, an easy tune with a theme that I could define as modal, close to some medieval compositions. In substance, it was similar to those the troubadours used to write. But with an unusual instrumentation, it lost the sense of that time period and it acquired a sort of indefinite one. This was the research I tried to carry out.

SAM SHEPARD

The music of Morricone is unbelievable, just extraordinary. It's so subtle, moving, and amazing. But another stroke of brilliance by Terry to understand that it would work, that it would fit into his scheme of things. There is such a sadness about it. It's this thing of mortality. That all these little people, these characters are doomed, just doomed. And the music pulls it in that direction. It takes on this tragic nature.

Linda (voice-over)
The devil just sitting there, laughing
He's glad when people does bad.
Then he sends them to the snake house.
He just sits there and laughs and watches
While you are sitting there all tied up
And snakes are eating your eyes out.

RICHARD GERE

Days of Heaven resonates in a peculiar way. I think it's a singular vision of the universe. I think that the connection that Terry has with the earth is also part of that. His movies are very much about things growing and things dying and things changing. And the universe itself doesn't have a lot of emotion about all these changes. But I think that quality can come into all the arts and in different periods of our race's development. And Terry really focuses on that; essentially, he makes the same movie every time. That's really where he is coming from. He is not a director for hire. He is expressing his own personal universe.

ENNIO MORRICONE

The atmosphere the film was supposed to convey was very clear to Malick, and he probably knew what contribution I could give to it. Logically, once the composer has listened to the intentions of the director, he goes his own way, his style remains his style. A composer cannot abandon his stylistic features. A director addresses himself to a composer because he has faith in him, he respects him even as he pushes the composition towards a certain direction through discussion – a very free and open discussion. I remember that I made Terry listen to eight themes for *Days of Heaven* and he chose those more in line with the film. Initially, Terry didn't tell me he was going to use 'Aquarium' from *Carnival of the Animals* by Camille Saint-Saëns, in the opening credits. I would have liked to write a piece for that sequence and he betrayed me a little in this. Camille Saint-Saëns is a very respectable composer, even though he is not among the great French composers – though, I must say, the piece works very well in the film, it gives a sort of liquidity that immediately accustoms the viewers with something suspended, without any binding connotations. However, now I would never accept a director imposing a musical piece, I would refuse the job. For Terry I made an exception.

JACOB BRACKMAN

My involvement as second unit director came about because *Days of Heaven* was so very different from *Badlands* where not only was there a script with real, defined characters, but the actors that he had found, Martin Sheen and Sissy Spacek, also understood the characters very well. This was not true of *Days of Heaven* – you could say that Terry had in mind a more open movie and it took some adjustments to really understand the characters. So, when we began the shoot, Terry brought in all the actors to improvise, but then he realized that this just wasn't going to work. It was stilted, it wasn't going to have 'the breath of life'. We were out there in Canada, with these sets and these

actors and all these extras and we had to figure out a different way to go. So Terry said, 'If we can't go Dostoyevsky, we gotta go Tolstoy!' – this is the most succinct way I can put it – he meant, 'We can't go down deep into the characters, letting the actors improvise, we gotta go broad with nature and sky and wheat.' And it was out of that that came the idea for the second unit. The idea of sending me out without a sound crew, but like a small college film, to shoot animals and extras and wheat fields.

PAUL RYAN

Terry had a description of what he wanted and he was very articulate. The script was very well written in terms of the visual presentation: when you read it, it gave you, as a cinematographer, the right feeling. When we talked about it, Terry didn't have specific locations. Montana was chosen, because it was similar to Canada and I went there before the first unit started shooting, pretty much on my own, with my crew – seven or eight people. We had to find things on our own, it was fantastic. I would have a little plane and fly around the wheat fields and I would have a little radio to our assistant director, Jacob Brackman, who was down in a truck driving around and I would tell him to turn left and then drive a mile and tell him there's a good field there. So we had to find places without telephone wires and no contemporary buildings or things like that. Terry didn't explain exactly the images that he wanted, but he did explain the feeling, which was sort of someone who discovers open space for the first time. There was only one thing I remember that he did want, and that was the idea of a pond of water with the wind coming across it, so what was once smooth would suddenly burst into ripples. It was quite difficult to catch, but we did it. I remember also that he definitely wanted some buffalo. And while I was shooting these scenes I understood that there was also a sort of tragic nature. For example, shooting the buffalo, I felt that there was something ominous about these big creatures that could suddenly turn on you at any minute. There was a sense of danger.

That your days may be multiplied, and the days of your children, in the land which the Lord swore unto your fathers to give them, as the Days of Heaven upon the Earth (Deuteronomy 11:21).

BILLY WEBER

There is one scene in particular – a scene where Richard Gere and Brooke Adams are walking through a stream – it took us months to cut that. It took us two years to cut that, we never stopped working on that scene, but it came out great. It has all this wonderful movement to it, but it wasn't planned. I mean, Terry had no idea how it was going to be cut together. He felt it was the right way to shoot that scene, he wanted them walking through the water and there was no way to dolly through the water with them without a special camera, the Panaglide,[7] and he wanted to do it in that light that he did it in, which was a very late light – I think we did it over a couple of days. It was hard to cut together but it was a scene we had to keep – we needed the information that they were talking about. We needed Richard to egg her on, saying, 'Go ahead, make this deal with him, stay with him, marry him.' But it ends with that wonderful moment when Richard is washing her feet which is almost like a moment out of the Bible, it's just a great, great moment. We were so lucky, if you look at the movie now you'll see the light in that shot is so low, we were ten minutes away from not having an image on film and it was just grabbed, just shot at the last second.

Linda (voice-over)
[The snakes] go down your throat and eat
All your system out . . .
. . . I think the devil was on the farm.

SAM SHEPARD

I don't think any character is pure. Just by virtue of something, you can't be pure. There's always gonna be something tainted.

This character is tainted by jealousy; immediately, it's like he's on fire, he's like Othello, he's ready to kill. He's not pure. If he were pure, he'd just let her go. But I also think there is a deep part of that pioneer cultural thing which had to do with a Christian ethic that was very much involved with jealousy. It's not as forgiving as we would like to think.

Linda (voice-over)
There was never a perfect person around.
You just got half devil
and half angel in you.

ENNIO MORRICONE
When we talked about which music suited the scene with the locusts, Terry showed me the sequence with a track I had previously composed for *The Good, the Bad and the Ugly*.[8] It's an excellent piece of music, but I would have preferred to see the scene without that music: I wouldn't have felt bound by Terry's musical suggestion and, maybe, I would have composed something more original. This is a common problem – most of the times the director is fond of a piece of music they have heard before. They control photography, they change the colours, they are careful about the sound effects, the dialogue, the special effects; they supervise the whole filmic process. But the musical aspect is left to its own. They find themselves with the composer who goes in the recording studio, records the music and when they listen to the result they are surprised. Positively, most of the times, but sometimes they are shocked. Often they turn back to something they have already listened to because they are shocked in front of something they didn't expect, even if it shows a new way. Nevertheless, in the end, Terry was capable of accepting my music.

BILLY WEBER
When Morricone did the score for the movie, he told Terry, 'You can do anything with this music but there is only one piece

that I don't want you to move, and that's when the locusts come and the wheat field goes on fire.' So we said, 'Okay.' I don't think that there is a piece of music, except for that part, that's in the place it was intended for – we just moved the rest of it elsewhere.

ENNIO MORRICONE

For the scene with the locusts I demanded that the music I had written for it not to be changed. That piece of music couldn't have possibly been put while they are in the house preparing dinner or when the aeroplane glides on the lawn. And I told Terry, 'This music must go there.' In fact, in the film the theme isn't repeated. There is no repetition like in the case of *The Carnival of the Animals*, or the other themes. It wasn't essential that there was music in that scene; for me, the locust scene could even have remained without music, because the sound of the locusts, that creaking 'assh assh' sound was perfect. It was Terry who wanted music there, and I wrote it precisely for that scene, supporting the sense of that scene.

BILLY WEBER

We wanted Morricone's music because it is so amazing and is capable of lifting a movie. I think that when we cut it together the way he wrote it, and screened the movie, it felt like it wasn't doing that, so we started to play with it until it did start doing that. And the result was great.

HASKELL WEXLER

I think Morricone's music for *Days of Heaven* was the best photography I ever did! One of the problems with film scores today is that the music is telling the same story that the actors are trying to tell, it never gives another level to the story. It sort of assumes that it has to help the movie along. In *Days of Heaven*, with Terry working with Morricone, and Morricone working with the images, they enhanced what was there rather than fighting

against the image, and saying, 'Listen to me, pay attention to me,' which is not the way to make films.

DIANNE CRITTENDEN
At the beginning, John Travolta was supposed to play the role of Bill but Travolta was doing a TV series for ABC, *Welcome Back, Kotter*.[9] I know this probably sounds weird, but Richard Gere really resembles my brother to the point where my brother's been mistaken for him several times. I just sort of felt that I had an affinity with Richard Gere, so when John Travolta wasn't available, Richard – who had only done a few films, I don't think he already had made *Looking for Mr Goodbar*[10] – was my first thought. I guess he was as close as we could come to John Travolta – that New York look with the dark hair, a sort of Italian thing that Terry was looking for in that character, to make it as far away from Sam Shepherd's character, the Midwestern farmer, as possible.

RICHARD GERE
I was involved almost a year in casting on this thing. I don't know if I even met Brooke Adams. Terry told me a totally different story. He was matching this actor with that actress and that actor with that actor. And Terry can't make a decision anyhow. This went on and on, on both coasts, forever. I finally went to Terry and said, 'Look, Terry, I can't do this any more. You've got to make a decision.' And I remember very clearly in LA he called me up and said, 'Look, I really want you to do this.' And I felt, very clearly, that my life was taking a certain direction at that point.

DIANNE CRITTENDEN
Sam Shepard was not an actor and I will say that that choice was totally Terry. He said there is this writer and I asked has he ever acted and Terry said, 'It doesn't matter.' He wanted something totally unexpected. We auditioned a lot of different actors,

Sylvester Stallone was another person that Terry had met with, I'm sure Bob De Niro was on that list too. I remember I felt very strongly that Tommy Lee Jones should play the role and it would have been such a totally different movie with him. But Terry liked Sam's silence, he liked the quietness that he had. He also was interested in Sam because he writes plays about the West and he knew his work; I had absolutely nothing to do with that. I would love to take responsibility, but it was absolutely Terry's choice.

BILLY WEBER

After Tommy Lee Jones and Sylvester Stallone were auditioned, our friend Rudy Wurlitzer said, 'Why don't you talk to Sam Shepard,' because he was known as a playwright so maybe he could even write his own dialogue. So Sam met Terry and Terry just thought he would be a more interesting choice. Sam is very good-looking and smart and understands life's pain, and so Terry just went with that decision.

SAM SHEPARD

I hadn't acted in film until that point, except for one little thing in a Bob Dylan film, *Renaldo and Clara*.[11] And so, Rudy and Terry came in and Terry was very shy, which enamoured me to him immediately – I mean, so shy he was so almost embarrassed about asking me about the possibility of acting. And I hadn't really considered it – I was totally devoted to writing at that point. He started talking about the script; he didn't even show me the script. By that time I was running a little ranch up in Northern California, and he came and visited me two or three times. And then, one day I got a phone call: 'Do you wanna do this movie?' and I said, 'Why not?' I rented a Ford Mustang and drove to Alberta, Canada, and that was it.

RICHARD GERE

At that time I had done a couple of Sam Shepard plays in New York. I was a great admirer of his work. Sam was one of the hip

young writers at that time. One play was *Killer's Head* and then there was another one called *Back Bog Beast Bait*, off-Broadway, which I don't recall too much. But I remember I had talked to Sam about *Killer's Head* – this stream-of-consciousness monologue of a guy strapped into an electric chair in the moments before he is electrocuted. And there was a lot of stuff in there about rodeos and Appaloosa horses. And I wanted to know where he was coming from with some of this. So, he clarified a lot of that over the phone for me. So, we had at least a working knowledge of each other before we met. And with this kind of a work, you kind of give yourself to the reality of the story in fashioning some of the relationships. So, I think the relationship between our two characters was kind of built-in. There was a little rivalry between Sam and me for Brooke Adams's affections. And so, I think on some subtle levels we were probably rehearsing during our off hours to play the movie. And that's pretty typical also. Sam is terrific in the film. He has a Gary Cooper quality about him – it's deep and real and very moving.

SAM SHEPARD

I don't think Terry was very much aware of my plays at that time because basically I'd written a bunch of one-act plays and Terry didn't really come out of a theatrical background. That didn't matter to me. However, I wrote some stuff in *Days of Heaven*, like the dialogue between me and Brooke in the bedroom. A little scene. Which was fun.

The Farmer

You know what I thought when I first saw you? I thought, 'If only I could touch her, then everything'd be all right.' You make me feel like I've come back to life. Isn't that funny? I always thought that being alone was just something that a man had to put up with. It was like I just got used to it. Sometimes it's like . . . you're right inside of me, you know . . . like I can hear your voice and feel your breath and everything.

DIANNE CRITTENDEN

Brooke Adams was just one of a number of people who I had brought in. Terry likes to remind me that I brought in Meryl Streep and anybody who was an up-and-coming person at the time. But I knew that Terry was responding to people who had a dark, Italian look. She was so special; she was the kind of working-class person he was looking for. Then the relationship that she had with Sam Shepard's character and Richard Gere's character grew during the shooting of the film.

RICHARD GERE

Brooke and I were old friends. And I had always loved Brooke, always had a crush on her actually. So, I was delighted to have her in the movie and have built-in feelings for her already.

DIANNE CRITTENDEN

Another important thing was to have the right people to play the field workers. Some of them were actors and some of them were real people, coming from the circus. I auditioned one-man bands and people who played kazoos; I went to people who booked vaudeville, who were looking for performers to come in and open up for a strip show or for something else. We found a lot of interesting people, which is something that is very rare nowadays, because movies cost so much money to make, you can't use as many real people because you can't take a chance that they are not going to be able to perform. It was a challenge, in a way, but it was the beginning of the change of films, now we have gone back in a sense to the point where, if you want to make a film, you need to have some stars.

Of the children in the schools that were taped for the part of Linda, there were two people who stood out; one was Linda Manz – she was the most unique and special person – and the other one was Jackie Shultis. Originally, in the script Linda had no friend, but because Terry couldn't make up his mind which one of the girls he liked better, he wound up using both of them,

and so Linda ended up with a friend and you had these two girls together, which changed the whole story tremendously. So, we were looking for a child to play a character who was totally uneducated, who you would believe was a sister of a migrant worker. Linda Manz was really a character and we decided to take the risk to cast her. Today you can't do that, the producers would probably fire her because they would say, 'She can't remember her lines and we aren't getting what we want.' Nowadays, if you are hiring a child, you would probably have two stand-by children, just in case one of them didn't work out.

BILLY WEBER

How Linda was cast is a wonderful story. Terry had Dianne Crittenden put out a casting call to schools in New York City, and Linda came in because her teacher thought she was a real character and so they sent her to the casting session where they gave her the script. So, when she came in to meet Terry, she looked at him and said, 'I liked your script.' He hired her on the spot! Just like that! Immediately! And the other girl, Jackie Shultis, was at the same casting session too.

I was on location when they were shooting the movie, and I spent a lot of time with Linda. She would come to my room, we would have meals together, her mother was with her, and she spent an enormous amount of time in my cutting room in Los Angeles when we were editing. She was so sweet and naive; it's very rare to meet someone like her in any line of life, in any point in life, and to meet her and have her be in the movie. She was someone who barely knew what movies were. It never got through to her that the people in the movie, the other actors, had names that weren't their real names. So she would call them by their real name and we had to change the characters' names. She's Linda in the movie because that was the only thing she would respond to. Then we tried to make things easier for her, so Brooke Adams became 'Abby' because it was 'A', Richard Gere was Bill because it was 'B', and Sam Shepard – you never heard

his name – but he was Charlie as that was a 'C'. So A, B, C! and that's how she was able to remember them. And she was Linda.

Linda (voice-over)
I met this guy named Ding Dong.
He told me the whole earth is goin' up in flames.

RICHARD GERE

Linda was instinctively brilliant. And with anyone with that kind of brilliance, you just give them space. Terry was smart enough and sensitive enough to just let her be. And she's extraordinary in the film because of that. I saw Robert Altman working with kids once in a movie he and I did together.[12] And I said, 'How do you get these incredible performances with kids?' And he says, 'The trick is never tell them what to do.' And I think that was true with Linda. I think the voice-over was something else. That was added on later. That was not in the original script. And I think she was directed a bit in that, although I think there was still a lot of improvisation of her looking at the film and Terry saying, 'Well, just talk to me. What do you see up there? Talk to me about Bill. Talk to me about, you know, this situation and that situation.' And she was such a kind of unique, eccentric wild animal of a teenager that some extraordinary jewels came out of her.

BILLY WEBER

I'll tell you a quick story about Linda: she was staying with my assistant's family for a few nights and my assistant's wife would read to her own children from the Bible every night. And one night she read to them from the Book of Revelations about the coming of the apocalypse. The next night Linda was going to record her last night of voice-over at Terry's house and she came over and told him that he had to listen to the story that Colleen, my assistant's wife, had told her the night before. And Terry said he really wasn't interested in it, he wanted her to do the voice-over that he had written, and she kept pushing and pushing until

finally he said, 'Okay, what? What was it that she told you last night?' And Linda told him the story of the coming of the apocalypse which he recorded – and that's what's in the movie, her version of it. And it's on the train and it's when Sam Shepard sees Brooke Adams and Richard behind the curtains of the gazebo at night and smashes the medicine cabinet, and Linda talks about the snakes that are going to crawl down inside of your body and are going to eat your insides out and all that. That's all from her version of the coming of the apocalypse – birds with their wings on fire, and the clouds on fire. Before, she would basically be telling the story of their trip out to the West, which gave it more of a linear quality. But then we tried that apocalypse voice-over over the train and it was like magic. So we felt like, 'All right, that's what we are going to do from now on, it's going to have this Linda quality to it.'

Linda (voice-over)
Flames will come out of here and there . . .
and they'll just rise up.
The mountains are gonna go up in big flames.
The water's gonna rise in flames.
There's gonna be creatures running every which way,
some of them burned, half their wings burning.
People are gonna be screaming and hollering for help.
See, the people that have been good, they're gonna go to
 heaven
and escape all that fire.
But if you've been bad, God don't even hear you.
He don't even hear you talking.

RICHARD GERE
The voice-over of Linda is brilliant. I probably should have realized that he would do that, because it worked so well in *Badlands*. If you use voice-over to underline what you already know or what you're seeing in the picture, it's useless. But Terry's

point of view was much more poetic than that – not in a purple poetic sense but a poetic sense of being real, funny and unexpected. You are adding information that was not there before and not just about plot, but more on a deeper emotional, psychological, spiritual level. Her voice and her ability to very nakedly, but kind of pleasantly and poetically, describe her universe is mind-boggling. This movie would not be that movie without that voice-over, wouldn't be that way without the quality of her voice, just the timbre of her voice is so interesting.

BILLY WEBER

When we first shot the movie it was full of dialogue. This made it more linear, it made it a little bit more conventional. But the conventional quality didn't work as well, it didn't feel like Terry's movie. So we started to experiment by doing a lot of shots of the characters where they didn't speak, trying to convey what they had been speaking about just through shots of them without them talking. And that started to work, so we continued along those lines. However, we needed the voice-over to give it some sense of a linear story. And Linda's voice-over made it not just linear, it also gave an interesting twist because it was all through her eyes.

RICHARD GERE

There is a difference between a screenplay and a movie. Shooting a movie is very different than shooting a script. And a script, in many ways, is a market that allows everyone to come to work. But the things that become meaningful are the accidents of the moment like in jazz improvisations. You can play the melody, but it's how you play with it and express yourself through it. Sometimes you make a mistake that has to be fixed. And you do something else to fix the mistake and that makes it interesting and leads to something else. I think it's almost impossible to do a script exactly as written. Most of the processes of making a film is cutting things away. You find that you don't need the

words. It's too many syllables. There's too many things being said when, in fact, you're saying so much just by the mere fact you're feeling something and how that communicates on film. And Terry was very much like that. The mere fact that he had two years to edit, he just got bored with his own writing and with our acting and started to see another movie in there. But I didn't know that. We shot a much more richly verbal movie with much more high emotions; let's say, much more dramatic. And when I came to look at the movie and I saw that it wasn't that, I clearly was not too happy about it. Because I could have saved myself a lot, all of us could have saved a lot of brain cells in the process. But Terry made his unique movie. There is another movie to be made there that probably wouldn't be as unique. But it also would have a certain richness to it as well, a different kind of intensity.

SAM SHEPARD

The use of the voice-over is another stroke of genius. Because Terry hadn't planned that. Terry told me very early on that he wanted to make a silent movie. He didn't want dialogue. He said in the best of all worlds it would be a silent film. And I knew what he meant. The dialogue somehow engages the audience too much. And he wanted, I think, a kind of almost voyeuristic thing from the audience, to witness the image. And the dialogue interfered with that because it engages – that's the function of dialogue – it pulls you in. And that's one of the reasons he uses narration, it seems to me, is to be able to watch. The use of the narration is as though it were like music. Linda was perfect for that, as a counterpoint.

> *Linda (voice-over)*
> This farmer,
> he didn't know when he first saw her
> or what it was about her
> that caught his eye

maybe it was the way the wind
blew through her hair.

BILLY WEBER

It just made it harder to cut the movie, because it gave you more
choices, it gave you many more directions to go off of the linear
line of the story. But to me it makes it more interesting, it makes
it more of an art form, it gives it more of a sense of the director.
You feel the vision of the director in the movie. For me that's
what movies should be. I'm more interested in those movies.

RICHARD GERE

Nature is about space. You can't rush it. You've got to just sit
with it. And part of that is getting your mind to slow down and
not follow errant thoughts that want to take you this way and
that way. So, you have to find quiet inside yourself to even see
nature. And I think Terry has a certain rhythmic affinity with that
slowing down. There certainly are places in this movie where it
gallops and it starts to take off. But, in general, he's like I am,
perfectly comfortable sitting on a rock and just seeing the world
go by. I think the movie very much has that quality.

Linda (voice-over)
He knew he was gonna die.
He knew there was nothing
that could be done [. . .]
This farmer, he had a big spread
and a lot of money.
Whoever was sitting in the chair
when he'd come around,
why, they'd stand up and give it to him.
Wasn't no harm in him.
You'd give him a flower, he'd keep it forever.
He was headed for the boneyard
any minute but he wasn't really going around

squawking about it like some people.
In one way, I felt sorry for him 'cause he had nobody
to stand out for him, be by his side
hold his hand when he needs attention or something.
That's touching.

PAUL RYAN

Terry always said, 'I'm not really interested in just a story, we have to have a feeling; it's not about the words only, it's about the feeling you have from the imagery.' That was very important to him, as much as the literal translation of what happened. He wanted to create something that would give you the same sort of feeling that you would have when you listened to a symphony; you can't say exactly what is going on, but you have a very powerful feeling from that. I think that was a big part of his filmmaking and it probably still is.

BILLY WEBER

There's a ten-minute section of *Days of Heaven* that only has two lines in it. Towards the end, when Richard Gere leaves the farm and they go through four seasons and then he finally comes back, he arrives on a motorcycle. I think there is probably only two or three lines of dialogue in that ten-minute section, except there's Linda's voice-over throughout. And when Richard comes back and he sees everyone and he talks to Brooke Adams for a minute or so, I think the scene between the two of them is forty-five seconds long, maybe one minute. The original version was a seven-minute dialogue scene. There was a lot of searching for pieces of footage that we could use to give everyone enough strength without having them speaking dialogue. I think that is the reason why I felt like I learned so much about how to tell a story without words, how to tell a story with a rhythm that will hold an audience and feel like it transcends you, and takes you somewhere.

SAM SHEPARD

It's frustrating for an actor, because of Terry's temperament, I think. An actor has to continuously realize that he is in the presence of – genius is a too cheap word – but in the presence of something you have to respect in another way. You can't expect a filmmaker like Terry, for instance, to have an attitude of indulgence toward the actor. So, if you are a spoiled actor, you won't get along with Terry. You have to be independent. You have to be able to come and say, 'I'm an actor, he's a director, and I'm gonna listen to everything he says, and I'm not gonna expect him to spoon-feed me, my motivation, or whatever else.' You have to be your own person.

RICHARD GERE

Terry is not a rehearser. He doesn't come from the theatre. I don't know how equipped he was to actually lead actors. I think he had a really good sense, broadly speaking, of what he wanted, and what he wanted it to look like and feel like. But I don't know that he knew the exact specifics. He is not that kind of a filmmaker or creative artist. And because he was new to filmmaking – as I recall he didn't really know how to talk to an actor like a theatre director does. So, that led to some frustration from the actor's point of view. Terry's main thing is he didn't know what he wanted. He just knew what he didn't want. So, it was kind of like, 'Do it again.' And, hopefully, you'd come up with something that he liked. It could be deeply frustrating, but that's just how Terry works. And it works for him. He was, in one way, incredibly assured about what he wanted and, in another way, incredibly indecisive. Terry is also very funny, very dryly funny. He would write stuff that you had to do in a certain way or it wouldn't work. You had to have a dry sense of humour in your approach. The inability to be able to tell you exactly what he wanted was sometimes very frustrating. But at the same time it throws you back on yourself to explore territories that maybe you wouldn't have otherwise, even if it just comes out of

pure frustration. But it certainly was healthy for me in the end, throwing me back on that. And, you know, it's like a musician in his first band. He'll always love that band. This was my first real movie. So, everything about this I will always love, and love where Terry is coming from.

BILLY WEBER

Terry doesn't tell the actors what to do, but gives them the idea of what the experience is for them.

SAM SHEPARD

I started to slowly get the impression – even if it was very frustrating for me to try to work in those circumstances, because I'm basically a writer – that I was involved in something really extraordinary. That this was not going to be just a movie. This was going to be a sort of event. And the more I worked with Terry, the more I got that impression. That he wasn't just trying to make a movie, but he was trying to make something that would last. There's a big, big difference, I think, between working with a filmmaker and working with just a director for hire, somebody who's doing it because they are contracted to do it by the studio. When you understand as an actor that you're working with a filmmaker, then it changes because you have a different kind of trust in the way things are gonna come out. You're not quite sure how what you are doing is gonna fit into the scheme of things, but you're sure that it's gonna be used in the right way. There's a kind of trust. You throw a lot of stuff out there, but he's gonna use the right thing.

JACK FISK

We were shooting a scene and it was August, and it started to snow and the workers were working out in the fields and we broke for lunch and everybody was saying, 'Well, we can't shoot, it's snowing and nothing's gonna match.' And Terry thought about it and he went to ask each person should we shoot or should we stop

shooting. And invariably all of us said, 'We can't shoot, nothing matches.' And then he decided to shoot in the snow because, he said, 'If you see them in the snow you are going to feel more the hardship of what they had to deal with.' And we went out from lunch and we shot the scenes of them trying to keep warm and huddled around the bales of wheat with the snow coming down, and it ended up wonderful. And a lot of times people don't even notice that it was snowing, but they think of how hard the character had been working. That's just a moment that will always stay with me because I realized what an important decision Terry made and why he made it – and it made sense.

Linda (voice-over)
He was tired of living like the rest of them
nosing around like a pig in the gutter.
He wasn't in the mood no more.
He figured there must be
something wrong with themselves
the way they always got no luck
and they oughta get it straightened out.
He figured some people need more than they got.
Other people got more than they need.
Just a matter of getting us all together.

RICHARD GERE
In building my character the work that Patricia Norris did with the costumes was very helpful. I remember there was a hat, a suit, and a shirt that was collarless, with stays in it. All those things were important to me. They were in photographs. I've always worked from photographs a lot. They stimulate my imagination. And there were a lot of photographs that I think Terry used as well when he was figuring out how to tell the story and communicate what he was trying to do with that period. There were a lot of dandies in the fields that had come from back East. And Bill seemed to be one of those. He was a dresser. He had the

perfect hat. There was one picture of four of these guys standing in a field. And they had canes and dark black, three-piece, four-piece suits and the perfect hats in the middle of these fields. And there were a lot of workers around them that were not like them, that were really just migrant workers. And Bill was coming more from the dandy city guy kind of storytelling. I was thankful that I had come from the theatre, and knew how to create a character. I wasn't expecting anyone to tell me what to do. Terry clearly came from this big space where it's okay to just observe the universe. And the foibles of human beings who are trying to control the universe is our own madness. It's not inherent in the quality of the universe itself. And I think there is a way of integrating that feeling into all creative work.

NESTOR ALMENDROS

On the artistic side I was lucky enough to have the best collaborators I could have wanted. In every film there is a small group of leaders whom the others follow. In *Days of Heaven* five people formed this group around Malick: Jack Fisk, who designed and built the mansion among the wheat fields, and also the smaller houses where the farm workers were supposed to live; Patricia Norris, who with extraordinary care and taste designed and made the period costumes; Jacob Brackman, a personal friend of Malick, who was the assistant director; and naturally the producers, Bert and Harold Schneider. This close little unit would drive for an hour each day in a van from the motel where we were living to the wheat fields. On the way we would invariably talk about the film, so each day the trip turned into a spontaneous production meeting.

JACK FISK

The cinematographers on *Days of Heaven*, Nestor Almendros and Haskell Wexler, were both great in their own contributions to the film. Nestor was there first and he worked with Terry to develop the backlit shooting. We shot everything with white

skies, trying to stay away from the brilliant blue, and have all the imagery backlit, which is just beautiful. We shot a lot of the film at magic hour. That was a time of the day that Whistler best described, saying that magic hour was the time of the day that warehouses become palaces. Patricia Norris's costumes only accentuated the backlight because of the darkness, it brought that dusk on a little earlier. She had the idea of dressing all the workers in dark colours to contrast with the landscape. The textures and the darkness, they were easily identifiable but they were not too present; you couldn't see a lot of detail because the stuff blended together. I really loved to work with Patty because we communicate intuitively, without talking, but the elements seem to work well together. We once worked on a film where I designed a set and she designed the costumes and it had the same design elements in the costumes as in the set, but we had never talked about it; it was bizarre, but it was that kind of continuity of consciousness that made it fun to work with her.

NESTOR ALMENDROS

The crew in charge of the set, props, and costumes worked together to choose blended, rather subdued colours. Patricia Norris got used fabrics and old clothes to avoid the synthetic look of studio-made costumes. Fisk built a real mansion, out-side and inside, not just a façade, as is customary. The interiors were period colours – brown, mahogany, dark wood. The white cloth of the curtains and sheets was washed in tea to give it the tonality of unbleached cotton, not the overly bright whiteness of modern fabrics. For the fact is that it is impossible to do good, stylish photography if the set designer, the wardrobe designer, and the prop maker do not collaborate, if the objects they put in front of the camera are tasteless or discordant. What is ugly can-not be made beautiful. In our profession many people think the director of photography should concern himself only with the camera and the technical aspects. I believe that, on the contrary, he must work in perfect harmony with the people responsible

for the sets, wardrobes, and props. Before my arrival in North America we had long telephone conversations about all these things; then, while we were shooting in Canada, useful adaptations and changes were made on the spot.

HASKELL WEXLER

Photography reproduces, but you can only do so much; what's important is also what's in front of the camera. And what Terry and Jack Fisk arranged in front of the camera was incredible! For example, I liked the house very much. They picked the spot for the house, they built the house, but it wasn't just a realistic house, it was a house that was built so that you could shoot in it. It was a house that was built in a way so that they knew what the light would be like at certain times of the day. It was done with a great deal of forethought. And it's a kind of forethought that nobody knows about. I knew about it because I can't say I was lucky too many times!

PAUL RYAN

Shooting the second unit, the most important thing is to have the communication with the director. In *Days of Heaven* and *A River Runs Through It*[13] it was much more about a feeling rather than specifics. I had to go out and find things on my own with a kind of freedom, but with the anchor of the visual intent that the director wants. I did choose all the locations that I shot for the second unit in Montana, which was mostly the river, the wheat fields and some things in little towns, because Terry and I were never there together; we would talk by phone and he would describe what he wanted and I would shoot it.

NESTOR ALMENDROS

When Harold and Bert Schneider asked me to do *Days of Heaven*, I asked to see *Badlands*. When I saw it, I realized at once that he was the kind of director with whom I would be able to collaborate successfully. Later on I learned that Malick had

very much liked my work on Truffaut's *The Wild Child*,[14] which, although it is in black and white, has something in common with *Days of Heaven*, in that they are both period films.

HASKELL WEXLER

Terry Malick probably saw what Nestor shot. Terry is a very visually alert person. And he might have seen something and that set him off. But Nestor had a previous commitment, so when I arrived in Canada, I saw Nestor, and Nestor was saying things about Terry which would be frustrating to him, but actually worked out well for the film. He said, 'So, when we are shooting in the late afternoon, and the light's moving, what I usually do is first I switch to my fastest lens, and then I push one stop, and then I just make a note to the lab: "Please print up."' It was that kind of conversation, and he said, 'Please, do what you can for me, I have to go with Truffaut.'

BILLY WEBER

If there was a loss-of-innocence scene for Brooke Adams's character it's the scene when she's with Richard in the bunk house, late in the day, discussing whether or not she should marry Sam Shepard's character, and Richard Gere is trying to talk her into it saying that this guy is going to die soon, he's got one foot on a roller skate and the other one on a banana. She doesn't want to, but makes this decision to do it and leaves Richard sitting there and walks out of the bunk house. It is actually one of the best shots in the movie and some of Haskell Wexler's finest work because there's no light, except for a lantern, and he's on the two of them and when she gets up, he pans up with her and he follows her around all the way to the outside and moves outside, and if you look at that shot it's amazing because he had to be changing exposure during it, and it's almost dark, but there is a wonderful light outside. It was right when Haskell came on the movie that they shot that.

SAM SHEPARD

Haskell did the interiors. That's the way it worked. Nestor had to return to do a Truffaut film,[15] because he was Truffaut's main guy. I think it was his first American film. And Haskell came in, and very selflessly, I think, just moved right in to the interiors and you don't see any discrepancy. It's beautiful. Could you get two cinematographers of that calibre to collaborate today on a movie? Maybe you could, but it was really extraordinary. Because they honoured the project and they honoured Terry and they knew they were involved in something extraordinary.

HASKELL WEXLER

In *Days of Heaven*, when Nestor Almendros had to leave early, he said, 'You know, I like available light,' that's his expression. So I said, 'Yes, Nestor. What's available on the truck.' When we light, we naturally try to imitate or enhance reality, but when you make a film you can't depend on the light hitting through that window all day long, because the scene's gonna take the whole day to shoot. So you have to use artifice, you have to use a 20°K light or a 12°K light to maintain what will be natural. So, film-making is an unnatural act. The reality of God's light moves. A cloud moves and the reality changes. But for the film, the reality has to seem as if what I'm saying at this moment and at that moment is the same moment. And it won't seem that way if God's reality changes. Nestor had deep theories about his approach to his work. And when he spoke about it – these ideas about the natural and the real, and so forth – I made jokes about it. I probably shouldn't have because it was the basis for how he thinks when he lights. I said 'when he lights' because we're dealing with film, you have to deal with the fact that what you're doing is putting it on, taking reality and putting it on a piece of material. And the material has a certain sensitivity, a certain range of contrast, and so you have to be a professional, you have to know what those limits are. Anyway, I miss Nestor Almendros. I had met him a few times before *Days of Heaven*, and sometimes afterwards, and

he was a very sensitive, beautiful person. And my assignment on *Days of Heaven* was to keep rolling what he got started. Actually, when we had seen the film together, Nestor told me he couldn't remember exactly what he had shot and I had shot.

JACK FISK

Nestor was a wonderful cinematographer and he worked well with Terry. He was so sensitive and was so excited about America. I remember when he saw the set for the first time, he couldn't believe the whole house was built out of wood. Living in Paris, and in Spain, he had never seen houses made completely of wood, and out in the middle of nowhere; he just loved that. He had to leave early because he was committed to another film, but he hated to leave. But then Haskell Wexler came in and he picked up, he looked at the film and he matched Nestor's style on all the exteriors. And the only interiors that we'd shot were being reshot, so Haskell was free to develop his own lighting for these interiors and I think that they turned out beautifully – they were right for the set, they evoked all the tones and the colour in there. We silk-screened a lot of the wallpaper, and the way he lit it was just luminous; you were able to see the contrast with what was outside the windows at its best.

NESTOR ALMENDROS

A month before I was to leave, I mentally reviewed all the cinematographers I admire in America. I thought of Haskell Wexler, who was also a friend, and we asked him if he could come and finish my work. Luckily, he accepted. We worked together; overlapping for a week so that he could see how the shooting was going. We also showed selections of all we had filmed up to that point, so that he could familiarize himself with the film's visual style. Haskell was wonderful, because as well as producing unbelievably beautiful images, he adjusted perfectly to the style we had established. I don't think anyone could distinguish between his footage and mine. Even I myself can hardly tell the difference

in scenes with an edited mixture of shots taken by each of us. Haskell tends to use filters and diffusion gauzes (as he did in *Bound for Glory*),[16] but since I do not, he did without them.

BILLY WEBER

The shoot of *Days of Heaven* was very tough, it was horrible being there, it was very cold and windy and bleak and we were in the middle of nowhere. We had a lot of production problems – it was a hard movie to shoot: Terry hadn't done a movie in three years; Linda Manz had never acted, Sam Shepard had only acted in one film before that; it was rough, the crew wasn't used to Terry's style. Nestor was great, but the rest of the crew were all Americans and they weren't sure who Nestor was.

NESTOR ALMENDROS

With a few exceptions, the crew (which I did not choose) was made up of old-guard, typically Hollywood professionals. They were accustomed to a glossy style of photography: faces never in the shade, deep blue sky, etc. They felt frustrated because I gave them so little work. The normal practice in Hollywood is for the gaffer and grip to prepare the lighting beforehand, so I found arc lights set up for every scene. Day after day, I would have to ask them to turn off everything they had prepared for me. I realized that this annoyed them; some of them began saying openly that we didn't know what we were doing, that we weren't 'professional'. At first, as a token of good will, I would shoot one take with arc lights and another without, then invite them to see the rushes to discuss the results. But they wouldn't come to the showings, perhaps because they didn't want to waste their free time. Or if they came, they were not convinced. For them the sky had to be blue and the faces completely illuminated.

HASKELL WEXLER

When I was brought into the film, it was not just for my professional background, but because I knew Bert Schneider, and they

were way behind schedule, and I think they thought there was a need for someone who could push Terry a little bit. Bert wanted me to keep things going. Keeping things going in a feature film is: keep the actors out in front, have them talk, say the lines, turn the pages of the script. To Terry, keeping things going is also some silent images, a peacock, an animal running on the hill, a bird flying. When I began to work, the crew was very happy because there was a lot of sitting around, nobody was cracking the whip. And the American style for director of photography is not just to wait for the director to say, 'Well, come on, where's the next set-up? Now what we're gonna do? What about this?' And the word came down to Terry, as well as me, that we were over schedule, not enough was being done, so the metabolism of the crew changed, and they liked it, because they wanted to work at a pace.

RICHARD GERE
I like Haskell, he is a terrific DoP. He is an artist. He knows what he's doing. He also has worked with Hollywood crews more. So, I think that when he came on board the crew felt better with him. Nestor was an extraordinary guy. But, as I recall, his English wasn't perfect. And he was also almost blind. He had very thick glasses which was not an advantage for a DoP. But Nestor was a major artist, maybe a genius, in his ability to feel light.

Linda (voice-over)
I've been thinking what to do with my future.
I could be a mud doctor
checking out the earth underneath.
[. . .] We never been this rich, all right?
I mean, we were just, all of a sudden
living like kings. Just nothing to do all day
but crack jokes, lay around.

PAUL RYAN

Shooting the sequences of the river, when Abby, Bill and Linda try to escape, the suggestion that Terry gave me was like a sense of discovery – a sense of expansion that suddenly everything is possible; they are coming from the steel mills in Chicago, where nothing is possible, but now they are out here with a feeling of 'I'm in a new world and everything is possible now.' On the other side of it, the dark side was: 'I'm not bound by the rules any more, because I'm in this new place and it's open and everything is changed.' That, of course, was the tragedy of the film – they felt they could break the rules. When you come to a new place, you feel that there is a freedom, and you think that maybe you can make your own rules. Antonioni expressed that feeling very well in *The Passenger*[17] when Nicholson is out in the desert and suddenly he sees that he can become a different person – 'I can take this other man's identity and just become him and take his life on' – if he was in the middle of London he probably wouldn't have had the feeling, but something about being out in the desert led him to believe that it was possible.

NESTOR ALMENDROS

I had several camera operators in *Days of Heaven*, because union regulations did not allow me to operate the camera myself, which is not the case in Europe. Therefore, Terry and I would work out and rehearse the movements both of the camera and of the actors in the viewfinder; after a series of try-outs, my operators knew exactly what we wanted. Fortunately, I was working with skilled and talented people: John Bailey, who has become since then a great cinematographer; the Canadian Rod Parkhurst; Eric van Haren Noman (a Panaglide-Steadicam specialist); and Paul Ryan as second unit operator. These, and others, would work together at the same time on several scenes. Usually, I would stand near the main camera, and whenever I could, I would go around giving instructions to the other operators. Sometimes I would pick up a camera and film myself, but this was sacrilege in the eyes of the

union. Some of the shots filmed by this crew on their own were excellent; strictly speaking, the praise lavished on my work when I won the Oscar should be shared among these unsung technicians.

STEVAN LARNER

In his Oscar acceptance speech, Nestor Almendros said, 'These images are Terry's.' Working with Terry Malick is a collaborative effort and Nestor was a beautiful cinematographer, he had a way of viewing light and of using it. He told me that working with Terry Malick was a very pleasant collaborative effort, and that's the way films ought to be made; it's a team making a film, it's not just a director yelling and screaming at people or a yelling and screaming producer – it's got to be done as a team – people have to like each other and people have to like the project, and you come off with a good film.

NESTOR ALMENDROS

All our individual efforts were unified by Terry's great talent, his technical knowledge, and his infallible taste. Malick would never let anyone do anything that went against his own ideas. Before filming began, he laid down a series of principles. The style of the movie was outlined in such a way that each member of the crew had to follow the guidelines, the most basic of which was to remain as close to reality as possible.

Linda (voice-over)
I got to like this farm
Do anything I want.
Roll in the fields, talk to the wheat patches.
When I was sleeping, they'd talk to me.
They'd go in my dreams.

From the time the sun went up
till it went down
they were working all the time.

NESTOR ALMENDROS

Basically, my job was to simplify the photography, to purify it of all the artificial effects of the recent past. Our model was the photography of the silent films (Griffith, Chaplin, etc.), which often used natural light. And in the night-time interiors, we often used just a single light. Thus, *Days of Heaven* was a homage to the creators of the silent films, whom I admire for their blessed simplicity and their lack of refinement. From the thirties on, the cinema had become much too sophisticated.

In this, as in my other films, there were a number of influences from painting. In the daytime interiors we used light that came sideways through the windows as in a Vermeer. There were also references to Wyeth, Hopper, and other American artists.

HASKELL WEXLER

When I saw the dailies, before I went up to shoot the film, I saw an unusual photography, photography that I hadn't seen before at all.

NESTOR ALMENDROS

At Malick's insistence, certain parts of the film were made at what he calls the 'magic hour', that is, the time between sunset and nightfall. From the point of view of luminosity, this period lasts about twenty minutes, so that calling it a 'magic hour' is an optimistic euphemism. The light really was very beautiful, but we had little time to film scenes of long duration. All day we would work to get the actors and the camera ready; as soon as the sun had set we had to shoot quickly, not losing a moment. For these few minutes the light is truly magical, because no one knows where it is coming from. The sun is not to be seen, but the sky can be bright, and the blue of the atmosphere undergoes strange mutations. Malick's intuition and daring probably made these scenes the most visually interesting ones in the film.

BILLY WEBER

The shooting was very experimental with the light. Terry had such a great understanding of the film stock itself, and how much light he needed for it and what he wanted on the film. I don't think anyone at that point, any director or any director of photography, would have done what he did in that movie. But he really believed he could do it, and Nestor would have told you that Terry was always absolutely right, he calculated it perfectly.

HASKELL WEXLER

The most beautiful light is the light that's transitory, the light of sunsets or sunrise. When I was growing up I noticed that European films would do a lot of their night scenes at the magic hour, because then you wouldn't have to light up the whole city. Actually the 'magic hour' is running after the sun goes, and you have to look and see where the sky is gonna be darker, or whether you can control the sky. So, everything has to be more quickly done, because even though the magic hour is longer in the northern latitudes, it always requires moving the cameras quickly, getting different angles. On Western films, when I was an assistant, if you wanted the sun – and the sun was going – I've many times put the camera on my shoulder running up the hill with the cowboys to beat the sun, as it was setting. The game that's played with nature in photography has some excitement to it.

NESTOR ALMENDROS

It takes daring to convince the Hollywood old guard that the shooting day should last only twenty minutes. Even though we took advantage of this short space of time with a kind of frenzy, we often had to finish the scene the next day at the same time, because night would fall inexorably. Each day, like Joshua in the Bible, Malick wanted to stop the sun in its imperturbable course so as to go on shooting. This system of working at the magic hour was not totally unknown to me, because I had used

it on other occasions for short, isolated vignettes, for instance in *La Collectionneuse*[18] by Eric Rohmer and *More*[19] by Barbet Schroeder. But I had never been able to use it for long sequences as we did here. There are few films like this with so many different exteriors, so full of opportunities for a cinematographer.

SAM SHEPARD

Nestor was one of those people whom you realize that his whole fascination was light. He was always looking at the clouds with the lenses. He was always calculating light. He was always configuring light and then realizing that light is something ephemeral, it comes and goes – if you don't get it now, it's not gonna be the same as it is five minutes from now. When you start to understand as an actor what that means in terms of film, it gives you a different patience than if you're saying, 'These guys are messing with my time.' It was so amazing to watch Nestor because he wasn't manipulating light bulbs and fixtures. It was waiting for these moments. And moving into these moments. And the light in Alberta was quite extraordinary. He was looking for God's light.

NESTOR ALMENDROS

The decision to shoot these scenes at the magic hour was not gratuitous or aestheticist; it was completely justifiable. Everyone knows that country people get up very early to do their chores (we shot at twilight to get the feeling of dawn). At that time people worked from sunrise to sunset.

We began with normal lenses, but as the light diminished, I would ask for lenses with wider apertures, always ending with the most luminous. To draw out the sensitivity of the film even further when all that was left in the air was a slight glow, we would take off the corrective 85 filter for daylight and gain almost one more stop. As a last resort, we sometimes shot at eighteen or twelve images a second, asking the actors to move more slowly – the normal rhythm would be restored when the film was projected at

twenty-four frames a second. This meant that instead of exposing at 1/50 of a second, we exposed at 1/16, which gave us another lens stop. When the people in the laboratory did the grading, they would have to harmonize-correct a negative with different tonalities. The work Bob McMillan did at the Metro Goldwyn Mayer lab was marvellous. In the rushes certain scenes were really like a patchwork of different bits and pieces, and McMillan was able to unify everything. I am in debt to him.

RICHARD GERE

There were days, very few, where we would spend hours during the day waiting to use a short, magic hour time. Because we were in Canada, it was up north, it was getting late in the year and maybe there was half an hour of really good light, magic hour light. But you can't make a movie that way, you shoot what you've got. So, a big part of the movie wasn't shot during magic hour. We were very lucky to get the light that we got. Almendros used things incredibly and Terry had great native intelligence about the use of light and space and the framing of shots. That was one of my first movies. In movies there is a lot of waiting, there is a lot of preparation that has to be done. So, in retrospect, probably there wasn't any more waiting than on any other film. I know the light issue was a big deal. But I don't remember waiting on that any more than any other film I've done.

> *Linda (voice-over)*
> Nobody sent us letters.
> We didn't receive no cards.
> Sometimes I'd feel very old
> like my whole life's over
> like I'm not around no more.

NESTOR ALMENDROS

In France the light is very gentle, because it is almost always filtered through banks of clouds; this makes working with exteriors

easy, since the shots match together with no difficulty when they are edited. On the other hand, in North America the air is more transparent and the light more violent. A figure standing against the sun appears as a silhouette. Traditionally, cinematographers solve this problem by filling up the shaded area with arc lights. Rather than compensating, Malick and I thought it would be better to expose for the shade, which would make the sky come out overexposed, burned-out, and not at all blue. Like Truffaut, Malick follows the current trend of eliminating colours. A blue sky bothers him, which is understandable when it makes land-scapes look like picture postcards or vulgar travel brochures. Exposing against the sun for the shade produces a burned-out sky, white and colourless. If we had used arc lights or reflect-ors, the result would have been flatter and less interesting. As measured on my exposure, I set the lens stop halfway between the luminosity of the sky and that of the faces. In this way the features of the actors were delicately visible and a little underex-posed, and the sky was a bit, but not totally, overexposed.

BILLY WEBER

There's a scene when the guy who's the foreman of the ranch is watching Brooke Adams and Richard Gere lying out on the ground. So there's a shot of him, watching, and then there's a shot of Richard Gere and Brooke Adams which is shot right where he was standing! We just moved him out – we did his shot, he walked away and we put Richard and Brooke in the exact same spot so the light would be exactly the same, and just shot it immediately. We were shooting out in the middle of nowhere, there are no signposts, there's no buildings that make you realize all of a sudden, 'Oh, everybody is standing in the same place,' so we were able to do that.

The scene of the locusts is shot from the tail of the film to the head of the film, shot back, in reverse. So that's what we would do: we dropped bags of seeds from a helicopter down on everyone to the ground, in very late light, and then – when we

processed the film – it looked like the locusts were rising up out of the wheat.

RICHARD GERE

I think we made a couple attempts, trying to make this locust sequence work, a very biblical moment. I think the movie has probably got more to do with the Bible then any kind of social commentary. There was a plague of locusts. I think they had tried to get some real locusts, and it just didn't work out. And someone had the idea to just drop stuff out of helicopters and reverse it. And then, of course, to make that work you have to have everyone in the frame also going backwards so when it's reversed they're going forwards. I remember rehearsing quite a bit. We had tractors moving in reverse, people walking in reverse, people had trick things as if they had dropped a handkerchief or a rag and then having a trick string that pulled it up into their hands. So, when it was reversed it looked like they were dropping it. So, you would have all kind of visual cues as to what our magic reality was. And it was great fun to do. I think we all were surprised how well it did work in the film.

BILLY WEBER

Apart from that scene shot in reverse, a tremendous amount of the locust footage was not shot in Canada, it was shot in Montana, without Nestor knowing it – without anyone knowing it, just me and Terry and the producer. All the tight shots of locusts, people beating on the locusts, it was shot by Paul Ryan.

PAUL RYAN

I don't think at the time I was filming the locust sequences that it had some biblical references. Terry used to say that when things like this happen people go crazy, they don't think logically, they are desperate and try to do things that wouldn't have any sense but they would do it anyway, as they didn't know what to do. The wider scenes of the locusts' invasion were done in Canada

by the first unit, I did the tighter shots of the locusts in the wheat. We had to put the locusts in a bag and then squirt in CO_2 (carbon dioxide) and they would almost fall asleep, then we would put them on the wheat and they would slowly come back up into consciousness. They would move slowly at first and you would film them exactly in the moment they were doing that, because otherwise they would just fly away instantly.

BILLY WEBER

The wheat fire – which turned out great! – took three weeks to shoot. We'd shoot a little bit each day, because what would happen is that we'd set fire to the wheat and then we'd have to put it out, and there was so much smoke and it was hard on the actors and hard on the extras because if the wheat was too dry, there was no control on the fire once it started. There is a scene where the fire starts and Sam Shepard waves his stick with a lantern on at someone and it catches the wheat on fire and then a horse is frightened by the fire and leaps up and takes off and there is a little wagon on the back of the horse which comes apart from the horse, then the horse drags the fire through the wheat. All that wasn't supposed to happen; it was as much an accident as it was planned. And then there were a couple of shots where we set the wheat on fire and it got much bigger than we anticipated! We had to put that out as quick as we could, but we didn't just want to put it out immediately because it was perfect for what was happening. It was a really hard sequence.

RICHARD GERE

I recall there was a section of about fifty acres of wheat that were not going to be harvested, because that was going to be the fire sequence. And it came late in the season. As I recall it was really cold too. It was getting very cold in Canada. I do remember the fire started on the horizon. And it was so extraordinary that we all just kind of stood, including Terry, including everyone, we just stood there mesmerized by this fire as it was lit on the

horizon and started moving towards us. I don't think anyone was prepared for the operatic quality of that and the intensity of it. A kind of a panic came over everyone. It is extraordinary in the film. And it's one of those elements – the locusts, the fire – that have to do with our DNA and the universe itself rather than kind of normal storytelling.

NESTOR ALMENDROS

In professional filmmaking, it was unheard of to take too many technical risks, because the cinematographer is responsible to the producer if a scene turns out badly. But in *Days of Heaven*, since Malick wanted to experiment in this area, he let me go as far as I could.

There are many night scenes in the film. The story was set in 1917, a time when the only way to get light outside in the country at night was by bonfires or lanterns. We wanted these scenes to give the impression of having really been illuminated by firelight. We employed a new technique: we used real firelight to illuminate the faces. Like all discoveries, it came about by accident. We had some containers of propane gas with flame-throwing jets to start the fire for the burning wheat field scenes. Noticing that they were easy to handle, and that the height of the flame could be controlled, I did some tests that clinched the matter. All the close-ups near the flames were filmed like this, both those of the fiddler at the country dance and those of the burning fields. The propane gas had the right colouration and movement. In my opinion, our method achieved great authenticity. At first, some members of the crew felt confused, because what we asked them was unusual. If the gaffer is an electricity specialist, why did he have to handle bottles of propane gas? Why did the prop man? After all, this had to do with lighting. But soon a feeling of common purpose overcame their sense of professional etiquette. The long shots of the fire in the wheat fields were filmed practically as they were, with no back-up lights. The fact is that when fire is illuminated, it loses some of its visual strength. With our

method, the characters were sometimes silhouetted against the flames like the negatives of prehistoric cave paintings.

PAUL RYAN

Terry wanted to have people in the background just doing something crazy. There was a lot of freedom. It wasn't like 'we had to do this or that'; there would be some last-minute idea, like 'drive that tractor through the fire!' and people would say, 'He wouldn't do that!' 'Do it anyway! Just go for it! Just do it!' And then somebody would say, 'I'll do that!' and they'd do it – just drive a tractor into the fire! There was this kind of spontaneity, because if you think about it, you would never do this kind of thing – why would anyone drive a tractor through the fire? It makes no sense! But it is a sense of impulse at the time.

SAM SHEPARD

Days of Heaven is also the first American film that uses Steadicam, the Panaglide prototype, assembled by Panavision. The Steadicam comes down the stairs and then walks out into the field. Terry was thrilled to death to be doing that. He's like a child, Terry, so enthusiastic. The only other time a cameraman used that was in a Muhammad Ali fight.

NESTOR ALMENDROS

At first Terry was so taken with the new device that he wanted to shoot the whole film with the Panaglide. We soon realized that, although it was very useful, sometimes indispensable, it was not to be used exclusively. In fact, to a certain extent, we paid for the initiation. It was like the early days of zoom lenses, when filmmakers made their audiences seasick by using their new toy too much. The Panaglide left us free to move in all directions, so the scenes turned into a merry-go-round. The whole crew, sound technicians, script girl, director, and I, were all constantly scurrying behind the operator so as to keep out of the frame. The rushes were brilliantly executed, but with too much virtuosity;

the camera was like another protagonist intruding in the scene. We soon found out that often nothing competes with a rock-steady tripod shot or the slow, invisible, regular movement of a classic dolly on wheels.

HASKELL WEXLER

The opening of the film has a section in the steel mill. Now, I'm from Chicago, I worked in steel mills, I've shot in steel mills, I know these locations very well. And so when Terry told me what he wanted to see happen, that section was done just like a documentary. That was all done by me, hand-held, with a Panaflex. When these discussions happen with someone like Terry, there's not a lot of talk. But as a director of photography you have to get the approval of trying to do something in a certain way. And in that case I remember that he said, 'Yeah, okay.' I mean, Terry would never say, 'Yeah, that's great! Let's do it!' or point like directors are supposed to point. Terry would say, 'Okay . . .' and that would be it. Another scene was the one between Sam Shepard and Brooke Adams, in their bedroom, when they have a strong argument. When I shot this scene I put the camera on my shoulder, had the actors do what they do in real life, and I stuck with them, I followed them. Of course, I repeated the action a few times, and I did it from different angles. I felt in these particular cases that my background was helpful and Terry allowed me to do that.

PAUL RYAN

There were two parts to my involvement – one was the true second unit that was done entirely apart from first unit and it was all in the wheat fields of Montana, and then there were some sequences that I shot with Terry and the actors. That was after the film had been finished and mostly edited, and we shot what would be called 'additional photography'. Regarding the steel mill sequence, Wexler worked for about three days but then he had to go and do something else. So, Terry called me and said, 'Can you come and help us film the last five days of this?' I came

in and we went out and filmed the second half of the steel mill, it was a real steel mill in Torrance, California – it was probably one of the last ones in the country to be working, an old-fashioned mill. I also shot outside of LA where there was a barn and we filmed things in the barn with Terry, Richard Gere, Sam Shepard and Brooke Adams.

Linda (voice-over)
Me and my brother.
It just used to be me and my brother.
We used to do things together.
We used to have fun.
We used to roam the streets.

SAM SHEPARD

It was my first movie, so everything was shocking to me. Everything; I could not believe it. It was like organized chaos. Incredible – but it turns out every movie is like that, but this one lasted a little longer. There's a shot we did much later . . . I think it was Jack Fisk's house up in the Hills where Richard Gere had to plunge his head into an aquarium in the living room. There is the scene where he is shot in the river and he falls into the water. We see his head from a low angle, under the water. This shot was made with Richard Gere hitting the deck in a big aquarium. And Terry was directing it. We shot a couple of other close-ups underneath the bridge of a freeway in Los Angeles. But I remember that water shot in particular, and Terry was very worried that Richard wouldn't do it. But Richard did it, being a soldier and a good man. But that's how he got that shot. It's great! It peels right into the editing. It's beautiful, it's seamless. And you don't even see it.

RICHARD GERE

We did these water shots in a fish tank in the back of Jack Fisk's house. I don't think there was any money left. So, it was a lot of just grabbing things as we could.

PAUL RYAN

That was one of the scenes we did at the end. We had an aquar-
ium with a glass bottom and we put the camera looking up and
Richard Gere just came 'pop' into that. It is interesting that sev-
eral people watching the film remember that shot. It is a very
simple shot, but it had a very powerful effect. Terry always had
a great vision, he could see things. He has a very good sense of
cinematography. If he was not making films, he could be a great
cinematographer himself.

JACOB BRACKMAN

The ability to see things is, in a way, Terry's signature. He kind
of invented that way of putting a movie together and relying
on this unusual dimension of nature, animals, sky, birds, and
trees – basically, second unit kind of stuff that most filmmakers
don't have in their arsenal because they haven't spent the time
shooting that kind of material. From this way of shooting his
marvellous, distinctive style was born.

NESTOR ALMENDROS

Since the film was set during the early days of electricity, I put
low-watt household bulbs in the lamps to obtain a warm-toned
colour temperature for the night scenes inside the mansion.
Apart from these scenes, we used hardly any artificial illumin-
ation in the film. For the few interior day scenes we followed
Vermeer's example and used the light coming in through the
windows. I had experimented with this technique earlier, par-
ticularly in Rohmer's *The Marquise of O.*[20] But Malick went
even further. Since Rohmer does not like any great contrasts in
lighting, I had had to add some extra light to make the back-
grounds visible, too, and fill up the shadowy parts of the faces.
For his part, Malick did not want anything added. Therefore,
the background remained in shadow and only the characters
stood out. This method produced some positive results, apart
from the most obvious, which is that we retained the beauty of

this natural light. The actors work better because they are not fatigued by the excessive light and the suffocating heat of artificial lights. No time or money is lost in complicated electrical installations. On the negative side is the fact that the lens stop must often be wide open, which produces minimal depth of field. Malick is one director who is very familiar with photographic techniques. Someone else might not have taken this lack of depth into consideration, but Malick organized the scene so that the actors were all on the same focal plane.

HASKELL WEXLER

A couple of things I did different from Nestor – which I don't think is obvious – but I used some diffusion. I used fog-filters occasionally; I wanted to smooth things out a little bit. But otherwise I did pretty much what Nestor did, with the naked camera. We blended together in the work. We couldn't tell, 'Did I shoot that? Did you shoot that?' I shot part of the fire scene, for example, some of the agricultural machinery. There were certain things that Terry wanted to continue, stuff that Nestor started. I have to mention that when I saw the cut and I saw that I had done about forty-five minutes of the film or so forth, I thought, 'Well, God damn it. I should get credit with Nestor on it.' And then I had talks with the producer, Bert Schneider, and he said, 'Look, you've won Oscars already. What the hell, Nestor should have it.' So then I said to myself, 'Well, Haskell, you're being a little selfish.' And then the real thing that convinced me not to say anything more than just have an 'additional photography' credit was that Nestor set the tone of the film. It was actually me maintaining his style to a certain extent, so if there was to be an award, which we didn't know there would be, he should get it. And I'm so happy now – particularly since he is no longer with us – that that happened.

> *Linda (voice-over)*
> Just when things were about to blow,
> this flying circus came in.

Days of Heaven

JACK FISK

When you work with Terry, the exciting thing is to be on set and as things change to accommodate his creative genius, providing him with the elements he needs. He has great ideas and then he has greater ideas, and you know any day you shoot something you might be the recipient of one of these new ideas that's completely different. In *Days of Heaven* we often planned to shoot a scene set in a bedroom and then he would say, 'Well, let's shoot it on the roof or in the barn.' So it was great for the actors because they were never able to plan completely, it was great for Terry because it was all new and fresh. I think that he thinks about things and once he's thought them through he wants something new so that the more time he has to think, the more things he wants to incorporate.

Linda (voice-over)

He seen how it all was.
She loves the farmer.

The sun looks ghostly when there's
a mist on a river and everything's quiet.
I never knowed it before. You could see people on the shore
but it was far off and you couldn't see what they were doing
they were probably calling for help
or something.
We seen trees that the leaves are shaking
and it looks like shadows of guys coming at you and stuff.
We heard owls squawking away,
hooting away.
We didn't know where we were going,
what we were gonna do.
I've never been on a boat before.

SAM SHEPARD

Europeans love Westerns and, in a way, *Days of Heaven*, through the farmer character, is related to Westerns. It has to

do with this idea of the man. What is a man? And this notion of the cowboy and of the West and this solitary character, this person who was able to fend for himself in spite of everything else, to be self-sufficient. It's a very important thing, which gets more and more lost as we move into our idea of civilization. We don't have that quality any more. We don't have that way of testing ourselves. Self-sufficient. At one point it wasn't myth. At one point it was real life. Now it's myth because the majority of us don't live in those type of circumstances. But at the time that was going on, it wasn't myth at all, it was absolute reality. You either knew how to find water or you didn't. And there are still a few of those guys left, a few. But, see, the difference is that now, in this culture, we go after the spiritual before the very essential things. We start on a spiritual quest but we even don't know how to find water. It's not the same. Those guys had to know where things were. And the spiritual came out of that, not the other way round. I don't think you can go on a spiritual quest if you don't know how to feed yourself. You gonna end up crow bait.

At the same time I don't think the European psyche understands what that vastness is, particularly back then when people were really, really alone.

<center>*Linda (voice-over)*</center>

Some sights that I saw was really spooky
that it gave me goose pimples.
I felt like cold hands touching the back of my neck
and it could be the dead
coming for me or something.
I remember this guy
his name was Black Jack.
He died. He only had one leg, and he died.
And I think that was Black Jack
making those noises.

Days of Heaven

RICHARD GERE

I don't remember the first time I saw the finished film. It might have been in Cannes. I think it was actually finished, totally mixed, colour-graded – everything was right. And Terry won best director that year. And it was a year of extraordinary movies. *Apocalypse Now* was that year and four or five other great films. In terms of having a big audience, I don't think it was a seen movie, but it has lived on. If you're in Paris or in London it is playing in some theatre somewhere there all the time. It had an impact in that world. In my career, just the mere fact that someone took a shot on me and made me a leading actor in a movie put me on the next step in a certain direction. I clearly remember when Terry asked me to do the film. I felt like my life had taken on a certain direction. And the next part of my life was in motion. So, for that, I will always be thankful to Terry, absolutely.

ARTHUR PENN

I had a different reaction to *Days of Heaven* from other people. I didn't think the story was very interesting. I thought it was very interestingly made, but as a film I have some doubts. The character of Sam Shepard and his relationship with other characters didn't touch me. I also thought that it was a little bit too sophisticated; I thought Terry became maybe too concerned with the camera. Different from *Badlands*. In *Badlands* he was working with a certain kind of primitivism. My feeling on *Days of Heaven* is that it is very good, it is very beautiful, it has interesting themes to it, but to me it doesn't connect. We had talked about *Days of Heaven* before it was written. I had a different impression of it, from many people. I could admire the filmmaking, but I didn't admire the story all that much.

IRVIN KERSHNER

Days of Heaven had its own rhythm, its own look, it didn't look like a Hollywood picture and it was full of ideas that were

wonderfully inserted. It also had great actors. It wasn't heavy on dialogue and it sort of worked, but not for the mass audience. I went to see it with an ordinary audience in a theatre, they didn't respond, but it was up there, it was Terry.

ENNIO MORRICONE
When I saw the finished film I understood how great it was, a masterpiece. I must say I very much appreciated Terry Malick as a director, I understood how careful and attentive he was to every phase of the making of the film. You can see it from the final result, how much he was able to narrate a story that in its essence is quite simple but, at the same time, the settings are very rich. The stubbornness of shooting without lights, with only fire to illuminate the faces, putting to the test the extraordinary talent of Nestor Almendros. Even when we recorded the music he was very demanding. In some cases, not always, he suggested some musical solutions, which annoyed me. I remember he asked me to orchestrate a piece for three flutes, something impossible, which of course was finally excluded. But, exactly this way of working made me appreciate him, for the attention and devotion with which he worked at the film.

NESTOR ALMENDROS
Though Malick is very much an American, his culture is universal; he is familiar with European philosophy, literature, painting, and music. So he spans two continents and, consequently, it was not hard for me to adjust to shooting *Days of Heaven* in the New World. When the Hollywood Academy awarded me the Oscar for my work on *Days of Heaven*, my career entered a new phase.

JACOB BRACKMAN
There is a scene in *Days of Heaven*, when they are in Texas and the president's train goes by and they don't actually see him. They are out by the railroad and Abby is putting Linda on the

train and suddenly you see all these soldiers who are going off so naively to the slaughter of World War I, little do they know what is in store for them, they got the brass bands out there, and they are kissing their girls and celebrating their own little chance at being heroes, it's all so deeply innocent and naive, compared to what we know is about to happen to the whole world at this moment in 1916. This is a moment that tells a lot about the era and, at the same time, it has an echo in the ending of the film.

Linda (voice-over)
She didn't know where she was going
or what she was gonna do. She didn't have no money on her.
Maybe she'd meet up with a character.
I was hoping things would work out for her.
She was a good friend of mine.

PAUL RYAN
When they blew up the film from 35 mm into 70 mm and I watched the final print it was wonderful, it was very magical. But the thing that impressed me the most was the ending of the movie. I think that it is one of the most powerful parts of the film: they are trying to make Linda and Jackie civilized in a proper boarding school. And then they crawl out and we see Jackie going away. We hear the voice-over of Linda saying goodbye to her friend. Jackie is not going to be tied down by civilization; she is going to go off again. That is another side of Terry, he understands these little, personal things that, in a way, are the melody of life.

The Years of Absence and
The Thin Red Line

PAUL RYAN

I, Richard Taylor, Billy Weber, Peter Broderick[1] and Jim Cox[2] were working on Terry's next picture, Q, which unfortunately never saw the light of day. We were all trying to figure out how to make this thing work, what new ideas we could come up with. Terry was very interested in doing things that were new – new ways of filming and finding places that had never been filmed before. We filmed in Sicily, on Mount Etna. People were filming in Australia, underwater stuff and many things like that. And we filmed an eclipse of the sun! At this point it was just getting things that 'we won't be able to get again', so it was very exciting.

Most films are done in a more self-contained way, rather than collecting images from all over and then combining them. The real challenge that Terry always put forth was that he never wanted to see something that had already been done before. So it's not simply just going to film an eclipse, but to go there and film something that was going to look different. I remember we didn't shoot the sun at all: we filmed what the land looked like when the eclipse came by. Everyone has seen the image of the sun during an eclipse, but what does it look like if you don't look at the sun? We just watched how the light changes on the land: it was quite interesting and quite spectacular. Suddenly it's getting dark, in a different way than when the sun goes down. It's a sort of line of shadow moving across, and suddenly a wind comes up for some reason, maybe it's because there is a temperature change. This is the kind of subtle difference that Terry was interested in. Even when shooting Mount Etna it wasn't about shooting things spewing up, but more about the cracks in the rock and how the lava would seep out, rather than suddenly explode. He

146

was always looking for something that was different – not that he would avoid something 'spectacular' – but he would avoid something that had been seen before.

All the research that we did was like that too; we would go to people that were not film people and say, 'Well, what would you do here? From a science point of view, how would you shoot this?' Again, he wanted to bring a new perspective to things that had been seen in other ways.

JACOB BRACKMAN

Terry at that time was subscribing to a bulletin of short-lived events that would tell you when certain animals were migrating and he would have the money to send Paul Ryan to shoot that migration. His approach was to pile up the footage and figure out later how to put it all together. I think Billy Weber, editor of *Badlands* and *Days of Heaven* and later of *The Thin Red Line*, was editing some of this footage. Anyway, whatever the real movie was, all this stuff Paul Ryan was shooting went into the prologue, and the prologue would be like the apes of *2001*, but instead of five minutes it was getting bigger and bigger and it was getting to be half the movie or more! Like that beast, the monster who ate Chicago!

PAUL RYAN

Terry always said, 'I'm not really interested in just a story, we have to have a feeling, it's more like a symphony. It's not about the words only: it's about the feeling you have from the imagery.' That was very important to him, as much as the literal translation of what happened. He wanted to create something that would give you the same sort of feeling that you would have when you listened to a Beethoven symphony; you don't see exactly what is going on, but you have a very powerful feeling from that about life . . . I think that was a big part of his filmmaking and I think it is a great thing for a cinematographer to work with that sort of freedom.

It would have been interesting to see what he would have done with that sense of exploration in Q.

IRVIN KERSHNER

At a certain point Terry disappeared and went to France. Then one day he appeared again in LA. We met together with Mike Medavoy at my apartment and he said he was interested in doing a film about his great-grandfather – a very interesting man. He had written a script about him, one that he had rewritten and rewritten. That's what he wanted to do.

JACOB BRACKMAN

I wonder if at one point his project on his Armenian great-grandfather was going to be the contemporary part of Q. In other words, there would be all this prehistoric stuff, all these animals, nature eclipses and then we go into some modern story and that had to do with the Armenian grandfather. That's just a guess.

IRVING KERSHNER

I lost track of him: he went back to Austin, he just disappeared. He is the type of person who just doesn't call for small talk.

I have never heard from him again. Except people talk to him and you know, somebody who has some business with him says, 'Hey, he was talking about you.' And I ask, 'Good or bad?' 'Good, good . . .' So you are still in touch in a way.

JACOB BRACKMAN

There is a community in Los Angeles that Terry was a part of for a number of years, say between 1969 and 1980: he was kind of socially, culturally, politically, part of that life, and then he disappeared, even though he was working and trying to get things on – some of it in going back to Austin, Texas.

Certainly some people thought he couldn't get work. That, of course, is not true! In this period, lots of people wanted to approach him with one thing or another and were not successful.

EDWARD PRESSMAN

I used to stay in contact with Terry by mail and through friends of his, like Max Palevsky, who would see Terry, but I didn't see him for a while. Anyway, I was aware of many of the projects he was involved in, including the theatre adaptation of *Sansho the Bailiff* and the script on Jerry Lee Lewis that would become *Great Balls of Fire!*

I knew the girl who was supposed to do *Sansho the Bailiff*, the Chinese actress Bai Ling. Terry was enthusiastic about her and then, totally by coincidence, we were working with her on her first film in the US, *The Crow*.[3] So there was communication going on and then years later – before *The Thin Red Line*, but still many years later – we started talking, we started re-exploring what the independent film scene was like and what were the pros and cons. *The Thin Red Line* was done with Mike Medavoy, who was Terry's old agent: they stayed in touch and he had a company that seemed to have the ability to finance really expensive films through Sony. In the end, it actually didn't get done by Sony but by Fox.

MIKE MEDAVOY

In those twenty years of absence, we hadn't lost contact with each other; we saw each other on and off. I think he did some rewriting for people and some writing for others, and when I was directing Orion Pictures, I gave him a project. He came to work on *Great Balls of Fire!*, the Jerry Lee Lewis story which he wrote a very good script on. But it was a very tough subject and we decided not to use the script, probably to our own detriment. Then our lives have diverged, until *The Thin Red Line* of course.

GEORGE STEVENS, JR

I'd hear from him every year or two. We weren't in close contact but every once in a while, one way or another, we would either talk or exchange a letter.

He went away to take some time off and suddenly twenty

years had passed. I don't think he was purposely taking the long detour that he ended up taking.

Then I was working with Mike Medavoy, helping him get Phoenix Pictures started and Terry's script of *The Thin Red Line* was brought to us by Robert Geisler and John Roberdeau, two producers who had commissioned it, and they had been unable to get the film made and we decided to see if we could get it made. Terry had said that he wouldn't direct it, but we felt that as he got closer to it he might decide he wanted to, and that's the way it turned out and so we were able to get the money from 20th Century Fox. I produced the film just to support Terry – and 20th Century Fox wanted some kind of assurance that it was going to be completed, in a timely way. I think it was just a matter that they would be spending $40 million and Terry hadn't made a picture in twenty years and they didn't know him very well. I suppose me being involved helped that process along.

MIKE MEDAVOY

I put up the first $100,000, which I borrowed actually. Sony had an option to do it and they decided not to do it, at which point we went to 20th Century Fox. I think they were a little nervous about it at first, but they did it – Bill Mechanic is a terrific film man. So, with Phoenix we put all of the pieces together and made sure that we got the financing for the film.

With this project I wanted to kind of complete the circle in my own life which was to make another film with Terry, so when he told me he was interested in it, I said that I would get involved.

EDWARD PRESSMAN

It's very reassuring when you maintain a relationship with the people you have worked with. One of the proudest things in my life is that I have reconnected with Terry, that there is something that's lasted so long and is able to continue and that he wants to work again together. One of, if not the most important kind of things that you can have is that there can be friendship, that

there can be relationships. Because film is always changing: you do a film, you have very intense relationships, then you go on to the next film and it's over. And that there could be something that actually can last a lifetime between people is something you get discouraged of: it's not there. And when it does come back, it really means a lot.

JOHN TOLL

Back when Terry made *Badlands* and *Days of Heaven*, there wasn't such a clear line between commercial pictures and 'thinking' pictures; nowadays, there's a real distinction between those types of films. I understand that the film industry is a business, but we don't all want to go through our careers just making commercial projects. The idea of making the type of picture that Terry seemed to be going for with *The Thin Red Line* was obviously desirable. I'm sure that the other cinematographers he spoke to were just as enthusiastic about working with him as I was, but I just happened to get lucky.

One of the great things about this project was that several key members of the filmmaking team – production designer Jack Fisk, assistant director Skip Cosper,[4] casting director Dianne Crittenden and editor Billy Weber – had worked with Terry on his previous films. So even though it had been two decades since Terry had made a picture, he came back into this core unit. They just sort of picked up where they'd left off, and we didn't really feel that twenty-year gap.

BILLY WEBER

One of the main themes in Terry's movies is that life goes on on every level: regardless of what's going on in *your* personal life, all of these other stories are continuing. I think this is a very spiritual quality that he wants to put into his movies, because he really believes that we are all one – one person living together in the universe – and how important it is to maintain that and not forget it.

I really believe that the way I edit, everything I know and

everything I do in editing, I learnt from working on *Badlands* and *Days of Heaven*. Everything I have learnt since then is nothing, it's not as much as what I learned on those two movies. This fit with my own sensibility and I found it, not easy, but organic to me, to my own personality. He takes films very seriously, it's an art form for him, it's not meant to be commercial or a commodity to sell, it's meant to be an expression that comes from within him, and that's what I appreciate most.

JACK FISK

I had a wonderful experience working with Terry on *Days of Heaven* and then he was preparing another film, *Q*, but it didn't happen and he ended up not making movies for twenty years. And then my daughter was acting in a film in Ireland. One day when I was over there, we went to a party and there was a gentleman there who said, 'Oh, I read Terry Malick is making another film,' and all of a sudden I went, 'Oh my God, I want to work with him!' He was talking about *The Thin Red Line*, and I got so jealous that somebody else might be working with him. I had been directing films but I really missed designing and I sent Terry a note saying that 'I finally recovered from *Days of Heaven* and I am ready to start again.'

That's because working with Terry has been great for me. In a way, Terry is probably almost a mentor for me in design: seeing how he worked gave me licence to work similarly; so I never try to commit to anything till the last possible minute. I think that Terry taught me to be free and brave enough to work in that way and to appreciate all the elements that come in: to listen to the movie gods.

> Then it's Tommy this, an' Tommy that, an' 'Tommy,
> 'ow's yer soul?'
> But it's 'Thin red line of 'eroes' when the drums
> begin to roll[5]
>
> 'Tommy', Rudyard Kipling

The Years of Absence and The Thin Red Line

There's only a thin red line between the sane and the mad.

Old Midwestern saying

JOHN TOLL

The idea of this particular project was really interesting to me, and not just because it was a war movie. I remembered reading the James Jones novel when it first came out, and finding it to be just fantastic. I wasn't in the film industry at the time, but I recall thinking that it would make a great motion picture. A film adaptation was actually made in 1964, but it was a pretty low-budget version, and I was a bit disappointed with it.

The book is an incredibly realistic depiction of the experience of combat. Jones[6] was a member of the Army's 25th Division; he was at Schofield Barracks in Hawaii during the attack on Pearl Harbor, and he also participated in the Battle of Guadalcanal, so *From Here to Eternity* and *The Thin Red Line* are both based on his first-hand experiences. The most interesting thing about *The Thin Red Line* is the way it gets into all of these soldiers' different personalities. While we were shooting the picture, Terry and I kept talking about how interior the narrative was. There's an enormous amount of material in the book about what the characters are experiencing internally – as opposed to what comes out in their conversations, which usually represents an entirely different aspect of their personalities.

The characters in this story are very well-drawn and diverse. Some are heroes, some aren't, and some are just there to do their job and get out as quickly as possible. It's really a story about the tragedy of war. I got very caught up in the book when I read it, particularly the realistic aspects of being involved in that kind of experience. It was a very truthful story that presented all of the good stuff and all of the bad stuff. You just knew that Jones had been there.

JACK FISK

To reach a certain universality, you have to go very deep in the

research of that period. For *The Thin Red Line* we never thought of it like a movie that was only on that particular war or battle; however, speaking with many of the actors, who had done research for their parts, they told us that the conditions of the soldiers facing death and the horror of the war was very typical of the particular mentality of a person of that period which was more innocent, with a certain degree of pureness in their mind.

SEAN PENN
Terry was looking at the time period. There was less irony and pathos in the characters; I think there was much more innocence at that time and in that breed of soldiers that he wanted to get on screen. When you came into later stories of the Vietnam War, there were a lot of questions about government support and the righteousness of the mission and so on. In World War II there was a deep, clear patriotism that he was trying to balance with what became the surprise of fear and death and horror that war was going to be in any circumstance. I think that if the characters had in their nature an anticipation of that, it was going to violate Terry's vision. He didn't want products of television, really, people who have known too much, seen too much before they ever get into this other place in the world. It was America of the '40s, not of the Millennium.

ELIAS KOTEAS
In different times, there's a different sort of mentality, a different kind of regard for human life. During the First World War something like 65–70 per cent of the soldiers did not want to shoot to kill: they'd shoot up in the air! And the officers would force them to shoot with the threat of court martial! Usually there were maybe like five guys who were shooting, and the rest of the guys saying, 'I don't want to kill anybody! I don't want to kill anybody.' But then, during the Second World War, it went down to 50 per cent, 48 per cent, 45 per cent . . . and with the Korean War it went up again, and then in Vietnam it was down to 10 per

cent! So it was just the times, maybe there was much more regard for human life. Now, with the computer age, it seems there's no *value* to human life. Not that it had any more value then, but at the time it just seemed less likely you would want to kill anybody. Knowing that – and Terry picked up on that – I think it was important to capture a certain mentality of the times. It was important that we were guys who were from the '40s, who in a sense didn't grow up watching the actors of today! Maybe we grew up watching Gary Cooper or Humphrey Bogart, James Cagney . . . These guys were men from the Depression who were raised a different way, they didn't have TV. It was just a different time and I think it was important to convey that.

JACK FISK

I think that Terry was attracted to the innocence of the soldiers, but I think it just came naturally for my work. There were a lot of young, innocent people being thrust into a do-or-die situation.

Most of them had never been away from home, and suddenly they were on this island in the South Pacific inhabited by natives, Melanesians, and they were being bit by mosquitoes and getting sick and the food wasn't good. They were living in dirt holes when they were in houses three months ago. They were eating out of tin cans when they used to eat off dishes. The army wasn't prepared: they didn't have the right uniforms, they didn't know about camouflage, they gave them grenades but they didn't have any pockets to put them in. They made them bright yellow because it represented that they were dangerous and you should be careful when you handle them, but it made it real easy for the enemy to see. And no matter how much planning they had done, you can't prepare yourself for a situation where you are going to die. You can think about it, but suddenly you are there, and you see your buddy dying next to you and hundreds of people getting sick and dying of disease and bullet wounds.

I think the danger of it is that once you are in it, you can get kind of hardened to it; for your own protection, you have

to shut off a certain part of your body, of your emotions. So, in contrast, Terry put these beautiful images of birds flying or lizards or snakes that were also affected in a certain way, but were also able to maintain an innocence. Their habitat was being destroyed, but they personally were not going to be destroyed because of the war or hopefully they wouldn't, or maybe it was all just the opposite, they were all being destroyed.

> What's this war in the heart of nature?
> Why does nature vie with itself?
> The land contend with the sea?
> Is there an avenging power in nature?
> Not one power, but two?[7]

JOHN SAVAGE

'Why are those planes shooting at us? That's the military! Jesus! They've dropped us off on the beach and now they're going away! They were going to protect us by shelling this place before we walked in front of all those guns with nothing, except these little pea-shooters that are outdated! I dunno why they kept those rifles from World War I, one shot at a time, poof!' Everybody had to be a marksman or you had very little chance to survive. Except for the guys with a machine gun! But even in that case, when they finally managed to set it up, probably the guy who was helping them got killed in the meanwhile.

I don't know what that must have possibly been like, but every individual goes through a process of being a small part of a bigger machine and a tremendous amount of courage as an individual is required to be there and do that job, whoever they are, I just feel . . . it's a bit mystical!

ARTHUR PENN

I was in the war, in Belgium and in the Ardennes. It was a very different weather: James Jones was down in the islands and we were up in the snow. But you get so dirty, so filled with bugs

and ice . . . It's very hard to describe how little consciousness you have of yourself except, 'I want to stay alive. I want to stay alive.' And Terry got that into that film. I met a guy, a couple of months later, who had jumped; he had parachuted down into a little French village. He then went on fighting for two more days till they got to a doctor who looked at him and said, 'Oh my God, I can see your brain.' He had hit the tree, broken a skull bone and went on fighting. It's that quality of . . . I don't know how to describe it, except that you lose everything except the sense of yourself and what you are doing. And that's it. You are hurt; our feet were cold, frozen, miserable. The ice in the Ardennes forest was really terrible.

The Thin Red Line had the feeling that you would eat dirt rather than put your head out. We were frightened, we were just frightened. And Terry got some of that into the movie: I'm surprised because he was never in the war. Well, he got a good deal of it from Jimmy Jones. That's a terrific book. And Jimmy had a lot of war. But Terry understood something about human terror and fear. And it's a funny word: ignominy, you know? It's a hard word in English: when you are ashamed and you strip away your own identity. War makes you ashamed of yourself. He got that quality into the film.

JOHN TOLL

There were a lot of conversations, and we also scouted in Guadalcanal, which was an unbelievable experience. The place has changed, but not a whole lot. It's a beautiful island, but it's extremely tropical and not very developed, because the region has one of the highest malaria rates in the world. During the war, enormous numbers of people came down with malaria; it was worse for the Japanese, because they weren't well supplied. That was one of the biggest drawbacks in their battle plan, and many of those crack troops wound up just starving to death. It was basically a win-or-die situation, because the Japanese simply would not surrender.

Being in Guadalcanal also helped to give us a better appreciation for what everyone there must have gone through. The jungle on the island is an extremely uncomfortable environment – it's very hot and humid. We visited the sites of many of the battles described in the book, and they were pretty amazing. You just cannot imagine how horrible it must have been. The idea of these men living out there for months at a time in such dangerous and brutal combat situations seems just incredible to me. I think we all came away with a real sense of the sacrifice that was made by everyone who participated in the war.

But one of the things that struck us immediately during the Guadalcanal scout was how loaded with colour this tropical environment was; after all, we're used to seeing black-and-white newsreels of World War II combat. At one point, we did talk about shooting the picture in black and white, but that notion didn't really take hold. The idea of all of this violence taking place in such a rich and colourful environment was very striking, and we felt that representing the story any other way just wouldn't be accurate. We got a lot of ideas about tones and colours as we explored the area.

JACK FISK

Terry has such a powerful, poetic interpretation of war: there is all this beauty and carnage side by side. The jungle is exquisite, the plant life and the animal life, but then there were these mosquitoes that would kill you.

I remember when we were working on *The Thin Red Line* we'd been trying to figure out the location and how we were going to shoot, and Terry would just say, 'Well, Jack will figure it out.' And I would say, 'No! I won't!' And John Toll was going, 'No, no! You gotta tell us.' We wanted Terry to give us some more guidance. But Terry, he likes to come to the location or the set at the last moment, kind of working with what's there. I think that the element of danger and of the unknown excites him.

So when we first started on *The Thin Red Line* Terry asked me if I would go to Guadalcanal with a cameraman and shoot some of the island. He hadn't been there but he wanted to see what the light was like because everybody knew we couldn't shoot there because it was too dangerous and too out of the way, there was no place to live. So we went to Guadalcanal and shot.

JOHN TOLL

One aspect of Guadalcanal that wasn't in the book, but which interested Terry very much, was the ethnographic aspect of the island. The story of the Melanesian people who lived there during the war is really interesting. They had existed for centuries in this very peaceful and tropical place when they were suddenly invaded by all this large-scale violence. Even today, it's a fairly isolated environment.

When we went back to the island, we wanted to find some native people to put in the picture. One of the lead characters, Witt, played by Jim Caviezel, spends time in a Melanesian village, and that's where the picture opens. Terry wanted to introduce this idea early on, and he wanted to present these people in their traditional lifestyle, as it had existed back in the 1940s. We did a lot of research, and we discovered that this culture no longer existed in the areas of Guadalcanal that were logistically accessible to us. We therefore put together a special third unit to find a village and shoot anthropological footage. The unit was headed up by Reuben Aaronson, who had done a lot of *National Geographic* shoots. He and his team went to this traditional village on the south side of the island, and stayed there for a couple of weeks.

Sometimes it worked out, and sometimes it didn't, but that's the nature of ethnographic work. Reuben had an anthropologist with him, Christine Jourdan, who has made a career out of studying the people of the Solomon Islands. She really knew the people, and how to blend in with them. They shot footage of these people existing with no trace of modernity around them,

and some of it's in the picture. Reuben had never shot 35 mm, and he suddenly found himself working with a Panaflex and anamorphic lenses. He did a great job, though.

When the first unit went in later, we recreated a portion of the village in an area that was accessible to us, and got some of the locals to come in and interact with our actors. They spent a few days getting to know each other, and then we improvised a few sequences. The people were very natural, because all they had to do was be themselves. We used a very reduced unit to make them feel more comfortable.

JACK FISK

I remember I contacted Terry and I said, 'You gotta come to Guadalcanal.' And he did and he had the same reaction that I had: he fell in love with the people; there was a Melanesian choir that he loved and he used them in the film. And after he saw that, he felt in the same way that we did – that we had to shoot at least some of the film in Guadalcanal. And we ended up hiring a second unit photographer, Reuben Aaronson, who went to the south side of the island, what they call the 'Weather Coast'. It's hard to get there, you have to get a boat or hike; it takes days to get there. There are no conveniences there like electricity, but there is a group of people there who purposely have gone back to live how they lived fifty years ago, before the missionaries came, and started recreating their craft. So he shot some documentary footage there that was incorporated into the film. And then we built a village on the nice coast and we used Melanesian labourers to build it. We were building houses and structures that were similar to what they were building fifty years ago and not what they are building today before the Peace Corps came in and kind of educated them. The people loved it, they would come by on Sunday and show their grandchildren: 'This is what our villages used to look like.'

HANS ZIMMER

Some pieces I composed for the film come from strange trad-
itional songs called 'Sacred Heart harmonies' from the 1700s
from America; they are very naive, like Rousseau paintings. They
were very much frowned upon by anybody who knew anything
about music, as they are very innocent and very naive and their
harmonies are also very strange, but we really liked them as they
bridged the gap with Melanesian music – they all come from the
same place, from Anglican hymns. They are these wonderful,
joyous translations, in a way, and the words go a little wrong
and the harmonies go a little wrong. It's all very unsophisticated,
but it comes from the heart. I thought it was a great place to start
looking for a cornerstone for us.

The Melanesian songs used in the film are in Pidgin English
and, in a funny way, harmonically what the Melanesian songs
get wrong in lyrics, the American songs get wrong in harmony.
They are folk songs and they are timeless. The American ones
aren't sung any more but the Melanesian ones in the Solomons
are sung: the thing that we thought was very interesting was
that it gave us that bridge across a whole world and we could
find a common humanity from America to the Solomons in these
songs.

PENNY ALLEN

Terry is such a secretive fellow, he's mysterious: it's almost dan-
gerous for him to decide beforehand. A lot of what you're doing
is sort of sneaking around and trying to feel, almost 'vibration-
ally' at times. Aside from all the things that had to be created for
the story to be told – the military, the island, and so forth, those
things which are intrinsic from the book, and from his script – I
began to see that Terry was in a relationship with these spiritual
elements. Man against man, man against himself, man against
his gods and man against the earth. Where does the self, the very
core of the human being begin to emerge? How does it behave
in all of its chaos, and irrationality, and violence, and gentleness,

and love and kindness? So this is the paradox that is intrinsic both visually and on a conceptual level with Terry.

JACK FISK

About the visual aspect of the movie, the way Terry and I always worked is that he'll send me books, or I'll send him books or pictures, or invariably he will be showing me pictures of paintings and photographers that he likes and that will kind of begin the basis of our research. And then I'll just expand on it, immersing myself in the period or in the elements of the pictures that I understand, or books that I have read. You look at so many sources for inspiration for the design that you don't leave any stone unturned. I looked at a lot of paintings, but I also looked at thousands of photographs, and I read a lot of stories: some people who were writers, some who weren't. And I actually liked those of people who weren't writers – excerpts from their diaries where they were talking about their day-to-day lives. And, with the paintings, they were just so personal that you would glean from that a little inspiration. I like to use paintings for research because the elements in a painting are all chosen, so that if the person who paints thinks something is important, they are able to convey that by the way they paint how they felt at the time. A lot of times photographs are so objective that they are great for studying detail, as are the markings on canisters of film, but if you want to know about the tone or the mood of somebody's feelings, a lot more painters seem to be able to accomplish that than photographers.

JOHN TOLL

During the shoot Jack Fisk brought us this book called *Images of War: The Artist's Vision of World War II*,[8] which presents two hundred paintings by many different artists. These were artists who spent time in the front lines and came back with fantastic artwork depicting the scenes they had witnessed, including many combat situations. All of the artists had different and unique

styles. We didn't necessarily try to reproduce these pieces of art, but they did give us good ideas about colour schemes and so on. The illustrations basically served as a guide to the kind of atmosphere we were after.

We'd looked at many photographs from the war, but they seemed too detailed somehow, and I wanted the imagery of our film to be a bit less clearly defined. The paintings were great because they were much more impressionistic and abstract in a way that I found more interesting than the photographs. For example, there was one drawing of Japanese prisoners sitting on the ground, and the light they were drawn in – bright sunlight which left their faces in shadow – looked very similar to the light conditions we were shooting in. There was detail in the prisoners' faces, but the highlights of the background were bright and burned-out. I thought it looked fantastic.

JACK FISK

John Toll reacted to that book, *Images of War*, and to the paintings, which was interesting because he is a photographer, and I think that all of us feel that paintings can sometimes tell you more than a photograph even though they are not as realistic or not as detailed. At the same time, that was just a small part of my research. But it's interesting that the artists were in a war situation, but they would take the time to paint it, they would feel motivated to paint it, to illustrate that moment.

The thing I like particularly about *The Thin Red Line* was Terry's take on the Japanese, to create a human enemy. And we spent a lot of time on that, we researched the Japanese, we actually hired a Japanese gentleman that lives in Australia to help us compile the research, and to translate books and to collect photographs. And we brought a Japanese military expert over to work with the Japanese actors, and he said there was much more detail in our presentation of the Japanese than in any Japanese film. That they had kind of forgotten, like we all do if we are not reminded, fifty years later you kind of forget what it was like.

But we had this wonderful researcher who got so much information from old manuals and stuff and put together a book of research.

Most of our research I left at a museum at Guadalcanal because Japanese and American veterans and their families go over there often because a lot of Japanese were killed, a lot of Americans were killed, and they wanna go back and retrace the area where their relatives died . . . and they had so few resources there about the war that it seemed an easy thing to leave the materials that we collected there, including video tapes and photographs and other research.

EDWARD PRESSMAN

I think Terry's stature as a filmmaker is unique. I think most people who love film, some of whom are still at the studios, were hoping or waiting for the time he would direct again and would jump at the opportunity to do it. I don't think it was ever the fact that it was difficult for Terry to get back into the studios after *Badlands* or *Days of Heaven*, but simply his choice. And when he was ready, I think nearly any actor would want to work with Terry, and then with that casting and Terry directing, I think there would be a lot of studios that would want to work with them.

SEAN PENN

I think that I met Terry the first time through Emilio Estevez at Martin Sheen's house, when I was probably fourteen, maybe a little older, anyway I was a teenager. Then I got together with him in LA – I had put the word out to him, I think probably through Mike Medavoy, that I was an enormous fan and where was he? I was eager to make a movie with him.

And then I was driving through Texas at one point and I gotta hold of him and we went and had lunch and I told him, 'If you are going to do something, let me know: I'll show up.' Then not long after that, I guess he was starting to get interested in

making a movie again. He had written something in which Mike Medavoy was involved, so we got together and talked about it.

GEORGE STEVENS, JR

One of the facts that made possible the making of the movie was that many good actors wanted to be part of the film. So we were able to cast it with enough stars to assure 20th Century Fox that it would be a picture of some importance. Sean Penn was very important in this process; Sean is the kind of person who, when he believes in something, he totally commits to it. He believed in Terry and he wanted to be part of this, he was very true to the project.

I think that was one of the things that made Terry more comfortable with the situation, so that he became confident that he could do a good job and decided to do it.

SEAN PENN

I think that in the reading sessions Terry was interested in getting to know everybody and looking for the balances of who was going to play who, and he was investigating his own material at the time. Before other actors were involved, he asked me early on which of the characters I responded to: there were a couple and I just left it to him. He decided on Sergeant Welsh. As I look at it now, every part in the script had an interesting journey that was going on.

I went and sat down with various people, I was there to sit down with whomever Terry wanted me to sit down with, or talk to, and I did talk to Terry about a lot of actors.

And after they would be involved, it was going to be difficult for everybody because no one was going to get any money out of it. They were going to be there for a long time and it was a difficult movie to get financed – so Terry needed some names that would enhance the value of it to the financiers. So I suppose my coming on board initially set a tone for this sort of career suicide that it was going to be, as we were all going to commit

an awful lot of time, it wasn't just the time shooting. We didn't really know when it was going to start shooting so it was like a blind commitment; you had to keep the time open to do it, not do other things.

JIM CAVIEZEL

Sean and I met on a film called *The Hi-Lo Country*,[9] Stephen Frears was directing it. At the time it was the furthest I had ever got on a movie: I thought I might get this one. I met Sean in Arizona in his hotel room with the director Stephen Frears and so we got to know each other. We got talking and then I told him how much I was affected by the movie he had just done called *Dead Man Walking*.[10] That film really stayed with me, so I was asking him about it. After that was done, I went to the restaurant and he was in there with Billy Crudup and we were drinking some shots together and having a good time. So that was the beginning of the whole film thing, because when Terry met with Sean, Sean mentioned me to him for that.

PENNY ALLEN

Terry had an idea of who he wanted for the character of Witt and he and I would watch the tapes of these actors. His casting woman, Dianne Crittenden, auditioned lots of people and then we would watch all the tapes and I saw Jim Caviezel's tape and I was blown away by this young actor! I have not seen talent quite like that in a long time. Terry was looking for new, young, unknown people – or people who had had slips and falls in their careers which left them with a kind of humility again, this kind of power in the humility, power in the fall, both of a career and inside somewhere, that left them so vulnerable, in a way that's so right for this world that he was creating.

JIM CAVIEZEL

I originally auditioned for the role of Witt. I had a good meeting with Terry and a couple of days went by and they had me come

in again to audition for the role of Staros, which used to be called Stein. When I walked out of the audition they said that Terry wanted to meet me. Maybe next day or two days later, I went into this big house where he lived. I didn't think that I would get the role because there were so many more famous guys who wanted the role and I felt like I needed something unearthly to help me – I felt like a lot of us do.

It was a revelation to me, because I was a basketball player and all I ever wanted to do was play in the NBA. But I wasn't given the gifts, I had to work very hard for what I have. I just took that work ethic and I applied it toward acting and that voice that was calling me to get into the acting profession led me eventually to this moment in time, to do this movie. When I met with Terry, I think he knew I felt uncomfortable because I had put myself out on a limb by giving his wife a rosary and I felt: 'Well, I just blew that audition.'

But he immediately tried to find a place where we both came from and made me feel comfortable around him. What impressed me about him, as I have gotten to know him, is that he has an extraordinary gift: Terry Malick has a mind that is extraordinary but he also has the gift of humility.

PENNY ALLEN

What I find in working with other directors, is that there is a sort of odd, love/hate, jealousy, Svengali[11] kind of relationship with actors.

With Terry there's nothing like that, it was about how much can I perceive this actor as a human being? – not as an actor! As a human being! And then how can I elicit that degree of humanness in a way that maybe I'll just have a stain of what I need? It was as though he treated actors with this reverent sense of humility for the human being, not as the 'prestidigitator', as a magician. It is so much about being able to bring the human colour of spirits, like a painting, to have people vulnerable enough to do that, as characters. The character is already written out, is

clear and yet in film there is so much more as there is so much more in life, and I feel he wants to make that an element of the film, making it as a living thing.

JOHN SAVAGE

He makes you feel a relationship to simple events, to simple human events! He captured the human quality beyond the character, the feeling of people. He had groups of people working, lots of different people, and some of them came across with their individuality as human beings, just as you or I.

JIM CAVIEZEL

When Terry offered me the role, he did it over the phone. He just called me up and said, 'I like you . . . I like you . . .' and I wondered why he was saying that. It took him a long time to say it and he finally said, 'I'd like you to play the role of Witt . . .' And I said, 'Are you saying that you would like me to play the role of Witt, but the powers that be out there, they are not going to allow it to happen?' And he said, 'No, no. You're Witt, Jim.' And I replied, 'Well you won't be disappointed.'

Elias Koteas, a Canadian of Greek origin – who had already played important roles in The Adjuster[12] *and* Exotica[13] *by Atom Egoyan, and in* Crash[14] *by David Cronenberg – was a rather atypical actor. He was chosen to play the part of the captain. In the book the captain is the American Jew Stein; in the film he became the American Greek Staros, embracing the origins of the actor. The figure of Captain Staros, an officer internally tormented by the responsibility of sending his men to die, who strives to bring his ethics onto the battlefield, initially seems quite far from the roles played until then by the actor. However, Malick saw in his personality something that brought him close to the character.*

PENNY ALLEN

Elias was an actor that Terry did not know beforehand. I worked with Elias, he was so extraordinary in *Crash*, and in the under-world things where he played the devil! So you can see how it affects him to play a leader of men, like with what happened with John Savage.

Elias is really an extraordinary actor and Terry turned his character Stein, who was a Jew, into a Greek, Staros. There is a scene of him praying that is much more powerful than him jumping into the pit! There's Elias in the tent – all of that's gone, it's not in the film[15] – he is stripped down to the waist, sweating, in the heat and he's got the candles up. He is praying in Greek and I feel it's so powerful and so Terry. The fact is that Terry was after something else which has to do with heritage, with what we bestow on one another, on our brothers, on the people that we kill; there is a lineage of violence and rebirth that takes place. And Elias is also very religious which Terry didn't know! I don't know how Terry knew this, but it's what I mean about how instinctive he is.

ELIAS KOTEAS

I auditioned a couple of times and I got the part, in the trad-itional way.

I had gotten the script about three months before. Penny Allen gave me the script to read, and then she told me that they couldn't find anybody for the part of the captain. So I read it. It was really very thick and I was going, 'How am I going to get through this thing?' And as soon as I read it, I thought that it was a good script, even if it was huge and I knew it was gonna be really difficult. Just the idea of trying to be honest and be present, trying to portray that kind of life as a soldier, to me it was like, 'No way!' I didn't wanna do that. I'm not an army guy, I didn't know anything about it and I didn't wanna go. Then, ultimately, you find out who Malick is and who's involved and the enor-mity of the situation, so when it lands on your lap, you couldn't

run away. At the audition I knew that Sean was involved, that Woody Harrelson might be involved. Nobody I knew was in the film.

SEAN PENN

I have never been able to read a script with this many characters in it, and understand it. I did this movie on faith because it's Terry Malick. I went through it, didn't know who anybody was, four different, five different times, and I gave up, and then just concentrated on what my guy has to do, and then I had to give up on that also, because it was going to change, and so for me the approach was really to give him a sort of blank slate to write the character with in the way he scored it, in the way he juxtaposed scenes and to allow things to be as movable as possible, in terms of the character that I was playing. So that I think it's probably a different experience to what Martin Sheen had in *Badlands*, which is a simpler story to tell, a simpler story to read. This one was massive.

ELIAS KOTEAS

My first impression was that the script was gonna be enormous. I read it from the point of view of the captain, so like Sean I couldn't relate to the whole thing as it was so huge. To me what came across was how thankless the job – the part of the captain – felt. His men weren't behind him, they didn't really believe in him until something happens that turns these men around. So, I felt that it was a really thankless role, you gonna get beat up, you gonna get fired, and you gonna get sent home. So, I thought, 'Where's the joy in that?' just on a visceral level.

I knew it was gonna be huge and it was gonna be tough, and it was going to demand a lot from everybody. It comes down to whether or not you feel like doing it. So, initially, I didn't wanna get involved.

PENNY ALLEN

Elias was cast quite late. He is terribly shy but also marvellously articulate, very much the artist. He needs enormous preparation and needs a strong character. And so he kept looking for a character but Terry kept taking away that need! So it left him exactly where the character is at! A misfit, not particularly liked by his men, not a particularly good leader, which then allows him to become a wonderful leader and someone who the men truly love. So, Terry was able to get that from Elias, by putting him into that position.

Before any of that, I just felt that Elias not only gave the best reading for Stein, but he had a kind of closed-off aspect, an unavailable aspect that was very right.

I felt that Elias was going from these underworld characters to someone who was open, straight, doing their job, going by the book, would enrich and begin to balance this wonderful talent that was interesting and unusual, and obtuse, and strange. I felt that his career could never break that pattern unless he were to really create another side of himself, which he did.

ELIAS KOTEAS

Penny Allen was the one who was involved with Terry from the beginning – with my thoughts and ideas. We spent a week before I got shipped out, working on what it's like to think in terms of being a leader of men, knowing how to handle a weapon, and going through the dialogue, just on a surface level. So, it was valuable as a way of opening up doors, because I was working on fear. And I needed her to somehow take all that fear and channel it; if it was all over the place, it wasn't going to go anywhere. So, it was just about centring and seeing: 'Okay, what's the task at hand? Concentrate on what you need to do.'

> *Pvt Bell (voice-over)*
> Well, where is she now?
> She's home.

Why should I be afraid to die?
I belong to you.
If I go first, I'll wait for you there.
On the other side of the dark waters.
Be with me now.

BEN CHAPLIN

I always wondered why Terry cast me in the movie because I was
the only Englishman. He always felt that I had a 1940s quality
about me that he wanted in the film. I know that because other
actors would come to me and say, 'Terry says you have a good
idea of the period.' And I was like, 'I'm English, I don't have a
great idea of America in the '40s.' That's something that Terry
saw in me; I don't know what it was, a gentleness or something.
Was it a Malick intention? This is something he mentioned well
into the shooting. I always thought that Pvt Bell's love for his
wife was real and genuine, whilst Terry felt it was romantic
love and therefore not real love. So he felt that the relationship
between Bell and his wife was a slightly childish one, in the
sense that he would grow to find a real love later on. I was quite
shocked when he said that, I felt that this was the real thing.
I remember he said real love is not romantic love, it is deep
friendship.

PENNY ALLEN

I had been working with Ben already and I was going to meet
Terry.

 Ben and I walked out of the workplace together and he met
Terry and the two of them just lit each other up. Being English,
Ben wanted to learn the right accent. Then there was the whole
element of the love relationship. Ben had such a thing with
being the 'pretty boy', so he didn't want people to see him as
the pretty boy; he wanted people to see him as the wonderful
actor that he is.

The Years of Absence and The Thin Red Line

BEN CHAPLIN

It was a long process just in getting there. I was in LA and I remember I had a general meeting with Mike Medavoy, and this was probably about six months before I finally met Terry for the film. I turned something down that he had offered me, an English period piece, and he said, being a little sarcastic I think, 'Anything that could interest you that I have?' And I said, 'Well, I heard Terrence Malick is making a film.' It was unbelievable in itself that Terry Malick was going to come back. He sort of laughed because I think it was a preposterous idea of me being in that film because it was all about American soldiers. But, you know, nothing ventured nothing gained. And I heard nothing about it for months. And I think by then Terry had seen so many people that he started seeing non-American actors. And I got a call from my agent: the casting director Dianne Crittenden wanted to put me on tape for *The Thin Red Line*. And I remember thinking, 'Wow! I am auditioning for Terrence Malick!' And I put something on tape, from the film, a speech. After Terry watched the tape, he wanted to meet me. So I met him in the kitchen of this great huge Beverly Hills mansion of a friend of his. And we just talked, we didn't talk about movies really, we talked about theatre, he wanted to talk about England, stuff like that. Then eventually he got me back in and auditioned.

My first meeting was with the casting director only, my second meeting was with Terry only, my third audition was with Adrien Brody and Henry Thomas. They were both auditioning for a role. I know Adrien Brody read for many roles, and Dash Mihok too. Most of us read for more than one role. I read for a different part, I read for the part of Witt, the role James Caviezel ended up playing. And that went on for a while. I went in two to three times for several hours and read with other people who were auditioning mainly for the role of Fife, who actually isn't in the finished movie very much at all. I never read for anyone else, although he was considering me for Staros, who in the script was called Stein, Elias's role. He considered me for that role also.

SEAN PENN

I think there were twelve or thirteen people pretending to know what the script was about or maybe that was just my experience. But I think he is one of those directors that if you love his work, like I do, then you kind of jump on board this train and you don't ask where it's going. You can ask where it's going but it doesn't help: it's not a destination where you have been before.

BEN CHAPLIN

Terry liked me, but he finds it very difficult to finally decide about casting. It's always a work in progress for him. So, for him, the final decision of casting somebody is cutting himself off from thousands of other possibilities – which he never really wants to do. He's always open to suggestion and persuasion. So, I remember a session where I was improvising with Terry. Terry was playing another role, he was acting. And then I didn't get that role. Jim Caviezel got it.

Then I was back in England and Terry kept calling me and saying he'd like me to be in it, but I couldn't come over and dig a hole, be simply one of the soldiers. And I said, 'No, I'd love to be in it but I want to play a role, something I could get my teeth into.' I was a bit arrogant, really. He kept ringing me and in the end – over weeks – I had to say, 'Look Terry, it's upsetting for me because I really wanna be in it, but unless you are going to put me in it, stop calling me because I wanna let go.' And then I ended up playing Bell. I never really thought about playing that role, I don't think he thought of me playing that role. The person who was playing it fell out, I think, and he rang me up and said, 'Would you like to play Bell?' and I said yes immediately even though I didn't even really remember the role. And that was the start of a long adventure. But it was a long process of at least two months. Because it was a dream, I was desperate to be in it.

PENNY ALLEN

Many of these boys went into this heritage thing in relationship to their fathers. I just found it fascinating. Ben did it too in an odd way, with the whole love thing with the girl, and the giving up. It certainly was a learning experience for me; in a way, I feel as though I haven't stopped learning from that experience, and it's been some years since I worked on it, and yet the learning process is as alive right now today as it was back then. It's intrinsic to all of his films – they resonate further than the actual film!

JOHN SAVAGE

I'd met Malick a few years before but I've known about him, outside the film business, through documentary film work in Africa. I'd worked with Community Film all through Africa. He was in Kenya and produced a wonderful film, *Endurance*,[16] about someone from a small community in Africa. I'd known of that film, and I'd empathized with it. And we talked in Texas a few times.

So we kept up a dialogue about my experience with my father and other people in the military, growing up, and about Guadalcanal. It was a small island and didn't have a lot of people there. My dad, a sixteen-year-old gunner sergeant in the Marine Corps, was separated from his squad by a few hundred yards. He didn't have any contact with the other marines for a while, for several days, until the army landed and sought out people.

My dad had a family with a military tradition; I remember his dad was in the military too. They didn't have a lot of money, they got through the Depression and being in the military was a way to make a dollar.

I saw a book of pictures that was found at the location that his unit was in. Somebody had taken those pictures, not him, someone who didn't have much of a family – and he kept them.

PENNY ALLEN

My husband is magnificent. He likes to hold court in the coffee shops down in Santa Monica and we're sitting outside, because

he doesn't feel like he's in a wheelchair then and people don't even recognize it. We're sitting there and John comes by and he has photographs of his father. And we began looking at them in the coffee shop. When John looked at those photographs you could see his identification with his father: his ears stuck out! And John said, 'Look! His ears stick out,' and they looked the same. Some of the pictures were filthy and others were cleaned up. You could see them as ten years old, as twelve years old, as seventeen years old, a seventeen-year-old gunner – it was awesome. All John did was look at that photograph and he became that! That's when I knew, no matter what, that he had to get over there!

JOHN SAVAGE

I still see men in their late eighties now who have had mental difficulty. They're still functioning as human beings, but they have memories – in Guam or other places – of walking through body parts before getting to the beach. My dad did that and he never spoke about that but he never had a night without a nightmare. So as the second generation, we wanted to give some homage, some honour to that. This was, I feel, what we all wanted. For me, it was coming round from a different place, a cycle from the Vietnam War, with *The Deer Hunter* – it was the same thing, wanting to pay homage.

I think that the movie should be made just because I felt that the generation that brought me into this world deserves some honouring specifically in that area. I will never understand but without my dad surviving that, without friends of his going through that, I don't know if I'd have been around; so I was there because of his survival of that experience in Guadalcanal. I believe that it was his training in the Marine Corps that got him home, something I couldn't do that way. So, to be put in a place to do something to honour that sacrifice that he gave, and other people gave, I was overwhelmed by that.

McCron
Show me how to see things the way you do.
Show me how to see things the way you do.
We're just dirt. We're just dirt.

PENNY ALLEN

One thing that Terry did with John was in relationship to the spiritual aspect that he kept looking for with everybody he hired. When I say spiritual, I do not mean religious; I mean the human spirit. I mean the contribution of the inner life of the human being and of the character, because Terry has this wonderful relationship with acting in that he doesn't want acting! In other words, I knew John ought to be in this movie, so from the beginning I'm saying to Terry, 'Terry, you've got to use him, by hook or by crook! This is the raw material that you want for your vision.' He said, 'I don't know what part . . . I don't know what could he do . . .' I said, 'John Savage can do anything!'

But John, being very shy, needs the mask of a character. Some actors, some instruments need the mask of the character. Look at the characters he's played; they're all quite different with the exception of a certain emotional rise, that for my money directors take too much advantage of or not enough of.

JOHN SAVAGE

A lot of folks, even people with military training, can't handle the military experience at all: they are still in the hospital. Their growth stopped at some point, watching people die; or their growth was so shocked or so stunned at this possibility in their life that they couldn't figure it out and their brain said, 'No more. You can stop now, just stop.' And some of them lived, some of the men could stand up in the middle of oncoming shells and bullets and not a scratch on their body. Were they sane to do that? Were they insane to do that? They led men? In all honesty, I wouldn't follow a guy that is going to stand up with bullets coming in like that if you paid me a million dollars! But I was

a leader on film. I was a sergeant and I had to lead men and I didn't get hit! All the people I believed in died in the blink of an eye.

PENNY ALLEN

You know the story of Mickey Rourke? He's not in the movie at all! But Terry and I both wanted him desperately on the film . . . He did some unbelievable scenes . . . I worked with him and Thomas Jane. But so many of the people Terry would bring in, he didn't know how he was going to use them, like with John Savage. He knew that somewhere these were the colours he was looking for, so it was like a painter or somebody who's in touch energetically with something, rather than a particular conventional look or the conventional army. He didn't say this guy is a 'leader of men' and this guy is a 'wimp', like in so many war movies. He was daring enough to say, 'I'm not sure how I'm going to use him.'

JOHN SAVAGE

It's the best place in the world to be but it's the most difficult, being with people that support you by giving you that space. That's why I appreciated that there wasn't a clear structure as far as scripted characters for all of us.

I went through the process of going through casting but it was more than that, as far as being chosen, it was a gracious place of preparation for everyone.

The preparation of a movie has become so businesslike and politically oriented that you don't get the sense of being a part of it from the beginning.

If I wasn't chosen for a part, at least I did my bit, if I go for an audition or a reading and they're going to make their movie I had my place, but the idea of being part of a developing process from the beginning to the end is different. It's a creative process and I felt that because of Penny's involvement and because of Terry's creative energy, he leaves that open in a wonderful way.

One of my problems with my passion is that I try so hard to get hold of a fact or get clarity and it becomes more and more murky to other people as I try to explain things.

BEN CHAPLIN

I don't think he wants actors who are going to try and control situations. Terry is the director and that's it, that's final. He's not a dictator, he does control but in such a very gentlemanly way that you don't even know it's happening. I think he doesn't want any star baggage. When a star comes onto a film, they can bring their personality, their celebrity with them, and I don't think there's any room for that in a Terrence Malick film. Plus, he's very humble himself, so, just on a personal level, I think he prefers to work with people who are humble.

PENNY ALLEN

Terry was seeking a spiritual core, not only to each actor, in each character, but he was seeking it in terms of the heartbeat of the movie – a spiritual search in the face of destiny, or fate or life or death or whatever. It's rare that a director or a moviemaker desires that in a war movie; they go right into the convention of Death and God! But Terry's originality is that he goes into those special little human ways, how the human spirit really stays alive amidst the horror.

SEAN PENN

I haven't met a non-desperate character on this earth, in some way . . . People are trying to balance their mortality, against their fears and their sense of themselves as men, as Americans – all of that stuff that's dealt with in *The Thin Red Line*; all that balancing against the mysteries: 'Is there somebody up there, is there not?' And short of the knowledge of that, there's some desperation. And war is as desperate as men can get. So, certainly, if there was a criminal in *Badlands*, there was certainly a criminal in *The Thin Red Line* and that was War, War itself.

PENNY ALLEN

I worked with Ben Chaplin, Jim Caviezel, Elias Koteas, John Savage, Nick Stahl, Will Wallace, and Adrien Brody. Terry said, 'We have to be as cunning as a serpent and as gentle as a dove.' As an artist, the way he worked with actors was different. With John I didn't realize he was there for such a short time, I only just found out today! Because of the way that Terry talked to me about him, I would have thought John was a star in the movie! It's that kind of ability to enter fully into the actor, the human being even with their resistance, not so much with John, but many, many times, a director will deal with an actor and the actor will resist, it's almost part of the excitement.

The question is 'How am I going to get out of the actor the kind of performance or colour that I want?' But even if Terry thought that, he couldn't even think that way, it was as if he was able to put that human being in a situation and even if that actor resisted, the very resistance was right for the moment – which kept it alive, in a different kind of a way because, in some odd way, it was almost as if he were embarrassed by actors.

BEN CHAPLIN

I am sure it was the same for everyone on it. Everyone there was experiencing loss to some degree. It was a very individual, together/alone film. We were all together but we were very much alone. We were given glimpses of that loneliness.

BILLY WEBER

He does care about the human qualities of the actors – but I don't think he has yet developed the way to get that out of the actor by talking to them. It's hard. He talks to them and he tries to convey to them what it is he wants, but it's all very intellectual, very literary, it doesn't necessarily get into what the actor needs to do it with. So it's not that it makes it harder for the actor, but it doesn't feed into what it is they need to do to get what he needs. He gives the actor lots of leeway, a lot of room,

but it's hard if he is the kind of actor that doesn't want room, but wants specific direction. So I think like from Elias Koteas you'll get a great response – he'll love the way it went, and Caviezel would love the way it went, but in a sense, they're undisciplined actors. Nick Nolte doesn't need a director to tell him what to do with a part, neither did Sean Penn. But all the actors in between those two groups need specific directions, need someone to put them in the place they're in and ask them questions that relate to their character and that's hard for Terry.

PENNY ALLEN
Terry called me in and asked me to give Jim Caviezel the gun – which I did. He asked, 'Will you work with him?' Of course I will work with him!

Jim is a wonderful athlete, so we'd be running up and down doing lines, while he was dribbling the basketball, talking about relationships. My coaching with Jim was extremely physical! Catching my breath, I'd say, 'Stop! I have to sit down now, Jim!' And we would sit and laugh and begin working again. This would get him out of his habitual patterns. Many young actors get into certain habits of expression that have to be shaken up, out of the groove.

We worked very hard and the performance was breathtaking. He was completely changed, and it broke my heart in a way!

Pvt Witt
I remember my mother when she was dying.
Looked all shrunk up and grey.
I asked her if she was afraid.
She just shook her head.
I was afraid to touch the death I seen in her.
I heard people talk about immortality,
but I ain't seen it.
I wondered how it'd be when I died.
What it'd be like to know that this breath now

was the last one you was ever gonna draw.
I just hope I can meet it the same way she did.
With the same . . . calm.
Cos that's where it's hidden –
the immortality I hadn't seen.

JIM CAVIEZEL

At the beginning of the film you have a character who says, 'I remember my mother when she was dying, she was all shrunk up and grey and I was afraid to touch the death that I had seen in her.' Many times in our lives we are all afraid of death and most of us don't want to talk about it, or be near it, but we are all going to end up there some day. What happened to him was that living with the natives on the island he saw beauty, peace and love; he had received grace in his heart. And that grace equates with God and the grace filled him and made him. But he saw something greater in Heaven than he did on this earth, that there's another life out there, that you can start living in heaven now, even in hell, and war. And that was a gift that was given to him and that grace keeps growing in him because he keeps finding ways to save men. He wished he'd saved his mother and was afraid to touch the death that he'd seen in her, but now maybe he could make up for that, which is why he is always trying to save people and trying to find ways to love them when others don't. It's easy to love people when they love you – but what if they hate you? Love your enemies . . .

PENNY ALLEN

Jim is very religious. I worked in relationship to the spiritual being of every boy that I worked with, but I just felt it so strongly from Jim.

I think that the way into the innocence that he was looking for relates to the way one deals with faith or what we hang onto in the moments of heightened reality, such as life and death.

With Jim it was different. We'd have terrible fights. I'm not

steeped in any religious background and there are many horrific
things that have been done in the name of Christianity, as in the
name of any religion that I know of. Jim was steeped in this, so
part of what I had to break through was to get him to be less
judgemental, so that the character could discover his spirituality,
rather than already own it. In an odd way, you see it in the film.

I don't know if Jim knew that's what I was doing. There are
parts of people's faith that you don't know anything about. I had
to get to him on a visceral level, not up in the head.

You do all different kinds of exercises, different for each per-
son. Sometimes physical exercises, sometimes simple relaxation
will open up an instrument, so that it's not bogged down in the
literal dogma of one's own personal faith, so that there's room.

BILLY WEBER
At the beginning, the character of Witt was more aggressive, but
we really felt like he should be almost Christlike in his behaviour
and that Jim needed to learn something in the process. It was bet-
ter to start the story with him in the paradise of the Melanesian
island, in innocence, and then put him into this other situation.

JIM CAVIEZEL
There were things I didn't understand when he was asking me,
like when Colonel Tall (Nick Nolte) was talking, he'd say, 'Look
kindly on him.' And I would say, 'I wouldn't, Witt wouldn't look
kindly on him because he didn't like him!' I just didn't under-
stand where he wanted to take the role of Witt.

MIKE MEDAVOY
I found the film to be very poetic, very religious: you almost have
a Christ figure giving up his life for everybody else, for the rest of
the guys. I thought it captured World War II in that venue very
well. And, well, for me that character is Terrence Malick.

JIM CAVIEZEL

I worked on the character with Penny Allen. Terry was spending much of his time in Australia so he didn't get to go over the character with me, but he wanted me to do two things. One was to be inclusive with the character, to take in everything I could, because he wanted to change directions with the role of Witt. The other thing was he wanted me to go to Kentucky to spend time with the people where the character was from, so that it could give me a real centre of what this guy was about.

So, I went to Kentucky for about a month and spent time in the Black Hills where they are a whole different kind of people. I also spent time with men that had fought in the Second World War who were from the same area of Jackson, Kentucky and got to listen to how they spoke. Their accent was real hard and that was how Witt's voice originally was. When I got down to Australia, we shot a couple of scenes and Terry said that he didn't want him being that hard, but smoother – like I'd been away for about five years. That's how the voice of Witt came.

When you have Witt being from Kentucky – not just from Kentucky, but from a specific area and not just that specific area, but with a couple of people from that area that have a strong belief system, it gives you a strong point of reference. So that when you pull away from that, you have a base to go back from, to pull from. The guy I was around when I was in Kentucky was named David Marcus. He still had opinions on things, but he used them more in a holier light.

Initially when I met with him, I didn't have any plans to spend time on a farm with him, but as I got to know him, I thought this guy is kinda like Witt in the book. And then I had to understand why he was like him, so it took him a while to warm up to me. He was reserved. He's a guy who worked till about 12.30 a.m. and then woke up about 4 a.m. to get his cows milked. He only slept three or four hours. He was in charge of a lot of cattle, from a lot of the owners' cattle. When they are breeding he had to get them bred, the shots and all of the things he had to do;

there was not so much time for him to rest. And I went to the Baptist church with him. Then I took time out of the day to meet and put on tape a group of about six men who had fought in the Second World War, so I could understand where they were coming from.

JOHN SAVAGE
There was something about Jim which looked like my dad at that age. They call it 'the thousand-yard stare' because once GIs are in that kind of situation, you don't get a lot of sleep. You just get that spacey look about you.

You try to keep a regimen in your life at this point, keep your teeth clean, wash your face, simple things mean a lot. God, no one really knows what it is, but it really helps to just have that.

BILLY WEBER
In the first 250 pages of the book there are the thoughts of every soldier as they're marching through the island. So we had a sort of a version of the movie like that, where it was a long time, maybe an hour or hour and a half, before you got to a battle – I think now, it's maybe half an hour before you get to it. We realized we couldn't be so faithful to the tone of the book. That's why the opening scene, the first ten minutes of the movie, the one with Witt and the natives, ended up like that. It was intended to be after they arrived on the island and Witt deserts and goes and lives with the natives for a while and then comes back. But it seemed like we didn't have a shot of Witt deserting and it felt like it was going to be too episodic if we did that. Moreover, the footage on the island was so remarkable that to open the movie with that made it more mysterious and also more interesting.

BEN CHAPLIN
In all Malick's films there's almost this question about original sin. Do we have this thing in-built, this ability, this desire to kill, to destroy what's around us? How can we maintain an innocence?

To a certain degree, they are all about the loss of innocence. And that loss of innocence is inevitable as soon as a child learns to speak. It's like the garden of Eden with the apple: if the apple's there you are going to try it. I suppose that's what his films share.

HANS ZIMMER

I was very conscious of the role of nature in the film; the movie for me starts off with the question Terry asks: 'Why is there a war in nature?' Why do these very civilized guys – what we called civilized guys – want to go off and kill each other? Then there are the Melanesians. The simplicity of it. Nature and the Melanesians take the possibility of cynicism away by having this pure world. But it's not easy: paradise is not fun, it's still a struggle, but a different struggle, a struggle where you can leave ego and all aside. I was trying to not have these different forces cross each other, I was trying to say they just 'are'. Everything influences everything, everything is a mystery and everything is a question, but isn't it great to have different things unanswered, different cultures and different point of views? Isn't it great to be part of the grass, part of the coconut on the beach? If anything, the music was playing from the side of nature. If I had to take any side, I could never take the side of the men so much as the side of the nature.

JACK FISK

We couldn't shoot the whole film in Guadalcanal. The studio was going nuts because you would have two hundred filmmakers on a little island where there was not enough room, so we ended up looking for another location. We went to Fiji, a place I always thought I would enjoy, but I didn't like it because it was so civilized, there were so many human elements in it – things that were not present in Guadalcanal where they lived in the jungle in grass houses and walked barefoot.

Then I went to look at locations in Costa Rica and Panama. They had jungle, it was close to the studios, it was the same time zone, and it would have been real convenient to shoot there, but

it didn't have any of the ambience or the character of the real place, of Guadalcanal. Then an Australian location manager, Mary Boyd, found it in Queensland.

JOHN TOLL

We didn't want to work in Guadalcanal for all of the same reasons that you wouldn't want to go there during a war. There's still a 50 per cent rate of malaria, and it just wasn't feasible logistically if we wanted to have the kind of technical support we knew we'd need. It's still a bit difficult to get on and off the island, and we had some scenes that involved two hundred or three hundred extras. We would have had to bring everybody to Guadalcanal and, financially, it just didn't make sense.

The real battlefields depicted in the book basically consist of grassy hills, and we began looking all over the world for that type of terrain. When we went to Australia, which is just a thousand miles from the Solomon Islands, we found the same types of terrain – beaches, beautiful coral reefs, and grassy hills on the north coast near Queensland. Australia also has some great crews and resources, and a good lab, Atlab, right there in Sydney. It made an enormous amount of sense to shoot there. I still knew a lot of people from my experience on *The Wind*,[17] such as gaffer Mick Morris and key grip David Nichols, and many of them were hired for this picture.

JACK FISK

It was amazing. Queensland looked just like Guadalcanal, the jungle was very similar, but there were a lot more dangerous snakes there than there were in Guadalcanal and a lot more dangerous crocodiles. There was a cattle ranch right in the forest; John Toll always used to say, 'Wouldn't it be great if we did a film about a cattle ranch in Australia?' But we had to move the cattle, we had to get the grass – we ended up bringing the helicopters to fertilize the grass to get it to grow back up before the cows had eaten it all. We put some four miles of road through

the jungle to get to the locations for the main battles, and we shot there for a long time.

PENNY ALLEN

When I lived in NY I lived on the Lower East Side opposite a Jewish delicatessen with all those salamis hanging down and they still had a sign from World War II: 'Send a salami to your boy in the Army'. That's what I felt: I had so many boys over there in that movie! I felt like sending them a salami all the time, so I know lots of different instruments were going through this.

SEAN PENN

It became a lifestyle. It was a beautiful place where we were and I had my kids down there. I also think I had a different experience than the rest of the group: I was the old man there. A couple of guys like Clooney came up for a day, or Woody Harrelson was around a little bit, but even those guys are younger than I am. So there was me there, the old man, with my family. The younger actors were having the kind of experience I had had twenty years ago, of being for many of them on their first film and all of that. I can imagine, from their point of view, that it was a magical time, it was for me also, but much more specific: there was the working with Terry, and there was being with my family in such a beautiful place. There was also like a kind of deeper cama-raderie. That was a bit like my character, who was a bit separate, and so it worked out. I wasn't really as much a part of that mass experience as some of them were.

But it's great when you are going to work and a director is allowed time for all kinds of experimentation and all kinds of reaction to what the world brought. We all know how Terry is invested in his natural surroundings and that shows up in all of his movies. It shows up as a way the characters balance their own experiences, and it showed up in the experience of all of us in Australia, because I think he had deliberately chosen a place that was going to be separating people from their other life. I'm sure

that we could have shot the film in Hawaii, but it was too close for people to go home on the weekend, and it was too close for the studio execs to come over during the week. So, I think he had deliberately chosen a more remote place for all those reasons. It was a very peaceful time and a very peaceful way to make a movie.

ELIAS KOTEAS

There was one time where I and maybe five others were walking through Port Douglas. I think we were there just a week, we hadn't started filming yet and we are walking alongside this road and this car came barrelling down towards us, just barely missing us. So, I thought he was kind of a jerk and I pulled down my trousers and gave him a good look. He took offence to that, stopped and started speeding back towards us. This big guy comes out. Red. Drunk. With this big wife, same size as him. Screaming: 'Who the hell you think you are?' And my legs are trembling now, because I'm not a fighter . . .

So you had these five other guys there. Suddenly it was like as if we were 'the squad'. Everybody covered everybody. This one guy, David Harrod, he took it upon himself to say, 'What's the problem? If you have a problem, you can take it over there.' And the guy just calmed down and left. I walked away, my legs are shaking, but suddenly we felt as a group. That's when I started feeling that we cover each other's back, that we protect each other.

And that grew; each day, we had little experiences like that, that kept us together. And these guys, you'll love them the rest of your life. And that kind of closeness we had, it's all in the movie! And that's just a movie! I can't ever imagine what it would be like if you are actually a marine in that situation! Now you see them forty or fifty years later, still emotional, still in that. I could understand in my own little minuscule way the closeness. It's a special feeling.

BEN CHAPLIN

The core of us – we were there the whole time. It was the same as

an army: there were arguments, there was infighting, but mostly just camaraderie. And it was very male. There were not many women up there. We had to look after each other as well, as they do in the army. If you were really down at the end of the day, or very tired, or upset, you had to ring one of the other guys about it and talk to someone about it, because you couldn't ring your friends in America because the time difference was huge. We had to help each other a lot. It was a very powerful experience. It was lonely, it was isolated. I have a bond with the people from that film that I will never have from another film, I am sure. We were a big family and it was hard. There were days when everyone got on the nerves. We all lost it a little bit at some point on that movie. We all had a bad week or two. As in the line at the beginning of the script, it's the thin red line between the sane and the mad. And we were all a bit mad at times.

Most of the guys lived together. There were a few of us who were separated, a few in different areas. It depends on name value: there were guys who had the Jacuzzi, there were guys who had the shower, there were guys who had the bathtub, there were guys who didn't have anything! So, just like the army, there was a tier system.

I was lucky, I was in a hotel. I was in a slightly higher tier. We called it *chez*, as in *chez* Ben like French. There was *Chez 1*, *Chez 2* and *Chez 3*. There were tiers like the Sean Penns of the world, they were the top tier. I and a few of the other actors were in the second one and then there was the third one. I am pretty glad I wasn't in the third one because they were too many. I was in one with Elias Koteas, Jim Caviezel, John C. Reilly, Adrien Brody. We were in the same hotel for all that time!

And you are a foot soldier, you know. It was appropriate to the story: soldiers don't really know anything about their mission, they are just told to go there. And we were pretty much like that. Of course, we were all constantly trying to envisage what the film would be. But you can never second-guess Terry.

JIM CAVIEZEL

When I come to Australia I showed Terry the footage I did in Kentucky, what I had worked on, and started going through the character. Terry eventually started to modify it a bit, because Sean's character was very hard and opinionated – so we had to show clearly two different philosophies on how to get things done and so that way I learned Witt would probably have been more like Sean.

Pvt Witt
I can take anything you dish out.
I'm twice the man you are.

Sgt Welsh
In this world . . .
a man himself is nothing.
And there ain't no world but this one.

Pvt Witt
You're wrong there, Top.
I seen another world.
Sometimes I think
it was just . . . my imagination.

Sgt Welsh
Well, then you've seen things I never will.
We're living in a world that's blowing itself
to hell as fast as everybody can arrange it.
In a situation like that all a man can do
is shut his eyes and let nothing touch him.
Look out for himself.
I might be the best friend you ever had.
You don't even know it.

JIM CAVIEZEL

In the scene on the boat Welsh is about ready to throw the book at me and put me in the brig. That comes from the original Witt, he stayed true to that: he was proud, very strong, very angry, which comes from a weakness in his ego – he says, 'I'm twice the man that you are . . .' And then Sean Penn gives him that look, with that stance. Witt wanted to fight Welsh at the beginning; he was a regimental boxer, and Welsh loved that about him, even though he had to discipline him. He loved him because of the spirit in him, but at the same time, Witt is fighting the forces of darkness inside him, the darker side of his humanness, he was trying to understand that, to love all people and not just your own. We are all part of one big soul and part of God and I think that's what Witt sees. That's the best part of him and that seed starts to grow from there. It had been growing on the island.

At times, you do the right thing and every so often those little horns come out of your head. You might say something and then you think, 'I shouldn't have said that, it's kinda more like that . . .' Witt doesn't hate him at all, it was just pride.

It ties into that part where Welsh says, 'Witt, you're goin' t'all screw it up again . . .' Welsh has got orders he's got to obey, he's gonna do what he's told and I kind of stray from that and put him in a bad position. So he's going to have to stick me and discipline me and reprimand me and I say, 'You do what you want. I'm still twice the man you are, and I can take you right here.'

It was that kind of attitude and he knows I'd fight him. I'm thinking that he's putting me down in a second, but I realize that he has to do it. And if you remember in the next scene, there is Will Wallace, who plays Hoke, who says to me, 'He hates you!' And I reply, 'Well, I don't hate him.'

PENNY ALLEN

Terry knocked Jim so off-kilter with it being different scenes, different dialogue, different relationships. Originally, Jim's character

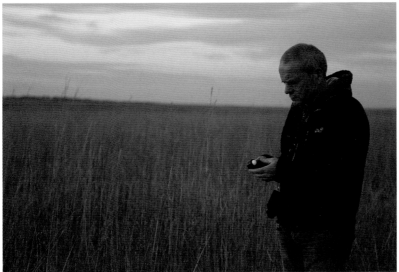

A still from *Rosy-fingered Dawn: a Film on Terrence Malick* (courtesy Citrullo International)

Cameraman and second unit DP Joerg Widmer on the set of *To the Wonder* (photo: Mary Cybulski)

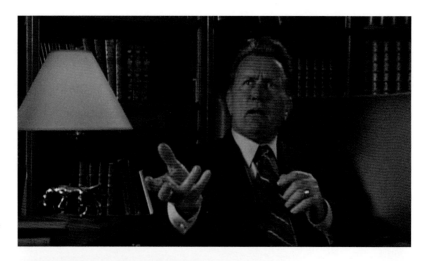

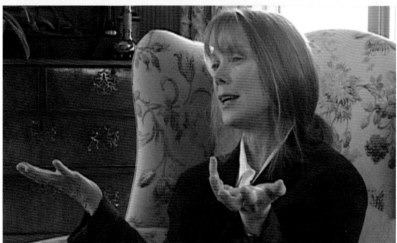

Actor Martin Sheen (top) and actress Sissy Spacek (stills from *Rosy-fingered Dawn: a Film on Terrence Malick*)

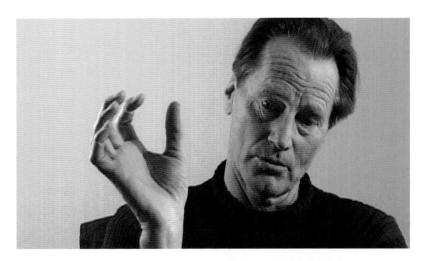
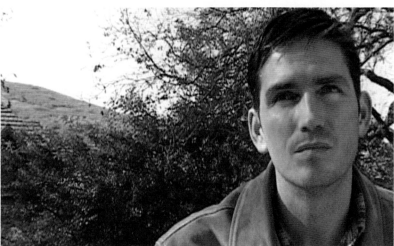

Actor and writer Sam Shepard (top) and actor Jim Caviziel (stills from
Rosy-fingered Dawn: a Film on Terrence Malick)

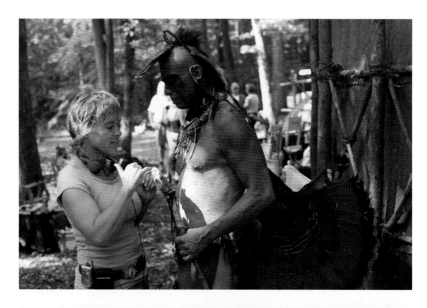

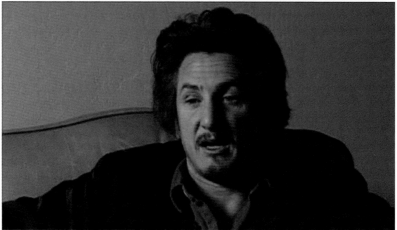

Producer Sarah Green and actor Raoul Trujillo on the set of *The New World*

Actor Sean Penn (still from *Rosy-fingered Dawn: a Film on Terrence Malick*)

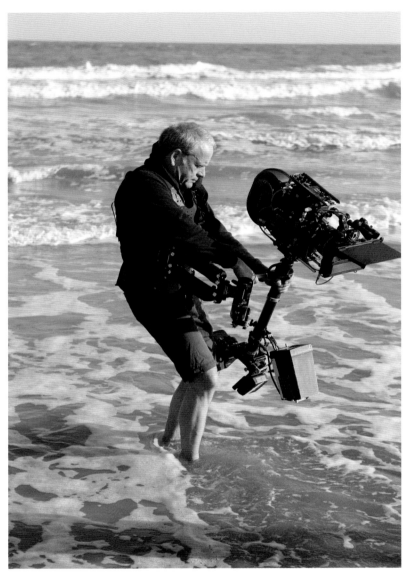

Cameraman and second unit DP Joerg Widmer on the set of *The Tree of Life* (photo: Merie Weismiller Wallace)

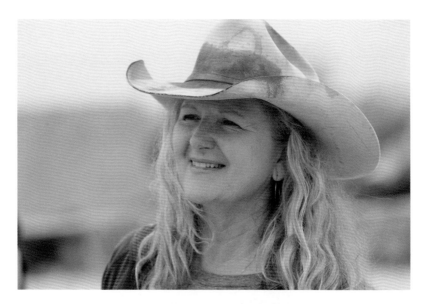

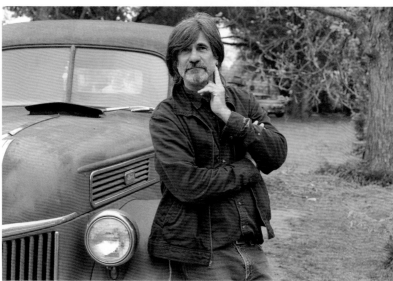

Costume designer Jacqueline West (top) and production designer Jack Fisk (bottom) on the set of *The Tree of Life* (photos: Merie Weismiller Wallace)

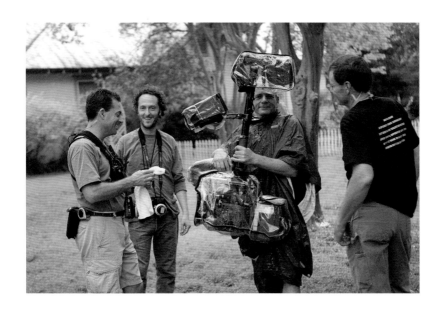

On the set of *To the Wonder*: (top) focus puller Erik Brown, DP Emmanuel Chivo Lubezki, cameraman Joerg Widmer, key grip Donis Rhoden, and (bottom) DP Emmanuel Chivo Lubezki (photos: Mary Cybulski)

Producer Nick Gonda on the set of *To the Wonder*
(photos: Mary Cybulski)

was man dealing with God! And Sean's character was dealing with man!

> *Sgt Welsh (voice-over)*
> Only one thing a man can do.
> Find something that's his.
> Make an island for himself.

PENNY ALLEN

That's the island, that communistic, possessive idea of life. Sean talking about ownership, about what you know, what you possess, the space you take up on this earth . . . Jim's character was in relationship to this, so that those two balanced one another and so ultimately in the script that didn't exist. You felt that subliminally that there was so much of Terry in that. You can't hit it on the head, which is so beautiful!

ELIAS KOTEAS

At first when he changed Stein to the Greek Staros it was a little disconcerting, because you felt that you weren't fulfilling something. But then you find out afterwards that he really looks at what's special about each person who he's cast. So why not take advantage of my own heritage, something that I was aware of but, first of all, something that he was aware of? That's Terry's genius – to really see what's unique about each one of us and really try and home in on that. No masks, just peel away all the layers, just questioning: 'Who are you? What do you become when the shit hits the fan? When you see your shadow up there, when you see what you're made out of, when things *really* get tough, what kind of man do you become? What kind of man did Captain Staros become when it really was about what's right? How was I when it really got tough at two in the morning, or at two in the afternoon, or after lunch, and suddenly you have to be the guy that conveys all this horror?' Because it's in your face! 'What in my experience and my life is gonna prepare me to look

out and pretend that all my men are getting slaughtered?' So you hope to God, that on the day you remember your dialogue, and you trust Terry, that he's gonna put it in context.

PENNY ALLEN

Elias gets very, very emotional and because the emotion is so powerful it locks, like if there's too much gas. So a lot of the work I would do with him was learning that when it comes up, you have to release it in order to go on. Most actors are too embarrassed or shy when they are under the gun to do that. Most actors will try to accommodate, try their best, but Elias, God bless him, can't, just can't accommodate. The instrument really doesn't know how: it's beautiful, like an animal. So, he would let off. He shocked everybody – the other actors, the crew, the camera guy, and Terry. I guess he was flabbergasted, but Terry would back off. I had told Elias that in order to get the performance he had to keep on going, keep on with what he was doing until finally the character became 'there' for him.

ELIAS KOTEAS

There was one thing that Terry Malick had told me in the beginning that I couldn't really understand, until much later. I would tell him we needed a rehearsal – some kind of in-joke. And he said, 'Your whole life has prepared you for this moment.' I asked myself, 'What does he mean by that?' Soon I found out how much my own experience in life paralleled, was similar to – without the insanity, obviously – the captain's responsibility. Coming out from nowhere, being a reservist, being almost on the fringes. Then suddenly you're called upon to be a leader of men! And most of the time when I was there, all I wanted to do was to hide, have somebody else scream out the orders: 'I don't want to be responsible!'

As an officer you feel by yourself, and it was important to convey that kind of loneliness for a person who has this responsibility. So, you felt very alone, alienated from everybody. Hoping

you're making the right decisions. Hoping you're making the right *acting* choices!

So, when I'm trying to make a good acting choice, it's really the captain saying, 'I hope I fulfilled this mission, I hope I don't make the wrong move and most of my men get killed.' My responsibility was to these guys, but ultimately my responsibility was to try to appear very captain-like! So, it worked itself out.

> *Pvt Train*
> Hell, we're gonna be landing soon
> and there's gonna be air raids.
> We're probably gonna die
> before we get off the beach.
> This place is . . .
> It's like a big floating graveyard.

JACK FISK

The transport ship set was built on a tennis court in Australia. But the research I did was here in Virginia where I live, down at the Mothball Fleet in Jamestown. I went down and went through some troop ships that were used in World War II and then in the Vietnam War; they were old and they had been decommissioned so they were vacant: there was no electricity and you had to go through with flashlights and you couldn't see the interiors clearly. But I got the sense of the scale and the way they looked. They even gave me sets of plans for those original ships. So then it was just a matter of scaling them down for our uses. The great thing about a ship's interior is that people were confined; they were going somewhere that they didn't know. The ships used to smell terrible because people would get seasick and throw up and then once one person would smell the vomit, he would throw up, and it would just escalate. So the soldiers would try and get up and away from the many tiers of beds down below just to get some fresh air, but often it was either cold or hot or miserable up on deck. It was a terrible existence to get to an island where you

were gonna be killed. There was no relief. So, the idea was just to compact it and make it as unpleasant as possible.

ELIAS KOTEAS

Here's a boat full of guys and here is this one lonely man who is responsible for his company. I think it's important, I think it does 'open the door'. It's a glimpse into this man's mind, his isolation. He wants to somehow relate, but he can't. There's nobody who can put an arm around him and then say, 'It's gonna be all right.'

So, it felt like a pretty thankless part when I first read the script. I didn't wanna be that guy. Everyone's gonna hate you, then you get fired, and get the hell out. But ultimately now you miss those kind of characters, you wanna be in that kind of experience, you wanna be tested, opened up. So Terry has completely spoiled the hell out of me.

Pvt Mazzi

All I know is Charlie Company's always getting screwed.
Always.
And I can tell you whose fault it is, too.
It's that captain of ours.
First he gets us stuck on this boat
where we don't know a fucking soul.
Then he gets us stuck way
down in fourth place on the list to get off,
this son of a bitch.

ELIAS KOTEAS

We did the initial scene in the boat three times, in different ways, in which I look at different things. It's important because it's the first time you see the character. And it's important to see the man, in that situation. He's got his responsibility and you see how lonely it all is, in the middle of all this. So we did that little moment three times. And all I remember at the time was that I'm walking and my shoes are too small! I was so out of it, I was

so nervous that I didn't realize that my shoes were too small, so I couldn't walk. So, as I'm walking in the scene, my feet are in blisters and all I thought was, 'My feet! My feet are killing me!' To me it's that reality but, in context, it's this lonely man with the weight of the world on his shoulders.

JOHN TOLL

In the scenes at the beginning of the film that take place within the transport ship, we wanted to play those scenes really dark, and we used a lot of Steadicam. Basically, we lit the ship interior with practical fixtures that were outfitted with really hot incandescent globes. It was mostly hot toplight that created little pools of light. In areas where we didn't have a practical fixture, we just cut a hole in the ceiling and popped a light down through it. Once again, we tried to create as much contrast as possible; the light was about three to four stops overexposed, and the shadow areas were very dark. I used more light in those scenes than I would have if it was a spherical picture; I was shooting at about T4.5 to get as much depth as possible. We were trying to really capture the claustrophobic feeling that exists within that type of ship.

JACK FISK

Terry's reference point for films is *Badlands*, because of the number of extras and because of all the effects, because we were shooting in two countries, because we had stuff on the water and on land, because we had aeroplanes – *The Thin Red Line* became a very big picture. But in his mind, it was still like *Badlands* which was made for $350,000. I remember, it seems like the day before shooting, I said, 'Come and look at the ship set.' Our first day of shooting was going to be in the interior of the ship. And when Terry came over to the tennis court where we built the set, there were fifty huge trucks and tents and carts and equipment. I remember looking at his face, which was in shock because it was the first time he realized he was making this huge movie.

Everybody had been telling him, but he sort of locked it out. The concept of working with a small crew was easier for him. It ended up that our second unit crew was bigger than our crew on *Badlands*. So I kidded him every once in a while, because he always wants to make small films but he writes big ones.

JOHN TOLL

Terry has a basic honesty, which is part of the reason that we get along. We were trying to recreate this historical event in a way that was truthful. The film is not a documentary, but we wanted it to have the integrity of a great documentary. We didn't necessarily want to shoot it like a documentary, but we tried to lend the story a natural kind of realism. We sought out to capture the book's honest depiction of the various types of reactions to the combat experience – the full range of human emotions. War itself, and the infantryman's experience of it, is probably as fundamental and basic as you can get in terms of the human condition and how people react to its extremes. It pushes people to their limits, and what emerges can be very surprising in both good and bad ways. Somehow, we had to weave that sense of honesty into the visual presentation.

Because this is a Terrence Malick film, a lot of people will just assume that we sat around waiting for the magic hour, but we simply didn't have the luxury of doing that. We had a 180-page script, and after we shot all of that, we went to Guadalcanal for twenty more days of unscripted improvisations. We shot relentlessly every day, in every conceivable lighting condition, from seven in the morning until it got dark at about 6 p.m. Yes, there are magic-hour shots in the film, but only because we had to shoot until it got dark!

It's amazing to me how often I hear cinematographers say that they think shooting good-looking day-exterior movies is all about sitting around and waiting for the right light to happen, and then just pointing your camera at it and shooting 'pretty pictures'. Doing good work in day-exterior situations means that

you have to be able to make great images all day long, even when the light isn't ideal for pretty pictures. You must make choices that will allow you to take advantage of natural light in existing conditions. Even when the light is 'bad', it is possible to do good work by making wise choices.

The predominant day-exterior lighting conditions on this film were either sunny high-contrast or soft-contrast resulting from overcast conditions. Because we were shooting all day long and didn't have the luxury of waiting for ideal light, we had to decide how to make existing light work for the scenes we were scheduled to do on a given day. It was impossible to entirely control all of the light in our shots because we were using wide-angle anamorphic lenses and constantly moving the camera. None of the traditional methods of light control, such as putting up silks, were possible, because of the terrain and the nature of the shots. Sometimes, if we were doing extended dialogue scenes and didn't like the way the contrast was affecting the actors' faces, we would try to create an artificial 'overcast' look by staging the scenes under trees or in the shadow of a hill. At other times, we would stay in the open and go with the existing high contrast, exposing the faces and letting the contrast go. There were also days when we had both overcast and high-contrast sun happening simultaneously because of low clouds moving quickly and causing severe light changes. We had some days when the light changes happened so quickly that we just shot through them. It could be blistering hot one moment, and completely dark the next – sometimes in the same shot. But that represented the reality of the situation, and we just went with it. We didn't fight the conditions; we just tried to make them part of the story. In fact, for one Akela[18] shot of the soldiers climbing up the hills, we waited specifically for a light change to happen. The scene starts out in heavy cloud cover, but the sun comes out and reveals these guys sneaking through the grass. That particular light change worked well for us.

The point I'm trying to make is that good daytime exterior

cinematography is not comprised solely of making 'pretty pictures' at magic hour; it's about being knowledgeable about your craft and being able to create interesting images in all of the various daylight conditions.

In the jungle, scouting is everything. We would basically clear out a path to get the gear in, and then take the actors in another hundred feet and let them struggle.

We did haul some lights into the jungle, but when we turned them on, they completely changed the character and nuance of the natural light. It was beautiful in there, but we were dealing with extremely low light levels. There were subtleties in the colours and gradations of the natural light that completely disappeared when we mixed in any artificial fill. There was plenty of contrast, though, because the sunlight that did filter in created great hot highlights. I decided to just expose into the shadows as much as possible and go for the natural falloff of the shadows to compensate for lack of detail. It worked out okay.

This became a general approach to lighting most of the exteriors. I started out using some amounts of fill, but I became less and less interested in controlling contrast; I would expose for the shadow detail that I wanted and then usually let the highlights go. At times, we would use indirect light bounced from muslin or beadboard to lift faces, and maybe use black for negative, but when we were working in heavy contrast, I was quite a bit overexposed from what a more normal exposure would be in those situations. When it was sunny, it was extremely contrasty, but rather than trying to balance everything by adding fill, I just ignored the highlights.

I thought the film actually started looking much better when we lost the details in the highlights; it seemed more appropriate for the story. The more contrasty things got, the better, because it felt as if things were out of control – just as they were in the story.

HANS ZIMMER

I remember for a year we were having these complicated conversations where I would never talk about the music and always talk about the images and Terry would always talk about the music and never talk about the image. So we sort of did a role-reversal for a while. We made an agreement very early on that we were never going to talk about the script and stuff like that; we talked a lot about Renaissance painting and colours; John Toll would come over occasionally and we would talk about colours a lot. It's impossible to talk about music in specific terms. But I remember there was a silly idea I had. In religious Renaissance paintings you see humanity in the mud, at the bottom of the frame, and you see the light streaming through the clouds. And I said, 'Wouldn't it be great in these battles if somehow we could find the light?' And, in a funny way, that ended up in the music. The things that he couldn't quite say or couldn't quite shoot that I knew he was quite interested in, I tried to put into the music.

JOHN TOLL

There's a sequence that I like between Nick Nolte, who plays this mad colonel, and John Cusack, who's his adjutant. In the scene, which occurs about halfway through the battle, Nolte tells Cusack not to worry about the men and to focus on the charge up the hill. We were on top of a hill in an area with all of these burned-out tree trunks. It was extremely contrasty, but we really wanted to get into the faces and show the actors' expressions. We chose to shoot in a direction that would allow us to take advantage of the light. We put them in areas where they were in direct sunlight that was broken up by the trees, and we also added smoke to soften the sunlight. We wanted to show the environment, but we also chose angles that were good for close-ups and dialogue. We used some white fill and black negative to give the characters some shape and contrast, but choosing the right angles was the most important consideration.

ELIAS KOTEAS

To me the moment that it becomes magical was at the start of the battle, when this one captain sends two guys out. The two first guys are both looking at each other. They seem to say, 'I don't want to be the guy, you go be the guy, what is he, crazy?' Then they go out. They go out and in one second they are shot, they're gone.

Suddenly it becomes quiet. You can see the golden wheat fields blowing in the wind. Gold, green . . . quiet. Then you see the captain, shocked by what happened in the blink of an eye. And now everything is quiet. To me that was the moment. The little that I knew of Terry Malick, suddenly when I saw that moment, it was magic. Underneath this beauty, the wheat just swallowed them up. To me, that was the 'Terrence Malick moment'.

JIM CAVIEZEL

We had clouds always coming in and out and light was a problem, but he used that to his benefit. All of a sudden a cloud would come in and it would represent so much to him, it would be like the forces of evil. To me it seemed the idea came from the book – you couldn't really see where the Japanese were shooting from. As soon as they'd shoot, you'd see a flash, and then the grass waves. It would be like a group of zebras running past you. Like being a lion after a zebra and all of a sudden he doesn't know which one to go after, they just all blend together as a whole.

SEAN PENN

I don't know if it's Malick's intention consciously, or if it's just the way he experiences things, but I never feel he is leaving the narrative to cover a bird coming out of its shell. He's aware that while we're killing each other, ten feet away in the grass, some new life is being born. And that creates a kind of drama in itself, and it's much more of a complete view. It's not just a human experience, it's a spiritual experience, it's a naturalistic experience and then there's all the things we do to screw it up.

JOHN TOLL

The Akela crane was a great asset. One of our biggest challenges was a daytime battle sequence in the grassy hills. The Japanese were in the hills, and the Americans had to go up there, find them, and kill them. To deal with those scenes, we brought in the Akela, which came with two American technicians. The terrain was very uneven, the grass was about waist-high, and underneath it there were a lot of rocks and holes. We spent weeks climbing up and falling down those hills. At times we could use the Steadicam really well out there, but at other times it became impossible because we wanted to see the soldiers actually going up the hills. One of the tougher challenges we faced was preserving the look of this waist-high grass. You couldn't walk through the grass more than a couple of times without leaving these huge paths. It was like working in snow, where you've got to cover your tracks. There's only so much you can do before you destroy the look of the location.

JACK FISK

I guess the hardest thing that Terry said when I originally talked to him about the film was: 'Grass, we need a lot of grass.' And once you bring in a company of 125 men and they trample it down, how are you going to reshoot it? How are you going to get grass? We developed a way to put grass in the ground sort of instantly. We were getting plugs of grass, and putting holes in the ground and then sticking the grass in the holes and recreating it. So we were building nature which is hard; if you are building a house or something that's man-made, it's kind of easy, but if you are trying to build stuff that God made, it's much more difficult to pull it off. So, I was excited with some of the elements that we added that were not real; they're difficult to tell from God's contribution: the great art director.

JOHN TOLL

I was contemplating this problem long before we got to the

location, because I knew what we were up against with the grass and the steep hills. I began thinking about using the Akela crane, which has an extremely long, 72-foot arm that would allow us to get the camera into places where we couldn't walk or lay dolly track. The only problem was that I wanted to install the crane on the sides of hills, which involved building some fairly substantial platforms, because the Akela weighs about 6,000 pounds. It worked out fabulously, though. The Akela's arm does have a slight arc, but it's a much more minimal arc than any conventional crane arm. Because of that, we could make shots that had the appearance of a dolly shot. That was the whole reason for bringing in the Akela, and we constantly had it at very low angles; I don't think we used it more than once or twice for a high-angled shot. Our expert technicians, Michael Gough and Mark Willard, kept wanting to show off how high it would go, but I kept hammering them with my mantra: 'It's a dolly, not a crane.' Basically, we turned our crane technicians into dolly grips, but they did a fantastic job.

There are some great Akela crane shots in the film where we follow the soldiers over really long distances. We did have to train the actors to stay with the crane arm, because it doesn't move in a perfectly straight line. If we were ahead of them, they could just follow the lens, but if we were shooting from behind, we would trace out the arc so the actors could follow it. But using the Akela really allowed us to get down in the grass and get shots that just wouldn't have been possible with a dolly or even a Steadicam because of the uneven terrain.

Right from the beginning, we talked a lot about making the viewers feel as if they were watching this story from close-up, almost as if they were participants. A lot of what the characters go through emotionally is unspoken, so it was necessary to convey those moments in a visual way. We wanted the camera to tell the story and yet somehow be part of the story. Terry and I talked extensively about creating a sense of movement throughout the whole picture. He loves to speak in metaphors, and he

kept saying, 'It's like moving down a river, and the picture should have that same kind of flow.'

During pre-production, we had talked about various ways to create that kind of style, but we never settled on a single approach. On the first couple of days of the schedule, we shot some scenes with a moving camera on a dolly, and some with stationary cameras incorporating conventional coverage and angles. It was all technically correct, and there was nothing wrong with the scenes, but when we viewed the footage, it sometimes felt very 'staged' and overly structured for the camera.

We knew we wanted something more, so we decided to loosen up our approach a bit. As a result, there's a lot of Steadicam and hand-held work in the picture. We had a great Australian Steadicam operator named Brad Shields. We allowed the camera to explore a bit, and Terry encouraged the actors to try something different if they felt like it. At times, the camera would drift from one actor to another; we might not get conventional masters or coverage, but it didn't seem that important. Every scene became a unique situation, and we just shot what seemed to be most appropriate for a particular sequence. We allowed the camera to follow the emotional thread of a scene without worrying about much else. What seemed to emerge from that was a feeling of unpredictability which completely supported the idea that Guadalcanal was a strange and dangerous place that these characters suddenly found themselves in.

Terry got into that style of shooting immediately; he has a rather spontaneous and unpredictable personality, so the idea made a lot of sense to him. Using the Steadicam and hand-held cameras certainly isn't a new idea, but the challenge was in shooting scenes that way without drawing unnecessary attention to the techniques themselves. I wanted to use the fluid, mobile camera movement as part of the overall style of the film, but in a way that supported the story.

BEN CHAPLIN

A lot of the poetry that's in the film, Terry wrote during the shoot and after the shoot. Considering that he writes so meticulously and so carefully, he's extremely irreverent with his own writing. He would just throw pages away, even if certain lines were absolutely essential to him.

He likes to use a very ordered, dense, long screenplay as a sort of structure for a film and then he throws a lot of it away. Then Terry is in the hang of that skeleton, of that structure.

RICK HESS

I remember when we were casting *The Thin Red Line*, we were getting very strong suggestions from Fox to put some marquee actors in the film. Terry knew that the casting would be paramount to the financing closing, so he collaborated and agreed that he could augment the size of one role to accommodate an actor joining the movie. But this actor asked to see some lines before committing. So, I was enlisted to go over to the production office and explain to Terry that we needed some dialogue so the actor could have more information about the character. I expected a bit of reluctance on his part, but after a brief back and forth, Terry agreed to write a scene. The most extraordinary part of this story is that he didn't go to write it later, but sat down at a desk in front of me and started to write longhand on a yellow tablet. I couldn't believe this was happening, watching this iconic director work in front of me. I felt like I was at a great party I wasn't supposed to be at. After fifteen–twenty minutes, he looked up at me and said, 'How about this, Rick, let me know what you think.' He then proceeded to read me one of the most poetic, moving passages I've ever heard – and he had just pulled it instantaneously from his head. I'll never forget that day.

ELIAS KOTEAS

That was the difficult part of a lot of the process, where you didn't really know what you were going to be doing on any given

day. But that's okay – I don't think that the soldiers would have known what they were doing, where they were going – so that kept you on your toes. A lot of us had a hard time working that way, but once you surrender to it, once you know that you're part of 'a bigger vision', then you can relax and say, 'Okay . . . there is John Toll, there is Terry Malick, they've got a camera on you, things are not that bad!'

SEAN PENN

Most of the talks that really became productive or made sense occurred while we were shooting. He had delineated a character in the script, but I felt there was going to be some room to play with it once we got there. Like I said, it took me a little while to figure out how to serve this director's process. There were times when you were in the middle of a scene and you could feel the camera peripherally drift away and cover some rare bird that's flying by, and so you take a cigarette break and wait until they shoot the bird, and come back – things like that happened. So, there was a point when I had a bit of crisis with it, where I felt that my understanding of it was that it was getting too black and white for me. I sat down and explained this with a lot of energy and emotion to Terry. After I had been up all night worrying about this, about two weeks into shooting, Terry just answered, 'Well, that's fine. I think we're just fine,' and that seemed okay with me. He didn't really address those things, but day by day he would be constantly coming back to things that he wanted to find in the character, or he wanted this character to be able to express in the context of those things he wanted to touch on in the movie. So we would come back to certain thematic notions of my character a lot, almost on a daily basis.

BEN CHAPLIN

There were definitely elements of a workshop in the sense that we were all struggling to find our way through the film. It was a very long shoot: there were days of running up hills. You would

find yourself more drawn towards some actors than others and Terry would recognize that and build upon it. It definitely had elements of a workshop in that he was always open to suggestions. If he sees a moment that he likes, he will go off there; he will roll the camera on people without them knowing.

I remember one time there was a scene with John Cusack where we were coming up over the crest to take the Japanese bunker, and Terry saw some birds flying that he really liked or he saw a sky, or a cloud that he really liked. John Cusack was standing there, exhausted, with the rifle, and Terry grabbed the camera and pointed it away from John Cusack into the birds. John was like, 'I was really trying!' I don't think there are many directors like that. And he's not being rude to the actors on purpose, the actors can never be offended because Terry is too nice. We can do it again, the birds can't.

JOHN SAVAGE
He did a wise thing, he gave time. Rehearsal is good, but sometimes spontaneity in a film is better. To prepare is good, but how to 'prepare' is not always clear, as far as learning your words, knowing your marks, the technical aspects of the stage, of film: 'Where's the camera? Where's the sound department?' By the same token, a director doesn't want you occupying your time thinking about those things, or trying to figure out a scene while the camera is rolling. 'Spontaneity' on film is supposed to be the 'most important thing' but, as I said, to prepare for something like that is not always clear. Things don't work that way. Things happen, things change, so it's important for a director to know all the possibilities within his filming, within the people and within the story to get what he has on film – so I felt he took a big chance.

ELIAS KOTEAS
Most films don't have five, six months to shoot. So we were lucky, as actors, and he was lucky as a director, that he has that sort of freedom.

For me, personally, it was tough because you come in with a bit of an ego that you kinda have some idea about how to play it and then you're told, 'Would you look to your left? That's it. Now turn around, turn to your right, look up there. Listen to the distant bird!' So you have this hands-on kind of direction and it feels a little humbling, but ultimately you realize that you're part of a bigger vision. And you've just got to surrender yourself to it. And in context it looks great! Even though I was looking out at something that's completely different, in context it works.

JIM CAVIEZEL

We shot 1.5 million feet of film. They always had cameras rolling on different things, so he'd covered himself and then he made his film in the editing room. If you don't shoot enough, you won't have anything to go from, so he had Witt being very strong and then Witt more peaceful. He had it both ways all through the movie so he could break either course and see whatever he wanted to.

JACK FISK

Terry didn't shoot all of the material of the birds, but he shot a lot of it. He loves to pick up the camera and shoot. John Toll was great because a lot of times he would just give Terry a camera or let him take his camera. John is a great artist but sort of a tortured soul, in that he is never happy with his work. He might be later, but during the creation he is always doubting himself. He had done some spectacular stuff on *Thin Red Line*, but he was worried about his contribution, saying, 'It's not good enough.' And it was hard for me to see him so tortured and doing such beautiful work. But I realized that that's just an element that a lot of artists have to deal with.

JOHN TOLL

We didn't use multiple cameras as much as I had on *Braveheart*.[19] There was only one day when we had a combined first and

second unit and we shot with four cameras. The majority of the time, the first and second units shot with two cameras. I was almost reluctant to do this movie because of *Braveheart*; I thought that the last thing I should be doing at this point in my career was another day-exterior battlefield movie, but I was drawn to the material and the idea of working with Terry. I tried not to think about *Braveheart* while we were shooting, and this movie didn't have that kind of scale. It didn't involve the same numbers of people, and we didn't put as much emphasis on the fighting itself. The battles weren't as grand in scope.

ELIAS KOTEAS

When we were doing the battle scenes John Toll would be in there, shooting around like a soldier in battle, crouched over, and suddenly you turn around and you forget that he is in the scene. He became part of the action! I'd look over to him and he'd look at me – sometimes he blinked. That gave you that bit of reassurance because it meant that you were in-frame and it worked. But he was magical because he knew exactly where to go and where to be, without getting in your way! He found a way to photograph everything that was going on. Really you've got to pinch yourself, working with John Toll. It just doesn't get any better than that.

BEN CHAPLIN

There is a scene when we take the bunker and I am shot. There is one shot of me while I am shooting the gun killing the Japanese, in a terrible sort of massacre, but we are also high on the taking of this bunker and thinking that we are gonna die and then suddenly it's over.

And there is this little scene where I sort of break down a little bit. Dash's character, Dahl, comes in and hugs me and I remember whispering something to him, I can't remember exactly what, but you can't hear it. This is how the film worked – Terry came up to me and said, 'I'm just thinking of ending

the sequence on you.' And I thought, 'Oh my God! That's a big deal.'

I felt very free with Terry, I felt like they gave me a chance and if I didn't get it, I could have another go. It was very family-like, that, he felt very fatherlike. I felt very protected. And yet, at times, he could leave you out there struggling. He would let you flounder while the film was running out through the camera – he was looking for something that he didn't really know and you could not find without going through it. Sometimes he would push you through and you would have to go through something painful in order to find a moment. He did that a lot too. It was an amazing experience.

PENNY ALLEN

What was interesting to me, after spending those three months working together on the script prior to him going over, is that when I saw some scenes I said, 'That's a whole new scene. I never read that one with Terry!' The film was wonderfully alive, because it was like being on the East Coast in Vermont, where the weather goes through every possible change that could take place, in only one day. That's like being with Terry: every change that is possible goes into a scene that he does.

> *Pvt Witt (voice-over)*
> Are you righteous? Kind?
> Does your confidence lie in this?
> Are you loved by all?
> Know that I was, too.
> Do you imagine your sufferings will be less
> because you loved goodness?
> Truth?

JOHN TOLL

That scene where the soldiers attack the Japanese camp is basic-ally the Japanese soldiers' last stand. Some of them are dying

of starvation, some commit suicide, some surrender and others decide to fight to the last man. I think we really captured the chaos and tragedy of that type of battle. No one really wants to be there, but they have to follow orders, and whether given individuals survive or get killed is really just a matter of chance.

The whole sequence was done with either a hand-held camera and/or the Steadicam – primarily the Steadicam – and Brad Shields did a great job on it. The Americans are running into the area and the Japanese are all around them, so you don't know if the guy next to you is friend or foe. Once we set up for that scene, we had the actors go in and improvise the action. We then kept repeating the sequence over and over, following different characters through this nightmarish situation. It was semi-controlled chaos, and it wasn't over-rehearsed to the point where everyone always knew what they were going to do. There were many extras in the scene, a lot of people firing at each other, and various guys taking some predetermined hits. We just let the camerawork be as free-form as possible.

JACK FISK

That scene ends on a Buddha in the fire. In trying to represent the Japanese as humans and equals; we wanted to show something of their spiritual life. I think that's why we incorporated the Buddha and an orchid. To me the Japanese sense of beauty and harmony in life is really important. In Guadalcanal they were thrust into the jungle, they were surprised by the Americans and they retreated into the jungle to hide, but that was the worst place to live because it was dark, there was no sun, there were more mosquitoes, they had a lot of malaria and dysentery. The water wasn't as good, it was really their downfall. So many of the Japanese died by living in the jungle and missing the light. It was kind of horrifying. War is terrible. Sometimes we forget: sometimes we see a movie and it looks exciting and we go, 'I wanna join!' But then you get there and you go, 'Oh, oh! I forgot!'

The Years of Absence *and* The Thin Red Line

JOHN SAVAGE

I didn't think the American soldiers needed to be at Guadalcanal. I have information that says that maybe the Japanese were starving to death and they knew that. All they had to do was wait for another couple of weeks or months for the Navy to starve them out, before they put the marines down. But MacArthur had his own plans, the Navy was taken away and a lot of violence went on, without a lot of support and a lot of marines just sat there being shelled.

HANS ZIMMER

You have to realize one thing: we had very little money, this wasn't a big blockbuster movie. One of the things Terry said to me early on was that he loved the idea of having the Japanese point of view. I told him I knew some Japanese musicians and he said we couldn't use American-Japanese, because it could be offensive to these Japanese. But I couldn't find any Japanese who would work for the kind of money that we had. I knew Johnny Mori, an American-Japanese, a brilliant percussionist. He came and he looked exactly like everything Terry feared. He had just bleached his hair blond with this spiky Mohawk; he was in his punk phase. And I see Terry's face when Johnny walks in with his gongs and stuff and then Johnny goes pottering around in the studio. There was one of the Japanese actors on the screen, with no sound, and Johnny comes back in and he goes, 'Is the guy doing a Buddhist prayer?' And Terry asked him how did he know – because there was no sound. And Johnny replied, 'I was sort of lip-reading it and I'm a Buddhist.' So that already softened Terry for this crazy punk doing things. Then he went and started playing and it was just jaw-dropping what he was doing. I think it was a good lesson: don't judge before you hear the man's soul. It was in the middle of the night and because he played with a discipline, with spirituality – these sounds, these bell-like sounds – of all the movies I have done, of all the sessions that I have done, it was a magical moment and I think it was a

magical moment for Terry as well. You know, we all start off with our own preconceived ideas and someone can come in with some genius ideas and all of those preconceived ideas go out of the window because someone is truly creating greatness.

BILLY WEBER

We had shot silent scenes before, especially in *Days of Heaven*, and so we did them in *The Thin Red Line* the same way. I told him before he left for the shoot, 'You know what? This time, every time you do a shot of anybody, do one where they say nothing . . . Just do the whole scene but don't let them talk.' So he did that a lot. We had shots that we knew we could always go to, we knew we'd be able to find a piece that conveyed a feeling that we were trying to do, but we wanted to do it without the dialogue.

So, in the case of the *Thin Red Line*, I said that to him, so we don't have to kill ourselves looking for pieces. With Caviezel you just watch the movie: he doesn't talk very much, he has a great face, and you can let the character emerge, just grabbing pieces between dialogue.

We had to do it with a lot of the actors; it just worked a lot better when they didn't speak! When you just saw them in that situation!

SEAN PENN

I wouldn't say the character of Welsh wasn't defined. I would say it was defined in a way that I had been able to attain in the context of this process. So, we would re-approach it and revisit these ideas that were clearly in the secret of what this movie was for Terry. There were specific things that he would consistently be touching on, and that we would address with improvisations, with dialogue, as well as with a kind of paring down of things, a simplifying of things. It is usually the case, particularly with Terry, because the way in which he is going to use what he gets of you on film is that he is going to tell a lot about your character

with the score, he's going to tell about your character with narration, he's going to tell you about it 'behaviourally'.

Sometimes we'd shoot for half a day doing one of the scenes in the story and then the second half of the day we would do the same scene, but as a silent movie. We would throw out all the dialogue entirely and just do a kind of dance of the characters, of them moving about and he found ways of weaving that stuff together in the cutting room. It isn't the difference between the writer-director and a non-writer director: it's the difference between Terry and all other directors. Terry has his way of working and I hadn't had that experience before, and it took me a couple of weeks to adjust to it but I adjusted, I loved it. And for me, what I loved was that when in doubt, I did nothing and when he needed something he would be very clear about what he needed.

You have to trust him. That's all you can do with somebody who works this way; other than that, you can try and violate the space about what's going on, but you only defeat your own purpose.

ELIAS KOTEAS

It's a great way to open up. You'd have a five-page scene and he'd spend half a day filming this. And the night before, the days before, you're stressing about whether or not you're going to learn your dialogue, hoping to God you're there. And then he does something really amazing where he says, 'Just do the scene without dialogue.' Suddenly it opens you up, it liberates you from having to speak. You can just feel, you just look. It all comes down to just looks. With intent. And that's a beautiful way to work. It spoils you because nobody really works that way, there's not much time.

BEN CHAPLIN

Film is a visual medium, isn't it? So the image has to come before the word. I don't think Terry distrusts dialogue. He writes it as a structure and as a skeleton for everyone to work from, and it's a

very strong foundation because he writes very dense, very structured screenplays. There is nothing unnecessary in them even if they are long, and he manages to cut a great deal from the final film. So, he's working on the principle that when it comes to shooting what doesn't need to be said shouldn't be said. Which is the 'less is more' school of thought. But because you have the understanding of the script, of the scene that was there, your silence is given a lot more depth.

You just played the scene with dialogue and then he'd perhaps cut a few lines, and then if he'd feel that he wanted to try something different, he would say, 'Just try the same thing but without saying anything.' It's like doing silent movie acting without overdoing it, without any Charlie Chaplin stuff. That's the essence of acting; you shouldn't need words to communicate. A good director can cut moments from it that are very real and poignant. I saw stuff out of my performance of *The Thin Red Line* that I totally forgot I'd shot because it had absolutely no real impact on me at the time. There is a shot of me lying in the grass. I remember a fly lands on my face. I bet you that's why Terry chose that shot, because a fly lands on my face. I didn't even feel it. That was shot in Guadalcanal, actually in Guadalcanal in the jungle, at dusk, because Terry loves to shoot at magic hour when it's just getting dark. He's a director who will put that shot into a film and it will have such significance, but when you shot it you were not really thinking about much at all. Not really. He just likes to keep it very simple. And it's where he chooses to put it with the music and everything. He doesn't allow you a false moment, he will cut every false moment that you had in your performance out of the movie. So he makes you look like a lot better actor than you are.

Capt Staros

Sir, I must tell you that I refuse to obey your order. [. . .]
I again request permission for patrol reconnaissance around
 to the right in force.

The time, sir, . . . is 13:21 hours, 25 seconds.
I have two witnesses here.
I request that you do the same with witnesses there. Over.

Col Tall

Staros, don't pull this guardhouse-lawyer bullshit with me!
Now, I know you're a goddamn lawyer!
This is not a court of law.
This is a war. It's a goddamn battle!
Now, I want that frontal attack.
I repeat my order. Over.

Capt Staros

Colonel, I refuse to take my men up there in a frontal attack.
It's suicide, sir.
I've lived with these men for two years,
and I will not order them all to their deaths. Over.

ELIAS KOTEAS

I remember the film had just come out, and they had this thing on the History Channel called *Is It Hollywood or Is It History?* I remember they had two Guadalcanal veterans on the show, and they were asking them questions and they showed the scene where Nick Nolte is screaming at me over the phone. He is telling me to advance and I refuse the order. When one of the old soldiers said that a good officer would listen to his officer out on the field, that Nick Nolte might have been a little bit off-base, in the way he treated me, I wept. I sat at home, alone, by myself, it's one in the morning, and I said to myself, 'What is happening here? Why am I weeping? Why am I actually feeling that Captain Staros did do the right thing?' And I felt vindicated, in some strange way, like a year and a half later. Maybe we should have done something else, go on the right, and ramp to the side but it was murder just to go straight up, just to fulfil this guy. And I felt very much that I did do the right thing.

BEN CHAPLIN

It was very important to have on the set such experienced actors as Nick Nolte and Sean Penn. Unfortunately, I did not have one scene with Sean. Actually, there was a scene where I was present with Sean, but I never got really to work with him. But when you've got an actor like that, just his talent inspires you, makes you want to be better. Nick Nolte, who I did work with, was amazing. He's got so much energy, he's so professional, he's well-prepared. He was a very good example for a lot of actors: some of us hadn't done very much. And he has a little Terrence Malick quality: he is very childlike. He is also very enthusiastic and not jaded at all from the industry; he comes and he works as hard as if it is his first job. If you are feeling a little lazy, then it is good to have someone like that around. Someone who is that experienced but that interested, working hard, always wanting to get it right. It had a big impact on me personally. It was a lesson.

ELIAS KOTEAS

Nick Nolte came in with pages and pages of back story for his character, he knew exactly what he wanted to do, and he came at me with it. I was the same way. Right from day one he was there off-camera, and I was the same for him. I guess, he's one of the reasons I became an actor and to suddenly be in conflict with his energy was a gift. But, at the same time, I felt that it wasn't just one-sided . . . we were both equals, coming together. With me it's very simple, try to learn the dialogue, and try to really breathe air into that dialogue and trust your instincts. And Nick Nolte is the type of actor who's gonna be in your face. When I say 'in your face', I mean just yelling at you! Screaming! You have Nick Nolte just beetroot-red and screaming in your face and you're gonna feel something. It's just the way it is. And I find that's a gift – because you don't have to pretend. He's there. He's gonna eat you up alive, if you're not gonna be present. So we both needed each other, he needed me

to get him to the place where he was gonna be, and I felt proud
of that.

Sgt Welsh
Hey, Witt. Who you making trouble for today?

Pvt Witt
What d'you mean?

Sgt Welsh
Well, isn't that what you like to do?
Turn left when they say go right?
Why are you such a troublemaker, Witt?

Pvt Witt
You care about me, don't you, Sergeant?
I always felt like you did.
Why do you always make yourself out like a rock?
One day I can come up and talk to you,
by the next day it's like we never even met.
Lonely house now.
You ever get lonely?

Sgt Welsh
Only around people.

Pvt Witt
Only around people.

Sgt Welsh
You still believing in the beautiful light, are you?
How do you do that?
You're a magician to me.

Pvt Witt
I still see a spark in you.

JIM CAVIEZEL

Every day when we were filming, Terry would ask me about Sean; ask me about the guys and what I thought about them. What I didn't understand was that he was making the role of Witt more or less a character which had a lot to do with me and a lot to do with him – the kind of kinship that we had together, how we saw things.

Terry eventually started to modify the character a bit, because Sean's was very hard and opinionated – so we had to show clearly two different philosophies on how to get things done. So, that way I learned Witt was probably more like Welsh, because at the beginning the role was very much a character who had strong opinions and didn't like certain people. He didn't like Tall, who was played by Nick Nolte, and he had problems with the Sean Penn character. That's why at the beginning of the film they were talking to each other and he was always in trouble. But there was something that was happening inside of him, changing him and that he wanted that to happen much quicker so that Sean and him could have a dialogue right from the beginning.

He has a love-hate relationship with Sean's character, but I love him more than anything. And I think that the veranda scene we shot at the end of the film was a really interesting one. It was a scene that we didn't have that day.

SEAN PENN

I remember there had been a written scene that Terry had kinda threw out and said, 'Let's just get out here and shoot this thing' – this is one of those scenes that Terry shot with both dialogue and without dialogue – Terry gave us a wide berth, a lot of places to move about through the thing. We shot an awful lot of footage on that thing but there were specific triggers, specific

notes that Terry had, specific ideas that are in the scene and there were others that he took out of the scene, that had come literally from Terry. Again, short of discussing what those specifics were, most of them are apparent but the process – that was Terry's. He didn't know what the whole scene was, but he knew what its place was in the whole movie that he was going to make and so we went about and talked for a couple of hours on camera.

Anyway, some of it was just there, between Jim and me. I think that we were not that wildly far off from understanding who each character was. We were very different people and I think that he could speak to this in some ways better than I could because he is a person of faith.

JIM CAVIEZEL

The day before the veranda scene Terry said to me, 'What do you think of Sean Penn?' I answered to him, 'He's like a rock. One day you can go up and talk to him and the next day he doesn't know who you are, that's Sean Penn.'

Then when we were shooting that scene with Sean, he said, 'Tell him what you told me.' And Sean came in and he says, 'Do you still see the big ol' light or something?'

Many days Sean and I would go out and run and work out together. I kind of talked to him a lot about where I came from, about my faith. One day, we were at lunch, and he asked, 'What makes you tick?' And I said, 'Do you really wanna know?' And he said, 'Yeah.' And I answered, 'Jesus Christ.' He took a drag of a cigarette and said, 'Well, I don't not believe in . . . I mean . . .' So I said, 'You asked me what makes me tick and so I'm telling you. You asked me, I wouldn't put that on you . . .' So when I came on the scene he said, 'Do you still see the big ol' light? Do you see the big light?' And I said, 'I still see the spark in you. I know he's in you, I know there is somethin' goin' on.' That's where Terry is brilliant – for putting all that together and bringing out the best and worst in each one of us.

That scene was not scripted and that is my favourite scene in the whole movie.

Pvt Bell (voice-over)

My dear wife,
you get something twisted out of your insides by all this
 blood, filth, and noise.
I wanna stay changeless for you.
I wanna come back to you the man I was before.

BEN CHAPLIN

I didn't have much time with Penny Allen before the film, but she gave me some exercises which were very, very helpful. I remember she told me to write lots of letters. One of the exercises she gave me was to hide somewhere in the dark, like in a closet or a cupboard, and write letters to anyone I wanted: people alive or dead. I had to write something I wanted to say to somebody who I knew had died, or write a letter to my nephew who isn't even old enough to understand it. It was a very helpful exercise. It was one of the most important things I did.

But it was one of those films in which so much work was done for you by being out there in Australia. Of course so much work was done by Terry's writing and Terry's direction, but so much also was done by the boot camp, just being out there and training. It was hard.

Marty to Pvt Bell (voice-over)

Dear Jack,
I've met an Air Force captain.
I've fallen in love with him.
I want a divorce to marry him.
I know you can say no,
but I'm asking you anyway,
out of the memory of what we had together.
Forgive me.

I just got too lonely, Jack.

We'll meet again someday.

People who have been as close as we've been always meet
again.

I have no right to speak to you this way.

I can't stop myself.

A habit so strong.

Oh, my friend of all those shining years.

Help me leave you!

BEN CHAPLIN

The twist, the turning point in the character, is the moment when
I receive the letter from my wife. I know Terry was really happy
with that scene. It was one of those scenes where there is a lot
of pressure on you and we had these planes, these really loud
planes coming in to land behind me. They would do touch and
goes, they would land and take off and go back round, so that
it made it look like there were more aeroplanes but there were
actually only two.

I know he wanted that thing of being a man in machinery, that
image of a man among steel. A man with a heart getting broken
but amidst something so cold – metal and war and machinery,
all that. I don't remember getting a lot of notes from him on that
stuff, it was just: 'Read the letter. Read the letter and we'll see
what happens.'

The greatest gift Terry gave us was that we shot chronologic-
ally. It was a long shoot of six months of principal photography
so you were able to get into the character. By the time I read that
letter, it was a long way into the shoot and I had been thinking
about my wife a long time. But not just my wife, I was missing
my own family, I was missing my girlfriend at the time. So it was
just a gift to shoot chronologically. If I had shot that on the first
day, the scene would have been terrible.

PENNY ALLEN

Miranda Otto, the girl that played his wife, was not cast when I worked with Ben, so a great deal of it had to do with this element that he should not be separated from her – on an instinctive level. A lot of that is cut and it culminates in the scene when he is eating too much. The way he did it is very neat. He eats and chews each bite equally, as though everything is in its place, so that a man and a woman being married should be in a certain form and when that form is broken . . .

This is a beautiful example in terms of what is it that we grasp in the eyes of fate, or destiny. You would have expected that someone, when the form is broken, to be much shakier, gaining more humility and surrendering, bereft of half of himself, in some kind of way. That isn't in the film – that was in the dailies that Ben did, and it was absolutely striking.

So Ben and I talked a little bit about that in terms of when he first read the letter, that it would have this effect of not knowing where you are, of having to put the world back together instead of playing the loss and going into that sentimental aspect. And now when you watch the movie, there's a tiny little bit and it's in a fairly long shot, where Ben doesn't look as if he has the direction thing down, he really looks lost. When he comes out from talking to the captain, you really get the impression that he is lost.

> *Pvt Bell (voice-over)*
> We.
> We together.
> One being.
> Flow together like water,
> till I can't tell you from me.
> I drink you.
> Now.
> Now.

BEN CHAPLIN

These lines of voice-over did not exist initially in the script. I was just crawling through jungle grass with a rifle and Terry chose where to add that stuff. So he gives you the gift of a great performance without you doing anything! He places that upon you and lets the audience see. I was just crawling through the grass, I wasn't thinking about my wife. He lets the audience see that I'm thinking about my wife and chooses where to put those moments.

I guess in the back of my mind I'm always thinking – that was part of my performance – if I was ever in danger, within the filming or within the story, I would always try and have thoughts of my wife, or I'd get through it because that was in my character.

JACK FISK

The main idea of the flashbacks was just to set up the contrast, the difference between the reality of where they were and what they remembered. A lot of those flashbacks weren't done necessarily to be realistic, but to evoke a feeling. When we did the house where Ben Chaplin's character and his wife were, we put lace curtains and stuff that would blow in the wind, so it seemed pleasant and simple, with a lot of light coming in, because in the war they were outside, they are being bombarded and in here it was quiet and lyrical. So it's more the contrast; I think that's what you would do naturally in those situations, you would try to retain some part of you that you liked, the environment that you liked, because suddenly you were in an environment that was foreign and not very pleasant. Those sets were built very simply, and Terry loved working with them. I think one of the reasons he loved working with them was because we were working with an actress. Because it was all these men and everything was army and rough, and then suddenly there was a female element that just changed everything. We shot a series of those scenes in Australia, built sets there, and then when Terry came back, he wanted to do it again and we ended up building sets in

California. And it was nice because the light was great and we were near the water, but it was different to the water we had out on the island.

BILLY WEBER

All the Witt flashbacks were done afterwards, here in California, the Ben Chaplin scenes with his wife were done in Australia, but then we brought her here, and she did some stuff here too. We didn't know exactly what the voice-over would be, we had an idea, but we weren't sure. But we had all of the Witt footage and so Terry knew what flashbacks he wanted to shoot. They didn't shoot any others, only Witt and Bell: we knew we were going to get into trouble if we did that, it was too much, because in the first half of the book you have flashbacks of almost all the characters.

BEN CHAPLIN

In the original screenplay, Pvt Bell was the only character who had voice-over. In the script there were moments where you could tell that he was going to be the only character with a strong back-story. Thinking about his past was getting him through the war. There were little lines between him and his wife in there. The only flashback I can specifically remember was in the back of a car, him and his wife, but I don't even know if I am imagining this now, because Terry wrote a lot of that stuff afterwards. Most of the moments between Bell and his wife that you see in the movie were shot after the movie. Some of them were shot during the shoot by the second unit, even if Terry was there. Most of them we shot in a week, in California, afterwards. Terry likes to shoot on the run, he likes to think of things as he goes; he says – but I don't know if he believes it – he's anti-preparation, he's always saying, 'Anything I can possibly plan for is not gonna be as good as anything that happens accidentally.' The skill is knowing what's good when you see it accidentally.

So when we were shooting the flashbacks, I never knew what

it was going to be. That's the beauty of Terry's approach: he puts you in there and takes your control away. A lot of the problems with actors' performances is that they try too hard to control the arc of their performance or try too hard to indicate what's going on and control the arc of their performance. You can't do that with Terry, he doesn't allow it: he's in control. You are just a piece of paint, and you can't see the canvas. That's what's so lovely: you are in the hands of a master and you are just providing what you can provide; you don't know the bigger picture. It takes the pressure off you in a way because you know you are in great hands. You have to trust him completely and he makes you innocent as an actor again. And the beautiful thing about *The Thin Red Line* was that you did. I did! Most people did. I have never been in a film where the crew and cast are so in the hands of a director.

JACK FISK

For Witt's flashback I built a set that had a ceiling and we shot in that. And then Terry said, 'I want you to build it outside and, you know, no ceiling.' And so we built other walls that looked like that, which he shot in a park in San Pedro, California. So it was Terry's idea: his mother was dying, Jim Caviezel's character's mother was dying, and we talked about what it would be like, what she would see. And I think that that was one of the elements that Terry liked: that this reality didn't exist. By taking the ceiling out it made it seem very thin, like paper, and unimportant because there was this bigger, stronger element above. It was the same thing with the little girl in the room, sort of representing family or spirits coming to take you to your heaven.

> *Capt Staros (voice-over)*
> You're my light.
> My guide.

ELIAS KOTEAS

I can't remember if the prayer was in the script or not; what I do remember was when we filmed it. We were filming the boat stuff up there in Catalina Island, a couple of months after the shoot in Australia. It was the last scene of the whole shoot, the last scene of the day. The boat is making noise, we're coming in to San Pedro and we're setting up this little area really quickly so we could do the shot. All around, you could hear the boat making noise because it's coming into port. And I remember how alone it all felt – they're setting it up, it was the last thing to do, and I was feeling very afraid that if we didn't catch this moment then it would be lost. In the beginning you think, 'Oh, I've been praying every day all my life, since I was six years old. It's going to be easy.' Because I do, I really pray every day. But on the day, it was like you were there by yourself, no one's listening. And suddenly you have no voice, because you're afraid. So we started doing the scene and it wasn't working. Then we set it up again, and it's almost done – the boat's almost in port. I remember looking up and praying to God and saying, 'Please, let me be here.' And it all just started: my own personal desperation just came there, and it worked. It worked because of Terry.

BILLY WEBER

Working on Terry's movies takes a long time and the reason they do is because he feels like he's walking down the garden path on every picture he does. He doesn't quite know where it's going to lead to, and it's not until we get it all together once that we can look at it and figure out in which direction we should go with it – and then we have to really spend a lot of time refining it to make it get to that point. Plus Terry is very careful and very meticulous about the direction it's going in and how he wants the flow of it to be; he wants to make sure it doesn't go in a direction that he doesn't want it to, even slightly, so it takes time to do that.

The Years of Absence and The Thin Red Line

HANS ZIMMER

I did the music about a year before the editing, and it was quite complicated because initially Terry was going to cut the movie at my studio – which would have been perfect – but, of course, Billy didn't want to come to the studio but be where he lived. So I had to move my studio to where they lived; so, for me, it was quite strange to be away from my place.

BILLY WEBER

I didn't do the editing of the film alone, there were two other editors with me: Leslie Jones and Saar Klein, and everybody worked very hard and very late. A lot of tedious experimentation went on. It was a difficult process, a tremendous amount of footage not just of the actors, but a lot of footage of everything in nature, of battle scenes, of the natives that lived in the Solomon Islands. So much of *The Thin Red Line* is a combination of music and voice-over and film – more than *Days of Heaven* and more than *Badlands* – each movie stepped it up a little more with more footage, more music, and more shots of non-linear storytelling. I have the feeling that the *The Thin Red Line* takes the most chances of the three of them.

SEAN PENN

Terry, in my view, is a purist. I think he makes the movie three times, once when he writes the script, once when he's shooting it and there's another writing period in the editing room. It took me a couple of weeks to adjust to this, and some heart-to-heart conversations with Terry about what kind of contribution I could make, because I had never been involved in something like that. I can't speak for what secrets Terry has in his head – when he shared certain things with me, he would often say, 'Loose lips sink ships,' Terry has a lot of secrets and, at some point, if you want to be supportive of a director, you have to be supportive of those secrets. But sometimes as an actor, it's hard to. It was a unique experience in the sense that, coming into it, I had always

worked in such a way where I was trying to put bits and pieces of a character together, based on the way in which the script was structured. In this case, it became clear to me that we were all going to be the ink and the pen in the editing room and that, in the end, he was going to write another story with us. So for me to analyse it would be to corrupt my view of it as an audience. I went into that movie and I saw something as surprising to me as it would have been to you, or anyone seeing it who was not directly involved in it. I think it's a beautiful movie, but it wasn't anything to do with the script and that became clear while we were shooting, and that's just the way he approaches things.

HANS ZIMMER

I wrote a large chunk of the music before Terry went shooting, but it was like a first draft, like finding our language. Some of those things did find their way into the film but never where I thought they would go. One of the things which I thought was good was to just give them pieces of music and see where Terry – or Billy – felt they should go once I found the tone. It was not so important that it had to be specifically tied to a character, even though Terry always wanted a theme for each of the characters, like a Witt theme and so on. So I kept trying to broaden that, because I felt it was not about a single character but about the whole. And it was nice to have a piece and just move it to something completely different. Of course, it was not up to me to move it, but just give it to Terry and Billy and see what it inspires in someone else. The question was really 'Where do they think this or that piece of music would work?'

During the editing, Terry had a weird way of wanting to work. At a certain point he wouldn't look at any images unless there was a piece of music to go with them, so sometimes I would write a piece of music first and then he would fit some images around it, or sometimes we would just move a piece of music to go over some images that Billy had cut. With the opening of the film, I can't really remember which way round it

worked, but without the image, the music wouldn't work and the image probably wouldn't work without the music. It was very much about symbiosis, about how are we going to create one thing out of two elements and these images would change all the time, would change for a year. It's not like Terry didn't shoot enough! I mean, we had more trees and crocodiles . . .

I would write things and then we would slowly sneak up on things, not jump on things. We would fiddle and tinker and modify, maybe get a performance slower, maybe get it a little faster: the notes wouldn't change that much. Sometimes it took Terry a long time to figure out that the notes were good; he had to get used to them. I wrote one theme which was really the theme for Witt and the first time I played it to him he said, 'Oh, no. It's all wrong, nobody can remember this tune. I want a tune you can remember.' Two months later, it was 11 o'clock at night, he called me: 'What's this tune? I like it.' He was humming this tune over the phone. And I'm going, 'Well, that was the tune you said nobody could remember! Okay, fine.' Then it was back in.

That was how we all worked. I'm not telling a funny story to be critical of Terry, but it takes a long time to figure out how all these pieces fit together and that's why I think we spent a long time on it. I somehow wish we had another six months on it, I think we would have done a better movie . . .

MIKE MEDAVOY

Terrence Malick is a unique individual; he works differently from other directors. He works, as he's said, from the 'inside out'; he works each scene by itself; he doesn't see the total picture at one time. I'm accustomed to working a little differently. We had a different sensibility, but as it was going to be a Malick film and not a Mike Medavoy film, I didn't participate much in the editing. This reminds me of what Billy Wilder once said about Marilyn Monroe. Someone asked Billy Wilder how could he put up with Marilyn Monroe being late, and doing all those things and not learning her lines and everything, he replied: 'I have an

aunt, her name is Sadie. She can be on time, she can remember her lines, she can be courteous and do all those things, but when I put her in a movie no one would come and see her.' This is a Terrence Malick film – so what else am I doing?

BILLY WEBER

When we cut the whole movie together, it was five hours long but the structure was very similar to what we ended up with in the final version; a couple of things got moved but not a lot. We did it according to the feel of each scene, and then, when you put all the scenes together, you see how the whole movie feels. It wasn't that long a process because the editing equipment made it possible to try things quicker than if we had been doing it on film. Once we'd reached a certain point, we would screen either the whole movie once a week, or sometimes we'd screen a third of it and see how that felt. And then part of it is just the very realistic sense that we had a release date on that picture – on *Badlands* and *Days of Heaven* we didn't have one – so we had to finish.

HANS ZIMMER

The thing we figured out pretty early on was that the more dialogue we took out, and the more we relied on images and music, the better it became. But it's a very fragile animal and you have to work very diligently and cautiously so that it doesn't just all collapse.

BILLY WEBER

The script was extremely long and it was sort of all over the place and it was only while Terry was shooting that he was able to refine and create the situations between the characters. We had so many actors in it, and they would come and go. We had a couple of others that we ended up not using. There is a whole section with Mickey Rourke that's not in the movie, because of where his character came in. We didn't want to start telling that

story so late in the movie, so he's gone. And Bill Pullman was in the movie.

But we had too much going on and we felt we really needed to focus on Witt's character, on Jim Caviezel. He's the one who was going to get killed and so we felt we really had to focus on him and the only way to do that was to cut away as much of the other stuff as we could. We cut out some wonderful scenes with Nick Stahl, including one particularly great one which we had to take out completely because he wasn't a main character. It really got in the way of being able to focus on Witt's character, and especially because of the voice-over we knew we had to home in on his character a little more. We were afraid we didn't have enough footage of Witt to do it, in the most ideal way, so we just had to take scenes out.

DIANNE CRITTENDEN
The casting of Terry's films shapes the way the final film comes out too, because if Terry starts to fall in love with a character, then that character will become the main focus of the film, even though in the script it might not have been that way. So in *The Thin Red Line*, the focus of the script was on Fife who was played by Adrien Brody, and then in the editing of the film he almost disappeared. I guess he must have shot enough film to make something approaching a six- or ten-hour mini-series, so in the editing of the film he decided that the story of Witt was the more interesting story and that's how he then switched the whole movie around.

BILLY WEBER
The biggest change in the editing was the opening with Witt on the island with the natives. We never had it in the movie where it was meant to be – ever. From the beginning – when we first cut it – we decided we should try starting the movie with this, and we did it. The movie had a story structure where it had to get from the landing to the first battle; we couldn't change where

the battles occurred. So the overall structure of the movie never really changed. We just moved little things around, consolidated things. There's a battle in the movie where they go up to this rocky point and fight the Japanese, that used to be three battles and now there's only one, but everything else that came between those battles is still in the movie: they just happen before and after, rather than during those battles. They would go up and fight the Japanese at the rocks and then come back down, then they would go up again and then come back down and they would finish it on the third one, now they just go up and stay there until they win. But the overall structure remained the same.

HANS ZIMMER

I keep questioning about *Thin Red Line*. There was a big cut we made in the middle of the movie where we took out a whole battle which seemed really the right thing to do at the time, but now I am questioning if we should have left it in the movie. It just made everything. There is literally them trying to go up the hill three times, and in the movie now they only do it once. It was really a very, very good cut, a genius cut that Billy did – but there was something about the balance of the elements. Making the innocence later on more poignant, by having more violence, longer violence, earlier. It is like the contrast of black and white and the black was blacker and the white was whiter. Because we were making an unconventional movie, so what was the difference if we became even more unconventional? You know, when you are making a movie, you always think it's too long or something. There are rules and we were breaking enough rules . . . so it's a pity we didn't break that rule as well.

Brig Gen Quintard
You're a humble man.
Nobody wants that island . . . but you.
How much do you want it?

Col Tall

As much as I have to, sir.

Col Tall (voice-over)

All they sacrificed for me poured out like water on the ground.

All I might have given for love's sake.

Too late.

Died . . .

slow as a tree.

[. . .]

The closer you are to Caesar,

the greater the fear.

BILLY WEBER

The words that they're speaking are all thought out. I would say that for *Days of Heaven* the use of voice-over is almost accidental; he didn't intend it and it became a necessity. In *The Thin Red Line* the use of the voice-over is so much part of the book; the Ben Chaplin voice-over was always intended and a lot of Sean's voice-over was always intended, so we decided: 'Well, let's just do everybody.' And it fed into the idea which was the James Jones idea, and also Terry's, that it's all one voice, it's all expressing the same thing in a different way. It's all one voice, one man, one idea.

JACK FISK

Terry used a lot of voice-over. But the scale of the picture was so different from the previous ones: what Sissy narrated was really about two characters and Linda Manz's narration was really about one little family, four characters. *The Thin Red Line* had thousands of characters and I think that by adding voice-over you get to appreciate the differences in the vastness of the involvement of that war – how many people there were and how many were coming from different environments and had different reactions to the war. I think James Jones was responsible because he wrote the main characters.

BILLY WEBER

The voice-over was recorded over several months. We tried voice-over with many different actors. We had voice-overs with Sean Penn, Elias Koteas, Jim Caviezel and Ben Chaplin too. It's all there in the movie, but most of the voice-over is by this little guy who you meet on the ship early on, Pvt Train, played by John Dee Smith. And then he's on the ship as they're leaving the island at the end. He does the bulk of the voice-over, almost all of it. Unfortunately, it's not clear enough to an audience, most of them think it's nearly always Witt, but it's this other guy.

HANS ZIMMER

It's not like the characters expressed themselves in words all the time; the movie was getting better and better the more we took the words out; you understood more by saying less. I think we all were striving to get the movie to be a visceral experience like a poem. The truly great thing about Terry is that he searches in a very pure and a very collegial and democratic way for something. He can't even pose the question, but we know there is a search on and we are going to find something that we didn't even know what we were looking for.

JIM CAVIEZEL

When we were on the plane going over to Australia, David Harrod said, 'Hey, guys, this film is all going to be voice-over.' We were looking at him as if he must be crazy, because when you looked at the script it was written in perfect script form. We all had dialogue; we all had scenes, so I thought, 'Where are you going to fit voice-over in?' I'd say that twelve or thirteen of the scenes that I did, that were with dialogue, got taken out of the movie.

When we were in the editing room, he had a lot of us come in to do the voice-overs. Some of them he kept; when he had a scene with me in it, he'd have the voice-over. But the biggest voice-over in the movie was by John Dee Smith, a kid out of

Tennessee, a kid who just walked in. His friend was auditioning for the film and he happened to be in the room and they just said, 'Why don't you audition?' and he got the part! And he had one of the biggest voice-overs in the movie. It's not a voice you'd recognize, because he had a little role in the film. He's the guy's voice that said, 'We are a big part of one big soul.' He was the guy down in the ship when Sean was cutting his hair. He says, 'I'm not afraid,' and he's clearly scared out of his mind with fear and then he says, 'I've gotta whole life to live, I'm too young to die.'

BEN CHAPLIN

Most of us who were involved in the film and a few others who weren't involved in the film actually tried to do some voice-over, because I think Terry just wanted to cover everything, same as he does when he shoots. He's trying to find a line through, because there are so many characters in this film, so many more than in the previous two films, and he wanted to cover himself in terms of the inner voices of each character. It's the first time he used multiple-character voice-over.

He wrote the voice-overs mainly after the film. He'd write some stuff during the film and I remember doing some recording sessions in Australia, during the shoot, of things that he had written. Then in the year of post-production, I would go in quite often. Every time I was in Los Angeles, I'd go in and do a few hours reading his poetry. That was one of the few times that he would actually tell me how to say it. He'd have a specific idea of how it should sound because it was difficult stuff, quite difficult to understand, a lot of it was quite abstract. I hate getting a line reading from a director, but I love getting them from Terry.

I did hours of voice-over with Terry – it's pure poetry. And he's almost embarrassed by it: 'Just try reading this . . .' And moments of it made it into the film.

It's a gift to be able to speak that kind of language on a film. It never happens. You never get to say something like, 'Let's flow

together like water.' And that flashback of us bouncing into each other by the window, that was reversed; the film was going backwards through the camera and then played forwards. It's a gift. It's like having your character's innermost thoughts which he could never really express himself. You get this whole inner life. No one else does that but Terry.

ELIAS KOTEAS

During the editing process I saw some of the material that he would give different actors for the voice-over. I thought that it was beautiful to actually hear what these men are thinking and fearing, because when you're by yourself in the mud and the grass, what are you thinking? What's going on in your head? You're not used to seeing what is going on in these guys' heads. How beautiful everything is, in the middle of all this madness. I think that if you see this movie twenty, thirty, forty years from now it will still speak to you even more, because he went into the thoughts of the characters. A lot of people come and say everybody sounded the same, as if we were all one unit, in one soul. I adore what he aspires to in all his films.

> *Pvt Train (voice-over)*
> Maybe all men got one big soul
> who everybody's a part of.
> All faces of the same man.
> One big self.
> Everyone looking for salvation by himself.
> Each like a coal
> drawn from the fire.

ARTHUR PENN

I think that the use of multiple voice-over is a sensible narrative path because the thing about the army is that there is no one person, there is no Tom Hanks, you know? That's what's crazy about *Saving Private Ryan*.[20] There's a lot of people who don't

know each other, who don't know anything except their own terror and their own fear. That was natural to Jimmy Jones and it was natural to Terry. It is not an unusual event to have several narrators in the film.

HANS ZIMMER

The main piece of the score is called 'A Journey To The Line'. Terry and I would argue a lot, and Terry would say that the way we argued was like brothers – only brothers could argue that badly. We would have big fights. I remember saying, 'I have this idea to use the minor third. It's like the waves crashing against the hulls of the ships. I think there is something good about the oceanic thing.' And he said, 'Oh, no . . . You don't want to do the oceanic thing . . . I think it should be open like a fifth.' Of course, I am getting really annoyed and I replied, 'Hey, Terry, you haven't even heard my idea yet and already you are criticizing it!' So I went back to my studio and, literally, in an hour I just wrote that piece. I bashed it out and it probably breaks every rule in music: it's all in minor thirds and none of the chords should follow each other. It's asymmetric as it's in eleven bars and I just dragged this over to the cutting room and said, 'Let's just put this on!' I think that was the first time that anyone felt that the movie was coming together, that these images were coming together and had a voice. Sometimes that's what happens – you go totally against what the director says and that's where the good ideas are. And, of course, Terry recognized it straight away.

Anyway, just after I read the script I thought, 'Oh, man . . . This is going to be tricky!' The script was full of words and I didn't think it was that interesting to have that many words, but I thought that music can really help it along the current of the river. Hence my conversation about the minor third, because I thought, 'Okay, the river was probably Terry's way of saying it.' Mine was the waves crashing against the hull, the endlessness of the sea, endless space, something propelling you forward. And if you listen to the piece in the movie, they all have that sort

of murmuring of water and rivers underneath them. Terry and I both love the Smetana's *Moldau*.[21] Terry is very romantic in his choices. In a funny way I think sometimes the music I was writing wasn't romantic enough for Terry and I tried to keep very disciplined about not being too romantic. I think it is very dangerous: you see people dying and hear romantic music – I just didn't want it to be another one of those movies . . .

BILLY WEBER

I feel like that if the movie flows like a river, it's not because of the Akela crane and it's not because of the Steadicam. It's because of some other sensory thing, some other sensibility that gives it that river quality. It's the music or the storytelling aspect.

HANS ZIMMER

I think all the music in *The Thin Red Line* has dignity. It speaks to the dignity of human beings and I think that comes through. Without being warlike or heroic, there is a nobility to it.

I used few horns because I didn't want it to be a war movie! It's so obvious! Every time somebody was shooting at you. I wanted to go and do the opposite and have the most delicate and beautiful and poetical sounds that the strings or woodwinds could produce; I never wanted it to become as rhetorical as 'We are going to war!' I think the times I did use the horns, I would always have them go in a tragic way.

I tried to make it emotional, not sentimental. I think it's an important word. Ridley Scott used to say that sentimentality is unearned emotion. I was always remembering that. We worked hard – I think we earned every emotion, every note. The story was working hard and the characters were working hard, so the emotion was earned, it was never gratuitous, it was never senti-mental, it was never that Hollywood bad . . . you know what I mean. It was abstract!

The main idea was to never answer a question with the music. I think what I loved about what Terry was doing with the movie

was that he was posing questions and never answering them; everything was a question. I was trying to do the same with the music, so the tunes would never quite complete and the structures were never really symmetrical and it left a door open for you as the audience to complete it. I wanted people hearing it or watching it to participate in the journey, in a way.

About the other pieces in the score – I have come from European film-making where we have always used classical music in our films; when I worked with Peter Weir on *Green Card*,[22] he used the second movement of a Mozart clarinet concerto. The first time I saw the movie I said, 'You don't want me to write something like that, it's a perfect piece of music. We will just buy this piece, I don't see why not if it conveys what you are trying to say so well!' As opposed to doing a cheap parody or imitation of it. If it's the right piece, I don't care where it comes from.

So Fauré's *In Paradisum* was one of the pieces that were always going to be in the movie. Both Terry and I love that piece and there was no way I was going to try and write something like it. Why bother? It's a perfect piece of music! I was very happy I didn't have to write it! I love Fauré's *Requiem*. Lots of people have started using it in movies now. It's just so different from anything else. I keep thinking of all the pieces that Terry has had in his movies – it is the piece that most describes Terry for me. Another piece that was absolutely a point of reference was *Annum per annum* by Arvo Pärt.

What was interesting for me was just how simple the music is. Again, it is about leaving space for the human being to come through – you can actually hear them. One of the nice things for me was that Terry would draw me into these new worlds, because I had heard some Arvo Pärt but had never really listened to him.

It was a good period of our lives – as crazy as these things get – having to finish and meet deadlines with all the machines that get in the way, as we are making a movie and spending other people's money. It was still a great, very interesting time.

BILLY WEBER

Basically Terry came in with very specific ideas about the music. Some of them had to do with old American folk tunes that had no ownership. They were just songs that people sang, which had specific melodies but no instruments playing them, so we used those as the basis of their themes. Hans just copied them and put instruments to them; then we used the Solomon islanders' music as a basis for some of the themes. Terry also had some ideas from some classical pieces we wanted to emulate, not copy them, but give the same feeling, which Hans did. Francisco Lupica then added this thing, the 'Cosmic Beam', which is a steel beam that has pick-ups on it, that he plays and it's amplified and it has this otherworldly quality to it that we use in the movie in several different places. We had met Francisco right after *Days of Heaven* where he was using his steel beam on the first *Star Trek* movie.[23] He used to play it out at the beach, on weekends – he'd set it up and play it there. It's just a bizarre-sounding home-made instrument. It's huge and makes a huge sound, it just shakes the ground when it plays, and so we decided to try it in the movie and ended up using it! It was very experimental in terms of where we'd use it . . . We tried it a lot of different places and ended up using it only in three or four places.

HANS ZIMMER

Terry was saying, 'No synthesizers in this score. It has to be pure, it has to be orchestral . . .' But for me it is just another instrument. I mean: a violin is a piece of technology, it is designed and it is built by human beings. Another sound Terry loves is the sound of a big church organ and that is a precursor to the synthesizer! Plus, Terry had this idea to work with an instrument called the 'Cosmic Beam'. Terry knew this guy from the '70s who had invented this crazy thing. It's a maybe twenty-foot-long piece of steel. On top of it are strings, and there are huge guitar pick-ups. Basically, you put it into a huge PA and you hit it with baseball bats.

Terry always said it should be like the sound of giants leaping under the earth.

I am not a purist – if you ask me what synthesizers I used, I don't know – I just use what is lying about in my room. I still have some of the original Moog modular systems so I can't remember exactly what I used; we build a lot of our own technology here as well. I didn't really want it so you could tell there was a synthesizer in there, I just wanted to create a coherent sound. But sometimes, quite honestly, the synthesizer strings sounded more acoustic than the real strings, because I could play it so delicately and so quietly – more quietly than human beings can play. One of the things I think was important for the whole effect was that the sound was very transparent. I think we managed to get quite a beautiful, transparent sound, some of it was just taking the real orchestra and treating it with effects. So the line between electronic and acoustic sound is for me very thin. Anyway, we recorded the acoustic instruments in an electronic way with microphones. I tried to do it so that Terry couldn't catch me at it, he couldn't just go and point and say that is too electronic or that sounds like a synthesizer.

BILLY WEBER

Andy Nelson is a great mixer and had a great feeling for what the movie was, the way it should be handled. Previously, I had mixed a couple of movies with him. We have a very good collaboration, so it made the mix very pleasurable and a good process. We brought Andy into the process very early – we would have him come to screenings of the movie, so that he really had a sense of what we were trying to do.

HANS ZIMMER

Andy used to work for The Who and so he has the same background as me, from rock and roll. He worked also for Stanley Kubrick on *Full Metal Jacket*.[24] I was around a little bit at the time . . . Andy and I have done lots of films together. We also

worked together on *The Simpsons Movie*[25] and that is a slightly different mix to *The Thin Red Line* – trust me!

I would be nothing without Andy, so you have your team and the people you love working with and part of it is the people you love spending time with, and enhancing each other's work.

JOHN TOLL

As much as any film I've ever worked on, this picture was about an idea. I believe that what Terry wanted the film to be about, most of all, was that the real enemy in war is the war itself. War – not necessarily one side or the other – is the great evil. It isn't often that one gets to work on films of this nature, and I'm grateful that I had the opportunity to participate in it.

PENNY ALLEN

Terry's work is all about the struggle for life. The fact that it's a war film for me is only that it's a metaphor for this and, in an odd way, I feel it's true of all his films. He never judges people, as if there is nothing in Terry that is about existing morality in the conventional sense; it's about man's need for the spirit.

ELIAS KOTEAS

Terrence Malick has such a little kid in him. He looks at things with a sense of wonderment. Cynicism doesn't seem to be part of it. So there's always this optimism, this joy for life, for all that's around us. And he wanted your input, he welcomed your thoughts, he didn't make you feel like you weren't a part of it – you wouldn't have been there if he hadn't seen something in you.

So, for me, it's life before Terry Malick and life after Terry Malick.

PENNY ALLEN

For all the boys I worked with, there is a before *The Thin Red Line* and after *The Thin Red Line* like there is BC and AD. Their lives are different regardless of how well they think they did in

the movie. People will do anything for Terry Malick. Probably it is his enormous humanity and lack of judgement – somehow seeing into you, feeling you energetically. I don't know if Terry believes in goodness; but when he looks at you, it's like you're okay. However you are in this world, at this time, at this moment, you are okay! This is very rare thinking. Terry gives you the space to be, to exist, to dwell in, without a judgement that you have to be anything. You simply don't have to be anything with Terry and it is very powerful. People will do anything for someone who gives them that.

HANS ZIMMER

For me, one of the most beautiful shots is one towards the end of the movie. It is just a coconut lying on the beach and it is completely random. It always really moved me and I remember saying to Billy, 'How did you catch that random coconut?' And he answered, 'What do you mean "catch" it? Terry spent a whole day moving that coconut around because it didn't look random enough!' That's how we did things.

JIM CAVIEZEL

Another thing that makes Terry Malick an enigma is that everyone is always going to have a different interpretation of his world and his movies. I'm sure Terry has a meaning for why he did what he did, but he never talks about it. It's how it strikes you, how we're all different, how we all have different views which will affect someone completely differently. Terry is so private he would never say, 'Well, this is what I meant.' He would just ask you questions on what you think about things, because if that's what you think, that's probably what's right for you.

BEN CHAPLIN

What I love about *The Thin Red Line* is when people come up to me in the street and say, 'I loved *The Thin Red Line*!' They really love it, they don't just like it. And people who don't like it, fine,

that's great too. It polarizes people, people hate it, people love it. The best films do that. But when people love it, it's like they're seeing a friend, they want to hug me and stuff. Women like this film, that's a great, great sign. Women don't like war films, so why do women like this one?

SAM SHEPARD

To tell you the truth, I was somewhat disappointed by *The Thin Red Line*. I hate to say that. The book was so tough, so hard-edged and rough in a way. It wasn't gilded at all. And I felt that Terry intellectualized it a little bit too much. I don't appreciate it as much as the other two. I don't know exactly why. It didn't feel as direct as the other two. It was more like he was thinking about it too much. And also the fact that it was based on a book and the other two weren't. Maybe that's it, I don't know. There are extraordinary things in it, but the book was so tough and so uncompromising. The other two films were brilliant. *The Thin Red Line* is my least favourite.

EDWARD PRESSMAN

I am a big fan. I loved *The Thin Red Line*. It seemed to divide people, it was definitely a split reaction, but I'm totally enthusiastic about the kind of poetic and non-linear aesthetic that Terry brought to this film.

I think Terry stands for something that goes back to the reason why I got into films at the beginning: he has a fundamental belief in the power of films, in their significance. When we started, we thought films could change the world and the films that I grew up with, whether it was the Truffaut films or the De Sica or Fellini films, they affected the culture in a way I guess maybe, in other years, rock music did too. As one of the Taviani brothers said, 'We're making the cathedrals of our times.'

ARTHUR PENN

What's the influence of Malick? It's the same thing that influences

dozens of people. People like Cassavetes, people like Altman, a lot of us went off and made movies because we wanted to make a movie, and Terry has done it. *The Thin Red Line* is a good war film, not one of the very best, frankly. It's very good but it's not one of the very best that I have seen.

JACK FISK

I think that, for myself, I get excited just to be in the presence of an artist as great as Terry and watching him work and seeing how his films are appreciated and affect so many people. I hardly ever see films that I've worked on after the immediate screening, but I get more enjoyment by seeing other people being affected by it. And I feel a sense of pride of being a small part of this work.

SEAN PENN

The importance of Malick is just showing that it's okay to put a couple of thoughts into a picture . . . in a culture that doesn't. I think it's really simple: he's an artist and we need art.

The New World

JACK FISK
Terry works on several films at the same time. He is continually experimenting with the art of film, changing the construction of films and continually experimenting with performance, editing and light. Before his career as a filmmaker, Terry was working in Bolivia as a reporter for an American magazine covering the trial of Régis Debray after Che Guevara was killed in October of 1967. So he wrote a script about Che and after *The Thin Red Line* we were planning to shoot the film in Bolivia. I spent time there retracing Che's steps through the country, from his first camp to the schoolhouse where he was executed. The challenge was how to support a crew in Bolivia since many of the locations we liked were in very remote villages and jungle. The image of Che was very alive in those places. In the markets of those small villages I would find a picture of Che hanging next to a picture of Jesus.

SARAH GREEN
Terry met cinematographer Emmanuel 'Chivo' Lubezki when he was planning to do *Che*. He asked him to do *The New World* instead and lucky for us he said yes. Chivo is a true master, and he and Terry and Jack Fisk formed a powerful team.

JACK FISK
I know the insurance bond company was hesitant about us shooting the film in Bolivia. At a certain point Steven Soderbergh, the producer on the project, decided to take on the direction and changed the script and location of the film. The movie that he made is very different from the film Terry was planning to make.

The New World

SARAH GREEN

When I was contacted the first time by Terry, it was a very great moment in my life because he had been my favourite director for many years. I was driving in my car and the phone rang and a voice said, 'Is this Sarah Green? This is Terry Malick,' and I just started screaming, 'Terrence Malick the filmmaker?' He called me out of the blue because a mutual friend, Michael Barker, who runs Sony Pictures Classics, had suggested me as a possible producer. Terry called me and we spoke for hours, and then we kept speaking, often, until finally we were in the same city a few months later and I met Terry and his wife, Ecky. It was probably five or six months before I knew anything about *The New World*. He had other projects he was trying to move along at that time and other people involved in them and so I began helping him – I would look at his budgets or talk through his plans. He said that he might be looking for a producer in the future; he told me what he was looking for and how he liked to work. We spent a lot of time talking about how we each liked to work, what we like in movies and what was important to us. Over time we began to understand that we had enough similar points of view that we might work well together and, in the meantime, I gave him advice on his other projects. One day he said, 'I have this other movie; this might be the right time for it, would you like to look at it?' 'Of course,' I said. 'Yes!' As soon as I read *The New World* I said, 'This is the right time for this film. We should do this now.' He had had the project for many years and he'd been thinking about it during the time that he and I were getting to know each other, but he didn't bring it up until he was ready.

Executive producer Bill Mechanic, who had been at Fox when Terry made *The Thin Red Line*, now had a production company called Pandemonium Films. We had all hoped that we'd finance the film through Bill's new fund, but it took a long time to put together, longer than anyone had anticipated, including Bill. At this point we had begun talking to Colin Farrell, who wanted to do the film, but had a narrow window of availability. We

were working with Rick Hess at CAA to put *The New World* together, who learned that the folks at New Line were offering Colin another project. He told them that Colin was waiting for this Terrence Malick film; they were immediately interested, and a deal was quickly made.

I was trained on low-budget, independent films. We had a lot of fun making them, and I think the directors felt protected. I have always been very director-oriented; I think everyone should have a voice on a movie, but ultimately it's the director's vision that we are all there to support. I know Terry spent a long time thinking about working with me, and I really enjoyed the time we had getting to know each other, because I need to know I can trust a director so that I can make the best choices to protect both the director and the film. From having seen his work, I know he is a great artist, so it is very easy for me to support him. I believe in what we are doing and I believe in him personally, in his integrity. The longer I work with Terry, the more I understand why we work the way we do, so now it is easy for me to talk about our process with our financiers. During *The New World*, I often turned to Grant Hill, Terry's producer on *The Thin Red Line*, for reassurance. I was lucky to have someone who had worked with Terry to consult with as I learned his style.

JOERG WIDMER

Sarah Green was always on location. She is a wonderful support for a director because she was very respectful for what Terry was about to create and she was already amazed by Terry as a person and by the movies she had seen. She was always supportive and never demanding. I'm not sure how much he needed it, but she was encouraging and hardly limiting. I think if you shoot a movie like this, as a producer, you have to be very strong and convinced of your beliefs. Because if you start a movie and instead of rehearsing you shoot and shoot and shoot – I think in the beginning we shot 15,000 feet per day! – usually the studio think that you are wasting stock and money. So if you are a real

producer, I think you have to believe in what you do, and she did.

I was the camera operator and director of photography of the second unit. I was involved from the beginning in the preparation and then was there the whole movie, as a camera operator, mostly with the Steadicam. I met Terrence Malick after the producer of *Che* contacted me. I was in LA and I thought it would be a good idea to meet Terry, so I tried to find out if he was there and we met up and he said that the film on Che wouldn't be made with him, but he asked me if I was interested in a new project and I really was. I was suddenly in a 'new world' and I met Chivo Lubezki who was shooting *Lemony Snicket*[1] at Paramount studios and we got on very well, so we decided to do it together. I was involved a bit in the preparation because Terry wanted to shoot everything in 65 mm from the beginning and then they discovered it was very expensive. But we prepared the 65 mm shooting, and shot some sequences on the Steadicam.

SARAH GREEN

The first person involved in the film – after Ecky, of course – was Terry's long-time collaborator, Jack Fisk. It was a given that Jack would be there; he is part of Terry's film family. During the time Terry and I were getting to know each other, and making inroads on other films, he had met with Emmanuel Lubezki. They had met for the *Che* project, and had really connected. So when it became clear that the *New World* project was a go, they had formed such a bond that he asked him to shoot this film instead. We wanted people who were appreciative of Terry's films and of his process. I think that one of the most important qualities for a crew member, besides being extremely skilled, is flexibility. To work on a film with Terry, you need to be comfortable with change.

JACK FISK

Terry loves working with a small crew and strives to pare down the support until he is comfortable. He often wishes for the size

of crew we had on *Badlands* (about thirty-five people). Actors carrying cable and the props people also doing craft service delights him. He likes to decide what he is going to shoot at the beginning of the day. This is difficult to prepare for, but his passion is infectious and the crew continually tries to accommodate his wishes.

SARAH GREEN

Regarding many of the crew, we put together a list of people whose work we admired, and whose reputations were strong, and we put them on the phone to Jack Fisk. Jack really responded to costume designer Jacqueline West because of her work, her enthusiasm and her knowledge of and interest in the native community.

JACQUELINE WEST

Honestly, it is a bit of a mystery how I got hired on *The New World*, but on a Terry Malick film you get used to mystery. I was surprised when my agent put me up for the film because I thought that Terry always worked with the same team, like Bergman, and Orson Welles. I knew that everyone would love the chance to work with him, and I was very curious to meet him. So when I walked into the office, I was first put on the phone with Jack Fisk! Terry was not in there. I was in LA and Jack was in Virginia. I had never met Jack, I knew his work, I was excited to talk to him, I knew he directed movies and so the meeting was more like talking with a director. I told him my vision for the film and we just started talking and got on really well. I had read the script about four times and had watched all the Tarkovsky films, especially *Andrei Rublev*,[2] just for my own enjoyment. I was so struck by the cinematic language of Terry's script. It was a script that posed more questions than answers, which was the beauty of it and so I knew I'd have to approach it from a really different way to any film I had done. I started talking to Jack about that and the last thing Jack said to me was

how much he loved the look of *Quills*[3] – the film that I worked
on before – and the meeting was over.

JACK FISK

Jacqui West loves the Indian cultures and had much to contrib-
ute to the look of this film. I think her work on the film and
especially with the Indian clothing was brilliant. After *The New
World* I have worked with Jacqui on several films and we seem
to be in sync without a lot of dialogue; I had a similar working
relationship with Patricia Norris.

JACQUELINE WEST

About a week later I was called in to meet Terry himself and to
bring all the visuals I had brought with me to the first meeting
that I hadn't really shown anyone. I was so fascinated when I
met him; it was like the first meeting between Annie and Alvy in
Annie Hall.[4] I think he had on a bow tie – he looked so beauti-
fully attired, it was kind of formal but he never asked me about
my previous work like *Quills* or *The League of Extraordinary
Gentlemen*.[5] I think Jack was responsible for me getting the meet-
ing with Terry. He never wanted to see my book, the other films
I had done, but he was fascinated by the images of the Native
Americans I put out on the table; he was being polite and still
talking to me, but he was so fascinated by these drawings of the
Prince of Weed and Bognor, from this wonderful book *Travels in
America*,[6] and about halfway through the meeting he asked me
if I would go and meet with Colin Farrell the next weekend and I
said, 'Am I hired?' And he said, 'Of course you're hired, Jacqui!'
I had never been hired in a meeting before.

SARAH GREEN

Emmanuel Lubezki and Jack Fisk were very funny together,
they would tease each other. Chivo is as talented as Jack and
is equally smart. Chivo understands light, framing and story-
telling; he brings a lot to the table. As Terry, Jack and Chivo

began to find their rhythm together, the jokes began to fly. It was a very friendly collaboration.

JOERG WIDMER

Lubezki is an amazing director of photography. We talked a lot about what we felt when we saw something happen in front of us. We started talking about other movies, and then about what is interesting when you look through a viewfinder, how can you get into the natural environment? Chivo is so modest, one of the most exciting cinematographers alive. He is very into the product, he is not selfish, he is not vain, he simply follows what is needed for the movie. I'm so amazed by this personality in the service of Terry and his ideas, and putting him in a frame where this could work out. A lot of the testing of lenses, choice of formats, choice of cameras, the means to light or not to light, how to build a set for the light as well as for the story, the choice of the locations – all these were made by Chivo, Terry and Jack Fisk.

SARAH GREEN

Jack Fisk is an enormously important member of the team. There are so many things to think about on a movie and Terry is so careful about everything on his films, it is really important to have someone he already knows and trusts – he trusts Jack personally, and he trusts his artistry. Terry doesn't have to worry about the art direction. Jack is so good and so thorough and so talented, and understands Terry's aesthetic so well that he always delivers sets that work. Having Jack there takes some of the pressure off Terry, leaving him to think about things that are less clear. Jack was really wonderful to have on the film; both Chivo and I, who were new to the mix, depended on him.

The film, set at the beginning of 1607, tells the story of the meeting between the English settlers and the native tribe of the Powhatan in the territory that today is the state of Virginia.

The centre of the story is the encounter between the princess of the natives, Pocahontas, and the English adventurer John Smith,[7] who arrived in the new world with the English expedition.

The story of Pocahontas saving the Englishman, who is captured by the natives in the midst of an increasingly tense association between the two communities, is based on historical fact and is found in John Smith's diaries. Pocahontas became one of the first symbols of tolerance and liberty, someone who would see beyond cultural and ethnic differences.

The young princess married John Rolfe, an English settler and tobacco planter, with whom she had a child and, in 1616, she accompanied him on a journey to London to meet King James during which she was struck down by an illness and died.

Captain Newport

Eden lies about us still. We have escaped the Old World and its bondage. Let us make a new beginning, and create a fresh example for humanity. God has given us a Promised Land. And let no man turn against God. Let us prepare a land where a man may rise to his true stature.

JOERG WIDMER

It was the story of an encounter of civilizations, the British and the natives. There were some specific moments to describe the importance of this event. When the British settlers came to this new land, Terry had the idea that it was like the first men stepping on the moon, so there was a footprint which I had to shoot. We shot several versions, first coming from the water and stepping onto the sand, of someone really having this impact on this new land, but then he thought it reminded you too much of the moon landing and, finally, he avoided this and didn't put it in the movie. The object was to tell the story about British settlers coming to Virginia, about how it would have been such a fantastic society if they hadn't killed each other but, rather, had founded this new nation by respecting themselves and embracing nature.

SARAH GREEN

Initially, I knew very little about the script, except that the characters in it were the historical figures – John Smith, Pocahontas and John Rolfe. After I read it and lived with it for some time, I began to think of it as a story about love, a love that had huge implications for the world – historically and politically. Ultimately, it is about a young person's coming of age and understanding that love comes in many forms. At different times of your life you may be more drawn to one form or another – it's exciting to think about.

I think that if Terry made *The New World* twenty years ago, when he conceived it, it would be a very different film. I think any work of art reflects how the artist sees the world in the moment in which he's creating the work.

JACK FISK

Terry first told me about *The New World* a few months before we started prep on the film. The scene at the tree house in *Badlands* was originally written to take place in a wickiup or Indian hut. At the time I couldn't understand why he was thinking of an Indian structure, but when he mentioned Pocahontas and *The New World*, I was sure he must have been working on the Indian story before we even shot *Badlands*.

SARAH GREEN

Terry had done a lot of historical research over the years, but we had no idea where we would shoot the film. We thought that we would never find anything like the kind of old-growth, untouched woods and riverbank that we needed and we certainly never thought we would find it in Virginia in 2005. We imagined we would have to go deep into Canada, somewhere very remote. We scouted in Quebec Province and in Ontario, and did not find the locations we had hoped for. Jack Fisk, who lived in Virginia, suggested we go to the source.

JACK FISK

At our first meeting on *The New World,* Terry mentioned the Chickahominy River near Jamestown and talked about how beautiful it was. The next week I was back in Virginia, and with a friend and a couple of jet skis we surveyed the length of the river. It was beautiful and on that first day I found two locations that we later used for the Fort and the Indian village. I had studied the Jamestown settlement as a kid in the Virginia public school system and like most students had made models of the fort for history class.

Then I learned that Dr Bill Kelso, an archaeologist, had discovered the exact location of the fort in 1996, buried under a Civil War fort on the James River. Dr Kelso was discovering facts about the original settlement every week and was generous in sharing his findings with us. I read the *Jamestown Narratives,*[8] which are various written accounts by different settlers at the fort, including John Smith. I never really trust written accounts – often people write about things they do not understand, like construction (one colonist referred to posts as planks). For example, I believed the description of demilunes on the corners of the fort were misinterpreted as circles and not the French military fortifications that might have been used at the time; this idea has since been confirmed by findings at the original fort. The Virginia Company[9] was trying to attract settlers and raise money, so many of the accounts of the time were edited and embellished, to attract investors.

SARAH GREEN

After a preliminary scout, Terry, his wife Ecky, line producer Trish Hoffman and I met up with Jack in Virginia and looked around the real places where the events had taken place. We took a boat up the river, and we went to the Jamestown Discovery archaeological dig to ground ourselves in the area. We were thrilled because in the very area in which those events had taken place, Jack had found good locations which were also relatively

practical places in which to shoot. The areas we chose were all close together, and one could feel that it was the real place. We weren't trying to pretend one landscape was another. The energy of the place was palpable.

The native community has been betrayed over and over again, so they were sceptical about people coming in to tell their story – and I don't blame them. As soon as we were all there and settled, we invited the local native community to visit our set and workshops. We showed them the costumes and props we were working on, and asked for their input. We invited all the tribal leaders and their representatives, and about half of them came. Many were unsure of us. There was one in particular, Chief Adkins of the Chickahominy tribe in Virginia, who was fairly aggressive in the meeting. He wanted to know why we called it *The New World*, and he explained that it was not the new world at all: they had been there for thousands of years.

Chief Adkins asked a lot of other questions, and we were very straightforward with him. I think what turned him around was the obvious passion and work that was being put into getting the research right, how we were going about things, who we were hiring, and the fact that only natives would play the natives in the film. Little by little, he started to feel a bit better about us. Most importantly, the two designers were so articulate and so passionate about what they were doing; I think people felt a little safer because of that. I know that Chief Green of the Patawomeck tribe took a liking to them right away and helped Jacqui out with turkey feathers and headdresses and all sorts of other things because he could see the honesty in her, could see that she was the real thing and wasn't out to exploit anyone. I became very fond of Chief Green, who has the same name as my father, and was incredibly moved when he made Jacqui and me honorary members of his tribe. Before we began shooting, we asked Chief Adkins, who is also a minister, to come and bless our set. It was a wonderful blessing about keeping everyone safe, and keeping the land safe, which he ended with 'And I pray that they get it right.'

JOERG WIDMER

It was very much the intent of the whole crew, and especially Terry, to work with respect for their ancestors, to respect the tradition and life of the natives. I think it is the first movie about Eastern Natives; all the other Indian movies were about the West. It was an expression of deep respect for these people who had lived in this country before the English came, and there was deep respect for their beliefs, religions, traditions and also their approach to nature. So, when they did their first rehearsal about how to move and how to behave in the camps, it was very much about their tradition of dancing. There are some native dance crews in America and their members, I think, were involved in the first native cast. They tried to work out how they should move, because it is not their life. It was amazing to watch them when they figured out how to dance, how to do their spiritual dances, how to move when they fight, because it was like a dance; it was like behaving like animals, like snakes, like dogs, or like rabbits, or running and suddenly stopping, completely different to what you are used to seeing when humans move. When they first meet the British, when they first touch them, they behave very strangely because it is so surprising for them to see other humans.

JACQUELINE WEST

Collaboration was fundamental in making the movie on all levels; every department wanted the support of the local tribes. Since the Indians passed on their history orally, I found that the local tribes had very few museum representations. Of course we had the John White[10] references. I was concerned about how a man and woman in 1607 would get up in the morning, how they would put their clothes on, then how they would go out to the ocean as those Indians had done for hundreds of years and see the very first invaders land. It was almost like an aborigine seeing and confronting a fairly cruel civilization for the first time.

JACK FISK

I studied the watercolours and drawings of John White, the paintings of Jacques le Moyne de Morgues[11] and the engravings of Theodorus de Bry.[12] From the work of these artists, I attempted to understand Indian construction techniques, the layout of their villages and examples of their dress. Terry also encouraged us to look at African natives for ideas. The writings of Henry Spelman[13] gave me many clues about the Indian culture.

JACQUELINE WEST

I agonized about making sure that the natives would be dressed exactly right; but the Indians weren't forthcoming with a lot of research. They dressed like Plains Indians at their pow-wows and I felt that they didn't really know what people looked like then, so I became obsessed with recreating it for them, so they could feel their ancestors. They loved looking at the research with me, loved where I came up with certain ideas for their individual costumes. What they did do was really help me with the materials, helped create that feeling with such generosity in both the Mattapament tribe and the Patawomeck tribe – the Powhatan Indians under Chief Adkins. So for me it wasn't so much collaborating with them on the look, but working on it until I was proud to show them what I had come up with – for them, and for their ancestors. They made me a tribal member of the Patawomeck and the Powhatan tribe because they said that they felt that I and Jack had done the most beautiful job of recreating, patching together their past, which many of them had no idea of what it looked like. My tribal name is White Deer Woman, so I feel that I pleased them in some way.

SARAH GREEN

We began by reading everything that was out there, books and articles and documentaries on the period and the events. One of the great advantages of working in Virginia is that we had not only the Jamestown-Yorktown Foundation who maintained

a recreation of the original fort but also the APVA – the Association for the Preservation of Virginia Antiquities – who were doing an archaeological dig on the actual site. So we had incredible, well-informed experts and access to information that was changing by the day. Jack worked closely with the anthropologists and learned from them, as they would learn from him as he was building the fort using the same techniques these folks would have used back in the day. It was a wonderful back and forth.

With the native community, there was less information because the only written reports from that time were from the European perspective; the tribes – and their languages – were mostly wiped out. We assembled the drawings and the writings that dated from the time and spoke with historical experts. We also spoke with the tribes themselves, their elders and their historians, to try to understand their oral tradition, and what has been passed down over the generations. We asked them their perspective on the legend and it helped to open us up to the different ways one might interpret the story. Ultimately, no one knows what really happened or how it really looked, so in many ways we had to go with our instincts and, in some cases, our dreams.

JACQUELINE WEST

My job with Terry was not to be abstract; it was to make real visual interpretations of the characters: I didn't think Patricia Norris was abstract at all in *Days of Heaven*. Terry wants to go out of the boundaries of real time into suspended time, but this subconscious process can only take place when everything is aesthetically and historically as real as possible for him. So I dive deep into Terry's characters, in the dress. I read the script so many times that Terry's characters jumped off the page and dressed themselves, so vividly were they painted in the script. So when I approached the native costumes, I was really dressing individuals in the most realistic way possible; I read a lot because John White's sketches are so classical, and almost heavy, like

they were in stone. From my first talks with Terry, we wanted everything to be very organic, not have a rigid, classical feeling: these Indians are very refined. They had the most refined show-work on their costumes, the cutting of their fringe was all done by hand and it wasn't cookie-cutter fringes like you see in the Plains Indians; every piece they made they decorated with shells, pearls and feathers. I knew it had to be much more flowing and free, so we made every individual Native American totally different – there was no duplication of jewellery or headdress. Every native had four to five different, complete changes which we could then reconstruct into even more costumes because we changed people almost every day. But I drew on some of the chroniclers of the Plains Indians: Edward Curtis,[14] George Catlin,[15] Thomas E. Mails;[16] I read all of Stephen Laurent.[17] I used Bogner,[18] Jacques Le Moyne de Morgues and I figured where those costumes had evolved. Those Indians had all moved from the Algonquian tribe of the Chickahominy to the Plains in Ohio and when they first saw those Indians they had never been seen by white men since the 1700s, so I just pushed a lot of those references backwards into the 1600s because they were their ancestors. Because there was so little research, I had to use both my imagination and my creativity. Then I read the writings of John Smith. He described these Indian costumes so beautifully, as did Strachey[19] and Henry Spelman who lived with Chief Powhatan and his tribe as a captive; these were brilliant descriptions and then I let my imagination take off from there. I even looked at African tribes because they have dressed themselves in the same way for many years; they gave me a real tribal feeling, so I could go beyond the John White descriptions.

SARAH GREEN
When we began to move ahead on this movie, we knew casting Pocahontas was our biggest challenge. We engaged Terry's casting director, Francine Maisler, right away. We knew we'd also need someone on the ground in the native community and

identified Rene Haynes who specializes in native casting. As it turned out, she and I had worked together years ago on a film in which she had to find hundreds of Chinese extras in Montana, not an easy task. Rene focused on the native casting and spent about eight months on a full-time search for Pocahontas. Rene cast the other native parts as well, but her main challenge was Pocahontas. She started by contacting all the native publications and the tribes and everyone she had contacts with, asking people to send in pictures if they were interested. Those whom she thought had potential were asked to put themselves on tape, and once we identified a number of possibilities, she travelled all over the USA and Canada, working with individuals and doing very involved audition work.

We were excited about what we saw – there would be one person who had one wonderful quality and another who had a different one – like the one with that beautiful young spark of energy, or the one who had a sense of tragedy, or the one who could act wonderfully but was the wrong age . . . but we never found anyone who embodied all of the qualities. The further we got into this, the more concerned we became. We were getting closer and closer to shooting without knowing who was going to embody this character who starts out an innocent, happy young girl, and progresses to a woman with a child who has experienced great loss. We didn't realize how hard this would be to find. After about six months, we expanded to a worldwide search; at one point we had thirteen casting directors working all over the world. We searched a variety of countries with indigenous populations. People sent us tapes from all over the world. Terry and I went back to Los Angeles after a casting session in London with Celestia Fox, and finally met Q'orianka Kilcher. She had been submitted for a TV series called *Into the West* who were looking for someone younger than we were, so the first headshot we saw of Q'orianka was one in which she tried to look as young as possible. We all thought she was too young.

Q'ORIANKA KILCHER

The same office that had cast *Into the West* was casting *The New World*, and one lady, Joanna, found my photo on the table, and she persisted for two or three days – risking her job because they were looking for someone who was eighteen years or older who was going to play down and I had just turned fourteen. It was a really big problem. Then they brought me in, but I was really too young for the role, so they thanked me very much for coming in.

SARAH GREEN

At first we didn't consider Q'orianka as she was only fourteen, and we felt it would take a more mature woman to play all the aspects of the character. Casting director, Francine Maisler, and her team kept bringing her back, though, because she had that spark, something very special and beautiful. Every time there was a casting session she would be there, and we started to appreciate more and more about her. Once we began seriously considering her for the part, we spent time with her and with her family, trying to assess whether she had the maturity and the stamina for such a hard job. We realized that she was well suited for this work; it was like she had been training for this all her life. She spoke several languages, she had lived all over the world, and she'd been singing in public since she was a small child. She was fearless.

Q'ORIANKA KILCHER

I didn't have an audition for two and a half weeks and I suppose they were talking and stuff. I got a call-back, saying that they felt I was too young for the role, and they didn't want to get my hopes up, but I kept on going for auditions. It was such a long journey, so many factors against me, because of my age and working such hours. So when they phoned to say I had the role, I stopped abruptly in the middle of Beverly Hills – I nearly became roadkill as I stopped dead in the street. I couldn't believe I was accepted! I met Terry around the fourth audition

just to do the scenes I had prepared. He was such a sweet, wonderful guy.

SARAH GREEN
The age of Q'orianka influenced the shooting mostly in a practical way. There are strict rules for working with minors: you can't work too many hours and you have to include school time. Because she was in so much of the movie, we had to schedule the shooting around which hours she was available to us on any given day. We had always intended this to be a chaste film with a PG13 rating, but with someone that young, you had to be even more careful about how you portray love, how you portray the growing connection between her and John Smith in a way that didn't feel inappropriate. We were always very mindful of that. Colin Farrell, who played John Smith, took the challenge very seriously, and spent a great deal of time with Q'orianka and her family, becoming a sort of family member himself so that there was a great ease and comfort between them.

Q'ORIANKA KILCHER
The only thing about Pocahontas that I knew was the cartoon version – but when we were doing pre-production, I had asked for all the different books of the history and the myth about Pocahontas and John Smith to find out about who she really was and this opened out a whole new world for me.

I really fell in love with who she was as a person: I loved her strength as a woman and her curiosity about the unknown. As well as reading through all the different books, I saw some traits in her personality that I see in myself – her naivety, her curiosity – and her vision of trying to bring two worlds together, to create a bridge and, hopefully, peace.

SARAH GREEN
The young men we cast to play members of the Powhatan tribe were, in fact, from all different tribes. This was initially

a challenge for them, but during the two-week rehearsal/boot camp – run by fellow cast member, Raoul Trujillo – they found a way to bond and form a new tribe. They spent most of their time together; they came on set at the same time and they left at the same time. One of them was a musician, and he learned enough Algonquian to create songs that this tribe might have sung; often they would spend their evenings working on these songs, then sing them for us on set.

They developed their own rituals. They would chant, or sing, or pray, which we all appreciated for the feeling it brought to the set. Sometimes it was very emotional. One descendant of Chief Powhatan, a woman called Rose Powhatan, was an extra on the day we filmed a funeral scene for Powhatan's son. She began to wail in mourning, and she got so emotionally involved, it felt like she had channelled her ancestors. It was a very powerful moment.

Q'ORIANKA KILCHER
They really wanted to pay homage and respect, because, even though they were extras and were way in the background, in certain scenes they really were present – emotionally and physically. Their whole being was invested in some of the scenes, some of them were crying, for example, when the villages were being burnt down.

I know that they were brought on board for that purpose. I personally got guidance from several Native American elders in Virginia. I felt that it was really important to turn to the elders, because in Native American culture the elders are the holders of the ancient knowledge and wisdom. I wanted to do the spirit of Pocahontas justice, so I turned to them. I was talking to elders of the Navajo Nation. Of course Terry was a big help to me. He was like a grandfather to me. He was always there to help me if I had any questions, but I have to say that it was the guidance of my elders that really helped me in terms of body language and movement; also, they told me about the spirit from where it all

comes. So I would just go out and sit down in a field, or in the forest, and listen to my heart. You would not know how somebody would have moved in the 1600s or what they would have done, if there was a little deer or something, so in the movie you see me pretending to be a deer putting up little antlers – I saw a deer, and I thought that would be a cute thing. I think she would have played with her brother, as well as playing a flute – which I did in *The New World*. Terry loves birds, especially one called the Wood Thrush. So when I was playing the flute, I wasn't quite sure what I would be playing, so me and my mum, we thought that they would probably make tunes out of their surroundings. So we wrote down the song of the Wood Thrush – it's actually a very mystical, intriguing and haunting melody.

JACQUELINE WEST
When I got to Virginia, I went out to the fort that Jack was building and then I went to Werowocomoco, the Native American village, and picked up everything off the ground for the colour palette. I thought the Native Americans should be almost at one with their environment, one with all the colours that I found out there in the rocks and soil and leaves. All the materials Jack would be using became a jumping-off point. Then I researched everything that was available to the Native Americans on the Chickahominy shore in that year and – having read Spelman – I knew they decorated their clothes mainly with feathers and shells and freshwater pearls. I started collecting them from all over. And then I actually had to take out a fur-trading licence to bring skins into Virginia because there were not as many skins as I needed: I think we dressed five hundred Native Americans. They weren't readily available there, so I had to start importing deerskin, which was one of the main items of their clothing and all different kinds: with fur, without fur, snakeskin. I had to go to the Natural History museum, the Smithsonian Institute, and find out everything that was available there. The buffalo had already left, but they used animal tails on their costumes, so I had to

find out which animals had tails; they wore a lot of bear. The costume of the chief of the Chickasaw is an entire bear, with the head and everything. I had to get the bear skins from the Parks Department, from bears that had died naturally or from illness or had been hit by cars; also, all the bear claws came from them and I had to return every piece. The Native Americans were so moved by having real bear claws that they didn't want to return them in the end, I had to talk them out of it, because we didn't want them to get into trouble by getting on the plane with bear claws. My biggest benefactor was Chief Two Eagles Green – the first night we met the Native Americans, he was very moved by the speeches that Terry, Jack and I all made and that night, before he left, he invited me to his home in Fredericksburg, Virginia to lunch with his wife. I went with my assistant and he filled a van with feathers, bones, antlers, everything you could imagine that he had been collecting his whole life. His wife was so happy to get rid of it all, and we used every single piece. I remember as we left, he walked out to the lawn and he saw a bird feather lying there, he picked it up and put it in his pocket – the collection started again! He was so wonderful; he really was our complete benefactor.

We did have to paint eagle feathers: we had to use giant bird feathers from another species. That is because no one is allowed to own an eagle feather but a Native American. A few of them brought eagle feathers to put on their costume, so it was all pretty authentic.

There was a core, a group of about twenty Native American men, to whom we all became very close. They are in every scene of the movie and they had many costumes, more than the more background Native Americans. They would all chant every morning before we started shooting. They all came from different clans, like the turtle clan, the snake clan. We tried to keep them in the clan of their people if they were within the four clans that the Chickahominy Powhatan tribe had. Sometimes we would push the envelope. There was a Native American that loved wearing

the snake headdress, because it was so much part of his ancestry. That happened very accidentally: for one of the big dances – it was almost a war dance – when John Smith arrives in the Indian village, they all have very extreme headdresses based on different animals. The headdresses were all done, and we let them pick them. Then we painted their faces; I worked with Paul Engelen and David Atherton, the make-up designer and the make-up artist, very closely, based on the animal each actor had chosen for this ceremonial dance.

It was amazing how they, especially the twenty core natives, became very in tune with their costume. Their movements would take on aspects of their headdress and their costume; they would start acting like those animals in their dance. It was just an incredible creative process with all of them. David Atherton and my daughter Naomi would make pots of paint every morning and set up a big tent and they'd put on their breechcloths, and they would go and paint themselves! Every one of those young men were artists, brilliant artists. They did the most incredible work on themselves. Somewhere along the way in my reading since college, it's occurred to me that all stories are about individuals, and when the script is strong – as Terry's scripts are – the individuals, with their differences, are found right there. I believe really deeply in the individual, and I approached each Native American, each colonist, like an individual. That's what I love about my work: I can design, or select costumes for individuals.

I gave every colonist a back story, so that their costume would be based on where they came from in England, or Wales, or Ireland and what they had done beforehand, as it was such a ragtag kind of army coming to America.

I did the same with the natives – first, I sorted them all out into clans, then decided where they were in the hierarchy of the tribe. Then, of course, we had to consider the season; they had to have all-new costumes made for that big winter scene when they bring all the food to the Jamestown colony. It's very different from the relative nakedness in their costumes for the rest of the year.

JACK FISK

For the fort I studied English building techniques from different areas of Britain and thought of someone today, in a foreign land, trying to recreate structures from their home country without the building knowledge or access to the building materials used at home.

A lot of my design ideas come from common sense and intuition. I try to place myself in the story and imagine how I would operate. In *The New World*, I located a sawpit near the front of the fort by the water. When Dr Kelso visited the set, he asked why I had put it there. I told him that I thought it would be more pleasant to do this work near the water and that logs could easily be floated down the river to the sawpit, facilitating the transport of the heavy wood. About a week or two later Dr Kelso called me, excited, saying that he had found evidence of a sawpit at the original fort in almost the same position.

SARAH GREEN

For the lead parts we looked first to England, from where the people being portrayed would have come. We brought a few people from New York and Los Angeles, but we also looked to the acting community in Richmond, Virginia. We found many of the supporting parts right there, and quite a few of the background extras turned out to be people who liked to participate in battle re-enactments. They were ideal to participate in the battle scenes we filmed. They tended to stay in the same groups they already belonged to in their own re-enactments.

They found housing together, and came every day that we shot in the fort. They loved being part of the film even if the days were long, or hot, or wet and muddy. It helped them to bond as a group who had been through a tough ordeal together. We looked for people who looked like they had been through this harrowing journey across the ocean, not robust, strong people, but people who looked a little undernourished and ill-prepared for this land.

The New World

JACQUELINE WEST

I figured out that the first group of colonists would be like a ragtag merchant marine boat in World War II; basically, men in their own clothes. Clothes then were very hard to come by; British sailors didn't really have uniforms at that point. At that time clothes were so expensive that when people died, other sailors would steal their clothes, their boots, their shoes. So you usually only had one outfit – unless you were royalty, or very upper-middle-class merchants. They wore those clothes until they disintegrated and if they were replaced at some point, and made it to the end of their lives – they were bequeathed as part of that person's will to other people. The English only looked like they were out of place because of where they were; they were in the 'New World'. In England, they would blend. Preparing the costumes, I gave every Englishman a back story, and dressed him accordingly. So they weren't just cookie-cutter colonists in 'canyon' pants. I did a lot of research on the 'sea dogs', the men on their boats. I didn't want them to look like a bunch of pirates; they had signed on to do a job for the Virginia Company and explore America. But I realized from my research that they never took a change of clothes with them, they would've only taken one set of clothing, so by the time they got to America they are pretty bedraggled. As time goes by in the script – and Terry tried to shoot in continuity – those clothes had to become more and more distressed, lived-in and dirty. The Native Americans they encountered were so clean, they bathed every day in the river, cleanliness was part of the Powhatan culture. Instead, these colonists were a dirty bunch, really filthy dirty – you can see in the film the beautiful job that Paul England and David Atherton did with the sores on them. They didn't bathe, they got filthy, got sick – they really were a ragtag army.

JACK FISK

The ships used in *The New World* are owned by the state of Virginia and were loaned to us by the state and the Jamestown

271

Foundation. We repainted them for use in our film and then repainted them back. I never agreed with the Jamestown Foundation's interpretation of the Jamestown colony. I do not think they agreed with mine either – lucky for us the Governor of Virginia, Mark Warner, commandeered the ships for our use.

JACQUELINE WEST

For me, the scene where Pocahontas rescues John Smith is one of the richest in the movie. There is this beautiful darkness, it's so dreamlike – very near to Joseph Conrad. It's such a beautiful ritual with the Indians in their high regalia. It is a kind of metamorphosis of the characters of Pocahontas and John Smith. The motivation for why a character changes, that all comes from Terry, from the script. My job is to help Terry figure out how to tell his story because when you change where you are living, who you are relating to, it tells a history. John Smith's story is that he arrives as a buccaneer, as a sea dog and adventurer. He has an earring from Transylvania and a cape which he probably got on some campaign; he's a very eclectic dresser and a free thinker and when he moves to the colony of Werowocomoco he goes native! It is dictated by the fact that his clothes just aren't practical; they are too hot, too constrictive. He sees the beauty of using things taken from nature rather than man-woven clothing. Then, when he realizes that that world is not going to last for him, that he is not going to be able to stay there and live with them, because of the demands of his career and society, with the pressure that Captain Newport has put on him, he maintains the articles of clothing that he made for as long as he can, because they are practical and warm.

The colonists didn't come with fur pieces and only when he leaves Jamestown does he go back to his more Jacobean sea dog attire. So the metamorphosis really comes from the script. As far as his contrast with the natives is concerned, I think it is just beautiful when they first capture him and he is in all that armour and they are so naked. It's like an army tank invading all that

beauty of fur and pearls and skins. I use clothes to tell Terry's story.

Regarding the scene, I think there was real curiosity about this person they had captured, and definitely curiosity on his part – I think it is as deep as or deeper than King James's court which Pocahontas attends later on in the movie. I don't think that scene with John Smith is really a ritual; I think it was a gathering together of the tribe to show off this very unusual specimen who was suddenly in their midst. There was enormous curiosity about why he was there, what he had come for, when would he leave? The Native American word, the Algonquian-based word, for white man is 'he who comes and never leaves'. I'm sure it was the beginning of the end, but at that particular point, it was just an opportunity for everyone to view the captive: John Smith. Beyond that – pretending to kill him was never really understood. Did Pocahontas really get there between the club before it hit his head and save him? Or was it a ritual of trying to befriend somebody that they were really nervous about? I think Terry leaves that question very open in the film. There are different versions told both by Henry Spelman, and in John Smith's journals – so like all of Terry's movies, they pose more questions than answers, they make you think and you have to decide for yourself.

SARAH GREEN

I see John Smith as a very rakish, bold character, a changeable man. This distinguishes him from the John Rolfe character, who is steady, more careful and thoughtful about things. Colin was a natural choice because he is an amazingly talented actor; he has this wonderful energy and rakish charm and a definite boldness. His heart is wide open, which is a truly beautiful thing. You can imagine him going out and conquering the world, falling in love as he goes.

Christian, on the other hand, was not an obvious choice for Rolfe, although he is one of my favourite actors. He often plays

very extreme characters, whereas Rolfe is the guy you don't notice, hard to imagine with handsome Christian. When we thought of Christian, we were in London while he was shooting the first *Batman* film. Terry met with him, and I am guessing that he was intrigued by the idea of playing someone so understated, the guy who blends into the background. I think Terry and he really liked each other.

Q'ORIANKA KILCHER

To me, Colin is very close to his character as he is such a free spirit. When we were together on set we were our characters; from what I saw of him and Christian I suppose they were very much like their characters. To me, John Smith was a first love for Pocahontas, but with John Rolfe, it was more in a fatherly sense for her, like a more mature love. John Smith was a traveller and discoverer of worlds and Pocahontas was a traveller of hearts. I think both of these loves affected her greatly. She always loved Smith, even after he was gone. Finally in the end, she realizes that she loved a dream and there was nothing more to it. I find that it happens a lot even in this day and age.

In the whole story she was never at peace because she pretty much gave up everything for John Smith and I think that when she understands that she actually loves John Rolfe, it is finally a letting go – a peacefulness inside her heart of something that was tormenting her for her whole life. I think it affected her greatly, but it also helped her to grow. Her love with John Rolfe was much healthier and more mature: the effort that was put into it was equally from both sides of the table, which is really important, I think, in love. Shooting in sequence really helped a lot because as we progressed through the story, I grew with the character.

JACQUELINE WEST

When Pocahontas is put into the corset and shoes, it's a strong and sad event. She is really a captive of that corset. It's such a

contrast from the freedom and contact with nature she's had. She's moving from a very natural environment to a developed society and she dresses accordingly. By the time they took her captive, she was already a broken woman; she had been deserted by John Smith, she was betrayed by her family. She was in the chains of that corset and that's what I tried to portray. It isn't until she resigns herself and marries John Rolfe that her clothes take on more of a softness, but it's still sad. Terry was never as happy with her British clothing, he missed her in her native freedom. He said he missed her in her skins. I think we all felt that way.

Q'ORIANKA KILCHER
I think she saw her son as an extension of a hope to bring the two worlds together; he was the bridge over the gap between the two worlds. He was the first inter-racial child, so her dream of bringing the two worlds together did come: she could see in the eyes of her son that there can be peace. So much is in that child.

For the motherly part, I had some help from my mum. I have two younger brothers and when my youngest brother was born, he was like my baby and I loved him to death, it was like having my own child. At the same time, Pocahontas was also still like a child when she had the baby and had not let go of her dream of John Smith.

JACQUELINE WEST
There aren't any paintings of the historical event of her going to court. I had to rely on paintings of King James and Queen Anne, and from descriptions of the event. They were not as flamboyant as the Elizabethans, or as rich: Anne tried to promote more of a sense of modesty. There are some wonderful paintings, etchings and drawings of all the people who were part of their court. Pocahontas in her costume was actually the only painting. It is the only verified image or painting of her ever done. I think King James and Queen Ann were the patrons of the painting. But it

was only from the chest up, so I had to use my own creativity to come up with the rest of the costume.

She was being used and it was very sad that she died there, in that circumstance, just when she had attained some kind of happiness with her husband and her son.

JOERG WIDMER
The idea was that she was there as if she was a parrot or an animal from the wild coming into civilization. She was watched as if she was like a strange bird. This was the idea of the whole English part, that she was welcome as a queen of her own people, but she was seen as if she was something very strange from a very strange world. She didn't become part of the civilization of the Europeans.

Q'ORIANKA KILCHER
I do think England was the New World for Pocahontas. For me, portraying the character was really sad because she had left her old world, the place where she grew up with her family back in Virginia. In a sense, she is really leaving that whole life behind and that life is turning into a dream. It's amazing, but it's scary and sad at the same time. I think Pocahontas was a really courageous young woman, a visionary, ahead of her time.

And she has a real empathy for the people around her in England. In the street Pocahontas sees this old man, a beggar, and she goes and gives him a ring and touches his face. I think it's a big part of Pocahontas. As you saw earlier, the life that she lived in Virginia, in the forest and her traditional ways, people take care of each other. They have no beggars, no one in need. In England she saw that people were surrounded with greater external prosperity, but she sees that they are sad; her people were not. So it's this motherly thing that she had for them: a human empathy towards the world and towards every living thing. This happens also when she meets a man who looks like he doesn't belong as well, a black man. I think she felt a kind of

recognition: she felt close to him, in a way, as they were both displaced.

Opechancanough
I'm going to put a notch on this stick for every Englishman
I see, and meet this God they talk about so much.

JOERG WIDMER

In the scene with Pocahontas in the garden, Terry showed how very important the topiary was. You really see how the English cut down Nature, shaping it into a form that they created. They didn't let Nature grow, which is what they did with Pocahontas, how they cut her down and put her into a shape which suited their civilization. This is what they did with the natives in general, or what they tried to do. I think this is a good image, since they look at her as if she is not part of them. I think you feel this in all the images of the last part of the movie.

Q'ORIANKA KILCHER

One of the metaphors Terry used for the character of Pocahontas was that she was like a river. He told me that Pocahontas is never just angry and never just happy, she is stronger. It's a mix of so many emotions: that is part of the mystic beauty of Pocahontas's character. You never really knew what she was thinking, you never knew whether she was happy or sad, because in one moment, like the wind, she would be dancing through the fields of fennel and the next moment she would be somebody else. That's what really helped me, never just having one emotion to play but several different emotions together.

JOERG WIDMER

There was less freedom in the English scenes: the only freedom was when she was running round before she dies, running around and climbing trees again – her soul had already gone to the spirit of her ancestors.

SARAH GREEN

The sets were all 360-degree sets; you could move in and out of everything, so the crew quickly learned not to put cable or equipment down, as the camera was liable to turn in any direction. When we were in the fort, everything was hidden either in one of the huts or outside the walls of the fort, neither the actors nor the camera operators were limited.

This also meant that the actors had the feeling of being in a completely real place. Terry and Chivo also chose not to shoot with dolly and cranes, but to keep most shots handheld or on the Steadicam. It meant that there were just a handful of people on the set; everyone else was hidden away. This was very different for the actors who were used to seeing a hundred people behind the camera.

JACK FISK

We built the structures as complete as possible so that Terry could shoot anywhere. No cars or equipment were allowed on the set because it was impossible to accurately predict where his camera might go. Christian Bale recounts a funny scene when he came to the set to show Terry his wardrobe for John Rolfe. Terry decided to shoot some film on Christian and Christian noticed how the crew was poised to move out the shot if the camera came close to seeing them. He then purposely strolled to where the crew was hiding just to see them flee from the shot, and then continued following them to their new hiding place.

JACQUELINE WEST

Terry is very demanding. Jack had to build the sets so that they were real and there were no 'front pieces' – you could walk around the whole fort and it was like travelling in time. His sets were more real than the actual re-enactment centre in Jamestown. Jack had perfectly replicated the descriptions of Strachey, John Smith and other writers of the time. I had to do the same with the Native Americans; they had to look absolutely real. I even

had to dress some of my artisans as Native Americans so they could watch the costumes within the shoot, both as colonists and as Native Americans. When you work with Terry, he never wants to see a crew member; he will mount that camera on his own shoulder and just turn 360 degrees and you'll see crew members diving behind the Indian huts or behind the cottages in the Fort. In order to give him that look, you have to go for total realism in all the departments – Jim Erickson's set-decoration, Jack, my department, the photography department – everyone worked so hard to give Terry that feeling of being in another time. The blending with the fort and the Indian village was of the utmost importance. When we made the costumes, we didn't cut them with shells – it would have been way too time-consuming – but we hand-cut every piece of fringe, the same way the Native Americans did. We didn't use glue; we stitched all the costumes with sinew. I read books like Thomas E. Mails and learned how Native Americans constructed their costumes from animal skins. They really used every piece of skin, every part of the animal – the teeth, the bones, and the intestines for sinews. So we got a waxed string, that is the closest thing you can find to real sinew, and all the costumes were hand-stitched. We used a whole skin, so when you see a seam in the Native American costume it doesn't run straight down the side, like costumes that you see in so many films; there is a zigzag down the side because it follows the line of the skin. The Native Americans never cut the skins except for the fringe, which was a very practical thing, as they were in the water all the time, and the fringe would move and swish and dry quickly when they got out of the water and not weigh them down. All these little things were very important for the film.

JOERG WIDMER
Terry tried to have a documentary approach. He always said, 'React like a documentary crew.' This was the common approach of Terry and Chivo Lubezki. Chivo encouraged this kind of attitude, which was amazing as he was capable of shooting such

highly technical movies as *Lemony Snicket* or *Sleepy Hollow*.[20] He tried to shoot this movie in such a reduced way – it was all about negative bounce, like black covers to hide the light, but the rest was very much about lenses and about camera movement. Some of the rules were different from documentary, because as a documentary crew, you circle around and try to get the details, while here it wasn't about getting too much detail, but discovering them by following the actors.

JACK FISK

On *The New World* I did not think I was building a fictional set, I was recreating a moment in our history. I approached it like a documentary. In 1974, I was in Beirut and saw the Palestinian refugee camps there. The Palestinian people were living in cardboard shelters and had nothing to call their own. Without passports or money, they were doomed to a lifestyle of discomfort and uncertainty. I imagined that the Englishmen on the river in Virginia were in a similar plight. I believe the newest findings on the settlement bear this out; there were many deaths from disease and injuries, and severe punishments for infractions, often resulting in death. It was not a healthy place to be.

SARAH GREEN

Terry and Chivo made a decision to shoot the entire film with only natural light. Except for the shooting in England, where we had to light those big dark interiors, we used almost no artificial light. Whatever the weather presented, we shot.

JACK FISK

Terry has trouble with man-made light and seems to have an uncanny knowledge of what film stock can handle. I remember scenes that the light meter would declare impossible to shoot because of low light and Terry would continue shooting. More often than not those scenes were in the film and were some of the most beautiful. Chivo has great respect for Terry and shares his

love of natural light, though often he would wish that he could add a few lights to extend the window of shooting-time for a scene. Terry's response was to move the actors to another area with natural light. Chivo's humour, talent, and frustration made me love him. We would cut holes in the sets to accommodate natural light – nothing was sacred – except light.

JOERG WIDMER
When I shot, Terry gave me some amazing directions: 'Do what you feel is right.' When I was shooting the second unit, I told him what I did, and he said, 'Okay, you did it right.' 'You don't want to see it?' 'No, I know it.' And when he saw it later in the editing room, he said it was right. Whatever you told him you did, he accepted; if you had a feeling it might be different, he would say, 'Okay, try it again.' He didn't watch rushes, he knows quite well everything he shot, he remembers every shot, everything you tell him. He really gave me a lot of freedom during the shooting, he trusted me.

SARAH GREEN
Joerg became a very important member of the team. He was so good with the Steadicam and at hand-held work that he never stopped shooting; he had a camera on him every minute of the day. He is a very calm, strong man, he never seemed to get tired, or suggest we use a dolly. He's very instinctive and worked well with the actors. Joerg, Chivo and Terry were always together; it was like they were playing in the same band.

JOERG WIDMER
We shot parts of the movie in 65 mm, and parts of it in 35 mm. The idea of the movie was that the English settlers in the New World should appear as crisp and colourful as possible. To get this sensation, he wanted it shot with a lot of sharpness and depth of field; he wanted it to have a superfine quality, so 65 mm was his first choice. In the end, we shot the whole movie

in anamorphic to have a larger negative and to have good reso-
lution. In fact, since the whole footage was reduced to the ana-
morphic, the result wasn't so outstanding as it was in the 65 mm
format, but I think when you see it for the first time, you are
amazed that you are entering this new natural world; we were
just amazed when we saw the film on a big screen.

JACQUELINE WEST
Chivo is always very involved in colour choices. We had meet-
ings with Chivo, Terry, Jack and myself about the colour palette.
Chivo likes things very dark and because they were shooting in
high contrast, everything had to be no contrast – white was the
'enemy of the film'. You don't find a lot of white except the pearls,
or the beads on Powhatan's big mantle which we reproduced
like the one in the Ashmolean Museum in Oxford. No white,
no primary colours, is the rule of a Malick movie. Anyway, the
characters decided the colour palette; I didn't keep to one colour
palette. I tried to keep it real, the way you would really find
it. The colour palette of the colonists is very dark and muddy
but by then their clothes would have been quite dirty, dark and
muddy anyway. And the native palette was dictated by things
you find in nature.

JACK FISK
Our palette for this film was influenced by and created by the
environment. We used all local materials in building the sets.
Everything we built worked with the nature around it because
they were made of the same materials.

JOERG WIDMER
At one of our meetings I asked Terry why he had chosen me
since there are so many American Steadicam operators and cam-
eramen who could work with him and he said he wanted a kind
of 'European approach'. I also asked Terry what films of mine
he had seen and he said he had seen all of them. For sure he

had seen *Buena Vista Social Club*[21] where I was the director of photography, and all the work with Wim Wenders where I had been operating the Steadicam. When I first met Chivo he told me, 'We start at 4 o'clock in the morning and we get the first light in the morning, that first light which comes up over the horizon, and then we break at 10, spending a very nice time during the daytime, and restart at 4 p.m. and take the last shots until the sun goes down: this is our day!' When we finally shot, it was completely different; we started at 8 o'clock in the morning, we used very high sunlight during the day, which we tried to avoid by going under the trees when possible and coming out late afternoon, shooting till sunset. The idea of shooting at magic hour didn't work out.

We shot a lot of film. We didn't have any short-ends, the camera always rolled out. We hardly stopped. It happened that Colin Farrell went into the water, encouraged maybe by Terry – or maybe he felt it was right – and the camera followed him as far as it could into the water. Other times the electricians thought, 'This might be part of the set,' and 'We have to suddenly clear that.' Sometimes the problem was that they didn't have a soundtrack which was completely usable, as everyone talked all the time – Terry always gave directions, the first assistant director had to put the extras where they needed to be because they were supposed to follow the action, which was not always worked out. In the beginning it was always, 'Let's shoot the rehearsal!' As so often, in the first shot you have the most amazing action!

JACK FISK

Terry approaches the sets like a location and alters or improvises the scenes around what he finds. Often Terry comes to a set or location without having seen it previously and seems to find joy in discovering ways to use it. It is extremely difficult to incorporate construction over time in a Malick film. Terry is not concerned with continuity and will shoot anything he likes. In *The New World* I had built some structures for the later part of

the Jamestown fort and he promised me he would avoid shooting them as he was picking up a shot from an earlier portion of the film because of an actor's availability. He understood that the continuity was wrong, but knowing Terry, I put on a bright fluorescent orange parka and stood in front of the new construction. The company began shooting and soon people were signalling at me to get out of the shot. Terry looked up from the eyepiece of the camera and saw me in the fluorescent parka and knew he was caught. He laughed and shot elsewhere.

JOERG WIDMER
The shooting was less stressful than *The Thin Red Line*. To be precise, we did two weeks of testing, but when we arrived in Virginia and started to shoot, it seemed to be a little chaotic. The crew was saying, 'Where does it end? Why shoot so much? Why no direction? Why aren't you using light?' The most frustrated people were probably the electricians because they didn't believe it would work out. As soon as it was too dark to shoot inside, we went out and shot the whole scene outside, so we didn't stick to how the script suggested we shoot it, we always reacted to how the conditions were. Nobody believed that we could shoot a scene in the morning and then go to the woods and shoot something else in the less beautiful light and then come back to the village in the evening to shoot the scene again. The crew was not used to this, but they adapted and, in the end, they were in good humour.

SARAH GREEN
The most important thing was to be very light on our feet; it was a very fluid set. Some directors know exactly what they want to shoot, they want everything prepared perfectly so that the moment they are ready to finish one thing, the next is ready, like clockwork. With Terry it's more about going with the flow. He always knows exactly what he wants to say, but I think he is mindful that there are many ways to say the same thing. He

welcomes ideas from everyone. We keep the schedule flexible so he can choose to shoot whatever makes sense for him in the moment. What was most important in running this set was that everyone was as flexible and as willing to roll with whatever came up as they could be – we emphasized spontaneity over perfection.

JACK FISK

Every day of shooting, Terry shows up with a stack of typewritten notes for the various departments. He usually doesn't give you the notes but reads them to you. Many times you have heard these notes before, but they are the things that are important to him – these guide us on a daily basis. These notes are more important than the script. He will not let you fail because that would hurt the film. There is some comfort working with Terry.

JOERG WIDMER

It was a bit like the *Buena Vista Social Club* experience, which means you don't stick to a script too much, you do what feels right, you do it like a documentary crew, you don't miss anything if you shoot something different, because it was worth it to shoot it – for instance, if you stick to the schedule for *Perfume*[22] you have to shoot this scene today because you have one thousand or two thousand extras, you have the crane, the light is set, it has to be shot the day it is scheduled. For this movie, when you don't use the technical preparation, you are prepared to do it but you don't have to – then you can react – it's completely different; if you feel something is better than what is written in the script or if you feel something is better than the one scheduled, you can change it. It was worth doing it this way; it is a different way of storytelling. What is in the movie in the end happens very much in the editing room. So a lot of scenes which we shot are not in the movie, but I don't think you miss them, as the movie has the impact it is supposed to have.

JACK FISK

Terry always uses animals and locations as characters in his films. Our relation to our environment is always present. Terry mentioned to me that he had thought of calling the film *The Mother of Us All* – I believe he was referring to Pocahontas.

SARAH GREEN

I will never forget the Sunday before we started shooting. Rain was pouring in buckets – and it suddenly struck me that this entire movie was essentially an exterior; even if we shot in a hut, it wasn't a real cover set, it was just a little flimsy, grass-covered frame. The weather had to work with us or we would be in trouble. I talked with Terry that day and we decided that whatever the weather, we would shoot through it, and that's what we did. It was really hard, mostly logistically because it got so muddy; at one point we had to lay railroad pilings on the road just to get the trucks to set. Once we had to go to the location by boat as, even with the railroad ties, the trucks got stuck in the mud. Our decision to shoot through it – which was partly due to budget restrictions – worked for the reality of the set, especially in the fort. You could see the settlers wallowing in the mud and the puddles, it was relentless, but we let it become part of the movie. There was so much mud, for so long, that my boots rotted.

JOERG WIDMER

In Virginia, Nature was uncivilized. So we shot the scenes according to Nature. When the settlers came in there was a lot of fennel, they had to cut a lot of it, so we were very careful about not destroying the places where we wanted to have nature untouched. For example, we shot the birds in a very specific period. Terry knows everything about nature. He knows which birds migrate at what times. Sometimes he would say, 'Shoot this bird now, but you have to finish before the end of August because it won't be there any more after that,' and again: 'The

fennel will be gone by the end of September, so we should prob-
ably plan to have the crop at the right moment and the corn ripe
at the right moment.' So they planned very much in advance and
we shot it when it needed to be shot. This was the only restric-
tion. It was all about nature.

JACK FISK

A garden or a mansion has the same importance in designing a
film. You cannot ignore any element that is seen in the film and if
you are building a rock or hill you must make it look as good as
one created by nature. A lot of the best design work is not seen,
but it is there.

JOERG WIDMER

The schedule for the shooting was a bit different from normal
because we were always on and around the same locations –
except for England. Nearly all the actors were available all the
time, apart from Christian Bale, and so we were able to choose
the time when we would shoot something. It was all about
nature: the four elements of water, sun, wind and earth. The
main idea of the whole shoot was, 'As soon as you have a chance
to capture this – do it!' Never wait for something, don't waste
your time sticking to the action – choose nature, and the rela-
tionship between human beings and nature. This means that
when the wind comes up, shoot the impact of wind on what-
ever's there – people, nature; if the wind comes up and it moves
the trees, shoot the trees, if you have the sun as a reflection on
the water and it is beautiful, shoot it! So it was always: look and
watch out what was happening in nature. When it was raining,
they changed the scenes completely as soon as the rain came up.
We had a very fast-moving crew, and since the whole set-up was
supposed to be flexible and able to respond to the elements, it
was not so difficult.

We decided also to shoot on Saturday with a really tiny
crew, which meant sometimes with Terry, sometimes without,

sometimes with the main actors, to catch all those moments that you can't catch when you have the whole cast waiting to be directed. I always had a boat rigged with a stabilized crane. I spent some days on it, doing crane movements on the water, following the ship, following Indians when they were working on the land, following the sun, the wind, the fish or simply the water, trying to catch something when it was about to happen.

When we shot the scenes between Smith and Pocahontas, the approach was similar to the scenes where the settlers approach the natural world. In the first case they discovered nature, in the second they discovered themselves. Since they don't have a common language in the beginning, they had to find means to explore themselves and get closer to each other. I don't think there is something particularly different from the rest of the shoot, but we did spend a lot of time creating these scenes. A lot of this dancing and finding and touching was shot by a reduced crew. Probably half of it was shot by Terry; we felt that it was even more intense when he looked through the camera.

In all these very intense scenes he talked directly to the actors. We shot a lot of stuff with two cameras, also hand-held. Terry is a good cameraman, really strong and since he talks to the actors all the time, he captures their intentions and intensity.

SAAR KLEIN

My first collaboration with Terrence Malick was actually on a film he produced called *Endurance*.[23] He needed an editor and I was contacted by Erin O'Rourke from Ed Pressman's company who was producing it and working with Terry. I watched a cut of the film and wrote him a letter with my notes and ideas. I got a call from his wife from Australia – Terry was there on pre-production for *The Thin Red Line*. She said, 'Terry can't talk, but would love for you to work on the film.' I had never even had a conversation with him at that time and I had only seen *Badlands*. But when I told an editor friend of mine, Joe Hutshing, that I'm thinking about editing a documentary for 'this director Terrence

Malick', he gasped and said, 'Thinking about it? Are you out of your mind? I'd give everything to work with that guy. Have you ever seen *Days of Heaven*?' When I responded that I hadn't, he came over to my house that day, we watched it and I called Terry's wife right back and told her that I wanted to edit the film. I started working alone on the film and met Terry months later when he returned from the *Thin Red Line* shoot. I didn't really know about the Terrence Malick 'mystique' at the time, but when I arrived to cut *Endurance* at the Warner lot, I started hearing rumblings of excitement about Terrence Malick's return. At that point I realized what a huge thing this was to the film community. Realizing that I was about to work with this mysterious, elusive figure, I started getting a little nervous. But when he finally arrived to start editing with me – and simultaneously working on *The Thin Red Line* – we really hit it off. Instead of this mysterious man, I got to know a funny, warm and engaging person. I believe it was over drinks at the Formosa – where we would have what we called our regular 'conceptual meetings' – that he asked if I would come and join Billy Weber and Leslie Jones on *The Thin Red Line*.

During the editing of *The Thin Red Line* I did not work together with Weber and Leslie much. I had a section of the film that I worked on. Terry liked to work individually on sections with his editors, so my relationship with Billy was more social than creative. We would work on our own sections and at times would switch sections when we hit a creative wall, but mostly those sections would return to their rightful owners. It was a great mind-opening and creative process. It was difficult, but Terry's unique approach to editing was so inspiring. The most unique element that I found with him is that I felt that I was spoken to more like an actor than an editor. He would be abstract in his direction, often describing the spirit of what he was looking for. In many ways Terry asks questions, rather than giving you specifics. It's always a process of exploration with Terry. For me this creative process is so embedded in the final

outcome of his films, which don't necessarily answer anything specific, but question, explore and provoke.

As an editor, there is a creative side and a managerial side. I had to pick up on the managerial side. This is the most difficult part of the editor–director relationship. Instead of playing in the 'sandbox' with the other kids, you have to ask unpleasant non-creative questions like 'How do we make the film shorter? How do we hit certain deadlines?' You become the cop, the hall monitor, the parent instead of the play friend. In fact, I developed a great appreciation for Billy's job on *The Thin Red Line* for being the sole editor responsible for that, because of the close and long relationship he had with Terry.

SARAH GREEN

When I saw *The New World* all together, married with the sound, it was a wonderful experience to see it from beginning to end, and not in pieces any more. I loved the editing process. The script was great, but I think the film was far more than the script. It worked on so many levels that you can't describe in words.

SAAR KLEIN

On *The New World*, we worked the same way as on *The Thin Red Line*. Terry decides – we oblige. There was more shifting around on that film, because we had more editors and Terry wanted to explore new approaches – but I feel Terry has a sense of who would be well suited for certain scenes. I have traditionally received many battle scenes. I think he senses a rage in me. He's probably right.

JACK FISK

I am always surprised when I see the finished film: principal photography is a small part of Terry's films. They are transformed in post-production. On *The New World* I was making a documentary about the settlement of Virginia, whereas Terry was making a much bigger film. I wanted to see my film, but it was hiding

in Terry's. He is a philosopher and an artist; he seems to thrive on the unpredictable, on what he finds. The symbolism that is important to him keeps occurring in his films; sometimes I think we are making one big film.

SAAR KLEIN

For the sequence when the settlers first arrive, we started putting things together but they kept mutating. There was a sense of two forces about to collide in the photography. The natives looking out to the boats in the river, the English to the new land. But these things are never specifically discussed. Things shift and move around, music changes, voice-over changes. It's never edited with a specific purpose, but with a feel which is usually dictated by the amazing strength of the footage. I am moved by the photography and it almost leads me. I have spent so much time with Terry that the conversations don't have to be long. I feel that Terry guides me so much by the strength of what he shoots. I also feel that I have an understanding of the footage because he taught me so much when we worked together on *The Thin Red Line* – almost like I have been imprinted or programmed by him. Anyway, I was not the only one to cut that scene. Many scenes go through different variations and changes and by the end you watch so much of a film that you are a part of it, but are unsure of your specific collaboration – and, in a beautiful way, somehow you don't really care.

Q'ORIANKA KILCHER

I had absolutely no idea that there was going to be that kind of voice-over in the film. I felt I learnt so much in doing that voice-over, because the words that Terry had written were so poetic and beautiful, I got so much deeper into the character, that I learned a whole new thing from just doing that. He inspired me to write. I read pretty much what Terry wrote, but during the voice-over sessions he let me play my Native American flute, that's the part that I completely improvised. It's actually in the movie.

SAAR KLEIN

Very often in the film the voice-over of Pocahontas is referring to Mother Earth. It is something that occurs also in the images, the camera is often shooting at the sky. This was a recurring pattern. For example, during the big battle scene, when the natives attack the fort, we cut to a neutral shot of the battle. We tried to stay subjective, but at that point we wanted to intentionally stop it; as if the heavens are watching this disgraceful folly.

I feel that some of the techniques we toyed with on *The Thin Red Line*, we pushed to a greater extent on *The New World*. Terry was intrigued with them on *The Thin Red Line* and was eager to do that in this new movie. This happens, for example, in the love scenes between Pocahontas and John Smith. As an editor, it's a rare and amazing opportunity to work with Terry. To explore, rather than follow some predetermined map; to work with a director who wants to push the film medium in such extreme ways and try to explore things that are so mysterious and difficult to film or even understand. I feel emotionally and philosophically stimulated working on his films. I ask myself questions, I wonder about things. At times I'm frustrated. The work is harder than on any other project, since it evokes so much. But I'd like to think that the work is very similar to people's experience of watching his films – you discover things editing the movie, as the audience does when watching it.

Q'ORIANKA KILCHER

I had absolutely no idea about the music that Terry intended to use. When I saw the movie I was really struck by the song that plays when John Smith and Pocahontas meet for the first time – I think it's a Mozart piece. The way that Terry did that was so beautiful, because whenever you hear it in the movie, it always flashes you back to when they first met and were kissing each other.

SARAH GREEN

Our release was challenging. New Line gave us as much time as they could, but they had a firm deadline for delivery to the international territories. We released right at the end of the year. Terry began work on an extended version for the DVD and, as well, on improving the theatrical version. This new cut was released in the third week of January 2006 and became the official theatrical release.

Q'ORIANKA KILCHER

When I saw the movie for the first time, I was shocked because it is startling to see yourself on the big screen for the first time. It is supposed to be a ten-hour movie! You could never tell the story in two hours; we shot so much film, five different movies could have been made out of it. The movie showed the beginning of the colonization of the Americas and the coming together of two worlds at the sacrifice of a culture. That culture still exists in the Native Americans who remain, but it started getting a hard beating when the English arrived. I really think the film showed that.

SARAH GREEN

I thought the response to the film was wonderful; we had a beautiful review in the *New York Times* by Manohla Dargis.[24] I was pleased at how well she understood the film. Chief Adkins and Chief Green spoke out in favour of the film on behalf of their communities. The cast was amazing – to a person; I think everyone who worked on it was very proud of it. People still tell me how moved they were by the film.

JOERG WIDMER

The first time I saw *The New World* was at the Berlin Film Festival. Some months before, Chivo invited me to come to London – he was shooting *Children of Men*[25] – and he said, 'Next week I will have a print of the film to grade,' but, in the end, I didn't see it and I was happy because I saw the film in

its completed form. The finished movie was three times more intense than I ever thought it would be. The whole movie is full of breathtaking sunsets and sunrises and a lot of spontaneous encounters with nature. I was able to see on the big screen the awareness Terry has about how to use technology. He told me, for example, that if you want to shoot a bird you don't need all this technology, you don't need a 600 mm lens, you can shoot it with a short lens, you can get closer to the birds – and he was right. You simply have to trust your skills, and something amazing will happen in front of your eyes. I remember a particular moment when John Smith was running through the wheat and a duck was crossing his way; we hoped we might get the right moment and, in fact, it hit him. To see this moment on the screen was really intense.

In 2008, two years after the release of the DVD with the double version of the film of 144 and 129 minutes, an extended cut of 172 minutes was released only for the American market.

Captain John Smith
How much they err, that think everyone which has been at Virginia understands or knows what Virginia is.

JACK FISK
I was very impressed watching the longer version of *The New World*, because it seemed shorter. I think Terry would have released this last version sooner but contracts with the studio prevented it.

SARAH GREEN
I think Terry is a truly unique voice. He tells his stories in his own way. This is very precious in a world where there is a lot of sameness. He is one of the directors we need to support because he broadens our perspective of the world.

JOERG WIDMER

I don't know how distributors like him, but I'm happy they always succeed in funding another film. Terry is very well respected, everyone who hears his name says, 'Fantastic, an amazing director,' but very few producers want to pay for films like *The New World*. Sarah Green is an exception. I think this kind of movie gives a completely different approach to American history for Americans themselves and for the world as well.

SARAH GREEN

I would produce another film with Malick – absolutely! On any film there is a balance you have to find between what you need to make the film and what the marketplace will bear. One great thing about working with Terry is that so many people want to work with him. Terry's reputation for artistry, and the high-level cast and crew, help to create a safety net for the investors, very important in the risky world of making movies.

The Tree of Life: A Bridge to the Wonder

The Tree of Life *has all the elements needed to be considered a milestone in Terrence Malick's filmography. It is a project imagined over a span of years where different motivations, film sets spread all over the world, long-exposure images, and a new definition of cinema come together. And yet the temptation to consider the film as the final goal, the sum of a world vision and a vision of filmmaking, fades to make way for a more attentive analysis.* The Tree of Life *marks a passage, a threshold that, once crossed, leads to a new chapter of film production for Malick and his team of loyal collaborators. It is a film about light, as the cameraman Joerg Widmer points out, and light never stops changing, transforming, and leading towards 'wonder'. Through this prism, as suggested by Malick's most assiduous collaborator, Jack Fisk, we can observe the new creative phase of a director who, less than a year after* The Tree of Life, *made* To the Wonder, *shot two other films, and completed a monumental film on the origin of the universe.*

The world was finally ready for Tree.

JACK FISK

Terry has always loved gates and I have constructed them for most of his films. I believe gates and doors are symbols of a passage into another world, another part of our lives. They can be exciting and frightening. I am not sure of Terry's reasons, but I know they are important symbols for him like water and fire are.

I think that by completing this long-planned and personal film, Terry has passed through a gate. It has opened up the possibility of new and experimental work – his post-*Tree* period.

The Tree of Life: *A Bridge to the Wonder*

JOERG WIDMER

During the shooting we are always, literally, crossing borders. *The Tree of Life* is about crossing borders and crossing spaces. Getting out of something into the light. Stairs, ladders, going up to heaven, or going into something – these are always the philosophical elements of his movies. I knew that we should also use nature in this movie, and be aware of nature, but it was not the crucial point as it was before on *The New World*, which was always about nature: as soon as the wind is playful, try and catch it; as soon as the sun is dazzling behind leaves, try to find those elements. This time that was not the task: if something happened go for it, but don't try to make this movie about nature, as it's a movie about light and about wind, and about curtains in the wind.

JACK FISK

After *Badlands*, Terry described filmmaking as war, doing battle for every scene. I do not think he thinks of filmmaking like that now. He works with a large variety of actors and craftspeople and appears to be having a wonderful creative time. I believe Terry has found a way to work that is fun for him, as well as being challenging. It is always difficult to make a film that may not appear commercial to investors, but Terry has stayed on course and made films his way. His drive and patience are unusual in such a passionate person. I always knew *The Tree of Life* would be a beautiful and important film, but it is difficult to see a movie you have worked on – there are too many experiences and expectations. I have seen the film three times and each time I see a different film and it has affected me differently.

SARAH GREEN

There is no question that, with each film, we all get better at it – we are more comfortable with our ability to react in the moment, we rely less on prepping for specific scenarios. Terry is a truly inspired director, so it is our collective goal to create an

environment in which he is able to follow that inspiration wherever it leads. On each film we find new people to add to the team, so that the next one is that much easier – we know and trust each other and we have our shorthand in place. Terry and the director of photography Chivo Lubezki believe in the power and beauty of natural light, so we are not tied down to lights and cables and generators, and that allows us to move very quickly and capture many variations of an idea on film. Jack is so in tune with Terry that he makes many of the location and set decisions on his own – Terry trusts him completely. And Jacqui West, our costume designer, can take one small note about a character, combine it with all she knows of Terry's preferences, and provide an entire wardrobe for that character. An important part of Terry's style that Nick Gonda and I work into the financing is time – as much shooting time as possible – and a long post-production period in which Terry and his editing team can explore the footage and the many ways of telling the story.

I'm not sure this film would have been possible to make when Terry first conceived it; technology had to catch up with his forward-thinking ideas. That's a practical reason, but there are many other less tangible ones. The world was finally ready for *Tree*.

It was fascinating as Terry had been living with it for so long – he was very clear on the feelings and ideas he wanted to express. We incorporated footage he had shot decades ago, and visual effects he could only have dreamed of back then.

I have no doubt that the creative team Terry has established, his designers and editors and camera team etc. is contributing to the increase in his creative output. I also think it's a happy mystery; he's fired up and we are all happy to help him realize his visions.

The Tree of Life is a ground-breaking film in my book, pushing cinematic language to a whole new place. It's thrilling to work in support of such a bold and creative artist. When Jack Fisk says that in completing this film Terry has passed through a

gate I can understand what he means and I defer to the wisdom and insight of Mr Jack Fisk.

Two crucial people joined Terrence Malick's crew while working on The Tree of Life: *the producer Nicolas Gonda, and the actress Jessica Chastain, who turned out to be the perfect embodiment of the grace and true love that permeate the character of Mrs O'Brien. Gonda first worked as a post-production assistant on* The New World *and then went on to become a multifaceted figure, crucial for many different production aspects of the film.*

NICK GONDA

I definitely attribute the fact that I work in the movies to the experience of watching Terry's films when I was much younger, a teenager; we had a very passionate teacher at our school who would show us everything from Tarkovsky to Bresson and other European directors. In that same semester he showed us both *Badlands* and *Days of Heaven*. This was before *The Thin Red Line* came out, and those films inspired a whole world of imagination and passion and inspiration in me. That's when I started having dreams of one day working in the movies. Years later, while attending New York University, I had the chance to work with Terry on a movie that ended up not happening, so I only started to work with Terry during the post-production stage of *The New World*. The job that was needed at the time was someone to drive him from where he was staying to where he was editing, so every day our days would start with a car ride and end with a car ride and the discussions we had driving together provided me with the best opportunity to learn exactly what he needed out of a producer. So my education when I was younger came from those car rides to and from the editing room. Then, once we finished *The New World*, he invited me to Austin to begin working on *The Tree of Life* and that's when the relationship extended and I began working with him as a producer. During the time of *The New World* I was doing kind

of everything that needed to be done that no one else was doing, from music supervising, working closely with our post team, to making sure that we were able to achieve the most out of the last hours before delivery, but most importantly, I was able to learn about his process. I've always known about his films but I learnt about his process and how to be a student of his process. So by the time I got work on *The Tree of Life* – which was obviously a very, very ambitious production from a logistical standpoint – I was able to understand what he wanted to achieve and the direction he wanted to go in and how he works to get there – and that gave me the tools to join a fantastic producing team and to produce specifically for him. One of the most inspiring aspects of working with him is that he is always expecting himself to grow and to be a student of the craft and of his surroundings, and it really does inspire the whole team – and the whole working atmosphere – from the first day of production to the last. You'll find a constantly changing culture, one where there's always laughter and enthusiasm, and a lot of hard work and resilience. The team approaches filmmaking as an evolving and experiential process, and what he captures in the final result is an element of surprise and discovery. Jack said it very well I think: Terry always strives to achieve more of the pure emotion and less of the artist's hand. Jack has seen him on that journey from the beginning, and has been a huge part of that journey; I would say Jack is one of the greatest muses to Terry's work. He inspires him constantly, whether it is phone calls while he is writing, or early visits when we are starting to scout, and Jack will come and bring the film to life and he will truly give the film its first heartbeat when he comes and transforms a setting, and starts to take an idea, and bring it into this world. Alexandra Malick, Terry's wife, is also a crucial member of the crew. Ecky – as she's known – is a great inspiration for all of us and for Terry, and she supports us to really keep working. It's a huge commitment to work for so many years on a film. I honestly think that right now there is a phenomenal team: it's

a pretty special collaboration of talents with Chivo and Jack and Jacqui West and there is a very trusted team in the camera department – one of the greatest assistant cameramen, Erik Brown, and Joerg Widmer, the Steadicam operator, an amazing man – and the list keeps going of people who love working together and love working on Terry's films and under his vision. It's a great recipe and people keep wanting to get back together and have more of these experiences. Terry is at a place in his career where he has a lot that he wants to say, and I think he is also comforted by the support around him; our goal is to keep bringing as many of his films into the world as possible.

JESSICA CHASTAIN

Terrence Malick films are like life flowing. When I spent four months making the movie and then years doing voice-over for it, every time I see the film I see something new in it, and I discover something that I didn't know was there. So it is like a living, breathing entity, that I believe in thirty years will still continue to live and evolve and grow and you will find something else that moves you and is a comment on our society. His films are so emotional – they are visual poems – it is not a film for entertainment; it's not a film that you go and turn your mind off; it's like a piece of art: a painting that when you go and see it, you see yourself in it and that's why you connect to it. I love this movie! It is more than a film: it's an opera; a visual poem that I believe will just live on and on and every time we see it, we will learn something about ourselves.

I also think that, as all great pieces of art, it divides people. I believe *The Tree of Life* does push the boundaries and it makes you look at the world and the medium in a different way, and because of that it is way ahead of its time. I try to define it not like a detective would, and I just try to look at it emotionally. The image of the Tree of Life can mean something different to me today than it does next week, or thirty years from now. I try not to put this movie into absolutes, because I believe it is always

growing and changing; I don't like to define it or confine the power of a great image.

NICK GONDA

I try not to analyse the films or put my interpretation of the movie in the foreground, because in reality there is no right answer – it is so subjective. When we were finishing the movie we would invite various people to see the film: I invited a priest, a rabbi, an atheist, a ninety-year-old and a fourteen-year-old and each of them were very moved by the film in completely different ways, the characters spoke completely different stories to them. I prefer to let people find their own understanding and not have to be in the shadows of other people; just because we worked on it that doesn't mean we know the story any better.

SARAH GREEN

One of the more beautiful aspects of this film for me is that it speaks equally to people with religious or spiritual beliefs, and those without those beliefs. There are symbols from many faiths worked into the film, and for those not looking in that direction, the exploration of nature and mankind works on its own. The Tree of Life is a symbol found in many religions, and in Darwinism. I personally believe that faith and Darwinism are compatible, but not everyone agrees. We were really interested to know if, in fact, the film was speaking to those of other faiths, or no faith, and how different perspectives might inform one's experience of it. The discussions were lively and fascinating and showed that the film was very wide in its reach. It's funny to think about Terry talking about the meaning he ascribes to anything in the film. I believe he honours his audiences by allowing them the right to come to their own conclusions. I love hearing about what each person takes from the movie. I believe there are a myriad of ways to interpret *The Tree of Life*. Every time I watch it, I respond to a different aspect of the film.

At the same time, I think that most viewers look for a narrative

path, as we are used to viewing movies through that lens and it helps to frame one's impressions. For me, the film works equally well as a sort of impressionistic piece in which the cumulative effect of the imagery leads to an emotional resonance. I've been told that many people enjoy the film more on the second viewing, because they are more able to relax into the experience. If I am speaking to someone who is about to watch the film for the first time, I might encourage them not to try to figure it out but rather to just watch and listen and let the film work its magic organically. This can lead to a profound cinematic experience for some. I think that *The Tree of Life* is a very powerful work of art, and it makes total sense to me that it evokes very strong responses. Some are transported and moved to consider their lives and the world around them in new and fascinating ways, and others are frustrated by the lack of a familiar structure on which to hang the story. We live in a modern, fast-paced world, and not everyone has the patience for the slow, rich burn that I believe *Tree* delivers. Interestingly, we found that many people (including many critics) were initially frustrated by the lack of a traditional narrative structure, but when they had time to reflect on the film became fervent supporters. We were very lucky on *Tree* to have extraordinary support from our producing partner and financier, Bill Pohlad. Bill had developed a relationship with Terry over many years, and both understood and, I believe, was motivated by the unique power of the material.

JACK FISK

It is wonderful when a film elicits comment and emotion with viewers. Too often we can walk out of the theatre without a feeling or comment. We all bring something of ourselves into the theatre that completes the film for each of us. It is difficult for me to understand how two intelligent people can have opposite reactions to the same film, but it happens. It is a different film for each of them at that time.

NICK GONDA

The film works best if people bring themselves to the film – where they bring their life, they open themselves up and the film becomes part of a greater meditation. I think that there are a lot of people who appreciate that experience in a movie theatre and with a movie, and there are other people who might, and might not, have that inclination, to interact with a movie in that way. But those who do are finding this to be a singular experience in their year and, in some cases, people are even saying, 'in their lives'. This is a film that is, in many ways, a reflection of the audience. It will play very differently to a mother than it would for a son, it will play very differently for somebody born in the 1950s than it does for someone born in the 1980s, the 1990s, or even more recently. So what I think is one of the most beautiful and magical things about this movie is that it is so various. It's one film – we call it *The Tree of Life* – but it is translated into a myriad of experiences for each person, and each experience is unique. Within that, obviously, there will be differences of opinion, because there will be people who aren't as moved, because they didn't watch it in this way and until they do, they won't understand why others feel the way they do.

JOERG WIDMER

I saw the film three times in different 'grading versions' and I compared it to digital and to analogue, with Digital Intermediate and without Digital Intermediate, and my impression was that it was a great movie. Then I got the sound and I thought it was much too spiritual, which hadn't occurred to me when I saw it mute. The voice-over and the music disoriented me the first time, especially the voice-over in the ending section of the movie – a sort of Paradise – and for the natural history part. I was simply surprised about how much my perceptions changed when I saw it with the soundtrack, because while we shot, obviously I never heard voice-over, I heard original voices. It was interesting to

see what changed after the voice-over was added. It gives you a completely different perspective.

The Tree of Life *marked the beginning of a new phase of film-making for Terrence Malick. The work on the film pervaded the lives of his collaborators for years. It became their world; a form of Hypercinema that overflowed into their personal lives. From the moment that happened, the shooting became increasingly more fluid and the crew more of a family.* To the Wonder, *in fact, became a freer film, less bogged down to a limiting and constricting form and, like* The Tree of Life, *it took on a life of its own. For both projects, it seemed limiting to anchor a story to the films. In* The Tree of Life, *we find a family in Texas during the 1950s with a father, played by Brad Pitt, who loves directing his three sons towards a practical vision of life and a mother, Jessica Chastain, who, abandoning all such intent, becomes the embodiment of pure love and wonder. Jack (Sean Penn), the eldest son, now an adult, relives his childhood and the traumatic event that upends his family: the untimely death of his younger brother. A powerful section, placed only a few minutes from the beginning, recreates the origin of the universe, as if it allowed them to melt into memory, dreams and the continuous flow of life.*

For the first time in Malick's career, computer graphics are used for this sequence. Instead of making the visual effects team sketch out and transcribe the visual arc of the birth of the universe and the origin of life on earth in a storyboard, Malick reinvented the modus operandi *of creating visual effects. He wanted to find the unexpected and surprising elements among the folds of the footage, whether composite or entirely computerized. Therefore, he tried to improvise or create the conditions to allow for improvisation, overcoming traditional cinema in favour of an experiential continuum.*

The special effects supervisor Dan Glass and the filmmaker, writer, producer and visual effects pioneer Doug Trumbull were the principal organizers of this process.

SARAH GREEN

A big life lesson for me has been to accept paradox, which I believe to be fundamental to nature and to human experience. A paradox that particularly resonates for me in *The Tree of Life* is that of death and its relationship to life. One level of this thinking involves the understanding that life and death are two sides of the same coin, and another – one that came to me as I was reading Terry's screenplay – is the idea that death is more than that, death or the threat of death is maybe what forced us to evolve, and continues to do so, and thus is a powerful life force.

Of particular delight to me when watching *The Tree of Life* was the connection I felt to mystery: the mystery of the world through a child's eyes; the mystery of life and death and spirit. I don't understand these things but I appreciate them and celebrate them, and sometimes am able to experience them wholeheartedly. *Tree* brought me to that visceral, experiential place.

JOERG WIDMER

I didn't know what this section of the movie was all about. I wasn't sure what was going to be in the movie, and how long it was going to be. It was impressive and if you let yourself be sucked in, it's incredible, I really love it.

They did it with a lot of knowledge; Mr Trumbull has incredible experience, as does Dan Glass. They were exploring something in the same way as we were exploring on set, and it wasn't by accident.

JESSICA CHASTAIN

I knew this part of the movie because I had read the script, I read that whole section and I understood that my character was a representation of grace, so to be a representation of grace is beyond being just a human being, it's bigger than a human being, so expansive, representing something bigger than the universe, but I never thought when I was doing the scenes that it was meant to create a relationship with the origin of the universe, I was just

trying to play the character as realistically and as humanly as I could, knowing that she represented something else.

SARAH GREEN

Challenging is an understatement when it came to this part of the movie! I had never worked with visual effects, and I was remarkably weak on my scientific theory of the origins of the universe. It became a delight to go back to school, as it were, and learn the various theories and think about how they might look. I did the first round of outreach to our scientific advisers as well, which was great fun as they were all so interesting and receptive. I was pretty quickly out of my league again, so I was grateful to have other, far more capable members of the team to head up this part of *The Tree of Life*. Fellow producer Grant Hill introduced us to visual effects supervisor Dan Glass who was a perfect fit, completely respectful of Terry's process and able to explain things even to me. I got to know Doug Trumbull whose work I've admired for decades, which was a great perk. Co-producer Nick Gonda got very involved in the day-to-day of VFX and could probably supervise a sci-fi epic himself at this point.

NICK GONDA

Another beautiful part of the process is that very few people knew the whole of the story, or read the whole script whether you were an actor or a crew member; it makes you ready for anything. If you think you understand it fully then – whether intentionally or unconsciously – you end up not being as open to surprises and discoveries and so a beautiful part of our set is that nobody knows, me as producer or Jack Fisk as production designer, nobody knows what could happen next and what the whole story will end up looking like in the final movie; it creates a really great spirit, because we know that we are working together, we know that we are working on a common goal, but the outcome and the result remains a beautiful mystery until we all end up going to see it when it's finished.

When we were doing the casting and we were looking for locations, there were beautiful, abstract, and ever-evolving ideas from Terry, and the question was how were we going to implement that in reality, but visual effects are different: telling the story of natural history and creating creatures and galaxies and nebulae, and all of these subjects that we embarked to create, using almost the opposite of our normal process, where it is more like a documentary with a sense of discovery and surprise. In VFX you have to determine far ahead of time so much of what you want and that is against the mentality that we usually work with, so the first step was to find not just a very experienced VFX supervisor, but also a very understanding one, a very patient one and a very creative one, beyond the normal criteria of a VFX supervisor, and we were lucky – our producing partner, Grant Hill, has worked as executive producer on films like *The Matrix Reloaded*,[1] *The Matrix Revolution*[2] and *Speed Racer*[3] with Dan Glass. He introduced us to Dan and he was one of several VFX supervisors we met. I knew immediately that he was the right one for the job, because he understood the challenge; he wasn't naive about how challenging it would be, he approached it with vigour and with humility and determination and what we ended up doing was creating a process that breaks the rules of most VFX processes. Dan helped create a process where Terry would have the same benefit of experimentation and exploration and being able to go about doing the VFX with the same mentality that he does with live action – and on a very limited budget, compared to other films with such visual effects. That was an incredible creation within the production infrastructure: to be able to bring artists to Austin who would be co-ordinating with VFX houses in London and scientists across the globe, creating this collaboration with people around the world, to provide imagery for Terry to work with that he wouldn't have to premeditate, he would be able to explore and be just as surprised with discoveries as he is on set. As producers, it was one of the more challenging components, just because of the way it was

built. We were able to maintain a responsible system, so we weren't going over budget or anything that would put the rest of the film at risk. When I look back on it now, I have a big sigh of relief, and also amazement that we were able to do it in that way.

Before the visual effects supervisor Dan Glass became fully involved, Terrence Malick had made many considerations about the role of special effects and the difference between analogue special effects and computer graphics. So he established a dialogue with Doug Trumbull along these lines which became a set of research guidelines to find the right approach for Dan Glass to put into action.

DOUG TRUMBULL

I met Terry many years ago in the early 1970s, when I was doing *Silent Running*[4] at Universal and he was doing his movies. We used to all hang out at Marina del Rey in Venice, California and see each other at the local cafés and things like that; we liked each other very much and we're contemporaries, though I think we are quite different filmmakers. Subsequent to that, I didn't have any contact with him for about twenty years. So more recently, maybe ten years ago, I caught up with him through a mutual friend, James Horner the composer, who was doing the music for *The New World*. We had lunch and in our discussions we realized that we were both amateur astronomers and both shared an interest in astronomy and space and I shared with him and he with me some books that we liked on the subject matter. A few years later, Terry contacted me again and told me he was planning to make *The Tree of Life*; he asked me if I would have any thoughts on how to solve the problem of the synthetic aspect of computer graphics, particularly when they are trying to replicate natural phenomena like galaxies, star clusters or intergalactic dust clouds and things like that. I said, 'I have never really seen good enough computer graphics with that kind of content; even some of the best supercomputers in the world were

having trouble making representations of the universe look photorealistic. Are you with me?' Terry completely agreed. So I said my suggestion would be to explore how to use natural phenomena under high-speed photography and use things like liquids and chemicals, water and paint and milk and some of the things that went back all the way to *2001: A Space Odyssey*.⁵ There was a huge sequence at the end of *2001*, after the 'Stargate', with a lot of organic-looking interstellar effects that were only four inches wide, shot only using paint on water, photographed with a high-speed camera. And he liked that, then we also talked about stuff I had done on *Close Encounters of the Third Kind*,⁶ where we created clouds in a tank using injected paint and milk, and special lighting and created a kind of cloud atmosphere in a tank, that was also very effective and it would have been impossible in those days, at any time, to make perfect synthetic clouds using computer graphics, because we had tried computer graphics on that film and couldn't make it work.

So for *The Tree of Life*, I suggested the way to move forward was to set up a situation that we dubbed 'the Skunkworks', which was named after the secret Lockheed laboratory⁷ where they were building advanced aircraft during the Second World War. This would be a place where we could explore, really quietly, what we could do by experimenting with high-speed cameras, water tanks, milk, liquids, paints and various other effects and try a new combination which would use digital compositing to put the elements together and which would work with Dan Glass and the team that Terry had assembled. So my role was just as a friendly, collaborative consultant for Terry; I don't take credit for doing the visual effects for *The Tree of Life* at all, I felt like I was a mentor to a crew of young people working on the film and we would meet on weekends in Austin, Texas where they would prepare certain things that I would plan in advance. But it was at the very beginning of that process that I realized that Terry does not like to storyboard or plan things very much. Terry's interest was in finding unexpected phenomena that were

almost unplannable, and so even though I started doing plans for shots that could partly be miniatures, partly liquids, partly computer-graphics or composited, Terry didn't like to work that way. He wanted to create a circumstance where unexpected phenomena could occur, then we could use it however best would be appropriate for his movie. So then I started designing more abstract phenomena.

Terry has been very consistent in his exploration of a kind of poetic and impressionistic – and sometimes non-linear – cinematic experience, where he's concerned more with finding the mysterious moments that often occur when actors don't even know the camera is running. Terry is encouraging the performers and cameraman to find the unexpected; his is a very bold and brave kind of film-making, because fewer and fewer people are ready to assimilate it. The fluidity of the editorial process continues on and on for many months after principal photography because he is finding how to assemble images and moments in a kind of continuity that's not literal and not linear, but that evokes the emotional response he is hoping the audience will have. He is quite an unusual and very rare director, who has the braveness to go into this kind of unexpected territory; most directors out there are very linear and very storyboard-oriented and very plotted, every line of dialogue and shot has to fit every pre-planned continuity and Terry is trying to go beyond that – you see it in virtually all of his films. So we needed to provoke the unexpected, while also doing the visual effects.

DAN GLASS

I would say the idea of working with existing materials and layering them together is the core of compositing. What you do is experiment with various tricks to finesse things, tuning imagery towards reality. You are trying to understand and interpret what you see and why you see it in a certain way, and massage imagery into that same manner, all of which was extremely applicable to what we were doing for *The Tree of Life*.

I studied architecture originally. My parents came from very different backgrounds: my father was a scientist and my mother was an artist and the combination naturally led me into exploring fields that combined those two things; architecture was the first, more apparent vocation that I entered into and studied initially. Visual effects and computing were really just being born at the time when I finished university and I was fortunate enough to start at a company that was creating a lot of the new techniques behind these things and really inventing sets of rules. There weren't existing procedures for most of the approaches at that time; it was really a question of just getting in and rolling up your sleeves and trying to discover how to make things work.

I think that was all very applicable to what we did on *The Tree of Life* – we have come a long way in visual effects in terms of what the technology can do and also understanding typical approaches to problems, so that a lot more has been established in the way that it is all put together. That's not to say that there are not still feats that haven't yet been attained but many things are more standard than they were ten or fifteen years ago. Working with Terry on *The Tree of Life* was really an opportunity to reinvestigate how we approach problems; as a filmmaker he is constantly questioning and that is a fabulous trait in life and in anyone's career, you are never necessarily satisfied with an existing approach, or an idea even, but you are continuing to see how things evolve either naturally or if you test an idea: 'Does it work if you go in a slightly different direction?' If it doesn't, it actually reinforces the path you were on and if it works better, you know you are actually on a new and improved path and a lot of those things were very exciting about the project.

I have worked with Grant Hill for ten years and he worked with Terry on *The Thin Red Line* and had remained friends and was aware of the project. It was a little over five and a half years ago in summer 2006 that Grant mentioned this project with Terrence Malick and he asked me if I would be interested in meeting him. At the time it was somewhat hard to believe, as

Terrence is a filmmaker whom I had read a lot about and had tremendous respect for, but never really felt in my profession and in the path I had followed in terms of a very technical and visual-effects world, that I would have the opportunity to work with somebody like that. So that was exciting in itself and Grant set up a meeting in a café in LA. As he talked about the project it was clear it was highly unusual and truly fascinating. That just added to the thrill of being involved, and I think one of the key things about it was that the project wasn't just about making a movie, but was almost a process of self-discovery or, at least, the acquisition of knowledge in filmmaking and one thing that I love about filmmaking is that you are exploring different areas of knowledge or ideas each time; you are always learning. This project was extreme in that sense, because we were delving into vast amounts of research and scientific theory, and at the same time poring over artworks and music, so you were completely consumed in this myriad of inputs of great inspiration, and to live and work in that environment for the several years it took us to pull the project off was quite a life-changing experience. When I met Terry I knew the majority of his works; he is an exceptional and extremely rare filmmaker – especially these days – and one of the things about him which I have tremendous respect for is that he always creates this atmosphere where he's nobody special. It's a product of all the people around him and really that's how these films become formed, and yet – you can readily watch his films and see distinct, common themes in the way that the pieces are edited, the way they are shot and photographed, the way the performances are played out. Even when several of the key roles are different on the different productions, he clearly has an effect on the individuals who are collaborating with him and it's an extraordinary process.

I think one naturally tends to reach out to a lot of people that one knows and trusts in life. This film particularly demanded a certain sensibility and a kind of broadness of mind and approach; there were relatively few candidates from my experience who

would understand and approach the material in the right way. I was in a fortunate position in that I knew several who seemed to quite fit neatly, in terms of their type and range of work, and so the whole thing came together quite naturally, from existing contacts and connections I had and each of the key contributors approached it with the same commitment as the rest of the crew, which made it so enjoyable as a project.

Practically, we divided the work into realms: to cover the macro-scale, the astrophysical, the micro-scale, the microbial, and the natural history realm which we termed for the life itself on earth, on land. And then we had the contemporary realm for things that took place in the relatively contemporary story.

For the astrophysical, we involved a company in London called Double Negative who are a very established and very successful company in the visual effects world. They were involved in *Inception*,[8] so they are known for large, complex motion pictures, but they have been always very smart about retaining a culture within their company that is about understanding image and filmmakers. They are also born from a core team that had a lot of skills in compositing, so I reached out to them for that, and they brought a sensitivity to the scale of the astrophysical shots that, I think, is apparent in the final results.

The microbial needed a very different kind of attitude; it needed a smaller, more flexible, nimble team; it needed to have a high degree of creative input to even really know where to start, so I reached out to a team, again in London, called One Of Us – a small boutique kind of place, one of the kinds of places you can ring up and say, 'I don't know really how to explain any of what we are going to ask you to do, but we want you involved,' and they loved the challenge of just leaping in and taking that on board. We also brought in a similar company later in the process called Method Studios who have a similar ability to leap in and help create from the ground up.

There was also another partner in that realm: a third father-and-son duo, Chris and Peter Parks – another English-based

team – who somewhat famously have a studio out in the country, outside London. They keep very much to themselves, but they photograph these extraordinary chemical and fluid elements in tanks, generating some very beautiful visuals.

For the natural history realm I approached an old friend, Mike Fink, who is a very established and very recognized visual supervisor in his own right, but at the time he was in a company called Frantic Films (which actually later became and are now known as Prime Focus). He has – I've known him for many years – a great sensibility for the nature of the creatures and the challenges that they were going to provide. He actually had already met Terrence many years ago – maybe even in connection with early ideas on this project – so he was very much a key figure in bringing life to the dinosaur world.

NICK GONDA

For the research and the preparation for the visual effects, the conceptualizing began many years before principal photography and much of the research even began in the 1970s, when Terry and Doug Trumbull began to speak, but in terms of the actual production aspect of the visual effects, we ended up meeting Dan Glass within several weeks of finishing *The New World*; we had lunch with him in LA with Grant Hill and sat and spoke for several hours about the visual effects and the challenges we would face, just given the restrictive nature of visual effects for a team like ours, and then Dan approached it with a lot of vigour and we started doing tests. There was an artist in Slovenia called Michael Benson who works tirelessly to create high-resolution images of the planets from interplanetary probes; he ties together these images of Jupiter and Saturn and Uranus and creates beautiful images, sometimes even greater than 4k resolution images. We created a collaboration between him and a visual effects house in London called Double Negative, with this visual effects artist there named Paul Roberts and he created a three-dimensional visualization using high-resolution space imagery.

When we were sitting in that room looking at these tests, truly, for the first time, we saw the universe taking shape. The result was something that many of us had never seen before. From there, we continued down that road with Dan Glass shepherding the visual effects process and always striving to find opportunities where we could marry the reality of nature to the imagery that we were able to capture and to anything else, whether it was with creatures or planets or microbial single-cell organisms. We always tried to find how to use the true elements of nature and have them be the heart behind every visual-effects shot.

DAN GLASS

I think quite often movies will work at 4k resolution these days, which is often felt to be the gold standard, as it has enough quality to hold up on 35 mm. Terry wanted to shoot the background material in part with an IMAX camera, he wanted that incredible wide-angle, very deep-focus imagery; the fineness of the grain when you photograph on a negative that large creates these very rich images, and we felt that we wanted our digital work to measure up to that. Even though the film was ultimately going out on 35 mm, we wanted to ensure that our work was done to the highest possible quality, so we scanned the material at IMAX and we basically worked and delivered the material on IMAX. There is a very subtle but perceptible difference, there are details that you simply don't put when you are working at smaller resolutions, whereas on that higher resolution you are much more attentive to what needs to be put into a shot and even when it is reduced in size for the final output, you see, or you sense, the detail inherent in that image. That was one of the important things for Terry; he wanted to feel that you could zoom into the images and keep finding detail, which you can in that material.

JOERG WIDMER

I tested IMAX so I was already prepared, but then I didn't have to shoot it, since it happened after principal photography. Most

of the backgrounds were shot by the second unit, and the plates for the dinosaurs. I think it was a very wise choice because shooting in IMAX gave an incredible richness and helped the CGI elements, because you were working on real backgrounds that were speaking for themselves.

DAN GLASS

Conceiving the visual effects there were, fortunately, many areas that were open to flexibility, a lot of the microbial imagery was something that we had quite a lot of freedom with, we could be quite abstract with it, so inventiveness actually worked in its favour.

With the astrophysical, we had a strong base to work with, in many cases we had this powerful, real imagery that we knew we didn't want to stray too far from, but we had to pair them with things that we didn't have representations of, like the Pop III star epoch[9] – that's where we turned to scientific data as our version of the 'truth' if you like. Terry felt that if it was true to the sort of core science underneath to it, then that was the closest we could be to being true to Nature in that context.

The dinosaurs were the bit that was clearly not going to be readily workable in that manner. We did work with pre-visualization, we did develop and work with a great animator, close to Terry; it wasn't that we came up with the shots that are in the movie, but we developed enough from that so that we knew where to shoot and the sorts of things to shoot; when we went out to Northern California to shoot a lot of the plates for that, we were carrying with us a feeling of what we were after and that suited Terry very much. We literally had our camera on the Steadicam and we wandered through the forest finding beautiful vignettes and light that came cascading through the trees at sunset. We were chasing beautiful moments of nature, like the beautiful shots on the beach, which was a mad dash to get there before sunset, leaping out of the van, running down the beach carrying the Steadicam, just trying to get the moments of sunset

pushing towards the ocean. So we had these magical plates in themselves and when we started to assemble the images we said, 'Okay, now how can we put these creatures into this and ultimately tell the story and get across the right moments of emotion and evolution?' And that was really where it became a little bit more traditional, but it was working backwards, in a way, than we normally do but it worked very satisfactorily because, I think as a result, the shots don't feel like they were framed for our ultimate intention because, in a way, they weren't.

There was a lot of extensive research into locations that were suitable analogues for the time periods that we were depicting, so they were very carefully selected. The North California Redwoods is often used as a background for that time period, in the same way that we went to Iceland to represent a time period before trees had evolved, because Iceland is incredibly treeless – it's quite extraordinary – and then we went to deserts like the Atacama desert in Chile; you're in a dry period where vegetation isn't even apparent on the land. So there was a great deal of thought and planning that went into the very specific places. This way of working was intended also to let Terry feel comfortable in the use of CG. In regards to the dinosaurs, he acknowledged that there wasn't really going to be an approach with traditional models or anything like that that would work. He always realized that it was going to be VSFX, so it didn't take much to convince him. Obviously, the challenge was convincing him that we could pull it off and make them as faithful and realistic as possible; that's one of the reasons we started on that earlier in the process. Terry was not familiar with the way things are put together and so he placed a lot of trust in us getting things to a stage to enable him to comment.

The shooting of the plates was really conceived around his way of filming: although we did some planning on the types of shots we might need, we left him a tremendous amount of free rein to really shoot plates that were about capturing the natural beauty of the light of the environments and just being there to

suggest, roughly, the size and maybe the placement of the creature, but leaving them quite a lot of freedom with the way that they shot. The exercise is finding the best place or the best plates to put the creatures in.

Shooting this way gave it a rather naturalistic feel; it felt that the creatures were more incidental rather than the total focus of the shot, because they weren't completely considered when the backgrounds were photographed. I think that played well into what Terry was trying to do.

As far as the other material is concerned, it was a mixture: there were certain things that were reasonably straightforward because we could take a lot of photographic reference, the stuff from NASA and the Hubble telescope for example – these beautiful, real photographs were used as a basis to construct the shots, so it was an easy thing to build compositions and shots from material that looked good, before we then took it apart and basically reconstructed it to build it three-dimensionally for him.

The microbial world was one of the most challenging because he definitely wanted to avoid CG overtly and yet the challenge in that arena is that the real material that you source is very limited in terms of the way electron-microscopy works; inherently it's very flat because you are looking at a plane as opposed to a full depth. Part of his composition and the way he visualizes and wants things to appear was with a considerable depth of field and the space-environment and microscopic footage works inherently against that, because it tends to be on a long lens; it's about photographing one plane on a slide and the depth of field doesn't hold at all on those focal lengths. So whilst we looked very keenly and attentively at reference footage of real activity, we often knew that it would have to be handled differently. The way we approached it with Terry, we mixed in a lot of practical pieces, things shot in tanks – like dyes, egg yolk or marmalade that were put into tanks and used as floating pieces and then incorporated into shots that were built with CG. We could layer the things together, so you would get this mixture of reality and

CG and he kept pushing the level of finesse on the whole shot, so that it felt like something much more organic.

NICK GONDA
Doug Trumbull was a constant voice of support and of advice; he came out to Austin several times and worked with us on shoots where we would create live elements: everything from smoke and liquids and paints and chemicals in order to find the patterns inside nature and not have to create them with digital tools. Doug was the guide throughout all of that and was a wonderful adviser on other visual effects and worked closely with Dan Glass to find opportunities to innovate, to go beyond the standard process, so he was, in many ways, a voice that encouraged all of us to think differently from the way most go about VFX today.

DAN GLASS
Whilst Doug Trumbull's approach comes from a time before digital, so that it was kind of the only way to solve some of these problems, Doug is highly convinced, as am I, that those approaches are as valid today as they were then, that those approaches can produce very striking results that somehow naturally retain an integrity and a sense of 'Tao', as Terry would say, a kind of natural energy that we detect, very subtly and you are almost able to forgive more of the illusion because there's something natural in the way that the imagery strikes you, as opposed to a very carefully constructed simulation that, no matter how much care you put into it, is always too clean or too perfect. The kind of dirtiness or imperfection that comes from that type of material is key to the way Doug works in the analogue world, and was very, very important to Terry for this film and clearly a big part of it. Working with him was a tremendous opportunity and I felt very honoured to have been able to collaborate with someone of such stature in the visual effects field.

The Tree of Life: *A Bridge to the Wonder*

DOUG TRUMBULL

My attitude is that everything in a movie is a special effect – everything – so if you look at any scene in a movie – the make-up or wardrobe or a location that has been made into a period location, or a photographic lighting style – it's all just one kind of illusion or another. My general philosophy is that I look at a whole movie as an illusion that is trying to create some kind of storytelling and experience for the audience. As a director-writer-producer myself, I have a very broad view, so I've taken it upon myself to understand as much as any one person can possibly understand, about everything that has to do with making movies, which has to do with photography, lenses, depth of field, lighting, motion, frame rates, compositing and what people generally refer to as special effects, as though they are some separate object that's added to a movie, like a spaceship or something. My philosophy is that I don't separate those things out; it's all part of one continuum. So even in a movie like *Blade Runner*[10] – which had relatively few special effects shots – they seemed to be very integrated into the movie because the atmospheric style and the lighting were contiguous throughout the live-action production and the effects production, and often overlapped on each other. So I think more like a director than an SFX guy, although I have been named as an SFX guru of some kind, but I am a writer-director-producer in my own right.

Terry and I both share an interest in amateur astronomy, so we are both already predisposed to an understanding of what the Hubble space telescope photographs look like, what intergalactic dust clouds look like, what black holes might look like, what galaxies look like and how they spin; we already have our own language for that. We were interested in that kind of thing already; we were up to speed on the aesthetic of that. Terry had been amassing his own collection of photographs probably for twenty or thirty years, and I have my own collection and then there was a really good collaboration with Michael Benson, who was one of the contributors to the movie, of 'real'

space photographs that could then be modified in the computer to create motion and things like that, by other companies that were under Dan's supervision. So there's a mixture of real space photographs that had been manipulated with some computer techniques, with some stuff that we did, that was completely organic and photographed with high-speed photography; editorially he was trying to dance between the material that we built and with real material, so that the audience never could tell which one was which and it never felt that you were just going into some synthetic sequence of computer-generated imagery.

In regards to the practical shooting, I commissioned a large tank to be built and I said, 'We gotta have a good clear piece of glass on the bottom of the tank because I think we might wanna shoot from the bottom looking up sometimes and I think one side has to be optically clear to shoot from the side of the tank. We need all these other tanks to be able to fill the water, or filter the water or heat the water and do some of the things that we did in *Close Encounters*: where we would fill the tank half-full with cold salt water and fill the top of it with warm fresh water to create a specific gravity boundary layer between the two and see what would happen.' So we would never know which combination would be an interstellar dust cloud, or a galaxy or a black hole or proto-planet; we were just making components that Terry could use with Dan, put them together in various ways; so it was a very loose, almost abstract kind of process to create circumstances under which the unexpected could occur while the camera was running. I thought this was a terrifically enjoyable process, completely unique to the movie industry, because we are in a world of computer graphics and animation now where everything is meticulously pre-planned, according to rigid storyboards and story-structure and things like that, and Terry wanted to go exactly in the opposite direction and find those mysterious, unexplained occurrences that no one had ever seen before! It wasn't the first time – because *2001* was 'my first time' and Stanley Kubrick had very much that attitude as well

that there had to be room for experimentation and discovery to occur in order to meet the needs of 2001. Kubrick supported me in doing experiments and tests and developing new equipment that would enable things like Jupiter or the Stargate to happen – things that had never happened before. So I was very much in sync with Terry's idea that we should explore the unknown and see what we could find and put it on the screen. I think that is a missing element of movie-making today.

When the script for 2001 was written, no one knew what a Stargate was supposed to look like, or any of that stuff, so it had to be experimented with and developed and delivered during production! It wasn't like an open-ended research and development project – there was the need to deliver something that would work – and that was the same for Terry as well. Our experimental time wasn't actually very much, it was only some weekends with a fairly small crew, on a small stage, trying everything that we could think of.

DAN GLASS

At the beginning of the process, we did a little bit of experimentation with what we called our 'garage band'; in some ways, it was like small experiments leading up to the Skunkworks, which were shot with a high-speed camera with a resolution of 4K. In most cases, we were taking those images and either layering them or taking pieces and shrinking them into other parts of the frame, so we were gaining resolution that way. We also processed through some special preparatory techniques to get every ounce of resolution out of that source material.

Doug was involved from fairly early on. We would send him some of the things that we were working on, especially the astrophysical material; we would send him examples in progress and look forward to his feedback and thoughts on things – so he contributed in a range of ways.

DOUG TRUMBULL

I wasn't involved in the compositing process, I was only involved in the very early experiments that I did with Dan virtually while we were on the set – just to validate that the direction we were going in was going to work. We had a compositor in a room adjacent to the stage, so the minute we would shoot some effect or some element that we thought would be useful for a galaxy or black hole or whatever, we would get it on a computer immediately within the hour and start looking at how our idea would work, and so we got instant validation while we were shooting. We would just shoot a lot more of those particular kinds of elements that would then be available to Dan and Terry to be put together in any number, in thousands of possible ways; I would create events that I thought would be generic for explosions, or shock waves, or beams of light, or star-twinkling or burning planets. In a way they were components that could be assembled almost like a Tinkertoy kit into various different assemblages, and Dan would do that post-compositing.

DAN GLASS

It was quite wide-ranging from theories of the early universe – as much as we can theorize about the most remote times of our own universe's evolution – and dialogue with scientists who theorize in those areas. We consulted with Dr Volker Bromm from the University of Texas, who specializes in so-called Population III stars, which really represent the birth of light, the earliest stars as the universe is expanding, that density expanded to actually enable things to combust or burn in some ways. And then, the whole idea of how matter spread and began to coalesce, first in galaxies and then within galaxies, in nebulae and then within nebulae into star-forming regions and ultimately within those, the accretion discs that were the first formations of solar systems, that were really beginning to revolve due to gravity around stars or suns, and how the debris around the stars would form into planets, which is really how they theorize that our own solar

system evolved. Reading and understanding how all these pro-
cesses happened was critical to trying to find, not just how to rep-
resent the moments, but for Terry it was which of the moments to
select that would best represent the stages that were in question.

Then, of course, there is the whole primordial soup – of how
life itself formed, leading to more complex cellular organisms,
that ultimately learn how to split and divide, and from there
develop into a form of more complex organisms and thereon to
more complex life-forms and so forth, and then the move from
oceans to land, and how that might theoretically happen and
stages of how it happened, and the formation of flora on land.
There's a shot, for example, of one of the first trees that's repre-
sented in footage in Iceland, and on and on really. It was just try-
ing to understand each of those as they are currently understood,
and finding very naturalistic ways of representing them; trying to
find existing analogies where we could represent them in nature,
or even with creatures that date back many eons.

We have had several consultants: Dr Volker Bromm, whom
I mentioned, was key; also the astrophysicist Michael Benson,
who helped source and contributed a lot of the original imagery
that was used to develop into shots. We had Dr Donna Cox
who works out of the University of Illinois and her colleague
Robert Patterson, who helped connect us with a lot of the com-
plex scientific data models that we used in some of the early
cosmological stuff. Then we had Lynn Margulis, who was one
of the key advisers in early cellular development. In regards to
the dinosaurs, we had a famous palaeontologist, Jack Horner.
There were three kinds of dinosaurs featured. There is a plesi-
osaur on the beach, there is the parasaur which we also called
'Junior', the younger dinosaur you see in the woods, that we
don't see at the river; in the background at the river there are
just some adult parasaurs. Then the predator that comes up and
attacks but then shows mercy is called *Dromiceiomimus*, a kind
of predecessor of birds. Of course, every aspect of the show was
heavily researched thanks to the work of Dr Jack Horner. There

are a lot of things that are fairly well known and documented about some of these creatures; but one of the difficulties is colour and pattern of the skin, so a lot of that is made as a best-guess, based on modern analogy. So for example the brightly coloured head of the *Dromiceiomimus*: Horner theorized that predators in nature tend not to be as concerned with camouflage and they actually nearly always tend to draw attention to themselves, whereas weaker animals are the ones that tend to need to hide and that was really the background behind those choices. Also the choice with all of those dinosaurs was to show them as slightly normal and slightly non-exotic creatures and that was intentional, because Terry didn't want it to feel overtly showy, or expositional. These are very natural moments that we happen to come across and to that end the choice of a relatively normal species was important.

In all this process of research, one of the main contributions was the one of Michael Benson. He seeks out these images that are generally in the public domain from NASA and the European Space Agency – they are shot in tiled images that you piece together to form a much larger and higher-resolution final image – but we took those which were beautiful in their own right but they have a lot of built-in aberrations; all the stars are laid one on top of another, so stars that are much nearer to us are very large in frame and they tend to obscure many of the things behind. Basically, we removed those larger stars, and in most cases we removed all the stars as a base and then brought them back in, but as tiny, tiny source-points of light; in many cases, from real little lens flares that were shot at the Skunkworks and placed into 3D space, so that the stars have this very subtle life to them, but no star really diminishes another, which is much closer to what would really happen if you were in space. It was a question of deconstructing the imagery somewhat and then rebuilding them and constantly referring back to feel what it was that was so convincing in the original and trying to be very faithful to that. We didn't shoot with any of our own cameras, other than the little

lens flares. In the Skunkworks, we shot things that would ulti-
mately double for moments in the astrophysical realm whether it
was small orbs that had been weathered to represent planets or
planetoids; we would film dry ice at high speed, that were kind
of cheats in a way, or analogies for larger-scale phenomena, but
the real source material of the planets, nebulae, and galaxies was
sourced material from NASA and the European Space Agency.

DAN GLASS
Terry works through a kind of suggestion, and I never even felt
the need to ask for explanation, the film itself led the way and
the symbolism was something that you drew for yourself, in the
same way that a viewer or a member of the audience would. It
is something also related to the title, *The Tree of Life*; I have
always assumed that there is a particular tree that he is drawn
to in his memory, as a young child – but, in a way, it is prob-
ably more expansive than any specific symbolism that can be
attributed to it. Early on, Terry had confessed that the idea of
storyboards and pre-visualization, which we often used to plan
out, wasn't something he responds well to, and that we needed
to come up with a different idea basically, but during discus-
sions with him he would frequently refer to music and you could
tell that there were a lot of musical themes going through his
mind, and I suggested that maybe what's easier than drawing
out what you want is to put down or create a CD of tracks that
appeal to you, hopefully for specific moments, but from which
we can draw ideas and he was able to very quickly get into it.
It's clearly a very abstracted way of working but from that, I
could immediately get a sense of the tone that he was after for
the piece. Terry was able more quickly to identify musical scores
than he could describe the visuals themselves, so in some ways
the music almost gave birth to it; it was very much involved
early on in the process and in some cases even led it. Terry also
encouraged us as we were submitting visual ideas that would
be cut in; he immediately tried different sounds over them or,

in some cases, we actually proposed sound with the visuals as a much more holistic way of interpreting the material. In a way, the very process of listening to music to devise images helps to pull away from the imagery, so you're deliberately not trying to make that imagery showy; you almost want the music to lead you through the imagery, and that was really what it gave to us in the process, as well as a lot of happy hours of listening. Terry would obviously relish the connotations that it brings. He likes to create an environment or atmosphere into which you partici- pate both in the way you work with him, in the way he makes his films, or also for the viewer; he isn't trying to dictate, he isn't trying to tell you how things are, he is actually about encourag- ing you to question. The indications that he gave me were quite varied, like the movie itself, in that each piece of the movie had different origins and a different evolution to its own design and what he had was less a script for the creation sequence than a mass of historical notes and thoughts and ideas and things he had seen over many decades, and so part of how we began was to try to accumulate that material and immerse ourselves in it, and try to understand a little bit about where his head was at. Then from that, there were certain key things that were easier to identify: for example, the astrophysical imagery which he held to be supremely beautiful, which it is, and the clarity and resolution of some of the Hubble and Voyager and Space Probe imagery show the immense spectacle of space, and its incredible natural beauty; things like that were great jumping-off points. In a way, the challenge there was to add 'life', but always to keep faith- ful to that original source material. For the microbial realm, it was much more about experimenting and trying to create a host of sometimes very abstract visuals – the Skunkworks that Doug Trumbull set up had a fundamental role.

The natural realm was probably the toughest, and maybe the most challenging for the work, as it simply had to be credible and had to be real – yet, when you create dinosaurs digitally you are completely up against it, because everyone knows that it's

fake from the start; they know you didn't find a real dinosaur to film, so you have to work very, very hard to deal with that, and draw the viewer in; one of the approaches that Terry had raised early on, which I really loved and drew me to it, was essentially to come across these creatures and treat them as much more incidental so that the lighting should be imperfect in a way, that we're not there to exhibit them, that they are really things that we are catching a glimpse of – and that, I thought, was beautiful. It's rarely done because usually the amount of work that goes into creating a creature convincingly is such that you tend to want to show off what you've done, not necessarily in a kind of show-offy way but in a manner of you've put that effort in so you might as well let the viewers see what you have created, but that wasn't the goal with this material, the goal was to be subtle about it and allow the creatures to really just feel that they were part of the scene. So that was how he led; it was more of a gentle guiding of ideas and constantly looking for a stream of suggestions and visuals that would help get us to where we needed to be.

DAN GLASS

The beginning of the universe for me is much more intentionally abstract, in large part because theories are allowed to be vague for that time, but it's also such a hard concept for anyone to wrap their head around – plus it's the first thing that comes up in the movie, in relation to this material; you have to switch people's direction from the material that they have just been watching, into this radically different kind of narrative. Terry went for a very abstract approach and he knew of this beautiful projector/ art piece called the *Lumia* which is almost like an eternal flame and it's built from a series of clockwork mechanisms that are filtering light and reflecting light, that create this really beautiful pattern that has a depth and yet is projected on the screen – that is one of the early things we see, and also occasionally throughout the movie, but there wasn't a great deal that we had to do

with it, other than source it, photograph it and put a limitless void around it. We also filmed some light leaks where we took the lens off and put paperweights on it and you get these beautiful patterns whose origins are impossible to understand, and we layered those up, to give them depth and life; basically we brought in some very abstract energies, to represent the birth of life; the universe itself. The end of the universe is not strictly represented: we get to the end of the earth itself, of our solar system, as is theorized: our sun goes first, a red giant which expands and burns off the atmosphere from our planet as it encroaches upon it, but then the sun, as stars like our sun do, burns its fuel and then it collapses back in under its own weight and then becomes a white dwarf and that is depicted right at the end, where we have a couple of shots of our earth. We filmed a plate in Iceland of just barren terrain and we stripped out the sky and left an empty sky that shows the collapsed, dwarfed sun and the remnants of Venus and Mercury in the distance, and then there is a final image of the earth eclipsing the sun itself, which is really just more symbolic imagery and indicating the death or end of earth time and, at least, but not specifically, maybe the end of the universe.

NICK GONDA

Terry had always wanted to find something visual that would represent the mystery of the universe from its origins until its eventual end. I spent many weeks searching through catalogues and archives of abstract artists in the era of Oskar Fischinger, Jordan Belson, Stan Brakhage and so many others, when experimental filmmaking was much more prevalent, and came across the Clavilux, the light art of Thomas Wilfred.[11] He was very inspired by astronomy, by the natural beauty of the universe, and he created these incredible installations that actually bring light to life. There are stories of them being found in basements and in closets and people don't even know what they are. Eugene Epstein, who lives in LA, became an avid collector and preservationist of the

Wilfred work, so Terry, Ecky and I went to his house one day and we were able to experience these works and see their powerful imagery. It is purely abstracting light through a tunnel, a light tunnel that Wilfred created that uses mirrors and glass and it has this almost indescribable mystery to it, it can feel like something that could live inside of a molecule or inside of a galaxy. It's this omnipresent natural glory and mystery, and so we were very fortunate to find that, because then we were able to just shoot it and not have to create it digitally, which immediately would have become artificial. We shot for a few days throughout a week; we were able to film at Eugene Epstein's house and then at the Los Angeles County Museum of Art where one of the works was housed.

DAN GLASS
We didn't always want the same look for the film, which made it less challenging than trying to make sure everything felt the same, but we did quite a bit of work to every image to make sure that it was holding up to the highest quality possible. In the case of some of the older 35 mm images it sometimes meant trying to degrain and enlarge, upgrade the quality and then add grain back on, or apply special filters to clean up some of the images; their stocks had much larger grain in the 1970s, so we were trying to extract that and improve the look of those images, the way that colours bleed in the older negatives and the way that colour itself responds in the older negatives was different. Whilst we enhanced a bit of that – made things a little bit more punchy – we left a lot of that in the material.

NICK GONDA
There was footage that Terry had shot over the years; there were eclipses, underwater footage in the Great Barrier Reef in Australia and different stock footage from the volcanoes in Kilauea in Hawaii. It was a massive effort to find the material, not just the footage, but the negative so that we could scan it

at the appropriate resolution so it would fit into the beautiful tapestry of imagery in the rest of the film. It was another great challenge. We shot this film with Master Prime lenses and it was very high-resolution, and so we had to carefully handle the footage from the 1970s and 1960s – film that was shot all over the world – to get that into a form that could seamlessly integrate within the rest of the movie. It was a great technical challenge, but it ended up working out.

DAN GLASS
We didn't concern ourselves with just the technological approach, it was very much a movie about trying to find artistic representations for these key moments in time, whilst there is a lot of technology used to create those images – in some cases, we had some supercomputer simulations, and full-blown creature animation and modelling – but there is a whole variety of palettes that we applied in order to create the work, and that's what I find exciting – there are so many tools available to us now, we are understanding them enough to take it beyond the technology itself. There was a long period in the earlier days of visual effects that the technology really hindered in some ways because it was so complex, and we were trying to figure out how to pull things off technically that would have an impact on how you designed or achieved shots. Now that is far less of a hindrance and our hand is freer as we design; it's a very exciting kind of phase we have entered. I think it's a phenomenal effort that Terry pulled together – the bravery and courageousness of the project and what it tried to do is really admirable, and I was incredibly glad to have had a chance to be involved in it. It took me five and a half years to watch the final finished film and the film itself has a real power to its sensitivity and the emotions behind it. For a director who is traditionally so philosophical it is his most emotional and heart-felt film.

The role of VFX is really displaying the wonder of the variety of the world around us, showing each image in its own light,

captured in its own way, created in very different ways, by different artisans. It lends a feeling of enhancing the sense of variety and differentiation. It also helps the passage of time in some ways; if everything felt very homogenous, I think you would naturally infer that it was already much more concurrent, whereas there are huge leaps of time between some of these events, so to try to mix up the look and the feel and the methodology behind them helps contribute to that sense of the passage of time itself.

DOUG TRUMBULL

I think that the work that Dan Glass and his collaborators did is really beautiful; it is stunningly realistic and the philosophy was great: basing those shots on real photography, finding locations in a forest or a stream or on the ocean front, shot on IMAX so that a large portion of the frame is actually a real place; a real scene to which has been added some animated creature. So in regards to the creatures, the CGI has been done in a very naturalistic way: it's interactively lit, it's in the correct perspective and matched into the scene, so that you look at the scene and still probably 80 per cent of what you see is 'real' and only a relatively small percentage of the scene is the computer graphics, the synthetic part, and even that is often in deep shadow or in a natural-looking way, so it almost looks like a documentary film of some real event.

SARAH GREEN

The dinosaur scene is interpreted very differently by different people. In my mind, I think that the big dinosaur (*Dromiceiomimus*) has the ability and likely the instinct to kill the baby (parasaur) in what we've seen to be a relentlessly Darwinian world, but it chooses not to, in what looks to me like a beautifully compassionate act.

JACK FISK

To me this scene illustrates how similar all living things can be.

Maybe it could be related to the contrast between nature and grace that we can see in all Malick's movies, but Terry's ideas are continued and sometimes expanded on in his work.

JESSICA CHASTAIN
When I see that moment in the film I end up seeing a moment of grace and compassion in nature, it is the beginning of grace in nature, absolutely.

DAN GLASS
Conceiving this section of the movie, there were several steps that we took into consideration that are about establishing different points of evolution: whether it's stages in the universe leading to what ultimately forms our planets, to processes that ultimately lead to the formation of cells that can control their own motion, to cells that can replicate in order to begin formation of a more complex life, and once we got onto living things themselves – creatures – he wanted to illustrate that there is a form of evolution that goes beyond the purely physical; that there are levels of consciousness that you can try to depict, even in creatures, where they become both self-aware and aware of others, and part of that evolution is not just to have a sense of others, but a sense of their pain and their situation and so what is captured in that scene is an element of mercy. Where you have a creature whose natural tendency is to hunt and kill – especially with this other species – a wounded or tired animal, and it had this moment, almost a kind of an epiphany, like a questioning of its own natural actions and that to Terry was an important idea to show, that that's part of an evolutionary process and one of the things that led towards mankind.

NICK GONDA
We were very fortunate that Terry has worked with people like Jack Fisk and Chivo Lubezki, and many others over the years. They are like the godfathers of the set, they instil a tremendous

sense of calm amongst everybody which is so important on a set, to remain calm and thoughtful. Actually, we had a great crew in Texas, a very ambitious and passionate crew. I think it comes from the fact that Texas is still a very young and growing film community; it is not a very jaded one. It reminded me a lot of when I came and worked with you guys in Italy[12]; people who love movies and love to be a part of the process of making them. We were very fortunate to have a crew like yours, where there was passion and happiness and extremely hard work, with long days and surprises that we had to react to at every moment, but it was a great crew where everyone seemed to be aware that we were working on something that we would remember for the rest of our lives. We were able, logistically, to shoot all around the world; we had a great production team and collaborated with groups such as yourselves in different places and so we were able to learn from local insight and create a plan around the experience of others who were local to that terrain, working with my fellow producers and constantly gauging the resources that we were spending and staying very close with Terry on his vision and what more he wanted and needed on a daily basis, making sure that the practical means and the creative vision were working together. This is only possible if people join the dream. We stood there at the end of *The New World* dreaming of making this film that Terry had been envisioning for many decades, but it would never have been possible if a movement hadn't started, if hundreds of people didn't start dreaming that dream for themselves. Because it is not a situation like with a studio film where you can just pay for everything along the way, and then everything will come together – a film like this will only come together if people believe in it and dream that it needs to be made and that there's a place for it in the world. That really is the most important thing that I found in the production: everybody from an assistant on set to a producer in Italy were willing to do so much to make it happen, and nobody, no individual can take credit for it because that comes from everybody's collective heart and generosity.

The method that Nick Gonda described illustrates a completely new way to produce a film. The contributions of different crews, artists and researchers converged to form the final result. In this process Terrence Malick remained almost hidden, letting the film take form by itself once he had thrown out a series of creative ideas. This decisive step towards a new form of cinema was reflected in his next film as well, To the Wonder.

SARAH GREEN

Terry talked about *The Tree of Life* when we were first getting to know each other, and I read a version of the script during the *New World* production. Terry had several projects he was considering after *The New World* but *The Tree of Life* was always of utmost importance. It was a project that he had been working on for decades and it began to feel like the right moment for it. Heath Ledger, who was originally meant to play Mr O'Brien, and Sean Penn signed on; we found our ideal Mrs O'Brien in the then-unknown Jessica Chastain. When Heath asked to be released due to overcommitments, we all had a 'can it be true?' moment of realization that Brad Pitt, who, along with his producer Dede Gardner, was involved in two of our other projects, would be an ideal Mr O'Brien; he was already a big supporter of the film, he responded to the character and, as Dede pointed out, had a rare window in his schedule. When he accepted the role, it was clear to us that the film was meant to be made at this time. Bill Pohlad was already on board as a producer and financier so *Tree* moved out in front of the other projects. Terry's friend and agent, Rick Hess, had introduced Terry and Bill Pohland some years back, and they stayed in touch, often discussing this project. Bill decided to fully finance the film through his River Road Entertainment. He worked with Summit Entertainment on foreign sales, and held the domestic rights until the film was completed. Once finished, it sold immediately to Fox Searchlight who were very passionate about the film.

The Tree of Life: *A Bridge to the Wonder*

NICK GONDA

I was directly involved in the early stage of production. I think we finished *The New World* in 2005 and we didn't end up shooting until several years later, so it took several years to meet Bill Pohland who was introduced to us by Rick Hess who was a wonderful advocate for Terry and for all of us. We spent several years in development; we started searching for the mother, searching for the boys, searching for the town where we would shoot the movie. As you can tell now, all of these were the most important ingredients that are pillars of the story. We spent over a year finding Smithville, the town in Texas; we were searching all over the state, and that same summer we started casting calls all throughout the major cities in Texas; then we learned we wouldn't find the boys in the obvious places, we were going to need to search in small towns, in rural communities in places that would never hear of a casting call – we would have to go to them. So then we devised a system with the schools in Texas. We searched hundreds and hundreds of schools and it took about twenty-four months to find the three boys, and it worked out well, because by the time we went to meet Bill Pohland we already had found the main ingredients: Jessica Chastain, the boys, we had found the community and it was almost like a ship that was starting to sail. That is something phenomenal about Terry: he will build with whatever he can find, he would not wait for permission, he will create with what's available and make the best of it, and so we were able to go about the preparation differently. Usually you have a few weeks to cast and you have to make a decision based on who you can find, whereas here we went about it somewhat philosophically, looking in communities that nobody had ever looked at before and ended up casting children who had never acted before, but they were naturally familiar with the lifestyles of the lives of the boys in this story.

When I came to Texas my assignment was not very clear. There were just a bunch of ideas, a bunch of concepts, but what I had to do working with Terry was to find a way to take those

ideas and try to apply them to reality. We were looking for boys who have a timeless quality and a wonder to them, and in the modern world where there are video games, and an overflow of media and distraction, it was much more challenging to find children that still lived the majority of their life outdoors, letting their imaginations get taken by nature. Another important thing was to find a community, a city that would resemble the past, that would resemble Waco in the 1950s; we searched every nook and cranny of the state of Texas to finally discover Smithville. Then an incredible effort was to find the actress for Mrs O'Brien, and we treated it almost like the search for the Dalai Lama, for what seemed to be unattainable, and then we ended up finding Jessica Chastain after about a year and a half. She had already been working with wonderful actors like Al Pacino and had graduated from Juilliard, and had this incredible training, but also possessed this mysterious quality that we had been looking for but had not yet found: she embodied the grace of Da Vinci's *Mona Lisa* or Michelangelo's *Madonna*. So we started with this idealistic approach – we didn't know if they were ever going to be discovered or whether we were just going to have to create them, if we were going to have to create a city, or if we had to get boys from the modern world and have them pretend to be boys from the past, but we were fortunate with a lot of this because of the amount of time we were able to spend doing this, we were able to find those people and that city and not have to do too much, just put them together and then the story would start telling itself. This element was really important to the production of *The Tree of Life*: while it was set in the 1950s and while obviously this family had never been together before, in real life once we put them all together, the story started to tell itself because they were so naturally in tune with what Terry had envisioned.

For this reason we hold the specific processes of casting very sacred, but generally speaking it's a matter of finding those people who have what we call a 'distinct nature' to them, a 'mystery'. You can feel as though you know them but there is also a certain

amount you won't know, a quality that Katharine Hepburn or James Dean had, or like so many of the great Italian actresses had, where you were struck by their beauty or by something that was very apparent, but also struck by some inner mystery. There is something fascinating about so many of the characters in Terry's stories on screen. There's a certain amount that you can identify with, because he doesn't paint the full picture, he leaves room for you to imagine what is in their thoughts. In casting the challenge is coming across these people who possess that mystery, who possess that nature and then once we do, it works so beautifully. It's also a very rare quality nowadays, a lot of times people are taught in acting school, or it's just the way the world seems to be, you are expected to be very polite, to be very giving of oneself, in communication and interaction. The quality we always go for is people who still have that mystery, which is very, very rare, and it takes a long time to find. The process is a fascinating one. The beauty of it is that it is always very different on every film. Normally casting follows a routine where people memorize their lines and sit down on a sofa and give their performance. With us it is more of a study, much more improvised and just seeing the natural emotion of the actor or non-actor, versus their trained ability.

SARAH GREEN

We looked at many, many actors for Mrs O'Brien. Our casting director Francine Maisler has excellent instincts, and is great at looking beyond the more obvious places. Mrs O'Brien represents Grace, she's almost a mythical mother figure; it was one of those things that one can't explain but you know it when you see it. The elements of nature and grace, whether they are in direct conflict or two sides of a coin, is certainly front and centre in *The Tree of Life*, so it was very important to find the right actress. Jessica is completely natural, her acting is invisible, but she's extraordinarily skilled. It's a rare combination which I suspect has to do with her inherent honesty.

NICK GONDA

I think with Jessica there are so many intriguing qualities; what Terry had always wanted in the film was a feeling of a river, a feeling of time passing and never to feel a repetition in emotion or even a visual repetition and Jessica can constantly evolve, without ever using the same technique, showing such incredible emotion. Where she was working with non-actors, she would never leave her character; she was and remains to this day like a mother to those boys. There is such sincerity and honesty and love in her heart that those boys were able to trust her, and that was something that we never could have taught or trained the boys to do, that was something that just had to come. It was either going to happen or it wouldn't, and if it didn't the relationships on screen would feel very forced, but if it did, which obviously it did, then there would be such a beautiful portrait of childhood and motherhood on screen. That came from Jessica's sincerity, and her genuine love for the boys and also the incredible trust that she has in the filmmaker, in Terry, that enabled her to give the performance that she did, but it came from her own heart and her own trust.

JESSICA CHASTAIN

I was a big fan of Terrence Malick. I loved *Badlands* of course, *Days of Heaven*, *The Thin Red Line* and *The New World* and before I had auditioned for him I watched them all in chronological order again – to get a feeling of his world; I recommend it to everyone to watch all his movies again one after another. Everything started when I got a call from my agent to go to the audition and I went and there were a lot of women there. And I met Nicholas Gonda who was in the room. Terrence Malick was not there and I did these activities, things like trying to put a baby to sleep, looking at someone with love and respect, reading a bit of text from a Eugene O'Neill play and after that experience, that audition, I got a call a few days later asking me if I would like to meet Terrence Malick, so I flew to Texas and met

him, had an interview with him and then did another audition.

So my first casting was 'doing behaviours', it wasn't necessarily going in and reading a scene and when I flew to Texas to meet Terry, it was the same kind of situation, where there would be bits of dialogue on a page, which I would look at and try and memorize as fast as I could. I could put it in any order I wanted to when I spoke it, but it was all about just saying what came naturally and not being forced into doing anything inauthentic.

I was really, really glad to be part of the movie, I remember also talking with Al Pacino about that and he told me how much he loved Terry's work. I felt a great responsibility. Every day before shooting I did a meditation. I would meditate on cultivating joy and cultivating gratitude before coming to the set; I would try and envision opening my heart to the world, I tried to do a lot of that; tried to do a lot of calming my mind and slowing down my modern energy and doing meditations on opening my heart. Terry was looking for something universal from my character, something out of time. The expression of an unselfish love, where sometimes in the love for nature, or for a husband, or in the primitive love between lovers, there is a sense of 'me', this is what 'I want'; in a way it serves yourself. But with Mrs O'Brien it was a kind of love that didn't serve her, a kind of love that was only for others, she would let go of herself, for the betterment of someone else. To me, it is the most beautiful form of love, and the most difficult to achieve, it is a pure love; it is explained a lot in Thomas Aquinas,[13] writing about the difference between nature and grace – there is the way of grace, it's a sense of always putting others before yourself.

NICK GONDA

There were several actors at different times considered for the role of Mr O'Brien. We were speaking with Brad Pitt about another film but, after a series of events, he learned that the film might not be made unless an actor came in and stepped up to that role, Brad was very supportive and generous. He helped to

ensure that this movie was brought to life: it was an incredible act that truly saved the film, otherwise who knows what would have happened; it was right at the time when the world economies were about to shift drastically, so if time had passed it might have been almost impossible to make the film in that way, so he was a great saviour of the movie. Brad is a very serious actor and he really took the time to understand the character and the story, and to really become a father figure to the children during the course of the production. He took a lot of time to really immerse himself in the story. For everybody on a set like that of *The Tree of Life*, it is a challenge because we are doing things in different ways, but at the end of the day, it's very rewarding; while at times it seems very demanding, it doesn't feel like a painful challenge, but more of a rewarding one. I think a big part of the preparation and in some way of the challenge was for the children to be around Brad and Jessica and for them to become a family.

SARAH GREEN

Brad is a father, a very involved one from the little I saw, and I believe that aspect of his life helped him to understand and empathize with Mr O'Brien. He made a challenging character sympathetic, in a beautiful way.

JOERG WIDMER

Brad Pitt was fantastic! He was really trying to find his role, to being this rude and stiff father. As soon as he came on set he was this father, he was never relaxed during the day, as soon as he comes on set he sticks to his role until he leaves. It was impressive that he learned to play the piano – I think he didn't do so before – but he played it for real during the shooting. It was probably the only relationship he is able to establish with his children. The character is very much addicted to music, he uses it as a means to educate his kids, but he is never close to them. He is not very sensitive, he's very limited; he can't really get out

of his shell. The interesting thing is that by using the method of 'discovering' the scenes, of performing them several times with different elements and intentions, a lot of things that related to his character emerged in a natural way.

JESSICA CHASTAIN

Brad and I didn't really 'work' that much off-camera, because there was a kind of formality to Mr and Mrs O'Brien that is interesting. Mrs O'Brien is constantly trying to bridge the gap between the two of them, but there is a gap to be bridged, and the more that we knew about each other, and shared our fears and secrets then the less of that gap there would be. So we just took advantage of what was naturally there, having just met him then on the set, where there was this sense of formality between us, and a slight bit of distance, not necessarily being incredibly connected to the other person.

Instead, the relationship with the children was very important: Mrs O'Brien lives for her children and I tried to create as real a relationship as possible. We spent as much time as we could – I got there two weeks before filming started and I hung out with them every day, so I think the love that you see between me and those three boys is absolutely real love and we created that.

NICK GONDA

The similarities between young and adult Jack were not the focus of our casting process. We were fortunate that the boy we felt strongest for Jack, Hunter McCracken, also had an emotional similarity to Sean's character. That was just a serendipitous discovery; we had found Hunter about a year before he was cast as Jack, we were going to cast him in a different role, then we kept checking in on him every few months and as he matured from about when he was eleven, to around the time we started shooting when he was around twelve, he grew into the qualities that we were inspired to build the role around; we were fortunate that visually and also emotionally he held similarities to Sean,

but we can't take credit for that – that was just a beautiful, serendipitous encounter and also a result of just having looked for so long, and in so many places; we were lucky to have well over 10,000 children that we had come across over two years of casting, so we had lots of candidates. At the end, the children that we chose never knew each other before. Through the course of the shooting they truly became like brothers, with the highs and the lows, the hugs and the punches. It was very moving to see them grow close to each other during that time; they shared a unique moment in their lives together and you can tell that to this day there will be a unique bond between them.

JESSICA CHASTAIN
The wonderful thing about working with Terrence Malick is that you are capturing 'real life'; there is no acting really allowed in his films, so when you show up on set you have to already be the character and all the homework needs to be done before you come on set. It's not good to see you muffle a character when you are in a Terrence Malick movie; he really loves simplicity and by creating the relationship with the children and by reading about cultivating grace and doing the meditations in the morning, by the time I came to set, there was a certain feeling that we were on the right path. We could film at any moment and I would be Mrs O'Brien. This is something precious and it is related to Terry's way of working: you are not filming a scene and then you take a break for half an hour, it's constantly going on and you are constantly in that world. We improvised all the time. The scene in the kitchen with Brad where we struggle, for example, that was completely improvised; we did not know that was going to happen, that the struggle would happen, but because we were completely in the moment of what our characters would be feeling, you see the explosion, I guess, of the two worlds. Another example is that of the butterfly landing on my hand – that wasn't planned, we were going to film something else, and we saw a butterfly and Terry said, 'Just go, be with the butterfly,' and

Chivo Lubezki grabbed the camera and I started running after the butterfly, and I just threw my hand in the air and it landed on my hand! All of those accidents happen on a Terrence Malick film because he allows the set to be fluid, like water, where you can move anything and go anywhere and are not confined to structure. In this way, little miracles occur.

NICK GONDA
Improvisation on a Malick set is an interesting thing to talk about, because it's something that you can't really characterize; it's not premeditated, it isn't very academic, it's more athletic, I guess. Everybody knows how to play the sport, the actors know their position and the grips, and the electrics, and obviously the production department and all of the different sectors know their 'position', but at the end of the day we have no idea what plays will run, what offence will run, what defence will run, we just know how to play our position the best we can and react to what we learn, so everybody is improvising. The cast's approach to improvising depends on the kind of day. For instance we will approach the day in one way if it's dreary and overcast, if it's sunny and cheerful we'll approach it in another way, and the same thing goes for all the other departments from the set medic always having to keep an eye out for everything we are doing, never knowing, not having the benefit of a script in order to prepare. Chivo Lubezki is obviously the ultimate improviser, he is the one who is constantly creating on the fly, constantly envisioning without any time to truly prepare. Everybody is improvising every day at any time.

JOERG WIDMER
The preparation for the shooting was less than ever. In *The New World* I had to test all the anamorphic lenses, and I had to prepare a 65 mm camera at Panavision, which took me a while, because they didn't have one ready any more, it hadn't been used for probably fifteen years, so we had to take it out and make it

Steadicam-ready. This time we didn't have anything similar to do, so we had no more than four days of preparation. I didn't know too much about the sets, I didn't know too much about what would happen in the movie; I read the script, which was informative, but it could change any time, so I knew only what the story was about. I knew every evening we would have a so-called 'death march' when we were walking through the community, the village, to find our places, and that we would always use the sun until the very end.

SARAH GREEN

What first drew us to Smithville was a feeling of spaciousness that is rare in modern towns. The streets were wide, there were sidewalks in some places, there were yards and big live oak trees in which young children played like they did in the '50s. The town had a good experience with another film some years back, so they were very welcoming and worked to find ways to accommodate us. Once we began to home in on the O'Brien house, which had to do with the floor-plan, the light and its position relative to streets and views, we had the idea of using other available houses and garages for our other needs, thus eliminating the need for trucks and trailers which would limit our shooting areas. There was an extras-holding house across the street which included the office for the assistant directors; we had rooms or houses for actor-holding; a hair/MU/wardrobe house; a grip garage; a sound hut; and so on. By closing those doors the camera could look 360 degrees from any position, which was very freeing for the actors and Terry.

NICK GONDA

Every day when we stopped shooting, the boys would immediately sprint towards the local swimming pool or ride their bikes until 9 o'clock in the evening around the town. These qualities, especially here in America, are more and more rare; that kind of childhood is almost extinct, but we were lucky to find boys

that still lived that life back home and to have found a city like Smithville that allowed them to continue that way.

JOERG WIDMER

The fact that we were shooting in a small town like Smithville helped a lot because you didn't have any restrictions, you could decide to go down three blocks and you never saw a modern car because it was always blocked. We had a lot of support from the municipal police and by the authorities of Smithville; we could really use the entire town as a studio, it was great!

JACK FISK

Terry likes to write around locations, so the search for locations has become a part of his creative process. This is great because we are able to get the most production value from the locations we choose. Terry had been searching for locations for *The Tree of Life* long before I showed up in Austin; I first scouted with Terry on that film about two or three years in advance of shooting. Chivo Lubezki often accompanied us on our searches.

Our scouts began in Austin and the small towns surrounding it. They were visited and filmed many times at different seasons of the year. We ended up choosing Smithville, about forty miles from Austin, because it had the feel of a '50s town that was familiar to us. I also liked it because the people of Smithville were excited about having us shoot in their town.

Smithville had a lot to offer and the people co-operated with us beautifully. We removed fences, covered modern buildings, and asked the residents to park their modern cars a few blocks away from their houses when we were shooting. The town was so co-operative that they even passed a law forbidding paparazzi from shooting cast and crew while we were there. Most of us rented houses in the town and travelled by foot or bicycle to work. One of the challenges of my job is to appreciate all that we find and incorporate it into the design of the film.

We were able to take a five-block square area of Smithville

and dress it for our film. We covered offensive or modern struc-
tures, planted gardens and trees, and simplified the neighbour-
hood, giving Terry a 'back lot' where he could shoot freely. Since
we were shooting with natural light, we worked to provide as
much sunlight as possible into the locations. In our main house
we added windows and simplified the rooms for ease in moving
with the camera. We also trimmed or removed trees that were
blocking natural light from entering the house.

My main reference in designing *The Tree of Life* was my life
as a child. I try to not use film as a reference for designing films.
We did look at several painters for inspiration on window light,
notably Vermeer. Terry may use film references, I personally used
what I remembered or thought of as a child in a small town
in Illinois. I was also very aware of Terry's remembrances and
feelings from his childhood that were not that different from my
own. My wife, Sissy Spacek, grew up in a small town in Texas
and I was able to use her memories as well. I think one strength
of the film is how familiar the images are for the viewers.

NICK GONDA
I got roped in, it was obviously a great honour but also a big
surprise. We weren't able to cast a schoolteacher in time, the
schedule moved around very quickly and there wasn't anybody
that we felt was close enough to Hunter, who plays Jack, for that
not to feel too superficial and, as a result of the casting process,
I had grown to care very deeply about Hunter and his life, and
so, I think, Terry felt that our interaction was most similar to
a schoolteacher in a classroom, because I also had to be a dis-
ciplinarian with Hunter at times. It's a very brief interaction,
but it was always intended to feel like somebody who would
awaken in Hunter an awareness of something great inside him,
of a destiny – and so it appears very quickly, but because of our
bond throughout the process, Terry felt that that would be most
genuine. Thinking back to the casting process, there were sev-
eral different stages and at a certain point we realized that we

were going to go to communities where people have never considered acting before and maybe might never even have wanted to. Me and A. J. Edwards,[14] who is also a director and did a lot of the casting together, promised each other and ourselves that we would do our very best to look out for the children that we ended up casting for this movie, because it can be a blessing and a curse to get cast as a child in a film. It changes a lot about the community that you live in and how they treat you, and what it's like when you walk into school every day; it does change your life and not only in great ways, it can be in ways that people don't always envy as much. So when we started casting, I tried to take enough time to really get to know the families, and the children, and make sure that everybody understood what they were getting into, so as a result of that, we did form a good bond; I care about those boys and those families deeply – they are great people. I think that this element reverberates in the movie.

JOERG WIDMER

Jessica Chastain adopted all the kids for her family. When we were not shooting, she tried to build the family, playing with them and keeping them close to her and pretending to be their mother. The whole environment was set up to make them feel comfortable so that they could act accordingly, so they could find the moment when they were motivated to do something. The most interesting things always occurred when we switched off the camera and they started to behave like normal kids, and this was the moment when we came back in and tried to catch the moment. We had also an element called 'the joker': it was the dog, which was also part of the family in the movie, and when we felt it would suit the purpose, we would send the dog in and let him play with the kids or interact with Brad and Jessica. Before they started to shoot, they knew of a lot of things which they should experience and try, so when they came in sometimes they got some directions from Terry, and sometimes the action was very natural. Brad had more direction than Jessica; Jessica

could be more playful, whereas after each take Terry and Brad discussed a couple of things and then they changed something. With the kids, direction was used even less than with Jessica: 60 per cent of their actions were just observed, some things were directed, but in most cases it was just to let them go as playfully as we could.

In *The Tree of Life*, the house was a kind of fulcrum: we could go into the house whenever we liked, whenever it suited our purpose. Having children involved, Terry wanted to catch their real emotions, their real personality instead of setting something up, so to have a proper set in order to freely follow the action was really important. The idea was to find the best time when they were in the right mood for acting, so it wasn't about making them do things, rather finding when they were in the right mood to 'perform'. Hunter was probably the person who had to do the most stuff which he disliked! He didn't know what this was all about, every day he asked: 'When is it time to go home?' So it was really hard to explain to him the purpose of why he was there, because he was the only person who didn't want to make movies any more; but this element helped a lot because his actions were fresh and surprising; he didn't know too much about movies and wasn't interested in movies at all and he doesn't want to perform in movies any more. Laramie Eppler and Tye Sheridan were playful and they knew what the process was about, but having him a little bit reluctant helped for the authenticity of his character.

JESSICA CHASTAIN

We shot a lot of scenes without dialogue, especially because we realized that was important in showing the contrast between nature and grace. The father is always lecturing the boys about life, on how to be successful in this life, but they are like the lessons of a man living through nature: how to get ahead in this world. Early on we realized that for the mother, for her to 'lecture' about grace wasn't very appropriate because it's not

very graceful to tell someone how to live. We understood that we had to do a lot of my scenes without the dialogue, and just think the thoughts; then a lot of my education to the boys would then come through the voice-over, because Mrs O'Brien speaks through her soul and through her actions.

Terry actually left the construction of the character up to me. I went to Kansas to a farm to see what that was like, because we talked about Mrs O'Brien coming from humble means and maybe having grown up on a farm. I never really talked to him about the difference between Brad's character and my own; he mostly gave me the Thomas Aquinas piece about grace and nature, that ended up in the voice-over and that was what really led me to Mrs O'Brien, to the way she goes about her life. The whole thing is about how a person living through grace should live, and that was very helpful but we never talked in terms of 'it's this versus this'. As an actor I always use myself, my history, where I come from, but most of the time when I work, I just believe I am the character. For example, when we were doing the section about Mrs O'Brien's grieving for her son, I didn't think or do sense memory or think about something sad from my childhood; I just thought about Laramie, the actor who plays my son, who I loved, because I love all these boys, and I just said to myself, 'Okay, he's dead,' I just said that in my head, 'He was killed and he's dead,' and that makes me emotional. I always think the thoughts of the characters, I never try and go back in time and think of something that is personal for me, because I find that that confuses the telling of the story. I just tried to play Mrs O'Brien as a mother, who was in the agony of mourning a child, and what that meant and because I have never had a child, I had to discover that on set through this incredible, strong relationship.

JOERG WIDMER

Emmanuel Lubezki is the mastermind: the few rules that we followed – all the good ideas were conceived by him. He developed

a method with Terry whereby he was able to shoot *The New World* with natural light, so Terry would say to him and the crew, 'In *The New World* you hardly lit with artificial light at all, you always pushed the lights away. If you succeeded in that movie, why can't you do that in *The Tree of Life*?' Most people would say, 'It's impossible, we need some lights in the house.' At the end even this was possible, because it turned out that you simply had to adapt things and the way that they adapted it was really Chivo's idea. He was also the guy who brought so much spirit, especially in the treatment of the kids. In a way, he was co-directing because he is so inventive in finding solutions. If there was something choreographed, it was always down to him to find solutions according to the rules. The rules are simple: back-light your subjects and find nice angles. It wasn't difficult to find the right way to film, because if you have your rules, you have only to look for the right moments. My assignment was to find the good angles following the characters and to decide to run with them, or let them get in the distance and follow them later. I had a lot of freedom, often totally unexpectedly; I decided to catch the shadows of a character, because I like this very much, when the shadows were playing and you didn't see the kids. We were playing with every element, finding a way to shoot. Chivo was the first person to do that: if it was too dark, then we went for silhouette, or if the characters were running into the room, we tried to bring them closer to the windows, so it was really about silhouettes and getting them in front of something bright.

But it was always according to these lighting rules – which was good, because if it wasn't, then we wouldn't have shot it; as soon as the actors went in the wrong direction, we simply closed the stop and said, 'Okay, we don't shoot it any more.' Terry has a fundamental role in these decisions because he wanted to have a movie which looks good, and Chivo is responsible for the whole look of the movie; so he was the man who decided how to expose the negative, how he wanted to shoot and how he wanted the colour balance, almost in a scientific way. During

post-production, he would work for months in order to find the best quality for the print. I think they had half a year of grading, and then deciding the scan process. I think they did a double scan for highlights and lowlights, they did something which treated the negative completely differently. The first time, they tried to do it in analogue and they compared analogue prints to the digital prints, and finally they decided that it was much better with the Digital Intermediate. Having in mind the whole process from the shooting to the post-production, Chivo was able to share his ideas with the crew. I was personally very linked with him: when Chivo was on camera, operating, I pulled the stop and when I operated, he pulled the stop for me – we were always together! We never had holidays! Because we always changed the stop, we didn't have to amend. For Erik Brown, the first assistant camera, it was difficult. Sometimes the stop changed and you needed to open up to 1.3. If you run into the house and you are completely in the dark, you open, open and open, the stop decreases – so the depth of field decreases, and for him suddenly it became really tough as he didn't have the chance to measure anything. Sometimes he had depth of field of 2 centimetres only, almost by accident, because we ran into the dark and we had to open without underexposing.

As usual, Jack Fisk was incredibly wise in preparing the house according to our needs. Originally, they planned to have the roof removable to have light shafts falling in, but then they decided simply to restructure the house to be lit by the sun. They also changed the garden – a tree was planted, if I remember it right. They organized the garden to make it the way the story required it, so there was some set design before we came in, but as soon as this was done, we started shooting. Texas, weather-wise, is quite reliable, so we could have the same rhythm every day. We shot in the house, but we also had two other locations for the little kids' room. We had three kids' rooms suited for different purposes, different angles and different actions. It was better to have other options for the kids' room, also to shoot at different

times of day and have the proper natural light, so sometimes the shot was angled differently but you don't realize the difference between the different locations, especially if they are not cut together. Consequently, continuity wasn't used so much in the movie. So one of the kids' rooms we could use in the afternoon and the other one was especially used in the morning. It was almost always sunny during the shooting. Dusk and dawn were the moments when we shot outside in the street, and used some source of lights like the little fireworks or a campfire, but never using artificial lights. The only things which lit the houses were the house lights, kind of practical lights, when Jack peeks into the neighbouring houses, for example.

As I said, there were just a couple of 'dogmas' in this movie, which consequently were followed much more than in *The New World*. The backlight and lateral movements were elements of that approach, so according to that we shot in the house following the way the sun went around it: in the morning it was the living room, at noon it was the dining room and in the afternoon it was the kitchen – and the same way outside – always facing the sun. If we were in front of the house, facing it, it was always shot in the evening; when we were in the garden, it was always shot in the morning; if we were in the garden and we had the house to our backs, it was always in the afternoon. When we were in the little garden, where they planted vegetables, and it was away from the house, we shot in the evening. There were no questions: it was always clear the sun must be behind the people. And it was the same with the very few reverse shots: it was also always facing the sun. People may realize there is always the sun in both shots, so the editing was completely different from a classical movie where you need to have continuity; here you can't tell the story in a regular way. The idea was to limit the options, the ways to shoot the movie, therefore creating a new style of editing and new style of visuals. I think it's more consequent or at least it feels that way. In *The New World* we always had the woods, where the light didn't have a visible direction, but in

The Tree of Life there was sun almost every day, and we only shot with backlight – backlight doesn't mean 7/8, but backlight so that it was really behind the people. In regards to the camera movements, we also had a few dogmas: if it was some walk and talk, then it was Steadicam mostly, no dolly at all; there were just some Technocranes involved when we climbed into the tree and when Mrs O'Brien is flying up in the air. Jack Fisk was always aware of these choices, always! He is so fast in adapting, he looks around and always finds something that suited the purpose. He uses the resources he has; he was also limited because budget-wise his department is not really well equipped, but he always found solutions fast and cheap. His knowledge of the sites is amazing; he knows everything! How to get it quickly, and how to find neighbourhoods which suit our purpose and finding places where scenes can happen.

DOUG TRUMBULL

Terry and Jack have collaborated in trying to find a very naturalistic look, that doesn't seem over-production-designed. The whole section of *The Tree of Life* that takes place in the small town in Texas, it's kind of a period town where things still look like they looked fifty years ago. The idea to shoot with a very natural-light look, without using a lot of dramatic lighting, is also part of Terry's production design, and I think Jack Fisk agrees with it. So when they are deciding where they are going to shoot a scene or how they will dress a set or how they are going to shoot in a real practical location of a house or building or a sky-rise, they are looking for the best natural-light effect that's going to happen in those circumstances, so that they don't have to resort to dramatic theatrical lighting that looks, often, quite synthetic. I think that's part of the integration of Terry's photographic and directorial style with production design – to find places and circumstances that lend themselves to that kind of naturalistic filmmaking.

JOERG WIDMER

We used Zeiss Master Prime lenses. We also tried Cook S4/i Prime lenses and we compared them for a while, shooting one scene with S/4 and one with Master Prime, but we stayed with Master Primes, simply for two reasons: it looked crisper and took the flares better than the other ones. The flares are beautiful and really important in this movie, with the Cook S4/i Prime lenses they were so sudden, they came in the shot and disappeared in a very perceptible way, so you could really see, 'Oh! Flares going in and flares going out,' as soon as you angled it one fraction further up – even if the sun wasn't in frame yet. The Master Prime lenses took the flares in a very beautiful way: as soon as the sun was in frame they flare and as soon as they were out of frame, they didn't flare any more. It was a kind of epiphany of The Light. This choice helped us to catch the better light including the flares without worries.

All the actors knew how to use the light, especially Jessica – she was really good with it. First of all, they knew that they looked better if they followed our rules; second, they also knew that if they turned around we wouldn't follow them, they had to be in the right direction. This was their 'playground', they always had to be between the camera and the sun, there was no chance if they 'escaped', we couldn't follow or we didn't want to follow them, they were out of frame and we'd take something else. Very often it happened that the leaves were moved by the wind and this was the moment when we may have continued with nature instead of them, so it was panning away from the actors, and looking for what happened in the frame, still the search for nature, for lights and for other things which happen, instead of always being strict with the action. It could happen that if the dog was coming in, we panned away from the actors and then panned back to them, or followed the dog for a second and came back to the actors. It would always be a surprise for the actors: they were aware of the rules, but they didn't expect things to happen sometimes. On the other hand, they have a lot

of freedom as long as they followed the rules. Jessica was especially good because she was also motivating the kids, helping to create very moving moments. In a way, the second unit was less free than us because they had to stick to the rules; they were not as playful as we were, because somehow they were 'morally' punished if they hadn't done it in the right way. We had the freedom of not respecting the rules, we were permitted to do something and then we could try something out and discuss it later because Chivo was the mastermind; if we did something different he could interfere immediately, he was with us on set. The second unit never had the space to decide something different because you have to stick to these rules, and if not, it will not be in the movie. Taking risks is easier if you have the mastermind with you.

Framing was a fundamental part of the shooting which was different from regular movies, because it was sometimes cutting off the head, sometimes only staying with the mouth for a while, the actors not knowing about it, but staying with details which tell more than looking into a face: sometimes the protagonists were mouth, eyes, hands, gestures, relations between people. So it's very much about framing and always having the liberty of framing differently. Freedom was the rule! You can concentrate on a gesture and sometimes you have a gesture of the hand and it will be related to a curtain blowing with the wind. We always tried to follow the natural phenomena, creating something, but making it happen naturally.

You deliver gestures to put in relation in the editing, like closing a door of the house, and shooting the same gesture but opening it, obtaining a completely different meaning. If you have a gesture as a silhouette, it's different from a gesture which is properly lit. It's really about this relationship between gestures and moments and it's never planned; you'll find it's one of the cinematographic ideas for the whole movie. The movements of the camera have the same importance: running through the corridor means something different to being static. It sounds very

simple, but it's really important to find the right spirit for the scene. Often a scene was performed several times under different conditions, different moods, the same lines again and again. We had probably ten scenes per day but over and over again, sometimes with different actors, in different combinations; sometimes with the dog, without the dog. It was kind of rehearsing without knowing which one will be the final idea. It is rehearsing the unexpected.

MARK YOSHIKAWA

All the editing was dictated by the camera trying to do the cutting and trying to capture life. All this came from Terry, Chivo and Joerg always wanting to capture life. They would never know where they were going to: it was all natural lighting, it would be free, it was 360 degrees so they could shoot in whatever direction they wanted. I heard Chivo say once that the script was written as a fiction, but then they shot it as non-fiction, as a documentary, and then in the editing we had to make it into fiction again. So that forced us, and we were happy to do it, to use a similar approach, because Terry wanted to extend the method to the editing: to catch things by chance. And things would be a lot more fleeting, not having the luxury of going to a close-up or a reverse shot when we wanted one, or a wide shot specifically. We never had to take a shot in the same way, following an action. You had to cut it more like a documentary, you couldn't think it out beforehand, like you normally do while editing. You just had to react and that was a lot like it was on set; they were just shooting and catching things as they were and in the editing room we would just experiment with two shots, just throw two shots together and juxtapose them. We never thought that they would go together to see if it would work, it was like the same sort of style: we were trying to do what Chivo and Joerg were doing on set.

The Tree of Life: *A Bridge to the Wonder*

JOERG WIDMER

The approach was very smooth and the Steadicam really suited the purpose. If it was a handheld camera then you would have an element in the far end, which would have been traced shakily. If you have the Steadicam you can keep this point in the centre of the frame and you get simply sucked in somehow. In the last two weeks of shooting Chivo wasn't there any more, I did it on my own – the whole desert sequence, the white sand and the Goblin Valley where Sean Penn is walking through the desert. The job was simply to follow the rules. So I used the Steadicam according to these rules: the film has to flow as a river. An example of that is when we move on the flat, light ground of the salt lake, towards Jessica; it really sucks you in.

Terry really likes to use a Steadicam because he doesn't feel limited: he can shoot anywhere, any time because nothing is in the way. He was calling it like a five-member documentary crew: just follow the action. If you light, you are limited because as soon as you set lights it is already over. He very much believes in the moment, and using the Steadicam delivers him from laying tracks and being limited to tracks. In *The New World* we had dollies at the beginning of the shooting, then the dolly shots were eliminated and replaced by Steadicam because he found it was much more flexible. So, flexibility and being fast are some reasons for using the Steadicam for him. Shooting time has incredibly increased working with Terry: we cut the moments between the takes, then we increased the takes themselves. Even if we had a reload, we didn't wait until it was reloaded, we simply took the other camera to shoot something. There is always this impatience to try; it's not about being sure about what is going to happen in the scene, it's really finding the scene during a shoot, because he doesn't believe in 'creating a scene' – he believes in finding the soul, finding the scene, the moment when it clicks.

SARAH GREEN

It was clear from the start that such a complex film would take time to edit, so we built a long post-production period into the plan. We scheduled a succession of talented editors to work for several months each, with some overlap built in to pass the baton. Different editors worked on different sections of the film, then they would all come together to consider the whole. We had a tremendous amount of footage, which allowed for much experimentation as Terry considered which moments and jux-tapositions best expressed his ideas. I believe that films begin to find themselves as much as we find them.

JACK FISK

Terry has many films he wants to make that are incubating inside him. *The Tree of Life* would be a different film had he made it in the '70s or '80s. Great ideas will have enough staying power to remain valid during a long gestation and the lesser ones will fall away. I don't think anything was lost by the amount of time this film was in planning, perhaps it has even more depth as a result. I do believe Terry and Sarah Green have developed a method for making films that will allow Terry to complete many of the films he has contemplated. I think Terry the philosopher is always exploring our existence, knowledge, and history. Terry and I seldom talk about the deeper meanings of his work. I don't think it is something Terry does. I think it is important for his films to work on several levels.

MARK YOSHIKAWA

The editing process of *The New World* was a little bit different compared to the one of *The Tree of Life*. In *The New World* he had four editors working the whole time through, so we were all working at the same time and Terry was bouncing between rooms. At the beginning Richard Chew was the main editor and I had been working with Richard for several years before that, so I got to work with Terry and when Richard had to leave for

another show, then Hank Corwin and Saar Klein came onto the film. I have worked through the entire process – that's how I developed my relationship with Terry. I was a big admirer of his, especially of *Badlands*; I remember seeing *Badlands* very early, when I was younger, and being very impressed by the story, the performances and the style. I also admired the work of Billy Weber, the way he edited *Badlands* and *Days of Heaven*; I knew that the pace was deliberate, because it made you think more than just following the progression of the story, and it was also interesting to see the evolution of the work in *The Thin Red Line*. When we worked on *The New World*, we divided the editing in some sections: Saar Klein came out and he worked on a big section and Hank on another section of the film, so Terry would just go between all the editors and see what each of us were doing and we'd see how he reacted to the different cuts. In the end we went to Los Angeles and at that point it was just myself and Hank Corwin; by the end, especially for the extended version, I was the only one involved in the editing. This time, on *The Tree of Life*, the editors were more of a relay system, where Billy Weber started, then Daniel Rezende came on, then I came out when Jay Rabinowitz also came out and Hank Corwin came in for a little bit and again I was at the end. Each section was going to be around four months or so, but I ended up being on it for about a year and a half, but it didn't surprise me because it happened also for *The New World*.

The approach to editing was different because *The New World* had a story we had to stick to, it was very narrative-based and had thought points that were very structured. Pocahontas couldn't meet John Rolfe before John Smith and certain things had to happen in a certain order – being a historical film, it had to follow a certain chronology. On *The Tree of Life*, from the very beginning, anything could happen at any time: it was apparent from early on that we were going to be experimenting with the different structures on both a macro and micro level. The script was divided into different sections and there was a lot of

experimenting about which sections would even go first and second and, internally, which shot we played with and which ones we moved around. So we had much more freedom but, of course, with freedom comes much more work: things were shot not necessarily for particular scenes and we were moving them around and seeing what worked, whereas with *The New World* we were trying to be true to the script, to the characters and to the story. There were things that Terry started to play around with also in that movie, he started to experiment with voice-over, subjective thoughts or stream-of-consciousness ideas, and we did a lot of that in the extended version of *The New World*. He was very excited to find a new way of cinematically telling the story, and we went further with that on *The Tree of Life*. Everything started with *The New World*, but this time we were less about the story and more about the experience, so we edited it differently.

In the end, it is a very long process, you never really finish, just walk away from it. We were always worried that sometimes we would overwork a sequence, but Terry was always very good about things. In the editing room he always likes to react to things, he doesn't like to tell you specifically, he'll never say take five frames off here, or cut to a close-up here, he would just like to react to things, tell you a feeling that he wanted. So any time we came upon a cut that we liked, we didn't even know how we arrived at it, because we were doing a lot of experimentation, we would say, 'Lock that in, with voice-over or music, that works, let's not mess with that any more.' When you do that with all the sections that you are happy with, then you can be happy with the whole film and be content.

I knew from the beginning that *The Tree of Life* could be a million different things, even more than any other film that I had ever worked on. Normally, you can do things several different ways, but it has sort of the same effect, the same story is being told, but *The Tree of Life* had so many remarkable energies, there were so many grand concepts that it was trying to address,

that I knew it could literally be a hundred different types of film. We had to just settle with things that we were all happy with, things that moved us and were emotional to us – that was the only guide we could have. At a certain point in 2010 we were pushing for the Cannes film festival, we were almost ready and we could put it out, but we knew it wasn't quite there, at that point. In the end, we edited for another year, not for the full year. It gave us that last bit of time to get the voice-over where we wanted and to get the music worked out and fine-tune it a little bit. Anyway, we were not looking for perfection; Terry never wanted perfection, he wanted it to have a little unfinished feeling to it, so we were careful to not polish it like a stone, because it was supposed to replicate life and memory, it had to have jagged edges and not be so smooth. At a certain point we said we were going to stop, so we stopped.

SARAH GREEN

I have a different favourite moment every time I watch *The Tree of Life*. One that surprised me, I think on my second viewing, was how resonant some of the simplest images were for me, the leaf that appears huge in the eyes of a small child, that moves mysteriously on what that child doesn't yet know as the wind. The wave that crests under a swell of music in the reunion scene moves me every time, as does the pain in Mr O'Brien's eyes when he learns of the death of his son. Mrs O'Brien's cry of grief, separated from her body. Adult Jack's hint of a smile as he considers his journey. I could go on and on.

JACK FISK

It seems to me that as we conquer the world around us, we make it less hospitable. Jack's childhood is a memory – he has moved far from his roots, he is imprisoned like the tree growing in a glass-covered atrium. A token of what we were. This is what adult Jack has to face in his working place in Houston, Texas.

JOERG WIDMER

Terry already knew where he was going to shoot the scene where adult Jack is wandering in his workplace, but by coincidence we found a tree in all that structure. This was especially interesting for Terry, because nature in construction is something which very much interested him, it is a sign of life in this non-living place, in this dead architecture.

NICK GONDA

I have probably seen the film over thirty times, in different parts of its gestation, and each time something different strikes me. Sometimes it occurs in the 'grief' section, in the beginning; other times it occurs in the city, in the modern world; other times it occurs towards the end of the picture. Considering the masterpieces that I grew up watching, I could pinpoint exactly where those moments are, where it strikes that emotional chord that lives with me forever; with *The Tree of Life*, it honestly isn't the same. It is really characteristic of Terry's work, it is playing in real time. It is truly like when you take a walk in the park – even if you take a walk at the same time, every day, there will be something new that you will notice . . .

JOERG WIDMER

The liberty of finding new ways to give life to a film is not only related to cinematography, but to the whole approach of the movie; the editing has a big importance: not caring about having the reverse shot, if you have a dialogue scene, I think this is of more consequence than in *The New World*. I think it is something linear, the step from *The Thin Red Line* to *The New World* to *The Tree of Life*. I think that the step to *To the Wonder* is even more radical.

Each time it's tougher to follow the action; each time you are more free. In *The Tree of Life* we had a base that was the house and the space around it; when we moved away from the base, it was tougher to follow with the gear. In *The New World* we

didn't have this special base, so every time we moved to a new location, we had to shift all our gear. This time it was different because we could simply start at the house, though we may have ended up five blocks further away; for the camera crew and the grips, it was very tough to find out what was going to happen, so everybody had to be prepared for anything, any time.

Sometimes they were desperate; after seeing the final movie I think they were proud, but during the process it was hard. There were some complainers, everything was so quick; when it started to rain, you had to say, 'Where's the camera? Give me the camera,' and it had to be there instantly, not just three minutes later, but right now. For Erik Brown it was tough as he had to have three cameras prepared at any one time, to be ready to shoot. He also worked on *To the Wonder* and he is doing the next two; even though it was so tough for him, he likes working for Terry, he is somehow addicted, but he suffers a lot. The shooting, the takes, become longer and longer and I'm afraid if we go for digital, we'll shoot forever. In *The Tree of Life* we never had any short ends, we simply let the camera run. Often we have used the equipment that was available, because if the kids started playing and if one camera wasn't ready yet, we would take another one; we had three Arriflex cameras, two LTs and one 235; the 235 is not soundproof, so it only could be used to run around and not record sound, but it was lightweight and so you could turn it round having fun; it was a toy for us and the kids to play with. In general, we didn't care too much about sound recording; as you can see in the movie, the original sound is almost nothing. This time the sound engineer was not suffering as much as he did on *The New World*; all the crew knew that there would not be even one track without Terry's voice – he was always saying, 'That's nice, great! Continue to do it.' He always talks to the actors, which helps a lot, or he commends what the operator does. The dog was called Dexter – he would say, 'Send Dexter in,' while we were shooting. He didn't care if the scene was silent or not, he didn't care.

MARK YOSHIKAWA

I actually liked very much the fact of not having continuity, so it felt more dreamlike, more like a memory where you don't remember things exactly as they really happened. The dots aren't connected exactly, so it was always very exciting to edit things without continuity. The one example that I am very fond of and I always think of in terms of the lack of continuity is when the boys are going downtown with their mother. The two brothers and their mother are wandering, shopping I guess, and Hunter and Laramie start doing a funny walk, playing around with each other, because they see a drunk man or something. They are having a fun time and then you cut to a shot of a crippled man walking, he notices them, and they look back at him. They immediately feel guilty, they realized that they were doing something wrong: this man with the lame foot is looking back at them, and they feel like they have offended him somehow, or they don't even know their feelings exactly. They keep walking but what you don't realize in that cut is that they have changed costumes and they've changed locations. They are in a completely different city, and one of the boys has changed: it's Jack with the other brother. Thinking about that moment! And it just happened by accident! By editing scenes together I was trying to keep locations together or ideas together and I thought, 'Oh, here are a few scenes of the kids walking with their mum, walking around down the main street,' and found these two moments that worked and seemed to go together. As soon as I put the cut together, it was very emotional to me, the great look on Hunter's face said it all for me, it felt like he was seeing some of the ills of the world, some of the people less fortunate than him. That cut worked emotionally, but it also worked because there was a lack of continuity, there was something that was just a little off in it that made it feel like a memory, like something you thought about much later on. That was just a very small example of the lack of continuity; the bigger things are cutting in the plants or a shot of a waterfall in the middle of a death sequence; or those

kinds of things make it feel more emotional, more like a sub-
jective emotion coming out of somebody. That's the way I like
continuity – like cutting to Sean Penn waking up right after the
end of the dinosaurs sequence.

There is also a jump of scale involved in this process. That is a
great power that Terry has. It is about making the moment big-
ger, like those thoughts that we all have, when you daydream for
a split second while you are in line at the grocery store and you
start thinking about your life. Those moments are reflected by
cuts like that: there is much more that came before and hopefully
much more to come, those moments are represented in those
types of cuts, from the intimate to the universal. I think that's
what we all do in our minds every day, that's just the way our
human brains work, and to represent it on film like that makes
you feel like someone is tapping into your brain. I think it helps
put things into perspective.

Terry had envisioned the origin of the universe sequence in
a totally separate section. Visual effects weren't new for Terry,
so he knew that he had to approach the work in a very specific
way. I think we used that to our advantage because we wanted
that section to have its own feel, sort of a prism through which
to see the rest of the film. Otherwise, it would just have been a
story about a grieving mother and the kids growing up in the
'50s – but by having that section in there, it gave everything a
different looking-glass through which to see the story, so the
VFX could have its own feel. When we started to edit that sec-
tion, one of the obvious ideas was to try to intercut some of it,
since we thought, 'Oh my gosh, it is too long, can we really have
such a long section in the middle of the film?' And so we experi-
mented with trying to break it up and intercut it throughout
the movie. But there was something that felt false about that,
something too easy about it, because if you go from the birth of
the boys to the birth of dinosaurs, or the eruption of a volcano,
it always felt silly, like we were doing it. If you went from the
story in the '50s to those moments it felt like we were trying to

make a point and that's the last thing Terry ever wanted. The main thing he tried to get across to us was that he never wanted to feel the filmmaker's hands, he never wanted to feel that anything was intentionally put in. This goes for the actors, for the music, for the camera work and especially for the editing – he never wanted it to feel the editor put it in, so he wanted it to feel natural and organic, like thought; like the film had its own consciousness. So any time we would cut to a sun spot or an asteroid after some dramatic event happens with Sean Penn, it just always felt wrong. We decided to keep the sequence in its own section, so we built up the entire film like a puzzle, with five big sections that he would always say it was like a rebus – like a puzzle – where you had five sections that you could recognize only after you solved the entire puzzle, if you put all the bits together. That was our reason for keeping the whole section together, for also keeping the whole Sean Penn section together for that matter; instead of intercutting, we wanted to keep them separate so that you could appreciate them on their own and then after the entire film is done, you can look back at them as entire sections and compare them and then try to figure out what they mean to each other. I don't think that Terry would ever say that that was a specific intention. Of course, including the origin of the universe section involves universal questions like our place in the universe, and our time on this earth, but I think Terry wanted to tell one specific story but most of the people watching it can bring something of ourselves to it; we understand the universal nature of these questions about grief, or about our place in the universe. If you respond to this film a lot – and a lot of people didn't – it is almost like somebody else is sharing your feelings or sharing your thoughts. All of our life has led us to what we are – all your memories, experiences, upbringing. It is a shared experience; Terry is so generous, he likes to collaborate with his crew, to discuss with his key collaborators, having everyone bring their own experience to it. It is not a singular vision; it's an idea that's out there, a universal

vision; it's not one man's vision, it's everybody's. It is a shared collective understanding of the world.

JESSICA CHASTAIN

Most of the scenes were fresh because I just did what Mrs O'Brien would do. For example, when Jack as a child is looking at the convicts he is learning something, he starts to see evil in the world, he would think, 'There are bad guys, they are getting in trouble, they are getting arrested.' But then, the whole thing gets turned on its head, because he thinks they have done something bad, but then he sees his mother giving them water on a hot day and then he can understand compassion. Just because you have done something bad doesn't mean you are a bad person, and that is a big lesson he learns at that moment, as he is developing into a man.

The same happened when the children are experiencing joy and love like the moments when Mr O'Brien is away and we are running around enjoying ourselves. There is pure love and pure joy in this scene but I worked normally, like I did for the rest of the film; I created the relationships with the boys, so they felt very free with me, they could joke with me, they could chase me around and we laughed a lot, when the camera was rolling and when it wasn't rolling. They were actually feeling joy because they knew they would get to tease me a lot and chase me around the house with a lizard; they loved shooting that section. I personally love all the scenes with the little boys, I feel those moments are really authentic. The boys are learning how to be men as they are growing up. There are no big dramatic scenes that explore this concept. It is like in real life where you have a collection of memories and moments – sometimes they are snippets – and that is what I think is really interesting about this film, about what Terry has created. It really is a film about memory and about someone's memory of their childhood and the decisions that they made that led them to be who they are. Every person is the result of where we come from, so the children are

the result of the mother's and father's behaviour. Thinking about Mrs O'Brien, there is a moment where she is really educating her children, this is the moment when the voice-over says, 'Love everything, every blade of grass.' She sees beauty in everything, like Thomas Aquinas, and this is a way to see the world with a new perspective.

MARK YOSHIKAWA

Perspective was always a big issue for the film. We knew it was going to be mostly through Jack's point of view – whether it be Hunter or Sean Penn – but there were moments in which Jessica's point of view was really important. When Jessica saw the prisoners, for example, it's like a shared perspective. The whole film opens with Jessica talking about nature and grace, when she was young and what the nuns told her, and so we know that a lot of the story is through Jessica's point of view and, of course, at the end it's all told through Jessica; but then again there's a strange shared perspective to the whole movie, and you never know in the end if the whole thing was in Sean Penn's mind – the memory of the way he first saw his mother, or the way he remembers, or wants to learn from her lessons, because even when Jessica is approaching the prisoner, it could be Jack or one of the boys seeing her grace and her kindness in feeding the water to the men.

Alexandre Desplat gave us all the themes, all the tracks with a single instrument or different sections of the orchestra. For example, we had a tune that we ended up calling 'the circle'. Terry always wanted to have the feeling of an underground river that would surface with alternating notes. Alexandre put different layers on top of it and we would bring it in and out at several different sections of the film to keep it tied together; we could play as many different themes as we wanted on different instruments to make it fuller or smaller. It helped us keep a continuity throughout the entire movie as we knew that there were going to be so many jumps in time and space, and in the themes that we wanted to address, so we wanted to give a sense of some

continuity of the whole and I think that Alexandre's music really helped in that, things would kind of creep in and out. There were different moments that we needed to relate to each other, but in a very subtle way – and Alexandre's music kept the film tied together.

NICK GONDA

Alexandre Desplat was recording music and providing music to Terry even before we started shooting, and throughout the production. Terry would give him ideas, just emotions, and then Desplat would go and compose these beautiful vignettes, these beautiful sketches around them, and then we would listen to those at night, and many times that would inspire the way we would shoot the next day. So the process was very different from most of the ways composers work with directors. Even though he was sending music from Europe, he was very much present on set because of the contributions he would make; sometimes we would play the music for the actors and from that they would get a sense of emotions and a sense of beauty and freeness that we were trying to achieve in a scene. So his spirit was on the set.

MARK YOSHIKAWA

Terry has such a vast knowledge of the classical repertoire, he knows a lot of pieces that he has always wanted to work into films or that he responds to, in a purely musical fashion. Terry can quote a musical symphony to express the feeling he wants to evoke or the rhythms he wants to get across. He always has music going on and is always trying to bring in different classical pieces. In regards to *The Tree of Life* I know there were already quite a few pieces he wanted to use: he always had Berlioz[15] in mind for the end section, and a lot of the classical pieces were always floating in and out, some of the Bach pieces – like the ones on the organ – were always in there. But the Smetana[16] and Couperin[17] and other pieces, they all came in as we went; Terry would come in and say, 'Let's try this and see if it works.'

What was really impressive about Alexandre Desplat was that early on he gave us a version of the score, without having seen any of the film. After talking to Terry, he started composing some pieces that we would play in and they were incredibly helpful, and sometimes Terry would bring in something that he was inspired by and Alexandre would bring back something that he liked, that he was inspired with as well. He even came out to Austin once or twice, sat down at the piano and played things for Terry. The same happened even when we went out to Los Angeles. We were there for one of the last mixes and even if he already recorded the score in London, at Abbey Road, we just played with some of his pieces as we did with the classical ones, just floating them in and out and not in specific places. We tried whatever felt right, just like anything else. Dick Bernstein, the music editor, also did a great job. He worked also on *The New World* so he knew Terry's way of working and he is also a great music director on his own.

JOERG WIDMER

When Chivo saw *The New World* for the first time, he was amazed at how responsibly Terry had acted; he took everything out which wasn't according to the rules, and which looked bad, and this deepened their confidence in each other. So, working on *The Tree of Life*, Chivo was more playful than before, because while filming *The New World* he was so scared of the flaring lenses, but since he knew that Terry would never take something which didn't look good, he was more risky. Working on *To the Wonder*, several times Terry said, 'Try it and if you don't like it, then it will not be in the movie' – so it's really the demand to take risks, and if it doesn't work out then it will not end up in the movie, which is really a great challenge, as well as an opportunity for a cinematographer.

JESSICA CHASTAIN

It is incredible how many things happened by accident during the shooting. For example, the scene in which I'm flying in the

air seems like something that you need to choreograph. We were going to film my feet walking along the grass and just getting lifted up for a second, but it wasn't quite working. It was at the end of the day, and we were losing the light. I was just so happy to be there, because it was fun, so I was just kind of swinging around – and I also used to be a dancer so I just started doing little turns and Terry just said, 'Ahhh, that's it Jessica, great! Just dance!' and so I just started dancing in the air! I had some ropes that they erased in post-production, but we had no idea it was going to happen and even when it finished, we didn't even know whether we had captured it, whether we had enough light or not. That is a good example of how, when you are free and open in a Terrence Malick movie, you stumble on little accidents like that.

JACK FISK

For me the sea represents the place from which we came. For the film it was a natural location close to Smithville, but for Terry it may represent much more. The idea of an underwater room as a place that a baby waits for birth was Terry's – it was a childlike interpretation of early life. The underwater house was fun to build. We constructed it out of metal and plastic and lowered it into a deep swimming pool in Austin. Knowing that a young child was going to be swimming out the door, we turned the room on its back so that the door was facing the water's surface, making it easier and less frightening for the child. It was also necessary to provide a rear entrance and a working area for the cameraman and his assistants at the bottom of the set.

Another powerful image that we incorporated into the movie was the attic sequence. The attic room was a location we found in Smithville after we had begun shooting there. Terry always had an idea for the attic scene and when we saw that tight, wood-panelled room in the attic of a real house, we knew we could not do better. I think we shot that scene two days after we found the location. It is an example of how we work: trying to incorporate elements found on location. Towards the end of

the movie, there is also a scene where the house that we used in Smithville was put in the middle of the salt flats. For that house we made a replica of a small portion of the house we shot in Smithville and transported it to the salt flats. In that scene I believe the mother is letting her son go on to his new life. The familiarity of the set with the awesome salt flats location was remarkable and hinted at another world.

MARK YOSHIKAWA

I really love the childhood section: they are young children, they wake up and we cut to them climbing a tree, playing in the streets, in the field, catching grasshoppers; there is an incredible energy in the music. That feeling moves me every time I watch it – a kind of flood of freedom, hope, family, neighbourhood and memory. Seeing the boys running home at dusk when their mother calls them home for dinner, a feeling I remember when I was a kid, even if I didn't grow up in that environment. Then immediately you cut to Brad Pitt, the father, looking enviously at the boys, and that great close-up of Brad – then you're right there at the scene of the dinner, when the boys suddenly have to be quiet and eat politely at the dinner table and listen to their father going on and on about life. Right in the middle of this scene there is one of my favourite moments: Hunter is trying to get the meatloaf onto his plate with a spoon or spatula, he is so nervous that his father is going to be upset at him and he keeps looking up at his father nervously. So much is said in that behaviour and those few looks, and that is what Terry is always going for – with behaviour and looks rather than dialogue. Another image that I liked is that right after that Sean Penn wakes up out of nowhere, being in the modern world. Those kind of juxtapositions – like before the origin of the universe when Jessica is in the woods and she looks up and closes her eyes and her voice-over says, 'Where were you?' and you start to see the light, the small wisps of light sneak in and it's the beginning of the universe and the 'Lacrimosa' by Zbigniew Preisner[18] starts to play and it feels

like something big is about to start, the beginning of a much larger sequence. The scope of the story opens up at that moment for me. Image-wise one of my favourite moments is when the mother is putting the children to bed and R. L. asks her to tell him a story. She starts telling the story of when she was at high school and got her graduation present of a ride in the biplane. You have the biplane floating and then you cut to the mother floating through the air. It was like the boy's imagination of his angelic mother floating in the air and I always loved those images together. It helped to cut to Sean as a quick flashback, looking down at the grass like a memory. Then we do a hard cut to the power plant and the industrial feeling of Brad at work, and you aren't even sure if that's a memory, or a dream or the imagination of one of the boys too, because just like they would imagine their mother floating through the air, they are imagining their father at this power plant. They don't know, none of us ever knew what our fathers did at work. Also, the images are beautiful! The sequence when the starlings are flying, doing a kind of dance – we get comments on that all the time. We couldn't get enough of it, you saw how much we used of it.

When you work on a film so hard it is difficult to stay objective, but because it is a film so much like memory and so much like a dream, I couldn't remember what was left in, and what we took out. I didn't go to Cannes, so I didn't see it at a premiere until months later and I was amazed how moved I was, because I had lived with those characters for so long, but especially because it evoked so many memories and so many feelings that had nothing to do with the film. Talking about the film with other people, we always end up talking about our lives, the things that we remember about our lives, or our experiences in relation to the film like losing a loved one, or having to grieve, or living in the modern world like Sean Penn and having to deal with these things: our childhood, our place in the world, the universe, or even our spirituality. People don't talk about the memories from the film, they just talk about their own lives. That's what makes

me proud about this film, it is really like a mirror that you look into and it brings out emotions from your own life.

DOUG TRUMBULL

At the very beginning when I read the script, I thought it was an extremely brave movie to think of making. I felt that what Terry was trying to do was extremely difficult and challenging, especially at a time in movie history when a small number of films account for the vast majority of the cinema-going audience's diet. *The Tree of Life* is much more poetic, impressionistic and non-linear, so I felt deeply concerned that there wouldn't be an audience that would be able to grasp the movie. There has been this whole story that audiences just don't get it – they ask, 'What's going on? Are the reels out of order?' They can't grapple with a movie that requires some imagination on their part. I think it's a very real issue: today's movie-going audiences didn't experience the French New Wave, the avant-garde filmmakers who were experimenting with how a cinema experience could be, how stories could be told in different ways. It's a very linear, stupid, cheap-literature world right now; it's extremely rare that you get movies that actually can get an audience without being banal. I think we are in the dark ages of cinema and the sad thing is that many film critics are increasing that lack of imagination, whereas certain movies are really far ahead.

MARK YOSHIKAWA

The very fact that a film like *The Tree of Life* can be made in a studio world with River Road and Bill Pohland, who actually financed it, and Fox Searchlight as distributor, amazes me. It was possible to reach so many people; it won at the Cannes Film Festival; it was acclaimed by many critics – all that really helped to get it to the mainstream. At the same time I know that a lot of people didn't really get it, they were expecting to see a Brad Pitt, Sean Penn standard film, but I'm really happy that people got to experience it on the big screen. That experience can show

that an unconventional film can come out in theatres and still have an effect. The fact that *The Tree of Life* can move people to re-examine their own lives is something very important; a friend of mine told me that it made him think about raising his kids, made him think about himself as a father; it makes people reflect on their own lives. I'm proud to have taken part in it.

NICK GONDA

The Tree of Life was a vision that endured time and endless challenge, it was a film that he was originally going to make in the '70s, but Terry never relented, he never let it become a secondary element in his mind. It was always something that he was creating, that's something that astounds me: the endurance, the resilience to carry an idea for several decades, and then once the opportunity came to finally realize it, he was able to make it with such vigour, and passion. It took me about five years to watch *The New World* with fresh eyes; after working so closely with something, it takes time to be able to see it as a member of the audience and so I'm looking forward to watching *The Tree of Life* for the 'first time', sometime in the coming years.

JOERG WIDMER

If the Sean Penn section had been edited regularly, it would have been half an hour, it's probably now around eight minutes. We never shot with Sean in Smithville, but we shot in several locations: in Houston, a little bit in Dallas and then in the Death Valley, in Goblin Valley and in the salt flats in Salt Lake City.

MARK YOSHIKAWA

They are working on an extended version of *The Tree of Life* but I don't know that much about it. I certainly know that there was a lot of wonderful material that didn't make it into the film, a lot of story that would fit right into the version that everyone is familiar with – a lot of story about the family, a lot more about Sean. I don't know exactly how long it will be, I'm not working

on it but I was advising on it. There is a lot more material that we would have liked to have put in, that we had to make sacrifices for the greater good of the film; for example we all loved the Italy footage, but we didn't use as much of that as we wanted to.

Terry makes a film like nobody else I know, so, working with him, my way of editing changed. You have to reject your initial instincts and what you are used to doing; you have to go against the conventional way of telling a story, cutting dialogue and all those kinds of things. Terry never wanted to feel like he was being shown a conventional movie. On the other hand I have gone back and worked on conventional films, so it's not like I had lost the feel, but it was very liberating when you have that feeling of being able to do anything at any time, and it has influenced my cutting on other films – in other films, I will be a lot more daring, I will do a bit more jump-cutting, do a bit more of cutting out from the macro to the micro, making the moment feel bigger than the moment at hand. But nobody does it like Terry.

After making The Tree of Life, *Terrence Malick entered a new creative phase. Just like the jump in scale in the film from micro to macro requires a juxtaposition of sizes, there is no precise borderline between the magniloquence of a project on the history of the universe and* To the Wonder, *an expression of love in all its facets and how it takes form.*

DOUG TRUMBULL

Terry and I talked about the possibility of having a completely different cinematic experience. The thing that Terry has been heading towards is something that's much more participatory: that's the thing that interests me most, the theme of my whole career is to make a motion-picture experience that goes beyond our normal perception about what a movie can be. I kind of got into that when I was working on *2001*, which has huge epic sequences and no dialogue, no conflict, no characters, no plot,

no drama, it's just an experience for the audience to go through, to enter into a different dimension of time and space and to go along with some personal transformation with the character in the movie. I think Terry also tried to do that in *The Tree of Life*. I think it attempted to reach towards that goal, but it's limited by the motion-picture technology that we have available today – we see movies on rectangular screens in movie theatres which are just like boxes! There isn't the palette that we had way back in the days of 2001, where the screens were 90 feet wide and deeply curved; it was a very immersive experiential medium which today is only available in the form of IMAX.

My whole mission right now is to go to the next step, because I think we can now develop a new immersive film technology that is indistinguishable from reality. That's where I'm going with my career and I think that's where Terry wants to go; it requires a complete redesign of our idea of what a movie theatre is. The screens must be much bigger, the image must envelop you, the frame rate must be much higher, the brightness must be much greater, the colour saturation needs to be more intense and then, when you have all that available to you as a filmmaker, you can enter into this cinematic language that's quite different from a normal cinema language of 35 mm or DCP in a rectangle: two-shots, over-the-shoulder shots, close-ups, inserts – that's just the language of most movies, but it's very clear to me that the audience craves some kind of hyper-experience that takes them into another kind of dimensional space and offers something that they can't see at home, can't see on their laptop, on their tablet or their iPad. I think that's what we need to do to reinvigorate the film business: make it better than it has been. I think that's what's needed for Terry to be able to deliver his desire for this kind of immersiveness.

I'm shooting tests right now, I've got special screens, I'm working at extremely high frame rates, I'm shooting 3D at 1120 frames a second and developing story ideas that lend themselves to this kind of immersive experience where the audience feels

like they are actually in the movie rather than just looking *at* the movie, so the movie experience becomes more like a walk in a park than a television show.

JACK FISK
It is always exciting to see what Terry is going to do next. Since Terry's work is constantly evolving and changing it never feels like you are returning but only going forward.

Afterword

Watching Terrence Malick's film cycle means opening yourself up to wonder. Just when you think you've grasped its essence, like the voice-over that grows into a concert of voices in *The Thin Red Line*, or the elliptical journey of *The Tree of Life* that explodes into *To the Wonder*, it slips through your fingers. His films elude a formula and force the audience to push conclusions aside and reflect.

What is, perhaps, at the heart of his cinema's power is its innate capacity to become a world that is constantly regenerating; its unstoppable quest into the realms of what has been dreamt and what has been forgotten – only to end up in a more mysterious space, the audience's mind. Long after its screening has ended, a Malick film continues to live on in our minds, either in its entirety or in fragments, just as lines of poetry continue to illuminate truth long after reading.

A profoundly humanistic credo lies behind all Malick's film work: his images, thoughts, memories and emotions unconsciously become shared by us all. Malick has never betrayed this vital urge; never deprived his audience of the freedom to inhabit the film and find their own lives in it.

In light of this, his latest cycle of production is not surprising. He has created one film after another: *To the Wonder*, *Knight of Cups*, the upcoming *Voyage of Time* and one last – as yet untitled – film, shot in Austin, Texas. This new season of creativity – encouraged and made possible in recent years by a complex production frame with Sarah Green and Nick Gonda – resembles the pulse of life, the tenacious desire to push film one step further each time.

After the dazzling *To the Wonder*, *Knight of Cups* carves an

indelible mark on the audience's consciousness. Cinema becomes more of a matrix, generating a constant flow of images. Our sense of perception thins out, and language such as a voice-over fades to the background, encouraging the audience to translate it into their own words. What Sam Shepard affirms for actors, 'You can't expect the director to spoon-feed you,' becomes crucial for the audience as well.

The interviews in this book finish with *The Tree of Life*, but it is what happened afterwards that is testament to how much Malick's films are a 'breathing entity'. We hope nonetheless that this book might help the reader to respond to a vital cinema that calls us forth to live fully.

Notes

FORMATION

1 Paul Johannes Tillich was born in 1886 in Starzeddel, Prussia, now
Brandenburg, Germany. In 1911 he received his doctorate in phil-
osophy from the University of Breslan. A year later he received his
theology certificate as a pastor within the Protestant Church. After
he served in the German army as a chaplain (1914–1918) he was
Privatdozent of theology at the University of Berlin and full profes-
sor of philosophy at Frankfurt am Main. During the 1920s he wrote
a number of impressive works on both theology and philosophy. In
1933 Tillich was removed from his teaching post. Tillich was one
of the earliest non-Jewish people to be targeted by the Third Reich.
He had openly opposed Hitler's rise to power, and he moved to the
United States of America, where he became a naturalized citizen in
1940. Teaching theology at Union Theological Seminary, New York,
Tillich served as a bridge between Continental philosophers and the
analytic traditions of American philosophy. In 1955 he retired, but he
decided to assume a professorship at Harvard, where he taught until
1962. He died in 1965.

2 Paul Lee was born in 1932 in Colorado. He obtained his Bachelor
of Sacred Theology at Harvard Divinity School. Then he obtained a
PhD at Harvard University, where he was Paul Tillich's assistant and
teaching assistant in Humanities courses until 1962. He subsequently
moved to MIT and the University of California. He was also a pastor
in 'Our Saviour's Lutheran Church' in East Boston from 1956 to
1961.

3 Adams House is one of the twelve undergraduate houses at Harvard
University, located between Harvard Square and the Charles river
in Cambridge, Massachusetts. It was named to commemorate John
Adams, the second president of the United States, and John Quincy
Adams, the sixth. Adams is often regarded as Harvard's most repre-
sentative house.

4 *Last Year at Marienbad* (original title: *L'Année dernière à Marienbad*,
1961), directed by Alain Resnais.

5 William Alfred, born in 1922 in New York, started his career as a
professor at Harvard in 1963, becoming a campus legend. He spent
his time teaching, writing, associating with colleagues and mentoring

multitudes of students. He was a point of reference for many students, who sent him manuscripts, plays, poems and novels. As a playwright and poet he won a number of prizes and he was acclaimed both in academia and in theatre. He died in Cambridge at the age of 76.

6 Born in Boston in 1917, in 1950 Robert Lowell was included in the influential anthology *Mid-Century American Poets* as one of the key literary figures of his generation. His book of poems *Lord Weary's Castle* won the Pulitzer Prize in 1946. Another acclaimed book of poems, *Life Studies*, was published in 1959. He won his second Pulitzer Prize for *The Dolphin* in 1974. He died in 1977 in New York.

7 *Hogan's Goat*, directed by Glenn Jordan, was aired on television in 1971. William Alfred wrote the play for the theatre and the screenplay for television.

8 The Phi Beta Kappa Society is an academic honour society with the mission of fostering and recognizing excellence in the undergraduate liberal arts and sciences. It was founded in 1776 at the College of William and Mary. Phi Beta Kappa is the first collegiate organization to use a Greek-letter name. ΦΒΚ stands for Φιλοσοφία Βιου Κυβερνήτης or *philosophia biou kubernetes* – 'Love of learning is the guide of life'. Since its founding very few undergraduates have received the honours. Others include Henry Kissinger (Harvard, 1950), Susan Sontag (Chicago, 1951), Francis Ford Coppola (Hofstra, 1959) and Michael Crichton (Harvard, 1954).

9 The Rhodes Scholarship is funded by the Cecil John Rhodes estate. Cecil John Rhodes was an English-born businessman, mining magnate and politician in South Africa, who died in 1902. The scholarship was the first large-scale programme of international scholarship. A Rhodes Scholar may study postgraduate courses in Oxford University – whether a taught Master's programme, a research degree, or a second undergraduate degree (senior status).

10 Hubert Lederer Dreyfus, born in 1929 in Terre Haute, Indiana, earned three degrees from Harvard University (BA in 1951, MA in 1952, PhD in 1964). He is considered a leading interpreter of the work of Edmund Husserl, Michel Foucault, Maurice Merleau-Ponty, and especially Martin Heidegger. His publication *Being in the World: A Commentary on Heidegger's Being and Time Division 1* (Cambridge, MA: MIT Press, 1991) is considered to be one of the most authoritative texts on Heidegger in the United States.

11 Jules Régis Debray was born in France in 1940. He is a professor, a French government official, intellectual and journalist. After having studied at the École Normale Supérieure under Louis Althusser he graduated in philosophy in the late 1960s, and started teaching philosophy at the University of Havana in Cuba. Subsequently he

became an associate of Che Guevara in Bolivia. Before Che Guevara was captured in Bolivia in 1967, Debray was imprisoned, convicted of having been part of Guevara's guerrilla group and was sentenced to 30 years in prison. In 1970 he was released after an international campaign supported by, among others, Pope Paul VI, André Malraux, Général De Gaulle and Jean-Paul Sartre. He moved to Chile, where he wrote *The Chilean Revolution* (1972) after interviews with Salvador Allende. In 1973 he returned to France after the rise to power of General Pinochet. His book *Revolution in the Revolution?*, written during his association with Che Guevara, was considered among armed socialist movements in Latin American as a handbook for guerrilla warfare that supplemented Guevara's manual.

12 William Shawn was born in Chicago in 1907 and died in 1992. He began to work at *The New Yorker* in 1933. He became the editor of the magazine in 1952 and held this position until 1987. For some critics he is considered to be one of the most prominent magazine editors in the world. He published the stories and novels of J. D. Salinger and Truman Capote's true-crime classic *In Cold Blood*. He also published a number of distinguished writers including Hannah Arendt, Milan Kundera and Philip Roth. He was driven by a sincere love for new writing. He called himself and signed simply 'Shawn', so for everybody he was 'Mr Shawn'. He was a shy, formal man and he seldom talked about himself. He gave almost no interviews and almost never let himself be photographed. He never gave a public speech.

13 *The Graduate* (1967), directed by Mike Nichols, starring Dustin Hoffman and Anne Bancroft.

14 Caleb Deschanel, born in Philadelphia in 1944, attended the University of Southern California's School of Cinema-television and then the AFI Conservatory. As a cinematographer he has worked on a number of films including *A Woman Under the Influence* (1974, directed by John Cassavetes), *The Black Stallion* (1979, directed by Carroll Ballard), *Being There* (1979, directed by Hal Ashby), *The Right Stuff* (1983, directed by Philip Kaufman), *The Natural* (1984, directed by Barry Levinson), *Fly Away Home* (1996, directed by Carroll Ballard) and *The Passion of the Christ* (2004, directed by Mel Gibson). He has been nominated for five Academy Awards, and directed three episodes of the David Lynch series *Twin Peaks*.

15 Thomas Rickman, born in Kentucky, has written several screenplays for cinema and television. He was nominated for an Academy Award for his adaptation of the biographical book *Coal Miner's Daughter* by Loretta Lynn. The film, directed by Michael Apted and released in 1980, won an Oscar for the brilliant performance of Sissy Spacek. Rickman is also a director.

16 Tony Vellani has become a very important teacher for many AFI students. He was also involved, along with George Stevens, Jr, in the production of student films financed by AFI. Among these is David Lynch's *The Grandmother* (1970).

17 *Gunga Din* (1939), directed by George Stevens and starring Cary Grant, narrates the story of Gunga Din, a young man born in British India, divided between his love for the Indian people and admiration for the British Army during the Thuggee rebellion that took place in India in 1830. The story was based on a poem by Rudyard Kipling.

18 *Two-Lane Blacktop* (1971), directed by Monte Hellman, in the end was written by Rudy Wurlitzer, a friend of Terrence Malick who suggested Sam Shepard for Malick's second film *Days of Heaven*. The film also starred Warren Oates, who appeared in Malick's first film *Badlands*.

19 *Deadhead Miles* (1972), directed by Vernon Zimmerman, narrates the story of a long-distance trucker and his experiences on the road. The film starred Alan Arkin.

20 *Pocket Money* (1972) was directed by Stuart Rosenberg. The film shows an honest cowboy, Paul Newman, who ends up mixing up with a crooked rancher, Lee Marvin. The script was based on the novel written by J. P. S. Brown, *Jim Kane*.

21 *Dirty Harry* (1971), directed by Don Siegel, starring Clint Eastwood.

22 *Great Balls of Fire!* (1989), directed by Jim McBride, starring Dennis Quaid.

23 *The King of Marvin Gardens* (1972), directed by Bob Rafelson, starring Jack Nicholson.

24 Harry Julian Fink has had a long career as TV scriptwriter. For the film industry he and his wife Rita wrote the Western *Big Jake* (1971), directed by George Sherman and starring John Wayne. He also wrote *Cahill U.S. Marshal* (1973), directed by Andrew McLaglen, again starring John Wayne.

25 *Bonnie and Clyde* (1967), directed by Arthur Penn and starring Warren Beatty and Faye Dunaway.

26 *Angels as Hard as They Come* (1971), directed by Joe Viola.

27 Paul Williams, born in New York in 1943, directed *Out of It* (1969), *The Revolutionary* (1972) and *Dealing: Or the Berkeley-to-Boston Forty-Brick Lost-Bag Blues* (1972), all of them produced by Edward Pressman. He also acted in several films. His last film as a director is *The Best Ever* (2002).

28 Terrence Malick has rarely participated in public meetings. He made a few comments about *Badlands* at the *Milanesia* in Milan in 2001, which was organized by the Italian critic and thinker Enrico Ghezzi. Malick spoke about his relationship with Kershner at the *Festa*

del cinema di Roma in 2007 which was co-ordinated by the critics Antonio Monda and Mario Sesti.

29 *Confidential File* is a TV show aired in America from 1953 to 1957. The programme included a studio debate presented by the journalist Paul Coates, followed by a documentary reconstruction shot, photographed and edited by Irvin Kershner. The treated case studies had a strong social angle and especially concerned current affairs, ranging from children's mental illnesses to religious sects, from the spread of new drugs to the starlets market in Hollywood.

30 *Stakeout on Dope Street* (1958) tells the story of a group of teenagers who casually find a suitcase full of heroin and decide to enter the drug market, attracting the wrath of other dealers.

31 *The Hoodlum Priest* (1961) is based on the true story of Rev. Charles Dismas Clark, a Jesuit priest who dedicated his life to working with former convicts in St. Louis.

32 Edward Albee, born in Washington in 1928, was adopted by Reed Albee, the son of Edward Franklin Albee, an American vaudeville producer. He moved to New York in 1948 and ten years later, thanks to his play *The Zoo Story* (1959), became one of the most distinguished American playwrights. The play was staged in Berlin, sharing the bill with Samuel Beckett's *Krapp's Last Tape*. After that he wrote a number of successful plays, winning three Pulitzer Prizes for *A Delicate Balance* (1966), *Seascape* (1975), and *Three Tall Women* (1994). One of his most popular plays is *Who's Afraid of Virginia Woolf?* (1962). Although he was considered as a successor to Arthur Miller, Tennessee Williams and Eugene O'Neill, his plays are closely related to the work of European playwrights such as Harold Pinter and Samuel Beckett.

33 *A Fine Madness* (1968) is the story of Samson Shillitoe, played by Sean Connery. Samson lives with Rhoda, who is used to his crises and excesses. To get over his emotional block, the woman convinces him to be visited by a psychiatrist. Samson will end up trying to overcome his crises surrounded by adoring women.

34 *Who's Afraid of Virginia Woolf?* (1966), directed by Mike Nichols, starring Richard Burton and Liz Taylor.

35 *Pillow Talk*, a romantic comedy directed in 1959 by Michael Gordon, starring Rock Hudson and Doris Day.

36 *Ashes and Diamonds*, directed in 1958 (original title: *Popiół i diament*) by Andrzej Wajda.

37 *The Seventh Seal*, directed in 1957 (original title: *Det sjunde inseglet*) by Ingmar Bergman.

38 *Easy Rider*, directed in 1969 by Dennis Hopper, starring Peter Fonda and Hopper.

39 *Five Easy Pieces*, directed in 1970 by Bob Rafelson, starring Jack Nicholson.
40 *Drive, He Said* (1971), directed by Jack Nicholson.
41 Edward Pressman produced *Sisters* (1973) and *Phantom of the Paradise* (1974), directed by Brian De Palma.

BADLANDS

1 George Segal, born in 1934 in Great Neck, Long Island, New York, acted in several minor films in the early 1960s. He began attracting critical attention in 1965 for his roles in *Ship of Fools*, directed by Stanley Kramer, and *King Rat*, directed by Bryan Forbes. The next year he was nominated for an Academy Award for Best Actor in a Supporting Role for his performance as Nick in *Who's Afraid of Virginia Woolf?* Then he worked with Michael Anderson, Roger Corman, Melvin Frank, Ted Kotcheff and Robert Altman, becoming one of the most respected actors in the American scene at the beginning of the 1970s, also for his ability to act in both comedy and drama.

2 Max Palevsky, born in 1924 in Chicago, Illinois, was an art collector, venture capitalist, philanthropist, and computer technology pioneer, also active in film production. In 1970 Cinema V, the movie-theatre distribution operation run by Don Rugoff, entered production in a joint venture, Cinema X, with Palevsky. Palevsky then went into independent production with Peter Bart, former production vice president of Paramount Pictures, signing a deal with Paramount in November 1973 to produce six features in three years. Palevsky has produced and bankrolled several Hollywood films, including *Fun with Dick and Jane*, directed by Ted Kotcheff and starring George Segal, and *Islands in the Stream*, directed by Franklin J. Schaffner. Both were produced with Peter Bart in 1977. In 1999 he produced *Endurance*, directed by Leslie Woodhead and Bud Greenspan, together with Terrence Malick and Edward Pressman.

3 Directed in 1964 by Larry Peerce, the film is about the difficulties faced in America by an interracial couple. It received an Academy Award nomination for Best Original Screenplay for Orville H. Hampton and Raphael Hayes, and gained Barbara Barrie the Best Actress award at the Cannes Film Festival.

4 William Weld, born in 1945 in Smithtown, New York, was an American politician educated at Harvard and University College, Oxford. He was the Republican Governor of Massachusetts from 1991 to 1997.

5 Warren Oates (1928–1982) was a cult American actor. He began working as an actor in live television dramas such as *Studio One*

(1957) during the 1950s. He soon became a sought-after actor for TV series and Westerns. Playing a variety of guest roles on *The Rifleman* (1958–1962), a successful American television series of the time, he met Sam Peckinpah, the director and creator of the series, with whom he subsequently became a long-standing collaborator. He appeared in Peckinpah's early films, including *The Wild Bunch* (1969) and *Bring Me the Head of Alfredo Garcia* (1974). In addition to Peckinpah, Oates worked with Monte Hellman, with whom he appeared in *The Shooting* (1966) and *Two-Lane Blacktop* (1971), and worked with several major film directors of his era, including Leslie Stevens on the 1960 film *Private Property*, which was his first starring role, Norman Jewison in *In the Heat of the Night* (1967), Joseph L. Mankiewicz in *There Was a Crooked Man* (1970), John Milius in *Dillinger* (1973), Philip Kaufman in *The White Dawn* (1974), William Friedkin in *The Brink's Job* (1978), and Steven Spielberg in *1941* (1979). His reputation will always be linked to his bravery as an actor. Among the many episodes that support this reputation was when, not to betray his deal with Peckinpah, he acted in *The Wild Bunch* even though he had hepatitis.

6 Cinema V grew from Rugoff and Becker Theatres, a chain started in 1921 by Don Rugoff's father. Rugoff (1927–1989) gained control of the company in 1957 and began a quick expansion into the burgeoning world of art-house exhibition. It became the best foreign distributor in New York, with films like Werner Herzog's *The Enigma of Kaspar Hauser*, Constantin Costa-Gavras's *Z*, Nicolas Roeg's *The Man Who Fell to Earth*, and Dušan Makavejev's *WR: Mysteries of the Organism* (*W.R. – Misterije organizma, W.R. – Мистерије организма*). In 1966, after its success at the Fourth New York Film Festival, Don Rugoff played commercially *It's Not Just You, Murray!*, the 1964 student film by Martin Scorsese, at his Cinema One theatres, after having the 16 mm print blown up to 35 mm.

7 Sissy Spacek had previously appeared in *Trash*, directed by Paul Morrissey in 1970, and in *Prime Cut*, directed by Michael Ritchie in 1972.

8 Dona Baldwin worked on *Badlands* in the costume and wardrobe department and as a hair stylist. She also appeared in a small role in the film as the dumb maid of the rich man.

9 Howard Zieff (born 1927 in Los Angeles, California) began working as a photographer. In the 1960s he became one of the most successful authors and directors of commercials in the States, famous for having introduced a blend of realism and humour. With *Slither* (1973), he also inaugurated a joyous series of cinema comedies including *Hearts of the West* (1975), *Private Benjamin* (1980) and *My Girl* (1991).

10 After his feature-film debut with *Badlands*, Tak Fujimoto, a graduate of the London Film School, has worked with the filmmakers Jonathan Demme, M. Night Shyamalan, John Hughes, and Howard Deutch. Early in his career he also worked on the second unit of the first *Star Wars* movie (1977).

11 *Playhouse 90* was a 90-minute dramatic television anthology series, telecast on CBS from 1956 to 1961, for a total of 133 episodes. Since live anthology drama series of the mid-1950s were hour-long shows, the title highlighted the network's intention to present something unusual, a weekly series of hour-and-a-half dramas rather than sixty-minute plays. The live television anthology drama series was the training ground for many post-war American filmmakers.

12 In the late 1940s the French company Éclair invented Cameflex, one of the first portable, light and easy-to-handle cameras. It revolutionized filming techniques, enabling directors to get as close as possible to the subject they were filming. In 1950 Éclair was awarded a technical Oscar for the portable Cameflex by the Los Angeles Academy of Motion Picture Arts and Sciences.

13 The Cinemobile Mark IV is a model of Cinemobile, which is the truck on which filming equipment is transported.

14 The BNCR Mitchell is a 35 mm camera which was popular in the 1970s.

15 The Arriflex is a camera model of the famous German firm Arri.

16 The Nine-Light Molefay is a nine-bulb quartz light used to light in exteriors.

17 Fresnel lights, a light having a bulb surrounded by a hollow cylindrical Fresnel lens. Inky means a power range of the bulbs that goes from 100 to 300 watts, which is not very powerful.

18 Lamps made up by bulbs that use the illumination of an electric arc maintained between two electrodes. This lighting system generates a bright light useful for lighting in exteriors.

19 HMI lights are ballasted sources (as are common fluorescents), which means they pulse on and off a fixed number of times per second. They are very flexible because it is possible to control the intensity of the light.

20 (1970)

21 He is referring to *Four Friends* (1981).

22 (1972)

23 James Taylor (1948, Boston, Massachusetts) was a singer-songwriter and guitarist who began his career in the mid-1960s and found success in the early 1970s, having developed his bitter yet romantic style of songwriting.

24 Amos Vogel (born 1921 in Vienna, Austria, as Amos Vogelbaum) is

among the most influential film people of the twentieth century. He is best known for his book *Film as a Subversive Art* (1974), still among the most unorthodox film histories ever published, and as the founder of the New York City avant-garde ciné-club Cinema 16 (1947–1963), where he was the first programmer to present films by Roman Polanski, John Cassavetes, Nagisa Oshima, Jacques Rivette and Alain Resnais, as well as early and important screenings by American avant-garde filmmakers of the time like Stan Brakhage, Maya Deren, James Broughton, Kenneth Anger, Sidney Peterson, Bruce Conner, Carmen D'Avino and many others. In 1963, together with Richard Roud, he founded the New York Film Festival, and served as its programme director until 1968.

25 Directed in 1975 by Jonathan Kaplan.

26 Vincent Canby (1924–2000) became the chief film critic for the *New York Times* in 1969. He was an enthusiastic supporter of many film-makers, notably Woody Allen, who considered his rave review of *Take the Money and Run* as a crucial point in his career.

27 (1972)

28 Edward Paul Abbey (1927–1989) was an American author and essayist famous for his advocacy of environmental issues and criticism of public land policies. His best-known works include the novel *The Monkey Wrench Gang*, which has been cited as an inspiration by radical environmentalist groups, and the non-fiction work *Desert Solitaire*. The writer Larry McMurtry referred to Abbey as 'the Thoreau of the American West'.

29 Wallace Earle Stegner (1909–1993) was an American historian, novelist, short story writer, and environmentalist, often called 'the dean of Western writers'. Edward Abbey was one of his students.

DAYS OF HEAVEN

1 Lewis Hine (1874–1940) is among the founding fathers of American social photography. After studying sociology at the Universities of Chicago, Columbia and New York, he taught at the Ethical Culture School of New York. He conceived of photography as an instrument for social change. He is particularly well known for the photographs he took in American working environments and the cycle he made with his students of the immigrants at Ellis Island. His reports on working conditions, especially juvenile work, also led him to collaborate with the American government. The photographs in the initial sequences of *Days of Heaven*, that portray men at work as well as other period images, include images shot by H. H. Bennett, Frances Benjamin Johnston, Chansonetta Emmons, William Notman and Edie Baskin, who photographed Linda Manz in period style.

2 *Metropolis* (1927), directed by Fritz Lang.

3 *Hearts and Minds* (1975), directed by Peter Davis.

4 Barry Diller was born in 1942 in Beverly Hills, California. He was hired by ABC in 1966 as commissioning editor and then was promoted to vice president in charge of feature films and programme development. In 1974 he became Chairman and Chief Executive Officer of Paramount Pictures Corporation, holding this position for ten years. From 1984 to 1992 he held the position of Chairman and Chief Executive Officer of Fox Inc. After this experience he worked with USA Broadcasting acquiring the assets of Silver King Broadcasting.

5 *Sorcerer* (1977), directed by William Friedkin and starring Roy Scheider.

6 Banff is the largest town in Banff National Park, in Alberta Rockies, Canada.

7 The Panaglide was the object of a legal dispute. The system, created by Panavision, closely follows the Steadicam invented by the operator Garret Brown, which, thanks to a mechanical arm attached to a top worn by an operator, allows fluid shots without the help of a dolly. Garret would undergo a legal dispute against Panavision, which in the end would be obliged to admit to having copied the model from the original and patented Steadicam.

8 *The Good, the Bad and the Ugly* (*Il buono, il brutto, il cattivo*, 1966), directed by Sergio Leone and starring Clint Eastwood, Eli Wallach and Lee Van Cleef.

9 *Welcome Back, Kotter* was aired from 1975 to 1979 by ABC Television. Starring the comedian Gabriel Kaplan as the teacher Gabe Kotter, the show narrates the story of a class in the fictional James Buchanan High School in Brooklyn, New York. Travolta played the role of Vincent 'Vinnie' Barbarino, a cocky Italian-American student, who has a strong impact on women and often breaks into song.

10 *Looking for Mr. Goodbar* (1977), directed by Richard Brooks and starring Diane Keaton.

11 *Renaldo and Clara* (1978), directed by Bob Dylan, starring a number of actors and personalities, including Harry Dean Stanton, the poet Allen Ginsberg and the boxer Rubin 'Hurricane' Carter.

12 The film is *Dr. T and the Women* (2000), directed by Robert Altman.

13 *A River Runs Through It* (1990), directed by Robert Redford, won an Oscar for Best Cinematography (Philippe Rousselot).

14 *The Wild Child* (original title: *L'Enfant sauvage*, 1970), directed by François Truffaut.

15 The film Shepard is referring to is *The Man Who Loved Women* (*L'Homme qui aimait les femmes*, 1977), directed by Truffaut.

Notes

16 *Bound for Glory* (1976), directed by Hal Ashby, won the Oscar for best cinematography.

17 *The Passenger* (*Professione: reporter*, 1975), directed by Michelangelo Antonioni and starring Jack Nicholson and Maria Schneider. The film tells the story of a frustrated war correspondent who decides to assume the identity of a dead arms dealer.

18 *La Collectionneuse* (1966), directed by Eric Rohmer.

19 *More* (1969), directed by Barbet Schroeder.

20 *The Marquise of O* (*Die Marquise von O*, 1976), directed by Eric Rohmer.

THE YEARS OF ABSENCE AND THE THIN RED LINE

1 Malick's special assistant on *Days of Heaven*.

2 Jim Cox made the special sound effects on *Days of Heaven*.

3 Directed by Alex Proyas in 1994 and produced by Edward Pressman.

4 Skip Cosper had been assistant director on *Days of Heaven*.

5 In his poem, Kipling refers to the red of the English army uniforms. In fact, English troops were informally called 'redcoats'.

6 James Jones (1921–1977) was born in Robinson, Illinois. He enlisted in the United States Army in 1939 and served in the 25th Infantry Division in the Pacific before and during World War II. He was wounded in action in Guadalcanal. His posthumously published novel *Whistle* was based on his hospital stay in Memphis, Tennessee, recovering from his wounds.

7 *The Thin Red Line* opens with this voice-over.

8 *Images of War – The Artist's Vision of World War II*, New York, Orion Books, 1990.

9 1998, with Billy Crudup and Woody Harrelson.

10 Directed in 1995 by Tim Robbins, with Susan Sarandon and Sean Penn.

11 Svengali is the name of a character in the 1894 novel *Trilby*, by George du Maurier. The novel was very successful when it was first published and created the familiar stereotype of the evil hypnotist.

12 The film was released in 1991. Elias Koteas plays the main protagonist, supported by Arsinée Khanjian and Maury Chaykin.

13 1994, with David Hemblen, Mia Kirshner, and Calvin Green.

14 1996, with James Spader and Holly Hunter.

15 The scene in which Staros prays is present in the film, however Koteas is not bare-chested. Penny Allen seems to be recalling a different scene, probably cut in the editing.

16 At the end of the 1990s Malick set up, together with Edward Pressman, the production company Sunflower Productions (formerly named Columbine Productions, after the state flower of Colorado,

where *Badlands* was shot, before the Columbine massacre happened), which produced among others *Endurance* (1999), directed by Leslie Woodhead and Bud Greenspan, *The Endurance: Shackleton's Legendary Antarctic Expedition* (2000), directed by George Butler, Zhang Yimou's *Happy Times* (2001), and *Beautiful Country* (2003), directed by Hans Peter Molland. The later productions, such as *The Unforeseen* (2007) directed by Laura Dunn and *The Marfa Lights* (2009) by Carlos Carrera, deal with Texan subjects. Edward Pressman told us that 'Throughout all the years Malick wasn't directing films, he had a lot of ideas for films that he hoped to see made, not that he would direct them, but as a "conceptualizer" and as a producer. They came from works of George Sand and Charles Dickens and other readings of his about the astronomer Hubble and a large number of ideas that were cinematic conceptions that Terry had.'

17 Directed by Carroll Ballard in 1992, starring Matthew Modine and Jennifer Grey.

18 Akela cranes are among the longest and highest cranes available. For instance, the Akela crane allows the camera to go from ground level to a height of six storeys in a single move, and can be used as an alternative to helicopter shots.

19 1995, directed by Mel Gibson.

20 He is referring to the movie directed by Steven Spielberg in 1998, starring Tom Hanks. The film, also centred on World War II, was released in the same period as *The Thin Red Line* and, effectively, became its competitor both with the public and at the Oscars.

21 Bedřich Smetana (1824–1884) was a Czech composer. He is best known for his symphonic poem *Vltava* (also known as *The Moldau* from the German), the second in a cycle of six which he entitled *Má vlast* (*My Country*), and for his opera *The Bartered Bride*. Smetana laid the foundations for a national musical language that, despite the continuous reference to foreign models – in particular Hector Berlioz and Franz Liszt – enhanced the cultural and ethnic heritage of Bohemia, giving a prominent role to his nation in the European music of the nineteenth century. His work had a great influence on Antonín Dvořák, who also used the Czech language in his operas, and on many subsequent composers including Schoenberg.

22 *Green Card* (1990). Directed by Peter Weir, starring Gérard Depardieu and Andie MacDowell.

23 *Star Trek: The Motion Picture* (1979), directed by Robert Wise.

24 Directed in 1987 by Stanley Kubrick, starring Mathew Modine.

25 Directed in 2007 by David Silverman.

Notes

1 *Lemony Snicket's A Series of Unfortunate Events* (2004), based on the books by Daniel Handler, directed by Brad Sieberling, with Jim Carrey, Jude Law, Meryl Streep.

2 *Andrei Rublev*, directed in 1966 by Andrei Tarkovsky, with Anatoli Solonitsyn and Ivan Lapikov.

3 *Quills*, directed in 2000 by Philip Kaufman, with Geoffrey Rush, Kate Winslet, Joaquin Phoenix and Michael Caine.

4 *Annie Hall*, directed in 1977 by Woody Allen, starring Allen and Diane Keaton.

5 *The League of Extraordinary Gentlemen*, directed in 2003 by Stephen Norrington, starring Sean Connery, Naseeruddin Shah, Peta Wilson, Tony Curran.

6 *Travels in America* by Thomas Ashe, London, Richard Philips, 1808.

7 Captain John Smith (1580–1631), admiral of New England, wrote several essays about his explorations in Virginia, about the English settlements and the Powhatan tribe. These include 'A True Relation of Such Occurrences and Accidents of Note as Happened in Virginia' (1608), 'A Map of Virginia' (1612) and 'The Generall Historie of Virginia, New England, and the Summer Isles' (1624).

8 Edward Wright Haile, *Jamestown Narratives – Eyewitness Accounts of the Virginia Colony, the First Decade: 1607–1617*, Champlain, Virginia: RoundHouse, 1998.

9 The Virginia Company of London was an English joint stock company chartered by James I, together with Virginia Company of Plymouth, on 10 April 1606, with the purpose of establishing settlements on the coast of North America.

10 John White (1540–1593) was an English artist who joined Richard Grenville's colonial expedition of 1585 to North Carolina as a settler. His numerous watercolour drawings made during his stay at Roanoke Island are the most informative illustrations of a Native American society of the Eastern Seaboard. He later became governor of the Roanoke Colony, which was the first – failed – attempt to create a permanent English colony in America.

11 Jacques le Moyne de Morgues (c.1533–1588) was a French artist and member of Jean Ribault's 1584 expedition, an ill-fated French attempt to colonize northern Florida. He portrayed the Native Americans, colonial life and plants of the New World.

12 Theodorus de Bry (1528–1598) was a Belgian engraver, goldsmith, book editor and publisher, who travelled all around Europe, from his native Liège to Strasbourg, Antwerp, London and Frankfurt. From 1590 he became famous through his publication of illustrated books based on first-hand observations by European explorers of the New

World, with engraved illustrations from John White and le Moyne's original works. He never visited the Americas. He and his son John-Theodore (1560–1623) made adjustments to both the texts and the illustrations of the original accounts to please the presumed readership, changing the representations in accordance with the varying national sensibilities.

13 Henry Spelman (1595–1623) left his home in Norfolk, England, in 1609 at the age of fourteen, to sail aboard the ship *Unity* as a part of the Third Supply to the Jamestown colony. A soldier and adventurer, he documented the first permanent English settlement in North America, at Jamestown, but especially the lifestyles of the Native Americans of the Powhatan Confederacy in his book *Relation of Virginia*.

14 Edward Sheriff Curtis (1868–1952), photographer of the American West and Native American peoples.

15 George Catlin (1796–1872) was an American author, traveller and painter who specialized in portraits of Native Americans in the Old West.

16 Thomas E. Mails (1920–2001) was a painter, illustrator and writer born in California whose work was mainly focused on the native culture of the Southwest. His books include *Dog Soldiers, Bear Men and Buffalo Women* (1973), *Fool's Crow* (1980) and *The Mystic Warriors of the Plains* (1995).

17 Stephen Laurent (1909–2001) was a Native American of the Abenaki Nation, settled in Canada (New England, Quebec and the Maritimes). Son of Abenaki Chief Joseph Laurent (1839–1917), he was a talented lexicographer who took on the task of augmenting an unpublished Abenaki–French dictionary compiled by a Jesuit missionary, Father Joseph Aubery (1673–1755), and translating it into English, with the intention of preserving Abenaki culture. After many years of work on this project he published five hundred copies of *Father Aubery's Dictionary* in 1995. To preserve the pronunciation of the Abenaki language, Stephen Laurent also recorded the entire *Dictionary* on tape.

18 Kristian Bogner (1976–), Canadian photographer of sport, nature and native communities.

19 William Strachey (1572–1621) was an English writer who described the early history of the English colonization of North America. Sailing to Virginia, he witnessed the 1609 shipwreck of the ship *Sea Venture* near Bermuda. Strachey's ship reached Virginia ten months later, and he went on to write about the colony there.

20 *Sleepy Hollow* (1999), directed by Tim Burton, with Johnny Depp and Christina Ricci.

21 *Buena Vista Social Club* (1999), directed by Wim Wenders, with Ry Cooder and Compay Segundo.
22 *Perfume: The Story of a Murderer* (2006), directed by Tom Tykwer, with Ben Whishaw.
23 Directed in 1999 by Leslie Woodhead and Bud Greenspan and produced by Terrence Malick and Edward Pressman. The film tells the story of the Ethiopian marathon runner Haile Gebrselassie.
24 'When Virginia Was Eden, and Other Tales of History' by Manohla Dargis, *New York Times*, 23 December 2005.
25 *Children of Men* (2006), directed by Alfonso Cuarón, with Clive Owen.

THE TREE OF LIFE: A BRIDGE TO THE WONDER

1 *The Matrix Reloaded*, directed in 2003 by Andy and Lana Wachowski.
2 *The Matrix Revolutions*, directed in 2003 by Andy and Lana Wachowski.
3 *Speed Racer*, directed in 2008 by Andy and Lana Wachowski.
4 *Silent Running* (1972), directed in 1972 by Douglas Trumbull.
5 *2001: A Space Odyssey*, directed in 1968 by Stanley Kubrick.
6 *Close Encounters of the Third Kind*, directed in 1977 by Steven Spielberg.
7 Skunk Works is an alias for the Lockheed Martin company's Advanced Development Programs (ADP). The Skunk Works started to operate in Burbank, California in 1943. During the war years a number of aircraft were designed in the laboratory.
8 *Inception* (2010), directed by Christopher Nolan.
9 The first stars in the universe after the Big Bang were named as Population III, because they were discovered after Population I and Population II.
10 *Blade Runner* (1982), directed by Ridley Scott.
11 Thomas Wilfred (1889–1968), born Richard Edgar Løvstrom, was an eclectic artist. He worked as a musician and visual artist, inventing the visual music he named Lumia. He also designed a kind of colour organ, an electromechanical device to represent sound in a visual medium, which he named Clavilux. He designed Lumia works for installation in museums and art galleries, but he also created a small Clavilux meant for home exhibition. Once he moved to New York, he founded, along with Claude Fayette Bragdon and Kirkpatrick Brice, a Theosophist movement called the Prometheans. The aim of the movement was to explore spirituality through artistic expression. He considered Lumia as the 'eighth art' and early on he decided to abandon any kind of sound to have just the light performing in his

exhibition. So the Clavilux became a very complex instrument which allowed him to perform Lumia compositions. He founded the Art Institute of Light and he also worked in theatre, becoming a pioneer of projected scenography.

12 The crew that worked on the Italy shoot was quite big. In the end credits of the film only Carlo Hintermann and the production company Citrullo International are credited, because the titles had to stay at a certain length. We are glad to list all the crew members here: ROME UNIT: DIRECTOR: Carlo Hintermann; ASSISTANT DIRECTOR: Giancarlo Leggeri; DOP/CAMERA OPERATOR: Matteo Ortolani (AITR); ASSISTANT CAMERA: Vittoria Tempo; CAMERA LOADER: Debora Vrizzi (AITR); CAMERA EQUIPMENT: Technovision; LAB: Technicolor; THANKS: Loreto Bonomo – Ministero del Commercio con l'Estero, EUR S.P.A. ITALY UNIT: CASTING DIRECTOR: Daniele Villa; LOCATION MANAGER: Gerardo Panichi; PRODUCTION MANAGER: Luciano Barcaroli; CASTING CHILDREN: Giulia Mazzoldi – Fotoarte Mazzoldi; CASTING CONSULTANT: Carmela Incatasciato – Accademia Nazionale di Danza; DOP/STEADICAM OPERATOR: Joerg Widmer; FIRST ASSISTANT CAMERA: Jan Moritz Kaetner; ITALIAN FIRST ASSISTANT CAMERA: Matteo Ortolani (AITR); CAMERA LOADER: Emiliano Massimo Canevari Intoppa (AITR); KEY GRIP: Paolo Frasson; GAFFER: Giuliano Pandolfi; SET DECORATOR: Marco Ficorella; ASSISTANT SET DECORATOR: Mario Frattesi; COSTUMES SUPERVISOR: Maria Galante; TAILOR: Giuliana Filogonio; MAKE-UP: Maria Grazia Tacchi; CATERING: Casino di caccia – Villa Lante, Società Giardino di Bomarzo, Catia Crespino; SECURITY ON SET: Framinia S.R.L.; ACCOUNTANCY: Studio Consulenza del Lavoro Amicone Sabrina; EXTRAS CO-ORDINATORS: Giulia Mazzoldi, Piero Pacchiarotti; TRANSPORTATION: Royal Bus – Massimiliano Passalacqua; CAMERA EQUIPMENT: Arri Berlin; LIGHTING EQUIPMENT: Panalight; LAB: Technicolor; RUNNERS: Gianni Pittiglio, Sara Nicotera, Gilberto Capurso, Roberto Fazioli; ANIMAL TRAINER: Pasquale Martino; CHRYSALIS: Butterfly Arc; ACTORS: Children: Rocco Waas, Adelchi Ghezzi, Alessandro Corvino, Leonardo Puleo, Federico Barbani, Tiziano Vesce, Gianluca De Felici, Daniele Sorbo, Sofia Sorbo, Carlotta Bonomo, Valeria Medici, Lucrezia Iori, Martina Russi, Beatrice Valiserra, Chiara Matteo, Aurora Fantasia, Sara Cracolici, Adriano Galli; Dancers: Giuseppina Del Prete, Eleonora Sgambetterra, Carlotta Ballanti, Angelica Mela, Carlotta Maggiorana, Martina Berrettoni; THANKS: Anna Rita Hintermann, Roberto Bettini, Check Sound, Maria Simmi, Felice Accamo, Roberto

Gambacorta, Margherita Parrilla (Director of Accademia Nazionale di Danza).

13 At the beginning of the movie Mrs O'Brien tells in the voice-over what the nuns said to her about nature and grace when she was a child. The concepts expressed in this passage of the movie are derived from the vast investigation of the concept of nature and grace in Thomas Aquinas's *Summa Theologiae* (written between 1265 and 1274).

14 A. J. Edwards started to collaborate with Terrence as editorial intern on *The New World*, and he also worked as cameraman for the documentary about the making of the film. He is now directing his first feature, *The Green Blade Rises*, produced by, among others, Nick Gonda.

15 The movie uses the following pieces by Hector Berlioz: 'Domine Jesu Christe' and 'Agnus Dei' ['Requiem Op. 5' ('Grande Messe des Morts')], performed by Wandsworth School Boys Choir, London Symphony Chorus, London Symphony Orchestra, conducted by Sir Colin Davis; 'Harold in Italy', performed by the San Diego Symphony Orchestra, conducted by Yoav Talmi.

16 *My Country – Vltava* (*The Moldau*), composed by Bedřich Smetana, performed by Vaclav Smetáček and the Czech Philharmonic Orchestra.

17 'Pièces de clavecin, Book II 6e Ordre N°5: Les Baricades Mistérieuses', composed by François Couperin, performed by Angela Hewitt.

18 Zbigniew Preisner (born 20 May 1955) is a Polish composer. He worked as a film score composer for several movies by Krzysztof Kieślowski, and for many other directors, among them Agnieszka Holland and Jean Becker. The 'Lacrimosa' is part of *Requiem for My Friend*, a composition premiered in 1998, originally conceived for a Krzysztov Kieślowski film project that became a memorial to Kieślowski after the director's death.

Index

Aaronson, Reuben, 159–60
Abbey, Edward, 81, 389
actors: 1960s and 1970s change in
 style, 18–19; New York acting
 scene, 20
Adams, Brooke: and Gere and
 Shepard, 107
 DAYS OF HEAVEN: casting, 107;
 character played by, 84–5, 87–8,
 90, 108; scenes featuring, 132,
 137, 138; shooting, 101, 106
Adjuster, The, 168
Adkins, Chief, 258, 293
AFI *see* American Film Institute
Albee, Edward, 17
Aldrich, Robert, 9
Alfred, William, 2–3
Allen, Penny: on Savage, 175–6, 177;
 on TM, 161–2, 167–8, 179, 244–5
 THE THIN RED LINE: casting, 166,
 169, 171, 172, 177, 178; on
 characters, 192–3; coaching,
 180–4, 194, 222, 224; as learn-
 ing experience, 175; reaction to,
 211; relationship with cast and
 crew, 188
Allen, Woody, 389, 393
Allende, Salvador, 383
Almendros, Nestor: and *Days of
 Heaven*, 84, 94–5, 118–32, 135–7,
 139–40, 144; and Wexler, 16
Althusser, Louis, 382
Altman, Robert, 109, 247, 386
American Film Institute (AFI) film
 direction school, 4–9
Anderson, Lindsay, 15
Anderson, Michael, 386
Andrei Rublev, 252
Angels as Hard as They Come, 13

Anger, Kenneth, 389
animal migrations, 147
Anne of Denmark, Queen of England
 and Scotland, 275
Annie Hall, 253
Antonioni, Michelangelo, 9, 126
Apted, Michael, 383
APVA *see* Association for the
 Preservation of Virginia
 Antiquities
Aquinas, Thomas, 341
Arendt, Hannah, 383
Arkin, Alan, 384
Ashby, Hal, 9, 383, 391
Ashe, Thomas, 393
Ashes and Diamonds, 19
Association for the Preservation of
 Virginia Antiquities (APVA), 261
Atherton, David, 269, 271
Atlab, 187
Aubery, Father Joseph, 394
Australia *see* Queensland

Bach, Johann Sebastian, 371
Badlands, 23–83; camera work and
 lighting, 55–63; casting, 18–19, 20,
 27–34; crew size, 252; distribution,
 74–6; editing, 67–72; fire scene,
 79–80; Gonda on, 299; influence,
 13, 84; inspiration, 23; reception,
 26, 73–82; research and plan-
 ning, 13–16, 23–7; restored copy
 screening, xiv; score, 68–72; script,
 characters and plot, 34–42, 60–1,
 63, 64, 65–7; sets, 50–5; shoot-
 ing, 42–67; spirituality in, 79–80;
 themes, 79–82; tree-house scene,
 256; voice-over use, 35, 62–5, 70,
 73, 77, 235; Yoshikawa on, 361

401

Malick, Terrence (TM): family background, 10; birth, 1; childhood and education, 1; at Harvard, 1–3; at Oxford, 3–4; at Massachusetts Institute of Technology, 3; as journalist, 3–4, 248; at AFI's film direction school, 4–9; student film, 8; Medavoy becomes his agent, 8–9; writing jobs, 9–13; works on Q, 146–8; long gap between films, 148–9; association with Sunflower Productions, 391–2
 FILMS: see individual films by name
 GENERAL: character, 31, 78–9, 105; favourite time of day for shooting, 128–31; film themes, 185–6; on filmmaking, 297; filmmaking style, 22, 60, 81–2, 310–11, 344–5, 360, 365; filmmaking team, 297–8, 298–301; love of nature, 60–2, 98, 139, 147, 201, 286–7; own camera work, 50–1, 55, 59, 61, 209, 288; public speaking, 15; relationship with actors, 21–2, 46–50, 64, 115–18, 167–8, 178–81, 207–9, 221, 227; spirituality, 151, 161–2, 201
Malraux, André, 383
Man Who Fell to Earth, The, 387
Man Who Loved Women, The, 390
Mankiewicz, Joseph L., 387
Mannix, 34
Manz, Linda, 77, 84, 107–11, 389
Marcus, David, 184–5
Marfa Lights, The, 392
Margulis, Lynn, 325
Marina del Rey, Venice, California, 309
Marquise of O, The, 139
Marvin, Lee, 384
Massachusetts Institute of Technology (MIT), 3
Matrix Reloaded, The, 308
Matrix Revolutions, The, 308
Maurier, George du, 391

Mechanic, Bill, 150, 249
Medavoy, Mike: and Badlands, 25; becomes TM's agent, 8–9; and Ben Chaplin, 173; on Days of Heaven, 92; on film industry in 1960s and 1970s, 15; links Sean Penn to TM, 164; and Q, 148; and The Thin Red Line, 149, 150, 183, 231–2
Method Studios, 314
Metro Goldwyn Mayer, 131
Mihok, Dash, 173
Milanesia (2001), 384
Milius, John, 15, 387
Miramax, 75
MIT see Massachusetts Institute of Technology
Modine, Matthew, 392
Molland, Hans Peter, 392
Monda, Antonio, 385
Monroe, Marilyn, 231–2
More, 130
Mori, Johnny, 213
Morricone, Ennio, 97–8, 99, 102–4, 144
Morris, Mick, 187
Morrissey, Paul, 387
Moyne de Morgues, Jacques le, 260, 262, 394
My Girl, 387

Native Americans, 258–61, 262, 265–9, 271, 278
Natural, The, 383
Nelson, Andy, 243–4
New Line, 250
New World, The, 248–95; alternative title, 286; camera work and lighting, 251, 254, 278, 280–3, 359; cast and casting, 249–50, 258, 259, 262–6, 270, 273–6; characters, 262–5, 272–7; coaching, 266–7; colour palette, 282; costumes and make-up, 252–3, 258, 260, 261–2, 267–9, 271, 272–3, 274–6, 278–9, 282; crew, 251–4; cuts, 294; editing, 290–2, 360–1, 362; Edwards's role, 396;

Index